Hans Richter
was well known both as a painter
and film-maker. While in Zurich from 1916-20, he
started the Dada movement with Hugo Ball, Tristan
Tzara and others. In 1940 he left Europe for the US
and became an American citizen. His films include:
Vormittagspuk, *Dreams that Money Can Buy*, *Dadascope*
and *8 x 8*, produced in collaboration with Arp, Calder,
Duchamp, Ernst, Huelsenbeck, Man Ray and others.
His paintings hang in galleries throughout the world,
and he was the author of several books on
the cinema and art. He died in 1976.

WORLD OF ART

This famous series
provides the widest available
range of illustrated books on art in all its aspects.
If you would like to receive a complete list
of titles in print please write to:
THAMES AND HUDSON
30 Bloomsbury Street, London WC1B 3QP
In the United States please write to:
THAMES AND HUDSON INC.
500 Fifth Avenue, New York, New York 10110

Printed in Singapore

DADA
art and anti-art

HANS RICHTER

179 illustrations, 8 in colour

Translated from the German by David Britt

Thames and Hudson

To the memory of my sister Vera

© 1964 DuMont Schauberg, Cologne
This edition © 1965 and 1997
Thames and Hudson Ltd, London

Reprinted, with updated bibliography, 1997

ISBN 0-500-20039-4

Printed and bound in Singapore by C.S. Graphics

Contents

Foreword

When I visited my old Dada colleague Tristan Tzara in Paris two years ago, he left me these parting words as food for thought on my journey: "Don't forget that polemics always played a big part in Dada." This may be true, especially where the literary side of Dada is concerned. But Dada has too often been regarded as a style of literary polemic directed at the overthrow of existing forms. Alongside the noisy literary movement there existed another which was not polemical at all: a total revolution in visual art, more radical than that which took place in literature, although intimately linked with it.

The life we led, our follies and our deeds of heroism, our provocations, however 'polemical' and aggressive they may have been, were all part of a tireless quest for an anti-art, a new way of thinking, feeling and knowing. New art in a new-found freedom!

> In setting out to describe this quest and this freedom,
> the people who made Dada,
> their day-to-day experiences,
> their life together,
> their enthusiasm,
> their independence of mind,
> their artistic discoveries,
> their joyous contempt for banality,
> the hostility, even the hatred evoked by this contempt . . .

I shall not be able to confine myself within the bounds of academic art-history. I shall depend above all on my own memories and those of my surviving friends. The dates and facts of those years, the pronouncements, denials and contradictions, the theories and the works of anti-art: these are the signs by which the living Dada movement is known for what it was, an artistic revolt against art. Having been involved in this revolt myself, I shall try to tell what I experienced, what I heard, and how I remember it. I hope to do justice to the age, to the history of art, and to my friends, dead and living.

KARAWANE

jolifanto bambla ô falli bambla

grossiga m'pfa habla horem

égiga goramen

higo bloiko russula huju

hollaka hollala

anlogo bung

blago bung

blago bung

bosso fataka

ü üü ü

schampa wulla wussa ólobo

hej tatta gôrem

eschige zunbada

wulubu ssubudu uluw ssubudu

tumba ba- umf

kusagauma

ba - umf

(1917)
Hugo Ball

Hugo Ball, *Phonetic poem*, 1917

Introduction

Today, more than fifty years later, the image of Dada is still full of contradictions. This is not surprising. Dada invited, or rather defied, the world to misunderstand it, and fostered every kind of confusion. This was done from caprice and from a principle of contradiction.

Dada has reaped the harvest of confusion that it sowed.

However this confusion was only a façade. Our provocations, demonstrations and defiances were only a means of arousing the bourgeoisie to rage, and through rage to a shamefaced self-awareness. Our real motive force was not rowdiness for its own sake, or contradiction and revolt in themselves, but the question (basic then, as it is now), "where next?"

Dada was not an artistic movement in the accepted sense; it was a storm that broke over the world of art as the war did over the nations. It came without warning, out of a heavy, brooding sky, and left behind it a new day in which the stored-up energies released by Dada were evidenced in new forms, new materials, new ideas, new directions, new people – and in which they addressed themselves to new people.

Dada had no unified formal characteristics as have other styles. But it did have a new artistic ethic from which, in unforeseen ways, new means of expression emerged. These took different forms in different countries and with different artists, according to the temperament, antecedents and artistic ability of the individual Dadaist. The new ethic took sometimes a positive, sometimes a negative form, often appearing as art and then again as the negation of art, at times deeply moral and at other times totally amoral.

It is understandable that art historians, professionally trained to distinguish the formal characteristics of particular stylistic periods, have been unable to cope with the contradictions and complexities of Dada. They were prepared to measure the length, breadth and depth of Dada, but found it hard to do justice to its actual content. This was as true of Dada's contemporaries as it is of the younger historians who were then still at school. Art historians describe Dada as a 'transitional stage' in the arts. Journalists mistake Dada's rowdiness for

its essential message. The Dadaists themselves, with a modesty that never exactly constituted the essence of the movement, give conscientious accounts of the parts they themselves played in Dada. From the beginning, Dada was thus replaced by a thoroughly blurred mirror image of itself. Since then even the mirror has broken. Anyone who finds a fragment of it can now read into it his own image of Dada, conditioned by his own aesthetic, national, historical or personal beliefs and preferences. Thus Dada has become a myth.

However, Dada was not a myth but an entirely real event which affected us seriously every day of our lives. In order to appreciate how serious and how real Dada was, it will be necessary to go back to the rules which make possible a measure of historical accuracy. In all cases where the dates and facts of Dada are overgrown with differing interpretations, I should like to establish three different categories of proof:

1. Dates and facts supported by published documents, diaries, etc., dating from the period itself.
2. Dates and facts for which there is no documentary proof dating from the period, but for which there are at least two disinterested witnesses or testimonies.
3. Dates and facts which can only be attested to by the author or one friend.

I have no desire to cast doubt on anyone's testimony. Many of these facts and dates can with the best will in the world no longer be substantiated except by the author himself. None of us thought that Dada was "for eternity". On the contrary, we lived in and for the moment. The fact that so many pieces of evidence still exist proves that among the carefree grasshoppers there were a few careful ants.

1 Zurich Dada 1915-1920

Where did Dada begin?

In order to unravel the tangle of confusion and misunderstanding that constitutes the present-day image of Dada, we need to pose a series of questions. The answers are unlikely to satisfy all my old Dadaist friends – nor those among my readers for whom twice two always makes four. Sometimes my experience of life, and my assessment of a situation, will have to bridge a gap where dates and facts are absent or untrustworthy.

Where and how Dada began is already almost as hard to determine as Homer's birthplace. This is the conclusion reached by Raoul Hausmann, paramount chief of the Berlin Dada movement, in his *Courrier Dada* of 1960. It is true that he believes that he himself discovered Dada in 1915. Claude Rivière, writing in *Arts* (19th March 1962), names Picabia as the originator of Dada. "In his [Picabia's] journey to the Jura in 1913, we can observe the first beginnings of what was later to be called the Dada movement."

The statement of Alfred Barr, former director of the Museum of Modern Art, New York, that Dada began in 1916 in New York and Zurich, contains truth and error in equal proportions. The sculptor Gabo draws my attention to Dadaist works in Russia dating from as early as 1915. In 1909 the Italian futurists were publishing manifestos which were as like Dada as two peas in a pod – typography à la Dada and public hell-raising in Dada style. Even André Gide has, on occasion, been called the first Dadaist. Mark Twain maintained (as no one but a Dadaist could) that man is a "mere coffee mill". And what of Brisset, Alfred Jarry, Christian Morgenstern, Apollinaire and all the others mentioned by André Breton in his *Anthologie de l'humour noir*? Where are we to draw the line? That celebrated Smith or Jones of antiquity, Herostratus, who burned down the temple of Artemis at Ephesus to awaken his fellow-citizens and draw their attention to himself, was surely a Dadaist who had nothing to learn from the Berlin or Paris Dadaists, nor they from him.

It is not difficult to find Dada tendencies and manifestations of Dada in many periods of the recent or remote past, without having to use the word Dada in speaking of them. It is nevertheless true that, around the year 1915 or 1916, certain similar phenomena saw the light of day (or night) in different parts of the globe, and that the general label of 'Dada' can be applied to all of them.

But it was only in *one* of these that the magic fusion of personalities and ideas took place which is essential to the formation of a movement. The peculiarly claustrophobic and tense atmosphere of neutral Switzerland in the middle of the Great War supplied an appropriate background. The Swiss Dada movement, which carried others after it and with it, began in Zurich, at the Cabaret Voltaire, at the beginning of 1916. No national, aesthetic or historical interpretation or manipulation can alter this fact, however firmly some people may cling to their prejudices. A writer in the *Times Literary Supplement,* 23rd October 1953, is perfectly right when he says: "The fact that Dada began life in Zurich and not in New York or Paris is significant, for the movement owes many of its characteristics to the peculiar atmosphere prevailing in that city at that time."

It was here, in the peaceful dead-centre of the war, that a number of very different personalities formed a 'constellation' which later became a 'movement'. Only in this highly concentrated atmosphere could such totally different people join in a common activity. It seemed that the very incompatibility of character, origins and attitudes which existed among the Dadaists created the tension which gave, to this fortuitous conjunction of people from all points of the compass, its unified dynamic force.

The real, unmythologised history of Dada is the sum of the achievements of all these individual particles of energy. This is the key to that 'unification of opposites' which became an artistic reality, for the first time in history, in the shape of Dada.

How did Dada begin ?

In 1915, soon after the outbreak of the First World War, a rather under-nourished, slightly pock-marked, very tall and thin writer and producer came to Switzerland. It was Hugo Ball, with his mistress Emmy Hennings who was a singer and poetry reader (*Ills.* 1, 2). He belonged to the 'nation of thinkers and poets', which was engaged, at that time, in quite different activities. Ball,

however, had remained both a thinker and a poet: he was philosopher, novelist, cabaret performer, journalist and mystic.

> *I had no love for the death's-head hussars,*
> *Nor for the mortars with the girls' names on them,*
> *And when at last the glorious days arrived,*
> *I unobtrusively went on my way.*

(Hugo Ball)

It is impossible to understand Dada without understanding the state of mental tension in which it grew up, and without following in the mental and physical footsteps of this remarkable sceptic. (The diaries of this extraordinary man were published after his death in 1927, under the title *Flucht aus der Zeit* ['Flight from Time'].) Guided and perhaps plagued by his conscience, Ball became the human catalyst who united around himself all the elements which finally produced Dada.

It was not until many years later, when he already lay in his grave at San Abbondio, in Ticino, the little village where he had lived with his wife Emmy, that I learned about the latter part of his life. He had renounced all the excesses of his youth, had become very devout, and had lived among poor peasants, poorer than they, giving them help whenever he could. Fourteen years after his death, people in Ticino still spoke with love and admiration of his nobility and goodness.

There can be no doubt of Ball's unswerving search for a *meaning* which he could set up against the absurd meaninglessness of the age in which he lived. He was an idealist and a sceptic, whose belief in life had not been destroyed by the deep scepticism with which he regarded the world around him.

On 1st February 1916, Ball founded the Cabaret Voltaire. He had come to an arrangement with Herr Ephraim, the owner of the Meierei, a bar in Niederdorf, a slightly disreputable quarter of the highly reputable town of Zurich. He promised Herr Ephraim that he would increase his sales of beer, sausage and rolls by means of a literary cabaret. Emmy Hennings sang *chansons*, accompanied by Ball at the piano. Ball's personality soon attracted a group of artists and kindred spirits who fulfilled all the expectations of the owner of the Meierei.

In the first Dada publication Ball writes:

When I founded the Cabaret Voltaire, I was sure that there must be a few young people in Switzerland who like me were interested not only in enjoying their

independence but also in giving proof of it. I went to Herr Ephraim, the owner of the Meierei, and said, "Herr Ephraim, please let me have your room. I want to start a night-club." Herr Ephraim agreed and gave me the room. And I went to some people I knew and said, "Please give me a picture, or a drawing, or an engraving. I should like to put on an exhibition in my night-club." I went to the friendly Zurich press and said, "Put in some announcements. There is going to be an international cabaret. We shall do great things." And they gave me pictures and they put in my announcements. So on 5th February we had a cabaret. Mademoiselle Hennings and Mademoiselle Leconte sang French and Danish chansons. Herr Tristan Tzara recited Rumanian poetry. A balalaika orchestra played delightful folk-songs and dances.

I received much support and encouragement from Herr M. Slodki, who designed the poster, and from Herr Hans Arp, who supplied some Picassos, as well as works of his own, and obtained for me pictures by his friends O. van Rees and Artur Segall. Much support also from Messrs. Tristan Tzara, Marcel Janco and Max Oppenheimer, who readily agreed to take part in the cabaret. We organized a Russian evening and, a little later, a French one (works by Apollinaire, Max Jacob, André Salmon, A. Jarry, Laforgue and Rimbaud). On 26th February Richard Huelsenbeck arrived from Berlin, and on 30th March we performed some stupendous Negro music (toujours avec la grosse caisse: boum boum boum boum – drabatja mo gere drabatja mo bonoooooooooo –). Monsieur Laban was present at the performance and was very enthusiastic. Herr Tristan Tzara was the initiator of a performance by Messrs. Tzara, Huelsenbeck and Janco (the first in Zurich and in the world) of simultaneist verse by Messrs. Henri Barzun and Fernand Divoire, as well as a poème simultané of his own composition, which is reproduced on pages six and seven. The present booklet is published by us with the support of our friends in France, Italy and Russia. It is intended to present to the Public the activities and interests of the Cabaret Voltaire, which has as its sole purpose to draw attention, across the barriers of war and nationalism, to the few independent spirits who live for other ideals. The next objective of the artists who are assembled here is the publication of a revue internationale. La revue paraîtra à Zurich et portera le nom "Dada" ("Dada"). Dada Dada Dada Dada.

Zurich, 15th May 1916.

I shall often quote from Ball's diaries, because I know of no better source of evidence on the moral and philosophical origins of the Dada revolt which started in the Cabaret Voltaire. It is entirely possible that any or all of the other

A ls ich das Cabaret Voltaire gründete, war ich der Meinung, es möchten sich in der Schweiz einige junge Leute finden, denen gleich mir daran gelegen wäre, ihre Unabhängigkeit nicht nur zu geniessen, sondern auch zu dokumentieren. Ich ging zu Herrn Ephraim, dem Besitzer der „Meierei" und sagte: „Bitte, Herr Ephraim, geben Sie mir Ihren Saal. Ich möchte ein Cabaret machen." Herr Ephraim war einverstanden und gab mir den Saal. Und ich ging zu einigen Bekannten und bat sie: eine Zeichnung, eine Gravüre. Ich möchte meinem Cabaret verbinden." Ging zu der bat sie: „Bringen sie einige Notizen. Es werden. Wir wollen schöne Dinge machen," brachte meine Notizen. Da hatten wir am Hennings und Mde. Leconte sangen Chansons. Herr Tristan Tzara rezitierte Orchester spielte entzückende russische Viel Unterstützung und Sympathie das Plakat des Cabarets entwarf, bei Herrn Arbeiten einige Picassos zur Verfügung „Bitte geben Sie mir ein Bild, eine kleine Ausstellung mit freundlichen Züricher Presse und soll ein internationales Cabaret Und man gab mir Bilder und 5. Februar ein Cabaret. Mde. französische und dänische rumänische Verse. Ein Balalaika-Volkslieder und Tänze. fand ich bei Herrn M. Slodki, der Hans Arp, der mir neben eigenen stellte und mir Bilder seiner Freunde O. van Rees und Artur Segall vermittelte. Viel Unterstützung bei den Herren Tristan Tzara, Marcel Janco und Max Oppenheimer, die sich gerne bereit erklärten, im Cabaret auch aufzutreten. Wir veranstalteten eine RUSSISCHE und bald darauf eine FRANZÖSISCHE Soirée (aus Werken von Apollinaire, Max Jacob, André Salmon, A. Jarry, Laforgue und Rimbaud). Am 26.

Februar kam Richard Huelsenbeck aus Berlin und am 30. März führten wir eine wundervolle Negermusik auf (toujours avec la grosse caisse: boum boum boum boum — drabatja mo gere drabatja mo bonoooooooooooo —) Monsieur Laban assistierte der Vorstellung und war begeistert. Und durch die Initiative des Herrn Tristan Tzara führten die Herren Tzara, Huelsenbeck und Janco (zum ersten Mal in Zürich und in der ganzen Welt) simultanistische Verse der Herren Henri Barzun und Fernand Divoire auf, sowie ein Poème simultan eigener Composition, das auf der sechsten und siebenten Seite abgedruckt ist. Das kleine Heft, das wir heute herausgeben, verdanken wir unserer Initiative und der Beihilfe unserer Freunde in Frankreich, ITALIEN und Russland. Es soll die Aktivität und die Interessen des Cabarets bezeichnen, dessen ganze Absicht darauf gerichtet ist, über den Krieg und die Vaterländer hinweg an die wenigen Unabhängigen zu erinnern, die anderen Idealen leben. Das nächste Ziel der hier vereinigten Künstler ist die Herausgabe einer Revue Internationale. La revue paraîtra à Zurich et portera le nom „DADA". („Dada") Dada Dada Dada Dada.

ZÜRICH, 15. Mai 1916

Hugo Ball, *Cabaret Voltaire*. The first Dadaist publication

Dadaists – Arp, Duchamp, Huelsenbeck, Janco, Schwitters, Ernst, Serner, or another – went through the same inner development, fought similar battles and were plagued by the same doubts, but no one but Ball left a record of these inner conflicts. And no one achieved, even in fragmentary form, such precise formulations as Ball, the poet and thinker.

To understand the climate in which Dada began, it is necessary to recall how much freedom there was in Zurich, even during a world war. The Cabaret Voltaire played and raised hell at No. 1, Spiegelgasse. Diagonally opposite, at No. 12, Spiegelgasse, the same narrow thoroughfare in which the Cabaret Voltaire mounted its nightly orgies of singing, poetry and dancing, lived Lenin. Radek, Lenin and Zinoviev were allowed complete liberty. I saw Lenin in the library several times and once heard him speak at a meeting in Berne. He spoke good German. It seemed to me that the Swiss authorities were much more suspicious of the Dadaists, who were after all capable of perpetrating some new enormity at any moment, than of these quiet, studious Russians ... even though the latter were planning a world revolution and later astonished the authorities by carrying it out.

Press announcement, 2nd February 1916:

"Cabaret Voltaire. Under this name a group of young artists and writers has formed with the object of becoming a centre for artistic entertainment. The Cabaret Voltaire will be run on the principle of daily meetings where visiting artists will perform their music and poetry. The young artists of Zurich are invited to bring along their ideas and contributions."

They brought them along.

On 5th February 1916, Ball writes: "The place was full to bursting; many could not get in. About six in the evening, when we were still busy hammering and putting up Futurist posters, there appeared an oriental-looking deputation of four little men with portfolios and pictures under their arms, bowing politely many times.

"They introduced themselves: Marcel Janco the painter, Tristan Tzara, Georges Janco and a fourth, whose name I did not catch. Arp was also there, and we came to an understanding without many words. Soon Janco's opulent *Archangels* hung alongside the other objects of beauty, and, that same evening Tzara gave a reading of poems, conservative in style, which he rather endearingly fished out of the various pockets of his coat."

Ball's night-club was an overnight sensation in Zurich.

CABARET

The exhibitionist assumes his stance before the curtain
and Pimpronella tempts him with her petticoats of scarlet.
Koko the green god claps loudly in the audience –
and the hoariest of old goats are roused again to lust.

Tsingtara! There is a long brass instrument.
From it dangles a pennant of spittle. On it is written: Snake.
All their ladies stow this in their fiddle-cases now
and withdraw, overcome with fear.

At the door sits the oily Camoedine.
She hammers gold coins into her thighs for sequins.
An arc-lamp puts out both her eyes;
And her grandson is crushed by the burning roof as it falls.

From the pointed ear of the donkey a clown catches
flies. His home is in another land.
Through little verdant tubes which bend
he has his links with barons in the city.

In lofty aerial tracks, where inharmonious
ropes intersect on which we whir away,
a small-bore camel makes platonic
attempts to climb; the fun becomes confused.

The exhibitionist, who in the past has tended
the curtain with a patient eye for tips,
quite suddenly forgets the sequence of events
and drives new-sprouted hordes of girls before him.

(Hugo Ball)

Readings of modern French poetry alternated with recitals by German, Russian and Swiss poets. Old music was played as well as new. This produced some unlikely combinations: Cendrars and van Hoddis, Hardekopf and Aristide Bruant, a balalaika orchestra and Werfel. Delaunay's pictures were exhibited and Erich Mühsam's poems performed. Rubinstein played Saint-Saëns. There were readings of Kandinsky and Lasker-Schüler, as well as Max Jacob and André Salmon.

He is a humble patron of a tenth-rate music-hall,
where, florally tattooed, the devil-women stamp.
Their pitchforks lure him on to sweet perditions,
blinded and fooled, but always in their thrall.

(Hugo Ball)

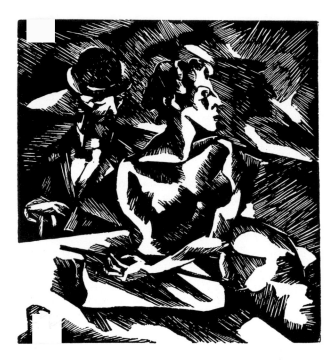

Marcel Slodki, *Im Kabarett,* 1916. Woodcut

The poster for the Cabaret Voltaire was by the Ukrainian painter Marcel Slodki. He was later to participate from time to time, both through personal appearances and by submitting his works, but he never really belonged to Dada. He was a quiet, withdrawn individual whose voice could hardly be heard above the general uproar of the Cabaret Voltaire – or, later, that of the Dada movement.

Thus the Cabaret Voltaire was first of all a literary phenomenon. The creative energies of the group were devoted to the composition, performance and publication of poems, stories and songs. For each of these poems, songs and stories there was an appropriate style of delivery.

Cabaret Voltaire: its members and collaborators

Ball's qualities of thoughtfulness, profundity and restraint were complemented by the fiery vivacity, the pugnacity and the incredible intellectual mobility of the Rumanian poet Tristan Tzara. He was a small man, but this made him all the more uninhibited. He was a David who knew how to hit every Goliath

18

in exactly the right spot with a bit of stone, earth or manure, with or without the accompaniment of witty *bons-mots*, back-answers and sharp splinters of linguistic granite. Life and language were his chosen arts, and the wilder the surrounding fracas, the livelier he became. The total antithesis between him and Ball brought out more clearly the qualities of each. In the movement's early, 'idealistic' period, these anti-*Dioscuri* formed a dynamic, even if serio-comic, unity.

What Tzara did not know, could not do, would not dare to do, had not yet been thought of. His crafty grin was full of humour but also full of tricks; there was never a dull moment with him. Always on the move, chattering away in German, French or Rumanian, he was the natural antithesis of the quiet, thoughtful Ball – and, like Ball, indispensable. In fact, each of these fighters for the spirit and anti-spirit of Dada was indispensable in his own way. What would Dada have been without Tzara's poems, his insatiable ambition, his manifestos, not to speak of the riots he produced in such a masterly fashion? He declaimed, sang and spoke in French, although he could do so just as well in German, and punctuated his performances with screams, sobs and whistles.

Bells, drums, cow-bells, blows on the table or on empty boxes, all enlivened the already wild accents of the new poetic language, and excited, by purely physical means, an audience which had begun by sitting impassively behind its beer-mugs. From this state of immobility it was roused into frenzied involvement with what was going on. This was Art, this was Life, and this was what they wanted! The Futurists had already introduced the idea of provocation into art and practised it in their own performances. As an art it was called Bruitism, and was later given musical status by Edgar Varèse, who followed up Russolo's discoveries in the field of noise-music, which was one of the basic contributions made by Futurism to modern music. In 1911 Russolo had built a noise-organ on which he could conjure up all the distracting sounds of everyday existence – the same sounds that Varèse later used as musical elements. This unique instrument was destroyed at the première of the Buñuel-Dali film *L'Age d'Or* at the *Cinéma 28* in Paris in 1930, when the *camelots du roi* and other reactionary groups threw stink-bombs at the screen on which this 'anti-' [Catholic] film was being shown, and then broke up the whole place: chairs, tables, pictures by Picasso, Picabia and Man Ray, and Russolo's 'bruitistic' organ, which was on show in the foyer along with the pictures. Bruitism was taken up again by the Cabaret Voltaire and gained a good deal from the furious momentum of the new movement: upwards and downwards, left and right, inwards (the groan) and outwards (the roar).

Tzara's anti-friend, the poet and physician Richard Huelsenbeck, was hardly inferior to him in lung-power or in pugnacity. He was very much at home in the turbulent setting of the Cabaret Voltaire, which he had entered by reason of his friendship with Hugo Ball, the man he admired more than anyone. His college-boy insolence infuriated the public as much as did Tzara's rapid wit, although in a totally different way. To enhance the effect of this, he accompanied his brand-new *Phantastische Gebete* ('Fantastic Prayers') by rhythmically swishing a riding-crop through the air – and, metaphorically, on to the public's collective behind.

Huelsenbeck was obsessed with Negro rhythms, with which he and Ball had already experimented in Berlin. His preference was for the big tomtom, which he used to accompany his defiantly tarred-and-feathered 'Prayers'. Hugo Ball writes: "He wanted the rhythm [Negro rhythm] *reinforced:* he would have liked to drum literature into the ground." Imagine the combination of Ball's piano improvisations, Emmy Hennings' thin, unrefined, youthful voice (which was heard alternately in folk-songs and brothel songs) and the abstract Negro masks of Janco, which carried the audience from the primeval language of the new poems into the primeval forests of the artistic imagination – and you will have some idea of the vitality and enthusiasm by which the group is inspired. "They are men possessed, outcasts, maniacs, and all for love of their work. They turn to the public as if asking its help, placing before it the materials to diagnose their sickness", wrote the press. Meanwhile Huelsenbeck sang on, unperturbed:

> *This is how flat the world is*
> *The bladder of the swine*
> *Vermilion and cinnabar*
> *Cru cru cru*
> *The great art of the spirit*
> *Theosophia pneumatica*
> *poème bruitiste performed the first time by*
> *Richard Huelsenbeck Dada*
> *or if you want to, the other way around*
> *birribumbirribum the ox runs down the circulum*
> *Voilà here are the engineers with their assignment*
> *Light mines to throw in a still crude state*
> *7,6 cm Chauceur*
> *and the Soda calc. not to forget 98/100 %*

Here is the beagle damo birridamo holla do funga qualla di mango
damai da dai umbala damo
brrs pffi and the beginning
Abrr Kpppi encore commencer and again
the beginning
Labor
Labor
brae brae brae brae brae brae brae
Sokobauno sokobauno sokobauno
Schikaneder Schikaneder Schikaneder
The garbage cans are pregnant
Sokobauno Sokobauno
and the dead how they rise above,
torches around their head
Voilà the horses bent over the barrels full of rain
Voilà the rivers of wax how they fall from the edges of the moon
Voilà the lake Orizunde how he reads the New York Times
eating a steak tartare,
Voilà the cancer of the bone sokobauno sokobauno
Voilà the placenta crying in the sweep net of the high school boys
sokobauno sokobauno
And now the vicar closing his pants rataplan rataplan
and the hair growing out of his ears
And the billygoat being catapulted from heaven
and the grandmother lifting her breasts
This is the moment when we blow the flour from our tongue
and we cry and the head from the top beam, here it goes without aim
The vicar again he closes his pants rataplan rataplan
he closes them good and the hair, how it grows from his ears
and the heaven again and the thing falls down
and the grandmother lifts now her bosom.
The flour we blow from nostrils and tongue and we cry and
it wanders around and the head on the top beam around us.
Dratkopfgametot ibn ben zakalupp wauwoi zakalupp
and the end of the ass it blows and it cracks and the
mugget of priests in heaven.
And the aposteme in the joints,
balu blau and toujours, here he is the flowery poet

wearing his headgear declining.
Bier bar obibor
Baumabor botschon ortitschell seviglia o casacacasaca casa
cacasacacasaca casa
Hemlock in hand and the purple in skin and worm here and apes
and gorillas
and hand and behind and he has them all here
O tschatschipulala o ta Mpota Mengen
Mengulala mengulala kullilibulala
Bamboscha bambosch
And the pants of the vicar are closing rataplan rataplan
and he closes his pants and the hair how it shoots from his hearing
Tschupurawanta burruh pupaganda burruh
Ischarimunga burruh and the pants of the vicar are closing
Kampampa kamo the flap of the pantis is a-closing
the flap of the pants of the vicars pants
The flaps of the pants are closing
Katapena kamo katapena kara
Tschuwuparanta da umba da umba da do
Da umba da umba da umba hihi
O the flaps of the pants are closing
Mpala the glass and the tooth is now out
and the poet kara katapena kafu
Mfunga mpala Mfunga Koel
Dytiramba toro and the ox and the ox and the verdigris covers
the tip-toes.
Mpala tano ja tano mpala tano tano ojoho mpala tano
mpala tano ja tano ja tano oo and the flap of the pants ohooho
Mpala Zufanga Mfischa Daboscha Karamba juboscha daba eloe.
 (English version by Richard Huelsenbeck)

Like Tristan Tzara, Marcel Janco and his brothers had drifted to Zurich from Bucharest, the 'Paris of the Balkans'. Before coming to Switzerland, Janco *(Ill. 6)* had been a hard-working and conscientious student of architecture. He had stored up in his memory everything from the rush basket, Moses' portable dwelling for the first few days of his life, to Bramante's *Studies in Harmony and Perspective* and the Renaissance theories of Leone Battista Alberti.

This was reflected in the abstract reliefs which he produced and which soon hung on our walls *(Ills. 11, 14)*. They were sometimes carved out of plaster and puritanically white, sometimes painted, and sometimes adorned with pieces of mirror, or even carved out of wood. They were meant to be taken seriously as art and had, as Ball puts it in his diary, "their own logic, without bitterness or irony".

Everything Janco touched had a certain elegance, even his horrific abstract masks. Ball says of them:

"Janco has made a number of masks for the new show, which bear the marks of something more than talent. They recall the Japanese or Ancient Greek theatre, and yet they are wholly modern. They are designed to make their effect at a distance, and in the relatively small space of the cabaret the result is astonishing. We were all there when Janco arrived with the masks, and each of us put one on. The effect was strange. Not only did each mask seem to demand the appropriate costume; it also called for a quite specific set of gestures, melodramatic and even close to madness. Although five minutes earlier none of us had had the remotest idea of what was to happen, we were soon draped and festooned with the most unlikely objects, making the most outlandish movements, each out-inventing the other. The dynamism of the masks was irresistible. In one moment we became aware of the great importance of such masks in mime and drama. The masks simply demanded that their wearers should start up a tragico-absurd dance.

"We now took a closer look at the objects in question, which were cardboard cut-outs, painted and glued. Then, inspired by their Protean individuality, we invented a number of dances, for each of which I improvised on the spot a short piece of music. One of the dances we called 'Flycatching'. This particular mask went with clumsy, tentative steps, long-armed snatching gestures and nervous, shrill music. The second dance we called 'Cauchemar'. The dancer unfolds from a stooping posture, at the same time moving straight forward. Her mask has a wide open mouth and a broad, twisted nose. The performer's arms, menacingly raised, are lengthened by means of special tubes. We called the third dance 'Festive desperation'. The arms are curved to form an arch and from them dangle long golden cut-out hands. The figure turns several times to the left and to the right, then revolves slowly and ends by suddenly collapsing into a heap before slowly returning to the first position and starting again.

"What fascinates us about these masks is that they represent, not humanity, but characters and emotions that are larger than life. The paralysing horror which is the backcloth of our age is here made visible."

Janco was as emotionally involved as Tzara, but slower-moving and quieter. He had just become a father, and lived with his pretty wife, a Frenchwoman, and two younger brothers in a sedate apartment off the Kreuzplatz in Zurich. There he worked; he pondered over the Dada posters, most of which were by him, helped to show people round the gallery, wrote scenarios and joined in bellowing *poèmes simultanés*. He was a willing and gifted collaborator. No soirée and no reading took place without him.

"At the moment I am very close to Janco", writes Ball in his diary on 24th May 1916. "He is a tall thin man, remarkable for the way he has of being embarrassed by other people's foolishness and bizarre behaviour, and then, with a smile or an affectionate gesture, asking for indulgence. He is the only one of us who needs to use no irony in dealing with the age we live in."

The pleasure of letting fly at the bourgeois, which in Tristan Tzara took the form of coldly (or hotly) calculated insolence and in Richard Huelsenbeck that of suppressed rage, was for Hans Arp *(Ill. 4)* primarily pure pleasure, the satisfaction of his sense of fun. The fortissimo of Tzara and Huelsenbeck would largely have drowned the soft flute-tones of the Alsatian painter, if he had not, by the magic of his strange personality and the childlike charm and wisdom of his poems, found himself a place during one of their pauses for breath:

KASPAR IS DEAD

alas our good kaspar is dead.
who will now carry the burning banner hidden in the pigtail of clouds
to play the daily black joke
who will now turn the coffee-mill in the primeval barrel
who will now entice the idyllic deer out of the petrified paper box.
who will now confound on the high seas the ships by addressing them as
parapluie and the winds by calling them keeper of the bees ozone spindle
your highness
alas alas alas our good kaspar is dead. holy ding dong kaspar is dead.
the cattlefish in the bellbarns clatter with heartrending grief when his
christian name is uttered. that is why I keep on moaning his family name
kaspar kaspar kaspar.
why have you left us. into what shape has your beautiful great soul
migrated. have you become a star or a watery chain attached to a hot
whirlwind or an udder of black light or a transparent brick on the groaning
drum of jagged being.

I Hans Arp, *Forest*, 1916. Painted wood, 32 x 21 cm. Private Collection ▷

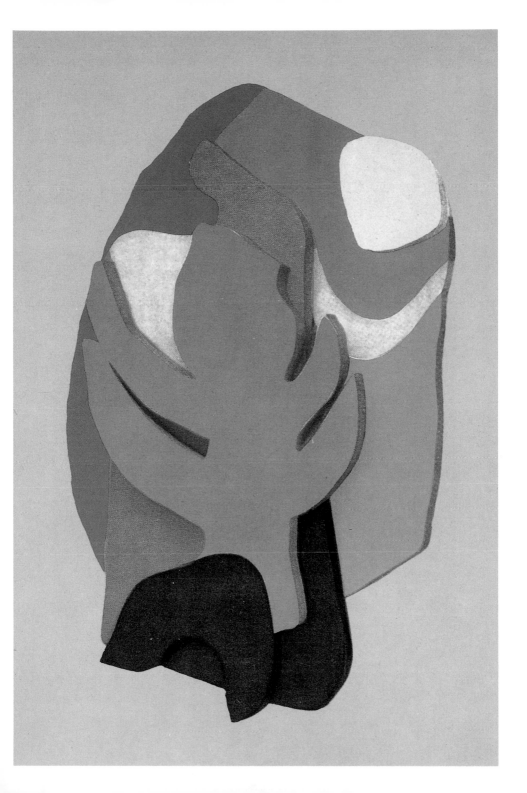

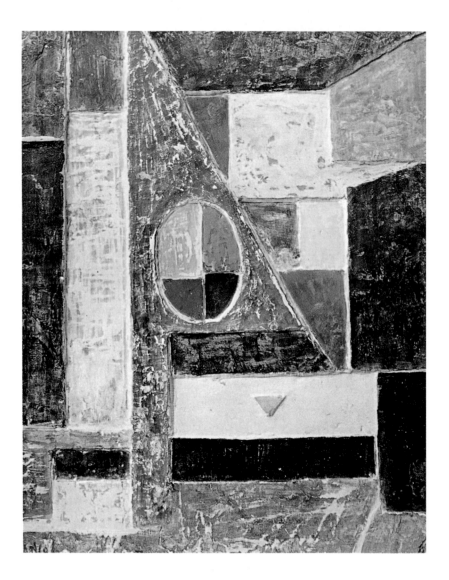

*now the part in our hair the soles of our feet are parched and the fairies
lie half-charred on the pyre.*

*now the black bowling alley thunders behind the sun and there's no one
to wind up the compasses and the wheels of the handbarrows any more.*

*who will now eat with the phosphorescent rat at the lonely barefooted
table.*

*who will now chase away the siroccoco devil when he wants to beguile
the horses.*

who will now explain to us the monograms in the stars.

*his bust will adorn the mantelpieces of all truly noble men but that's no
comfort that's snuff to a skull.*

<div align="right">(Hans Arp, translated by Ralph Manheim)</div>

When war broke out in 1914, Arp was in Paris. As an Alsatian, born in Strasbourg, he was in an awkward position; his background was originally French, but he was a German citizen by virtue of the conquest of 1870. He was later to migrate away from Paris and his conflict of loyalties; but he did not remain idle in the intervening period. In 1915 Arp was commissioned to enliven the bare walls of a theosophical institute belonging to M. René Schwaller. As he told me later, he cut out great curved paper shapes in various colours and used these lyrical abstractions to decorate the walls. This was well received and fitted well into the context of the Institute. But, as a German national, his situation in Paris became rather precarious and he went to Switzerland.

"Revolted by the butchery of the 1914 World War, we in Zurich devoted ourselves to the arts. While the guns rumbled in the distance, we sang, painted, made collages and wrote poems with all our might. We were seeking an art based on fundamentals, to cure the madness of the age, and a new order of things that would restore the balance between heaven and hell. We had a dim premonition that power-mad gangsters would one day use art itself as a way of deadening men's minds." (Arp: *Dadaland*)

Janco: "We had lost the hope that art would one day achieve its just place in our society. We were beside ourselves with rage and grief at the suffering and humiliation of mankind."

In Zurich, where Arp joined Ball in 1916, his paper-cuts soon became woodcarvings. His first reliefs were gaily-painted pieces of fun, rounded openings in flat pieces of wood superimposed on each other. I myself owned one of these until Arp 'changed it into something else', which 'disappeared' in its turn.

◁ II Marcel Janco, *Prière, éclair du soir*, 1918. Polychrome plaster relief, 50 x 40 cm. Galerie 'Im Erker', St Gallen

These reliefs were unpretentious and had nothing in common with the reliefs known to art history, on which we spat. They pleased us by their wit, the balance of their proportions, and their novelty.

A little later Arp was nailing pieces of wood, for which he no longer needed the help of a carpenter, on to oblong box-lids. He found some wooden rods, coloured variously by age and dirt, and set them side by side to produce their own kind of harmony.

All this brought in neither money nor fame; but in the end a certain Herr Corray, principal of a girl's school in Zurich, invited this unusual artist (and his older friend Otto van Rees, another who preferred painting in blobs and patches to reproducing mountains and flowers) to paint the entrance to his new school building. This they willingly did. On either side of the school entrance appeared two large abstract frescoes (the first to be seen so near the Alps) intended to be a feast for the eyes of the little girls and a glorious sign to the citizens of Zurich of the progressiveness of their city. Unfortunately, all this was fearfully misunderstood. The parents of the little girls were incensed, the city fathers enraged, by the blobs of colour, representing nothing, with which the walls, and possibly the minds of the little girls, were sullied. They ordered that the frescoes should at once be painted over with 'proper' pictures. This was done, and *Mothers, leading children by the hand* lived on the walls where the work of Arp and Van Rees died.

The only female member of the Cabaret Voltaire, Emmy Hennings, had, as may be imagined, a hard time holding her own against on otherwise all-male cast (*Ill. 2*). Emmy had a thin, anti-diva-ish voice, but she had a strong personality. During her youth, she had met, and inspired, some of the best poets in Germany. Since as far back as I can remember her (1912), she had lived exclusively in a bohemian world of artists and writers. I never felt at ease with her, any more than I did with the black-clad, priest-like Ball. But the reasons were different. I found her child-like mysticism as hard to believe in as Ball's abbé-like earnestness. Her child-like manner, the deadly earnest in which she said the most wildly improbable things, were a mystery to me. She was alien to me, as a woman and as a human being. Only Ball, in his loving humanity, fully understood her. Without overlooking her affectedness, he saw through it to a simple girl whose often-abused trustfulness appealed to his masculinity without making excessive claims on it.

As the only woman in this cabaret manned by poets and painters, Emmy supplied a very necessary note to the proceedings, although (or even because) her performances were not artistic in the traditional sense, either vocally or as inter-

pretations. Their unaccustomed shrillness was an affront to the audience, and perturbed it quite as much as did the provocations of her male colleagues.

AFTER THE CABARET

I go home in the morning light.
The clock strikes five, the sky grows pale,
A light still burns in the hotel;
The cabaret shuts for the night.
In a corner children hide,
To the market farmers ride,
Silently churchward go the old.
Bells ring in the silent air,
And a whore with tousled hair
Still wanders, sleepless and cold.

(Emmy Hennings)

The Cabaret Voltaire was a six-piece band. Each played his instrument, i. e. himself, passionately and with all his soul. Each of them, different as he was from all the others, was his own music, his own words, his own rhythm. Each sang his own song with all his might – and, miraculously, they found in the end that they belonged together and needed each other. I still cannot quite understand how one movement could unite within itself such heterogeneous elements. But in the Cabaret Voltaire these individuals shone like the colours of the rainbow, as if they had been produced by the same process of refraction.

I myself came to Zurich through a curious accident.

In September 1914, shortly after the outbreak of war, when I already had my mobilization papers for the German army in my pocket, some friends threw a farewell party. Among them were the two poets Ferdinand Hardekopf and Albert Ehrenstein. There was no knowing how, where and when we might meet again, and so, to cheer me up, Ehrenstein made this suggestion: "If the three of us are still alive, let us meet at the Café de la Terrasse in Zurich in exactly two years from now, on 15th September 1916, at three in the afternoon." I knew neither Zurich nor the Café de la Terrasse, and my hopes of being there seemed more than slender.

After eighteen month's war service, I was discharged, hobbling on two sticks, and suddenly remembered that improbable rendezvous. I was to have my first comprehensive exhibition at the Hans Goltz gallery in Munich in July 1916, so

I should be more or less half-way to Zurich, and as I had just married the nurse who had looked after me at the military hospital, we decided to go to Zurich, via Munich, for our honeymoon. In the middle of a war, this was rather a forlorn hope, but with much patience and ingenuity, and a pile of recommendations, we arranged it. On 15th September at three o'clock in the afternoon, I was in the Café de la Terrasse – and there, waiting for me, sat Ferdinand Hardekopf and Albert Ehrenstein. This unlikely encounter, like something in a dream, was followed by another. A few tables away sat three young men. When Ehrenstein, Hardekopf and I had exchanged our news, they introduced me to the three young men: Tristan Tzara, Marcel Janco and his brother Georges. So it was that I landed on both feet, squarely inside what was already called the Dada group. My work in *Die Aktion,* my Goltz exhibition, my paintings and drawings, and the truculent introduction I had written for the catalogue, served as my credentials:

"To be an artist is stimulating. If not, there are better ways of amusing oneself . . . We all know the profound importance of those questions which have no answer. Complexity at the price of 'absence of effort' is a result of the bourgeois cowardice which is so attached to the conventions it has always taken for granted, that an attraction toward negro sculpture and cubism appears as a precious artistic trick, on which they may elaborate the intellectual judgments of their 'along-the-wall thinking'. For anyone to move on from realistic subjects to invented ones is to them a sign of a soul in anguish (in reality it is exactly the opposite – final liberation and power in a wholly new medium)" (HR: Catalogue, Galerie Hans Goltz).

In the next few days I was taken to meet the other members of the group – Emmy Hennings I already knew from the old Café des Westens in Berlin. And so I became a member of the family and remained one until peace came and Dada in Zurich ended.

The Cabaret Voltaire becomes Dada

The Cabaret Voltaire fostered a unity which resulted from no act of will, an enthusiasm based on mutual inspiration which started things moving – although no one could tell what direction they would take.

Ball (30th November 1916): "All the styles of the last twenty years met together yesterday; Huelsenbeck, Tzara and Janco performed a *poème simultané.*

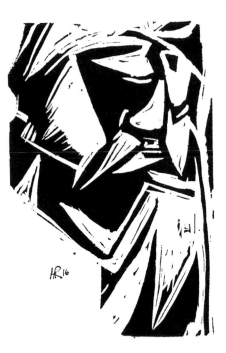

Hans Richter, *Theodor Däubler*, 1916. Linocut

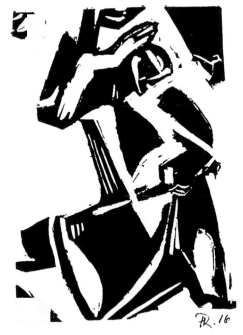

Hans Richter, *Cellist*, 1916. Linocut

L'amiral cherche une maison à louer

Poème simultan par R. Huelsenbeck, M. Janko, Tr. Tzara

Poème simultané from *Cabaret Voltaire*, 1916

This is a contrapuntal recitative in which three or more voices speak, sing, whistle, etc., simultaneously, in such a way that the resulting combinations account for the total effect of the work, elegiac, funny or bizarre. The simultaneous poem is a powerful illustration of the fact that an organic work of art has a will of its own, and also illustrates the decisive role played by accompaniment. Noises (a drawn-out rrrr sustained for minutes on end, sudden crashes, sirens wailing) are existentially more powerful than the human voice."

And Arp tells us: "In the Café de la Terrasse, Tzara, Serner and I wrote a cycle of poems entitled *Die Hyperbel vom Krokodilcoiffeur und dem Spazierstock* ('The Hyperbole of the Crocodile's Hairdresser and the Walking-Stick'). The Surrealists later christened this kind of poetry 'Automatic Poetry'. Automatic poetry springs directly from the poet's bowels or other organs, which have stored up reserves of usable material. Neither the Postillion of Longjumeau nor the hexameter, neither grammar nor aesthetics, neither Buddha nor the Sixth Commandment should hold him back. The poet crows, curses, sighs, stutters, yodels, as he pleases. His poems are like Nature. Unregarded trifles, or what

men call trifles, are as precious to him as the sublimest rhetoric; for, in Nature, a tiny particle is as beautiful and important as a star. Man was the first who presumed to judge what was beautiful and what was ugly."

Ball: "The subject of the *poème simultané* is the value of the human voice. The vocal organ represents the individual soul, as it wanders, flanked by supernatural companions. The noises represent the inarticulate, inexorable and ultimately decisive forces which constitute the background. The poem carries the message that mankind is swallowed up in a mechanistic process. In a generalized and compressed form, it represents the battle of the human voice against a world which menaces, ensnares and finally destroys it, a world whose rhythm and whose din are inescapable."

Ball's diary: "2nd April. Leonhard Frank and wife visited the club. Also Herr von Laban with his ladies [the dancers of the Laban School].

"One of our most regular customers is the elderly Swiss poet J. C. Heer, who has brought joy to many thousands with his honeyed garlands of verse. He always appears in a black cloak and knocks wine-glasses off the tables with his voluminous cape as he passes."

In the Cabaret Voltaire Ball had created a state of affairs which had its own forward momentum. He continues: "18th April. Tzara concerned about the magazine. My proposal to call it *Dada* is accepted. We could take it in turns to edit; a common editorial board which would entrust the task of selection and arrangement to one of its members for each issue."

This sentence by Ball, or rather its implications, had the strangest consequences. To this day it is impossible to be sure who discovered or invented the word Dada, or what it means. When I came to Zurich in the middle of August 1916, the word already existed and no one cared in the least how, or by whom, it had been invented. But I heard the two Rumanians Tzara and Janco punctuating their torrents of Rumanian talk with the affirmative '*da, da*'. I assumed (for, as I have said, no one bothered to enquire) that the name Dada, applied to our movement, had some connection with the joyous slavonic affirmative, '*da, da*' – and to me this seemed wholly appropriate. Nothing could better express our optimism, our sensation of newly-won freedom, than this powerfully reiterated "*da, da*" – "yes, yes" to life.

However, the sentence that Ball unsuspectingly wrote in his diary that day released a veritable hornets' nest. It was to lead to a Homeric struggle over the ownership of the trademark. The battle was waged with an expenditure of energy (especially by Huelsenbeck against Tzara) which would have moved the Uetliberg in Zurich. Forty years later, Huelsenbeck described the battle, with

praiseworthy self-irony, as the 'battle of the Dada greybeards'; but the struggle goes on. Some claim that the word was 'discovered' by opening a dictionary at random, others that it means a rocking-horse. Ball leaves the question open. "In Rumanian *dada* means 'yes, yes', in French a rocking-horse or hobby horse. To Germans it is an indication of idiot naivety and of an preoccupation with procreation and the baby-carriage." On 18th April 1916, when the movement was still young, Tzara gave this version of the story: "A word was born, no one knows how." The newspapers informed us in addition that the Kru Africans call the tail of a sacred cow 'dada'. In a certain part of Italy a die or cube and a mother are called Dada. "Dada is a wet-nurse" – and whatever other edifying facts may be discovered as to the origins of the word.

Arp, in *Dada au grand air* (Tarenz-Imst, 1921), says, "I hereby declare that Tzara invented the word Dada on 6th February 1916, at 6 p. m. I was there with my 12 children when Tzara first uttered the word . . . it happened in the Café de la Terrasse in Zurich, and I was wearing a brioche in my left nostril." Huelsenbeck, on the other hand, says: "The word Dada was accidentally discovered by Ball and myself in a German-French dictionary when we were looking for a stage-name for Madame Le Roy, the singer in our cabaret. Dada is a French word for hobby-horse."

The word Dada first appeared in print at the Cabaret Voltaire on 15th June 1916; this is a fact.

In a letter to Huelsenbeck dated 28th November 1916, Hugo Ball writes: ". . . and last of all I describe Dada, cabaret and gallery. So you have the last word on Dada as you had the first."

"What we call Dada is foolery, foolery extracted from the emptiness in which all the higher problems are wrapped, a gladiator's gesture, a game played with the shabby remnants . . . a public execution of false morality" (Ball).

This pointless and childish dispute is only worth mentioning because it does not make the historian's task any easier, and also because it reduces to a minimum the respect due to the so-called dates and facts that we give. A historian of Dada once said to me, peevishly: "If you yourselves don't know what happened, how are we supposed to?"

He was right; but these petty jealousies only appeared after Dada had become a world-wide enterprise with branches in New York, Berlin, Barcelona, Cologne, Hanover and Paris. Some of the leading members of Dada set out, *a posteriori,* to cut off each other's supplies of vital fluid even, as it were, in the womb, and many, with an insensitivity that was totally foreign to the Zurich group as I remember it, are still trying.

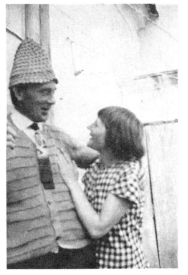

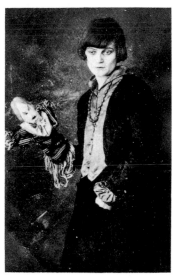

1 Hugo Ball and Emmy Hennings, Zurich 1916

2 Emmy Hennings

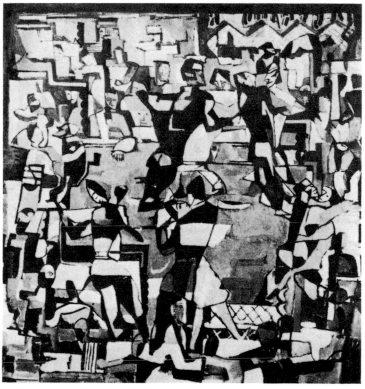

3 Marcel Janco, *Dance*, 1916. Oil

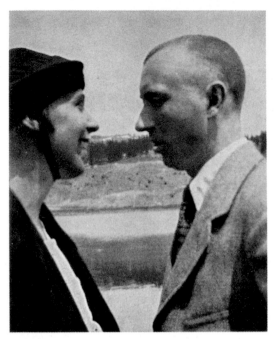

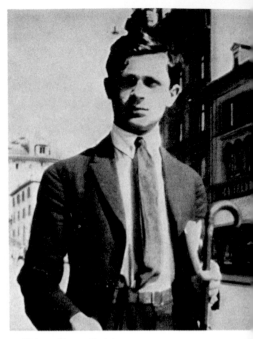

4 Sophie Taeuber and Hans Arp, Zurich 1918

5 Tristan Tzara, Zurich 1917

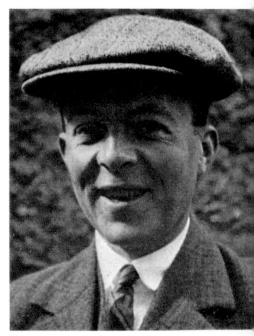

6 Marcel Janco, Zurich 1916–17

7 Dr Richard Huelsenbeck, Berlin 1917

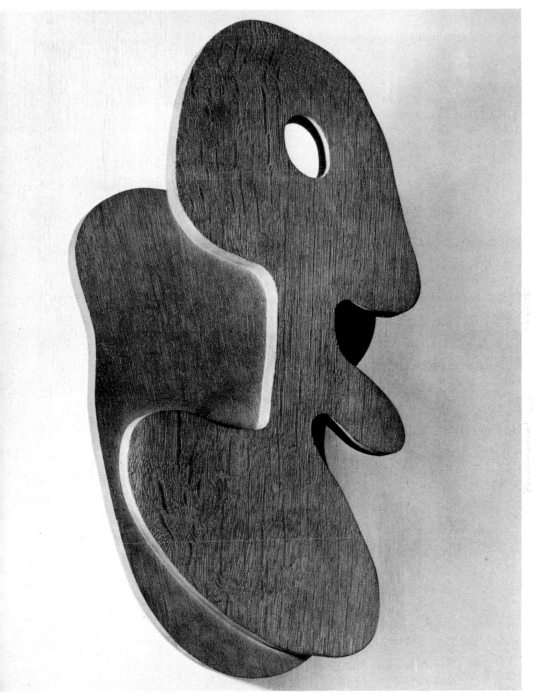

Hans Arp, *Poussah*, 1920. Plain wood relief

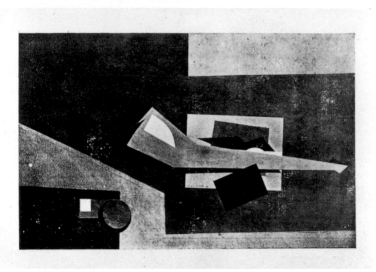

9 Otto van Rees, *Still Life*, 1916. Oil and collage

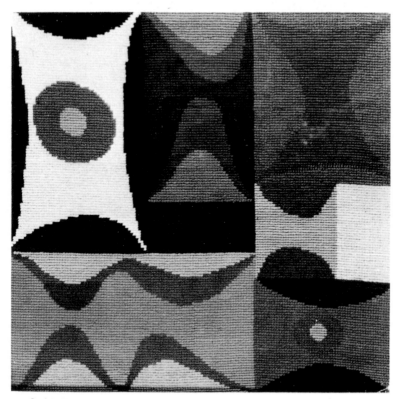

10 Sophie Taeuber, *Formes élémentaires*, 1917. Tapestry

The Periodical 'Dada'

Less disputed than the authorship of the name Dada is the fact that it was Tzara who edited, directed, propelled, designed and administered the periodical *Dada*. Ball's plan of circulating the editorship was not carried out, simply because no one but Tzara had so much energy, passion and talent for the job. Everyone was happy to watch such a brilliant editor at work.

While the publication *Cabaret Voltaire* (15th June 1916) was more or less a communal affair controlled by Ball, *Dada* was from the very first issue principally Tzara's work. Not, of course, his alone, but produced in friendly cooperation and agreement with all of us: Janco and Arp, Ball and Huelsenbeck (though he soon went back to Germany), myself and a number of others.

Tzara was the ideal promoter of Dada, and his position as a modern poet enabled him to make contact with modern poets and writers in other countries, particularly France. There were Breton, Aragon, Eluard, Soupault, Ribemont-Dessaignes . . . although, as I found out later, these adopted at first a very cool and distant attitude to this new movement in the Swiss mountains. It was nevertheless through these contacts that Dada later became something more than a solitary Alpine flower, became in fact an international movement.

The aggressive, polemical manifesto was a literary genre which suited Tzara perfectly. "The new artist protests; he no longer paints (symbolical and illusionist reproduction) but creates directly in stone, wood or iron, rocks which are locomotive organisms capable of being turned in any direction by the limpid wind of momentary sensation." Like all newborn movements we were convinced that the world began anew in us; but in fact we had swallowed Futurism – bones, feathers and all. It is true that in the process of digestion all sorts of bones and feathers had been regurgitated.

The youthful élan, the aggressively direct approach to the public, the provocations, were products of Futurism, as were the literary forms in which they were clothed: the manifesto and its visual format. The free use of typography, in which the compositor moves over the page vertically, horizontally and diagonally, jumbles his type faces and makes liberal use of his stock of pictorial blocks – all this can be found in Futurism years before Dada. Bruitistic poems, in which words alternated with noises, had shocked audiences under the Futurist motto that a new dynamic age had dawned.

But here the influence of Futurism more or less stops. Motion, dynamism, *'vivere pericolosamente'*, 'simultaneity', did play a part in Dada, but not as

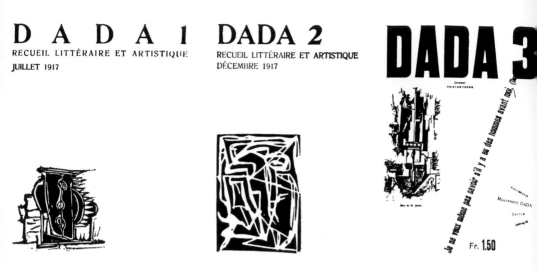

Covers for *Dada*, 1917/18

elements in a programme. Here is the fundamental difference: Futurism had a programme and produced works designed to 'fulfil' this programme. Whether the result was a work of art or a mere illustration of the programme depended on the talent of the artist.

Dada not only had *no* programme, it was against all programmes. Dada's only programme was to have no programme . . . and, at that moment in history, it was just this that gave the movement its explosive power to unfold *in all directions*, free of aesthetic or social constraints. This absolute freedom from preconceptions was something quite new in the history of art. The frailty of human nature guaranteed that such a paradisal situation could not last. But there was to be a brief moment in which absolute freedom was asserted for the first time. This freedom might (and did) lead either to a new art – or to nothing. Unhampered by tradition, unburdened by gratitude (a debt seldom paid by one generation to another), Dada expounded its theses, anti-theses and a-theses.

Tzara writes in his manifestos:

"I smash drawers, those of the brain and those of social organization: Everywhere to demoralize, to hurl the hand from heaven to hell, the eyes from hell to heaven, to set up once more, in the real powers and in the imagination of every individual, the fecund wheel of the world circus."

"*Order = disorder; self = not-self; affirmation = negation;* ultimate emanations of absolute art. Absoluteness and purity of chaos cosmically ordered,

34

eternal in the globule second without duration without breath without light without control. – I love an old work for its novelty. It is only contrast that attaches us to the past."

Dada manifesto 1918: "Dada means nothing." "Thought is produced in the mouth."

"Art falls asleep . . . 'ART' – a parrot word – replaced by Dada . . . Art needs an operation. Art is a pretension, warmed by the diffidence of the urinary tract, hysteria born in a studio."

These negative definitions of Dada arose from the rejection of what needed to be rejected. This rejection arose from a desire for intellectual and spiritual freedom. However differently this freedom may have expressed itself in each of us (and there were big differences, ranging from the almost religious idealism of Ball to the ambivalent nihilism of Serner and Tzara) we were all propelled by the same powerful vital impulse. It drove us to the fragmentation or destruction of all artistic forms, and to rebellion for rebellion's sake; to an anarchistic negation of all values, a self-exploding bubble, a raging *anti, anti, anti*, linked with an equally passionate *pro, pro, pro!*

Thus we let sense escape into the realm of nonsense, although it never left that of the senses. Ball's idea of the *Gesamtkunstwerk* (total work of art) played a part in this; the interplay of different arts was maintained in all our activities. Ball writes in his diary:

"Munich housed at that time an artist who by his presence alone gave that town a leading position in the world of modern art: Wassily Kandinsky. This assessment may seem exaggerated; that was how I felt at the time. What greater honour could a city have than to house a man whose achievements are living signposts of the noblest kind . . . the many-sidedness and genuineness of his interests were astonishing; still more so the loftiness and purity of his aesthetic ideas. His concern was to bring about the rebirth of society through the union of all artistic media and potentialities. He essayed no branch of art in which he did not tread entirely new paths, unperturbed by scorn and derision. Words, colour and musical sound were alive within him in a rare harmony . . . His final goal was to be not only a creative artist, but a living representative of art as such. In 1914, when I was thinking over the plan of a new theatre, I was convinced of this: a theatre which experiments beyond the realm of day-to-day preoccupations. Europe paints, composes and writes verse in a new way. A fusion, not merely of all art, but of all regenerative ideas. The background of colours, words and sounds must be brought out from the subconscious and given life, so that it engulfs everyday life and all its misery."

Towards the end of 1916, Dada gained a new member, a rootles figure who took root in anything that was extraordinary. It was Dr Walter Serner (*Ill. 15*). He was a nihilist and published an appropriate periodical called *Sirius*.

Serner, a tall, elegant Austrian who wore a monocle, or sometimes pince-nez, seemed made to measure to complete the "Voltaire" team. He was a moralist and a cynic, a nihilist who loved mankind and who identified himself with the dictum of the Parisian *grisette* Margot: "Peut-être que je serais bonne si je savais pourquoi." He was the cynic of the movement, the declared anarchist, an Archimedes who meant to lift the world off its axis and let it hang.

He was afflicted with a disgust for mankind (and with a lack of money) because he had found out the thing Brecht proclaimed all his life, that mankind was too weak to be really good and too good to be really bad . . . only weak and, in consequence, base.

His bearing, the impeccable precision of his language, his remarkable intelligence, his superb psychological insight – together with his occasional use of caveman tactics towards women – all this made him a sort of aristocrat of Dada. Neither Tzara nor Huelsenbeck, both always monocled, could compete with him in this respect. To Serner his monocle came naturally. In many ways it was he, rather than Ball the idealist or Tzara the realist, who was the incarnation of revolt in what would now be called its existential form. Despite the radical nature of his programme, or perhaps because of it, he was a moralist ("Dehumanization is not the same as spiritualization"), in contrast to the practical Tzara, who saw, and used, the world unhindered by moral scruples.

Serner's neat, if sometimes shabby, appearance was more than the sign of Viennese good breeding, it was an expression of the personal cleanness on which he placed the greatest value, despite his negation of all values. His was a valuable contribution to Dada; he was at once the focus and the spokesman of a psychology that devalued all ethical and erotic values.

BEST PAVING IS RED BLESSING

Pottery crashing to the floor:
o so sweet drank Ninalla's lips Pommery greno first.
Minkoff, a quite a Russian, dérouté on a siding.
Past us flaps a hand-palm: used bosom blows blonde. All-in.
Fall-in.
Mouthful of wine (length: 63 centimetres) into red-improved nostrils
SPAT.
Cat!!!

Because (ensemble-courageous) Kuno whispers to plump posterior.
Tangle, which sweaty underarm escapes.
Bent forward, he thunders! Sibie screamed out, by nature immensely,
Hemiglobes upwards.
Now-burning pedal brushes (delightful!) an elsewhere-caressed
Abdomen. An omen.
Unsurpassed licks his lingua fattest thighs along, Isidor.
O how I love life's rabble! (In the evening, naturellement.)
Kurschewaz ogles the o so distant delta-folds of Zuzzi.
Baynes Destiny (Massachusetts-fairest of all) surges fiddle-randy
round the corner;
Sheet-metal lurches out and goes aloft with some effort:
sparsely-tufted lower-half (?Gaby!) sways tactfully this way.
"Fidelity is no hollow tooth" . . . (a cross between child and ninepin)
Madame V. expertly twines a glass into Roger's fingers;
crushes the whole thing stooltoher.
Quart. Athwart.
(By the way: take away venereal disease,
and coitus would become universally popular as a parlour-game;
you could get it in the shops. Basta.)

(Walter Serner)

Serner's friend and collaborator, Christian Schad (*Ill. 64*) also sometimes joined the Dada circle. After painting expressionist-cum-naturalist portraits of Marietta, Serner and others, he had by 1918/19 turned to the abstract.

Where Tzara's accents were those of the Last Judgment, and Serner's those of moral disgust, Arp announced *his* demands in his own individual way, like a bard in clown's disguise, strumming on his lyre his instructions for the dissolution of a world come apart at the seams.

"Dada is the ground from which all art springs. Dada stands for art without sense. This does not mean nonsense. Dada is without a meaning, as Nature is."

"The bourgeois saw the Dadaist as a loose-living scoundrel, a villainous revolutionary, an uncivilized Asiatic, with designs upon his bells, safe-deposits and honours. The Dadaist thought up tricks to rob the bourgeois of his sleep. He sent false reports to the newspapers of hair-raising duels said to involve the bourgeois's favourite author, the 'King of the Bernina' (J. C. Heer). The Dadaist gave the bourgeois a whiff of chaos, a sensation like that of a powerful but

distant earth tremor, so that his bells began to buzz, his safe-deposits wrinkled their brows and his honour developed spots of mould. 'The Eggboard', a sport and social pastime for the top ten thousand, in which the players, covered from head to foot with egg-yolk, leave the field of play; 'The Umbilical Flask', a monstrous consumer durable which is a cross between a bicycle, a whale, a brassiere and an absinthe spoon; 'The Glove', designed to be worn in place of the traditional head; all these were designed to bring home to the bourgeois the unreality of his world and the emptiness of all his endeavours, even including his profitable nationalism. This was of course a naive enterprise on our part, as the normally constituted bourgeois possesses rather less imagination than a worm, and has, in place of a heart, a larger-than-life-sized corn which only troubles him when there is a change in the weather – the stock-exchange weather."

Hans Arp, *Wash Drawing*, 1916/17

THE GUEST EXPULSED 3

Gravestones I carry on my head.
From water-bearing mortal clay
I cast offending Adam out
– To pass the time – twelve times a day.

Standing in light up to the hilt,
I leap out through my mouth perforce
And, carrying owls to Athens town,
Harness myself before my horse.

Farewell a hund- and katzen-fold.
In line with Time's polarity
I follow in disguise, lead-glazed,
The Spirit of hilarity.

I mingle camphor of my own
In with the elder-pith of Time,
And into all eternity
Innards and upwards still I climb.

(Hans Arp)

Dada Events

Meanwhile Dada activity went forward along other lines. The idea of the *Gesamtkunstwerk*, which Ball had taken up in Munich under the influence of Kandinsky, now led him to add exhibitions to the other Dada activities. In these exhibitions he sought to achieve total art by linking lectures, readings and ballets with the pictures. At the 'Meierei' the Cabaret Voltaire was under notice to quit, since Herr Ephraim, the proprietor, had listened to the complaints of respectable citizens outraged at the nightly excesses committed in the name of Voltaire.

Ball wrote on 18th March 1917: "Tzara and I have rented the premises of the Galerie Corray (Bahnhofstrasse 19), and yesterday we opened the Galerie Dada with a *Der Sturm* exhibition. This is a continuation of what we did at the Cabaret Voltaire last year. The exhibition opened three days after we were offered the gallery. About forty people were there. Tzara was late, so I spoke about our plans to build up a small group of people to provide mutual support and stimulation." This *Der Sturm* exhibition was followed by two shows devoted to the 'fathers' of Dada, Kandinsky and Klee (March 1917). These were followed by an exhibition of the work of the Italian painter Giorgio de Chirico (*Ill. 16*). Through this, his first exhibition, Chirico was forcibly incorporated into Dada, just as he was later compulsorily elected a member of the Surrealist movement. What was he to do?

These events gave Dada, for the first time, some slight appearance of seriousness in the eyes of the Zurich public. Although the pictures were judged "frightful", by and large, at least they raised no riot and did not curse back if someone called them crazy. Also, Klee and Kandinsky already had a certain reputation, even if a dubious one. Klee's work seemed to open the way to the Elysian Fields we saw stretched out before us.

There were of course some who came closer to Dada as a result of these exhibitions. The influence of Dada on these people, and their influence on the public, finally prepared the ground for Dada to be, if not loved or understood, at least tolerated with a sort of disapproving curiosity. "The Gallery was too small to admit everyone that came, despite the high admission fee. A German poet insults the visitors, calling them nitwits. Another German poet raises the question, in connection with the *Der Sturm* exhibition, whether it is generally known that Herwarth Walden is an enthusiastic patriot. [Untrue!] A third German poet thinks we must be making "a hell of a lot of money" in the

Gallery, and cannot make up his mind to allow readings of his peace story *Der Vater* ('The Father'). *In summa*, there is dissatisfaction, springing from our radicalness or from other people's jealousy" (Ball).

It was not always possible to avoid nasty scenes. Envy and vanity, two human failings that Ball never reckoned with, because he was free from them himself, troubled and discouraged him, and led in the end to his withdrawal from Dada.

The exhibitions contained works by Janco, Jawlensky, Arp, Helbig, Luethy, Richter and others, and there were guided tours with the aim of establishing direct contact with the public. This contact did not always take place without friction. As an experiment, the public was treated with the open rudeness of which Tzara and Serner were such masters. But we were too full of all that we knew and wished for and the public was too empty. Similar provocations were later brought to perfection and, in Paris, Berlin and elsewhere, became the essential trademark of Dada.

GALERIE
D A D A

BAHNHOFSTRASSE 19 (EINGANG TIEFENHÖFE 12)

BIS 29. MAI

AUSSTELLUNG VON GRAPHIK, BRODERIE, RELIEF

H. ARP, F. BAUMANN, G. DE CHIRICO, O. GŒTZ, W. HELBIG, M. JANCO, J. ISRAELEWITZ, P. KLEE, O. LÜTHY, A. MACKE, J. MODIGLIANI, NADELMANN, E. PRAMPOLINI, O. VAN REES, Mme. VAN REES, H. VON REBAY, H. RICHTER, A. SEGALL, M. SLODKI, J. VON TSCHARNER, KINDERZEICHNUNGEN, PLASTIKEN.

GEÖFFNET TÄGLICH VON 2—6 EINTRITT 1 FR.

JEDEN SAMSTAG NACHMITTAG 4 UHR FÜHRUNG DURCH DIE GALERIE.

tristan tzara
vingt-cinq poèmes

h arp
dix gravures sur bois

collection dada
zurich

Abstract Poetry

One of the high-spots of those early shows was the evening of 25th June 1917 in our Dada Gallery in the Bahnhofstrasse (actually it was in the Tiefenhöfe, an insignificant side-street). It was a high spot because it introduced a new art-form in which Ball carried his quarrel with language to its logical conclusion. The consequences of the step he took have lasted until the present day.

The entry in his diary for 5th March 1917 reads: "The human figure is progressively disappearing from pictorial art, and no object is present except in fragmentary form. This is one more proof that the human countenance has become ugly and outworn, and that the things which surround us have become objects of revulsion. The next step is for poetry to discard language as painting has discarded the object, and for similar reasons. Nothing like this has existed before."

On 14th July 1916, at the first great Dada evening in the Zunfthaus zur Waag in Zurich, advertised to include music, the dance, theory, manifestos, poems, pictures, costumes and masks, and in which Arp, Ball, Hennings, the

composer Heusser, Huelsenbeck, Janco and Tzara all took part in one way or another, Ball had recited his first abstract phonetic poem, O *Gadji Beri Bimba*. In the overwhelming mass of unknown and startling experiences, this innovation had failed to register properly. A whole evening was now devoted to this new form of poetry and made us and the public finally conscious of it.

"In these phonetic poems we want to abandon a language ravaged and laid barren by journalism. We must return to the deepest alchemy of the Word, and leave even that behind us, in order to keep safe for poetry its holiest sanctuary."

So a reading of 'abstract poems' by Hugo Ball was advertised to take place in our gallery. I was a little late, and the room was already packed when I arrived: standing room only. Ball:

"I wore a special costume designed by Janco and myself. My legs were encased in a tight-fitting cylindrical pillar of shiny blue cardboard which reached to my hips so that I looked like an obelisk. Above this I wore a huge cardboard coat-collar, scarlet inside and gold outside, which was fastened at the neck in such a way that I could flap it like a pair of wings by moving my elbows. I also wore a high, cylindrical, blue and white striped witch-doctor's hat.

"I had set up music stands on three sides of the platform and placed on them my manuscript, written in red crayon. I officiated at each of these music-stands in turn. As Tzara knew all about my preparations, there was a real little première. Everyone was very curious. So, as an obelisk cannot walk, I had myself carried to the platform in a blackout. Then I began, slowly and majestically.

"gadji beri bimba glandridi laula lonni cadori
gadjama gramma berida bimbala glandri galassassa laulitalomini
gadji beri bin blassa glassala laula lonni cadorsu sassala bim
Gadjama tuffm i zimzalla binban gligia wowolimai bin beri ban
o katalominal rhinocerossola hopsamen laulitalomini hoooo gadjama
rhinocerossola hopsamen
bluku terullala blaulala looooo . . ."

This was too much. Recovering from their initial bafflement at this totally new sound, the audience finally exploded.

In the midst of the storm Ball stood his ground (in his cardboard costume, he could not move anyway) and faced the laughing, applauding crowd of pretty girls and solemn bourgeois, like Savonarola, motionless, fanatical and unmoved.

"The accents became heavier, the emphasis stronger, the consonants harsher. I very soon realized that my powers of expression were not going to be adequate

to match the pomp of my staging – if I wanted to remain serious, and this I wanted above all things.

"In the audience I saw Brupacher, Jelmoli, Laban and Frau Wigman. Fearing a débâcle, I pulled myself together. I had now completed *Labadas Gesang an die Wolken* ('Labada's Song to the Clouds') at the music stand on my right, and *Elefantenkarawane* ('Elephant Caravan') on the left, and now turned back to the middle stand, flapping my wings energetically. The heavy sequences of vowels and the ponderous rhythm of the elephants had allowed me one last crescendo. But how could I get to the end? Then I noticed that my voice, which had no other way out, was taking on the age-old cadence of priestly lamentation, the liturgical chanting that wails through all the Catholic churches of East and West."

> *zimzim urallala zimzim urallala zimzim zanzibar zimzalla zam*
> *elifantolim brussala bulomen brussala bulomen tromtata*
> *veio da bang bang affalo purzamai affalo purzamai lengado tor*
> *gadjama bimbalo glandridi glassala zingtata impoalo ögrogöööö*
> *viola laxato viola zimbrabim viola uli paluji maloo*

"I do not know what gave me the idea of using this music, but I began to chant my vowel sequences like a recitative, in liturgical style, and tried not only to keep a straight face but to compel myself to be in earnest.

"For a moment I seemed to see, behind the Cubist mask, the pale, anguished face of the ten-year-old boy who, at parish requiems and high masses, had hung on the priest's every word, avid and trembling. Then the electric lights went out as arranged, and, bathed in sweat, I was carried down from the platform, a magical bishop."

This event was the climax of Ball's career as a Dadaist. The abstract phonetic poem, which was later to find numerous imitators and continuers and to reach its close in French *Lettrisme*, was born as a new art-form. After this date Ball progressively disengaged himself from Dada. "The most direct way to self-help: to renounce works and make energetic attempts to re-animate one's own life."

Ball went to Berne, in those days the most spy-ridden capital of all, to work as a journalist on the *Freie Zeitung* of Dr Rösemeier, and as political adviser to the *Weisse Blätter* of the Alsatian poet René Schickele. Then he retired to Ticino to live the religious life in voluntary poverty. The paths along which Tzara was leading Dada were not for him. "I have examined myself carefully, and I could never bid chaos welcome."

Ball's unpublished novel, *Tenderenda, der Phantast*, dates from his Dada period. In his *Kritik der deutschen Intelligenz* ('Critique of the German Intelligentsia', 1919), he gives an analysis of the mental climate in Germany, and foresees the horrors of Hitlerism.

Die Flucht aus der Zeit ('Flight from Time', Munich, 1927), a selection from his diaries, is a fascinating document of the turbulent years from 1913 to 1921. This exceptional man passed from the world of the theatre ('Prelude – Backstage') to Dada ('Romanticisms – the Word and the Image') and finally became a seeker after God, a convert ('God's rights and man's rights', 'Escape to Fundamentals' and 'Byzantine Christianity').

Ball and Tzara were the two opposing poles of Dada. After Ball's departure, the leadership quickly passed into Tzara's practised hands.

The Language of Paradise

> The painter as advocate for the contemplative life – as proclaimer of the supernatural language of signs – influence on poetic imagery – the symbolic aspect of objects is a result of their employment, over many years, in paintings. *Is sign language the true language of Paradise?* (Ball)

In 1916 it was not yet quite clear in what direction Dadaist visual art would move. But by 1917 it was evident that the dialectical process would necessarily lead to so-called abstract art.

The first abstracts I saw in Zurich were pictures and silk embroideries by Otto Van Rees and his wife, shown in 1916 *(Ill. 9)*. In addition, the beetles and cucumbers that sprouted like blades of grass under Arp's hands could no longer be called representational. He gave his reliefs representational names, but they did not represent anything. Collages and drawings piled up in his studio in the Zeltweg. One morning I visited him and stood for a while watching as his hands danced over the paper, calling forth beetles, plants, fragments of human bodies, violins and stars, snakes and ears. When I called for him again at lunchtime, the table was festooned with Arpian vegetation. I did not understand how anyone could produce so much in such a short time, without inhibition and without a qualm.

"What can I do? It grows out of me like my toenails. I have to cut it off and then it grows again", said Arp.

And then Sophie Taeuber *(Ill. 4)* came to fetch us to a vegetarian restaurant for lunch.

Sophie was studying dancing under Laban, in whose hallowed halls I was a frequent visitor. The spacious practice rooms in the Seehofstrasse could only be crossed on tiptoe. One dancer or another would be practising there, and the stern Laban might be concealing himself anywhere. If he sprang out from some hiding-place, we would be shunted into a little room where Tzara's girl-friend, Maja Kruscek, and Sophie would be bent over a costume-design. Maja Kruscek talked a great deal, Sophie said little. She usually obviated the necessity of speech with one of her shy or thoughtful smiles. She was still the same when I met her again in Berlin and Paris, and later when she worked with Arp in a little studio-house in Meudon-Val-Fleury. During the Dada period she had a job teaching at the school of arts and crafts, as well as being a painter and a

Hans Arp, *Drawing*, 1917

Christian Schad, *Woodcut*, 1917

dancer. In all three capacities she was closely associated with Arp. The first things of hers I saw were embroideries of pictures by Arp *(Ill. 18)* and, later, of her own designs *(Ill. 10)*. There were abstract drawings, extraordinary Dada heads of painted wood *(Ill. 20)*, and tapestries, all of which could hold their own alongside the work of her male colleagues. She was Arp's discovery, just as he was hers, and in their unassuming way they played a part in every Dada event. I was engaged at that time in a search for the elements of a language of sign and image, and Sophie's work was always a stimulation to me. She had lectured at the Zurich museum of arts and crafts for years, and had by necessity acquired the skill of reducing the world of lines, surfaces, forms and colours to its simplest and most exact form, and formulating ideas in the simplest way. What her words left unspoken was revealed in her pictures. Her preliminary studies, especially, revealed the sensitive artistic endeavour which lay behind the extreme formal simplicity of her pictures, with their rising and falling circles. The circle, more than any other shape, seems to have expressed the self-contained, tranquil strength of her character.

Janco's sharp-edged figures and Negroid masks soon evolved into abstracts. Arp called them "zig-zag abstracts". Luethy's Madonnas became progressively more abstract, rhythms rather than figures. Segall's prismatic configurations retained their representational structure and content, but this was distorted and dissolved into the colours of its spectrum. Helbig stuck to (expressionistic) representation and did not venture into the field of the abstract until long after Dada. He was alarmed at the increasing tendency towards non-representationalism, and urged me not to commit myself wholly to abstract art. But I had taken my first halting steps towards the abstract in 1916, before I came upon Dada. Even Jawlensky, who did not belong to the Dada group at all, brought out a series of far-ranging abstract variations on the human head, which made a particularly deep impression on me. The exhibitions of 'fathers of Dada', de Chirico, Klee, Feininger, Macke and so on, put on by Tzara and Ball, created an artistic climate from which one could not escape; nor did one wish to. Even here, however, the voice of criticism was not stilled.

Ball: "Arp denounces the inflated reputations of the reigning gods of painting [the Expressionists]. He calls Marc's bulls too fat; Baumann's and Meidner's cosmogonies, their lunatic fixed stars, remind him of the stars of Bölsche and Carus. He would like to see things more disciplined, less arbitrary, and with less show of colour and poetry. He prefers plane geometry to painted Creations or Apocalypses. When he advocates the primitive, he means the basic abstract

Marcel Janco, *Woodcut*, 1918 Hans Richter, Linocut from *Dada*. No. 4/5, 1918

outline, which holds aloof from complexities, but not through ignorance of them. Sentiment must go and so must the dialectical process which takes place only on the canvas itself.

"If I understand him rightly, he is not so much interested in richness as in simplification: establishing a line of demarcation between oneself and all that is vague and nebulous. He wants to purify the imagination, directing attention not so much to its store of images as to the stuff of which those images are made. He makes the assumption here that all images produced by the imagination are in themselves composites. The artist who allows his imagination free play is deceiving himself if he thinks he has achieved immediacy. He is using material which is already formed and his work is therefore compilation."

It was naturally not easy to get material for continually changing exhibitions in the middle of a war. And we were neither willing nor able to rely entirely on our own works. It was the always resourceful Tzara who discovered that the governments of the belligerent nations were only too anxious to compete with each other in neutral Switzerland, even if only in the field of culture . . . and even if the insubordinate Dada movement was the means by which this took place.

47

From Italy, Germany and France Tzara received works which were normally almost unobtainable, post free, as propaganda material – and used them as propaganda for us.

But it was not by following the example of other artists – or by reacting against it – that we gradually made our way from representational to abstract art. It was a reaction to the general disintegration of the world around us, the process that Walter Serner followed to its logical conclusion in his pamphlet advocating a *Letzte Lockerung* ('Final Dissolution', 1918).

This dissolution was the ultimate in everything that Dada represented, philosophically and morally; everything must be pulled apart, not a screw left in its customary place, the screw-holes wrenched out of shape, the screw, like man himself, set on its way towards new functions which could only be known ofter the total negation of everything that had existed before. Until then: riot, destruction, defiance, confusion. The role of chance, not as an extension of the scope of art, but as a principle of dissolution and anarchy. In art, anti-art.

I am not quite sure to what extent Tzara identified himself with Serner's ideas in 1917–18. The events that took place in the Waag hall in 1916, and in the Zunfthaus in der Meise in 1918 were artistic performances on a high enough level to be sometimes recognizable as such, on occasion, even by a wholly hostile press.

This was true even when we spoke not of art but of anti-art; art as an 'industry' having lost all its relevance for us. We were looking for a way to make art a meaningful instrument of life. Arp called it identification with Nature, and I called it 'musical and human order'. Janco called it architectonic feeling and Eggeling called it *Generalbass der Malerei* (the elements or 'groundbass' of painting); but all this made no difference to the fact that we were all united in a search for new meaning and substance in art.

Ball commented on this problem in his diary on 5th May 1917: "We discussed the theories of art current in the last few decades, always with reference to the mysterious nature of art itself, its relationship with the public, with the race and with the cultural environment of the moment. It is true that for us art is not an end in itself; we have lost too many of our illusions for that. Art is for us an occasion for social criticism, and for real understanding of the age we live in. These are essential for the creation of a characteristic style." And then he asks this question: "Art everywhere stands in contradiction to its own ethical purpose. What are we to do? Everywhere the ethical predicament of our time imposes itself with an urgency which suggests that even the question 'Have we anything to eat?' will be answered not in material but ethical terms."

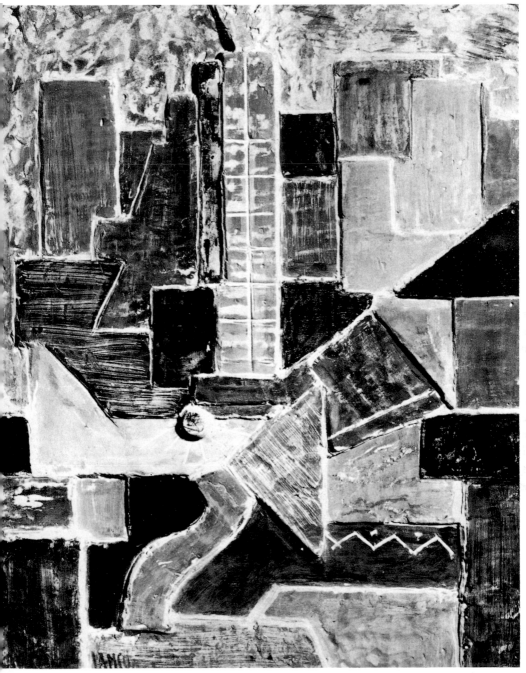

Marcel Janco, *Relief*, 1917. Painted plaster

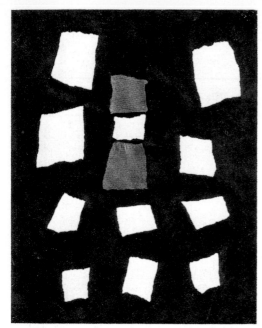

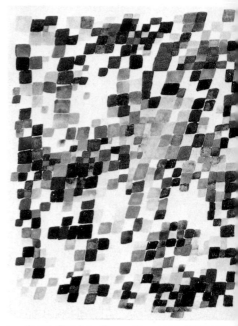

12 Hans Arp, *Nach dem Gesetz des Zufalls* (According to the Laws of Chance), 1920. Torn paper

13 Sophie Taeuber, *Composition*, 1920. Watercolour

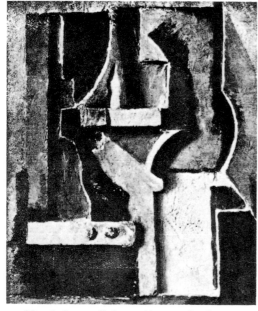

14 Marcel Janco, *Petite architecture lumière*, 1919. Painted plaster relief

15 Dr Walter Serner, Zurich 1917. Portrait by Hans Richter

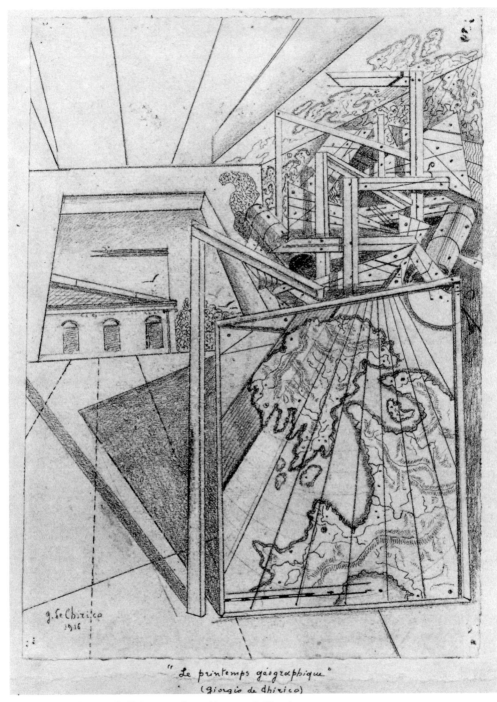

"Le printemps géographique"
(Giorgio de Chirico)

16 Giorgio de Chirico, *Le Printemps géographique*, 1916. Drawing

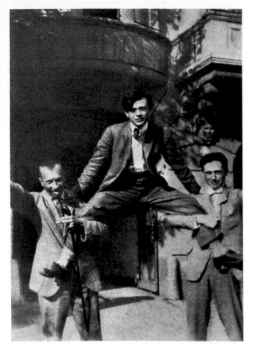

17 Hans Arp, Tristan Tzara, Hans Richter, Zurich 1917–18

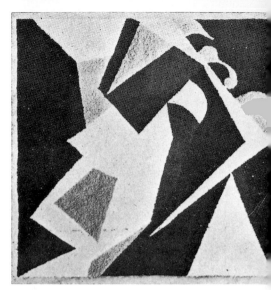

18 Hans Arp, Tapestry, Zurich 1918

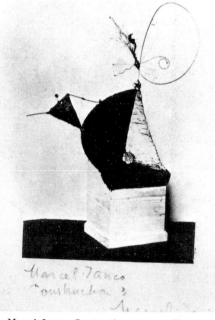

19 Marcel Janco, *Construction* 3, 1917. Plaster and wire

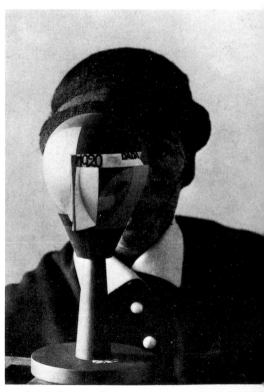

20 Sophie Taeuber, *Dada-Kopf* (Dada Head), 1920. Pain wood

By casting doubt on the claims of the spoken, unspoken or written word to priority, Ball the poet revealed the deeper causes which made the Dada writers, despite all their anti-art declarations, finally unable to arrest the *pro-art* tendencies within the movement. Our search, as visual artists, for the true 'language of Paradise' went much deeper than the wild anti-art propaganda of the movement's published statements, which was based on social, moral and psychological arguments. If Ball, whose chosen medium was words, could feel this to be true, we as painters, whose medium was the 'paradisal' language of signs itself, were necessarily even more conscious of it. This duality explains the fact that Dada visual art, although it went on its way within the framework of Dada literature, had its own independent evolution.

"A creative art, a power of the creative instinct, a heroic art which embodies all that is serious and all that is fortuitous in life's laws. Dada regarded art as an adventure of liberated humanity."

"We 'painted' with scissors, adhesives, plaster, sacking, paper and other new tools and materials; we made collages and montages."

"It was an adventure even to find a stone, a clock-movement, a tram-ticket, a pretty leg, an insect, the corner of one's own room; all these things could inspire pure and direct feeling. When art is brought into line with everyday life and individual experience, it is exposed to the same risks, the same unforeseeable laws of chance, the same interplay of living forces. Art is no longer a 'serious and weighty' emotional stimulus, nor a sentimental tragedy, but the fruit of experience and joy in life."

"Dada was not a school of artists, but an alarm signal against declining values, routine and speculation, a desperate appeal, on behalf of all forms of art, for a creative basis on which to build a new and universal consciousness of art."

"From its beginnings in poetry and visual art, the Dada revolution was carried into architecture, the film, music, typography and articles of everyday use."

As long as Ball's gaunt figure was still part of the Dada scene in Zurich, the anti-art movement never took on the aspect of anarchism. Arp, Janco and I accepted Serner's and Tzara's 'final dissolution', but as a means to an end: a new and brilliant weapon to destroy what was outworn and useless, to ward off the bourgeois and to strengthen the line that separated us from banality (even in ourselves). Besides, we were all in our twenties and ready to defy all the fathers in the world in a way that would rejoice the heart of Freud's Oedipus.

We were ready to sow unrest to the limit of our power – and this unrest sprang from various sources. Some felt the possibility or the certainty of a new path; with others it was lack of faith in society, in the nation, in art, in morality, and, in the last resort, in man himself, man the irreclaimable wild beast, man the lost wager. With others it was simply their own inner unrest, whether this was a reflection of the unrest that surrounded us, or just youthful rebelliousness. With every one of us it was youth as well as a mixture of all these elements, which were present in each of us in varying degrees and at different times. According to the degree in which each element was present, each of us later went his own separate way.

Chance I

> There is no such thing as chance. A door may happen to fall shut, but this is not by chance. It is a conscious experience of the door, the door, the door, the door.
>
> (From *Lieschen* by Kurt Schwitters)

There is no denying that the trumpet-blasts with which we proclaimed our theory of anti-art also resounded in our own ears. They progressively drowned the seductive notes of those conventions that still lingered within us. Even when we were practising art as art – and this was our concern morning, noon and night – our friends the poets, philosophers, writers and psychologists left us not so much as a mousehole through which to smuggle a single conventional idea.

Dada's propaganda for a total repudiation of art was in itself a factor in the advance of art. Our feeling of freedom from rules, precepts, money and critical praise, a freedom for which we paid the price of an excessive distaste and contempt for the public, was a major stimulus. The freedom not to care a damn about anything, the absence of any kind of opportunism, which in any case could have served no purpose, brought us all the closer to the source of all art, the voice within ourselves. The absence of any ulterior motive enabled us to listen to the voice of the 'Unknown' – and to draw knowledge from the realm of the unknown. Thus we arrived at the central experience of Dada.

I cannot say who exactly it was that took this decisive step, or when it happened. It probably arose out of a great variety of observations, discussions and

experiments which took place within the Dada movement. However, the fact that there is no mention of it in Ball's diaries and theoretical works seems to show that it did not originate in the sphere of literature but in that of the visual arts.

Here is an anecdote which, although totally characteristic of its central figure, has no real claim to be regarded as the true story of the 'beginning' or 'invention' of the use of chance. The part played in it by Arp could have been (or was?) played by Janco or Serner or Tzara. Dissatisfied with a drawing he had been working on for some time, Arp finally tore it up, and let the pieces flutter to the floor of his studio on the Zeltweg. Some time later he happened to notice these same scraps of paper as they lay on the floor, and was struck by the pattern they formed. It had all the expressive power that he had tried in vain to achieve. How meaningful! How telling! Chance movements of his hand and of the fluttering scraps of paper had achieved what all his efforts had failed to achieve, namely *expression.* He accepted this challenge from chance as a decision of fate and carefully pasted the scraps down in the pattern which chance had determined *(Ill. 12).* I was not there, of course, but I have seen the results of similar experiments of his. Was it the artist's unconscious mind, or a power outside him, that had spoken? Was a mysterious 'collaborator' at work, a power in which one could place one's trust? Was it a part of oneself, or a combination of factors quite beyond anyone's control?

The conclusion that Dada drew from all this was that chance must be recognized as a new stimulus to artistic creation. This may well be regarded as the central experience of Dada, that which marks it off from all preceding artistic movements.

This experience taught us that we were not so firmly rooted in the knowable world as people would have us believe. We felt that we were coming into contact with something different, something that surrounded and interpenetrated *us* just as we overflowed into *it.* The remarkable thing was that we did not lose our own individuality. On the contrary, the new experience gave us new energy and an exhilaration which led, in our private lives, to all sorts of excesses; to insolence, insulting behaviour, pointless acts of defiance, fictitious duels, riots – all the things that later came to be regarded as the distinctive signs of Dada. But beneath it all lay a genuine mental and emotional experience that gave us wings to fly – and to look down upon the absurdities of the 'real' and earnest world.

Chance became our trademark. We followed it like a compass. We were entering a realm of which we knew little or nothing, but to which other individuals, in other fields, had already turned.

Chance, in the form of more or less free association, began to play a part in our conversations. Coincidences of sound or form were the occasion of wide leaps that revealed connections between the most apparently unconnected ideas. Tzara, Arp, Serner and Huelsenbeck were masters of this art and Arp's poems masterpieces of this technique of exploration and experiment.

THE GUEST EXPULSED 5

Their rubber hammer strikes the sea
Down the black general so brave.
With silken braid they deck him out
As fifth wheel on the common grave.

All striped in yellow with the tides
They decorate his firmament.
The epaulettes they then construct
Of June July and wet cement.

With many limbs the portrait group
They lift on to the Dadadado;
They nail their A B seizures up;
Who numbers the compartments? They do.

They dye themselves with blue-bag then
And go as rivers from the land,
With candied fruit along the stream,
An Oriflamme in every hand.

(Hans Arp)

Huelsenbeck's native wood-notes were more Expressionist in tone:

END OF THE WORLD (1916)

This is what things have come to in this world
The cows sit on the telegraph poles and play chess
The cockatoo under the skirts of the Spanish dancer
Sings as sadly as a headquarters bugler and the cannon lament all day
That is the lavender landscape Herr Mayer was talking about
when he lost his eye
Only the fire department can drive the nightmare from the drawing-room
but all the hoses are broken
Ah yes Sonya they all take the celluloid doll for a changeling
and shout: God save the king
The whole Monist Club is gathered on the steamship Meyerbeer
But only the pilot has any conception of high C
I pull the anatomical atlas out of my toe
a serious study begins
Have you seen the fish that have been standing in front of the
opera in cutaways
for the last two days and nights . . . ?
Ah ah ye great devils – ah ah ye keepers of the bees and commandments
With a bow wow wow with a boe woe woe who today does not know
what our Father Homer wrote
I hold peace and war in my toga but I'll take a cherry flip
Today nobody knows whether he was tomorrow
They beat time with a coffin lid

if only somebody had the nerve to rip the tail feathers
out of the trolley car it's a great age
The professors of zoology gather in the meadows
With the palms of their hands they turn back the rainbows
the great magician sets the tomatoes on his forehead
Again thou hauntest castle and grounds
The roebuck whistles the stallion bounds
(And this is how the world is this is all that's ahead of us)

(Richard Huelsenbeck. Translated from the German by Ralph
Manheim in Motherwell, *The Dada Painters and Poets*)

And Tzara was adept at combining lyricism with pugnacity, polemics with the
tones of the nightingale. Despite the Biblical wrath of his denunciations of Art
as such, he could not help furthering the cause of art. Poems as exquisite as
freshly-picked flowers poured from lips dedicated to the cause of Dada. He
was not in the least ashamed of this contradiction:

LA REVUE DADA 2
pour Marcel Janco

Cinq négresses dans une auto
ont explosé suivant les 5 directions de mes doigts
quand je pose la main sur la poitrine pour prier Dieu (parfois)
autour de ma tête il y a la lumière humide des vieux oiseaux lunaires
l'auréole verte des saints autour des évasions cérébrales
tralalalalalalalalalalala
qu'on voit maintenant crever dans les obus.

(Tristan Tzara)

It was left to Tzara to follow the principle of chance to its logical or illogical
conclusion in literature. Sounds are relatively easy to put together, rhythmically
and melodically, in chance combinations; words are more difficult. Words bear
a burden of meaning designed for practical use, and do not readily submit to a
process of random arrangement. It was however exactly this that Tzara wanted.
He cut newspaper articles up into tiny pieces, none of them longer than a word,
put the words in a bag, shook them well, and allowed them to flutter on to
a table. The arrangement (or lack of it) in which they fell constituted a "poem",
a Tzara poem, and was intended to reveal something of the mind and per-
sonality of the author.

The diversity of possible applications of this principle of random arrangement is illustrated by this example dating from 1955, when I witnessed it in André Masson's studio. He showed me how he made sand paintings. With a small quantity of sand held between his hands, he moved over the prepared canvas like a dancer. After a period of intense concentration, he let the sand trickle from his swinging hands. "It is when I have completely switched off my will that my body and my nerves, my subconscious self, know best when and where to let the sand fall."

Even without going to extremes, the use of chance had opened up an important new dimension in art: the techniques of free association, fragmentary trains of thought, unexpected juxtapositions of words and sounds. In the field of visual art this new freedom had consequences that were possibly even more far-reaching.

I have already discussed Arp. He became one of the most consistent exponents of the use of chance and finally made of it an almost religious presence, one which has dominated his pictures and his sculpture right up to the present day.

"The law of chance, which embraces all other laws and is as unfathomable to us as the depths from which all life arises, can only be comprehended by complete surrender to the Unconscious. I maintain that whoever submits to this law attains perfect life."

Each man explored the new discovery in his own way. Janco used whatever unregarded objects Nature happened to place in his path. These *'objets trouvés'* he incorporated in abstract sculptures and reliefs of a new kind *(Ill. 19)*. Wire, thread, feathers, potsherds, were welcomed as materials and heralded the work that Schwitters had begun, more methodically and thoroughly, but probably at the same time as Janco.

For my own part, I remember that I developed a preference for painting my *Visionäre Porträts* (Visionary Portraits, *Pl. VII*) in the twilight, when the colours on my palette were almost indistinguishable. However, as every colour had its own position on the palette my hand could find the colour it wanted even in the dark. And it got darker and darker . . . until the spots of colour were going on to the canvas in a sort of auto-hypnotic trance, just as they presented themselves to my groping hand. Thus the picture took shape before the inner rather than the outer eye.

ô

He placed his hat upon the ground and filled it up with earth.
Then, with his fingers, he sowed a tear in it.

A big geranium grew from it, o so big.
Under the foliage ripened countless pumpkins.
He opened his mouth, which was full of gold fillings, and said:
I grec!
He shook the boughs of the willow of Babylon, which freshened the air –
And his pregnant wife showed her child, through the skin of her belly,
 the horn of a stillborn moon.
He placed his hat, which was an import from Germany, on his head.
The woman had a premature confinement, for which Mozart was
 responsible.
Meanwhile, a harpist raced along in a blacked-out automobile
and in the midst of the heavens, doves, such sweet
Mexican doves, ate – cantharides.

(Georges Ribemont-Dessaignes.
After a German version by Alexis)

Chance II

"We Chinese ... are obsessed with the totality of things ... That is why we often fail in the specific and practical. We see cause and effect as but two of several aspects of the paramount drive and purpose of life. Cause and effect to us are really by-products of the ultimate purpose which causes and effects all. Chance or what you call 'luck' is another manifestation of the same thing, not just an accidental occurrence unrelated to the general order of events, but also part of a funda-mental law of whose workings you are either painfully ignorant or arrogantly contemptuous. We, however, have profound respect for it and are continually studying it and devising methods for divining the nature of this law. We do it instinctively. You see, it is precisely the togetherness of things in time, not their apparent unrelatedness in the concrete world, which interests us Chinese."
(Laurens Van Der Post, *Flamingo Feather*, London, 1955, pp. 23-4)

We were concerned with chance as a mental phenomenon. It was not until later that I discovered that psychologists, philosophers and scientists were facing the same intractable problem at the same time.

What is chance? The story of Arp's drawing is a vivid example of its work-ings, but where does it lie *within us*?

This question touched us all the more closely when we realized how big a role chance coincidences had played in our own lives, and also that that role became greater as we became more conscious of it. Carl Gustav Jung speaks of such coincidences as "the power of attraction of the Relative, as if it were the dream of a greater, to us unknowable Consciousness" (see bibliography).

He includes chance in his concept of 'synchronicity', which he describes as an 'acausal orderedness'. This order independent of causality is not, according to Jung, to be thought of as a God standing outside the world, but as the momentary pattern formed by a continually-changing order whose shape at any given moment includes every human being, every animal, every blade of grass, every cloud, every star. The duty of man, as distinguished from the animal or the blade of grass, would thus be to be conscious of this order, to become aware of this continuous act of creation, and to achieve, through meditation, intuition and concentration, complete identity with the orderedness which has no cause.

In his book *Das Gesetz der Serie* ('The Law of Seriality'), which came out at the time (1919) when we were working with chance, Paul Kammerer attempts to develop a whole theory around these 'dreamlike' associations, and to discover the laws which govern acausal relationships.

Chance appeared to us as a magical procedure by which one could transcend the barriers of causality and of conscious volition, and by which the inner eye and ear became more acute, so that new sequences of thoughts and experiences made their appearance. For us, chance was the 'unconscious mind' that Freud had discovered in 1900.

This conscious break with rationality may also explain the sudden proliferation of new art-forms and materials in Dada. In the years that followed, our freedom from preconceived ideas about processes and techniques frequently led us beyond the frontiers of individual artistic categories. From painting to sculpture, from pictorial art to typography, collage, photography, photomontage, from abstract art to pictures painted on long paper scrolls, from scroll-pictures to the cinema, to the relief, to the *objet trouvé*, to the ready-made. As the boundaries between the arts became indistinct, painters turned to poetry and poets to painting. The destruction of the boundaries was reflected everywhere. The safety-valve was off. However unsafe and unknown the territory into which we now sailed, leapt, drove or tumbled, we were all sure where our path lay ... And the paths led in all directions.

Such an absence of boundaries, such a 'jungle of contradictions', cannot be expected to have much in common with the cut and dried herbariums of art

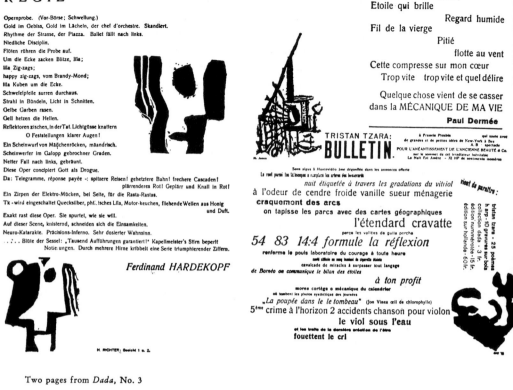

Two pages from *Dada*, No. 3

history. Compared with all previous 'isms', Dada must have seemed hopelessly anarchic.

But for us, who lived through it, this was not so. On the contrary, it was something meaningful, necessary and life-giving. The official belief in the infallibility of reason, logic and causality seemed to us senseless – as senseless as the destruction of the world and the systematic elimination of every particle of human feeling. This was the reason why we were forced to look for something which would re-establish our humanity. What we needed to find was a 'balance between heaven and hell', a new unity combining chance and design.

We had adopted chance, the voice of the unconscious – the soul, if you like – as a protest against the rigidity of straight-line thinking. We were ready to

embrace, or be embraced by, the unconscious. All this grew out of the true sense of fellowship that existed among us, the climate of the age, and our professional experimentation. It developed as a necessary complement to the apparent and familiar side of our natures and of our conscious actions, and paved the way for a new unity which sprang from the tension between opposites.

Chance and Anti-Chance

The adoption of chance had yet another purpose, a secret one. This was to restore to the work of art its primeval magic power, and to find the way back to the immediacy it had lost through contact with the classicism of people like Lessing, Winckelmann and Goethe. By appealing directly to the unconscious, which is part and parcel of chance, we sought to restore to the work of art something of the numinous quality of which art has been the vehicle since time immemorial, the incantatory power that we seek, in this age of general unbelief, more than ever before.

Proclaim as we might our liberation from causality and our dedication to anti-art, we could not help involving our *whole* selves, including our conscious sense of order, in the creative process, so that, in spite of all our anti-art polemics, we produced works of art. Chance could never be liberated from the presence of the conscious artist. This was the reality in which we worked, notwithstanding all Tzara's press-cutting poems and Arp's fluttering scraps of paper. A situation of conflict.

This conflict is in itself an important characteristic of Dada. It did not take the form of a contradiction. One aspect did not cancel out the other; they were complementary. It was in the interplay of opposites, whether ideas or people, that the essence of Dada consisted. When Ball declared, "I have examined myself carefully; and I could never bid chaos welcome", and Tzara received chaos with open arms, they completed each other, like belief and unbelief; they belonged together like good and evil, art and anti-art.

One day in 1917 I met Arp in front of the Hotel Elite in Zurich (*Ill. 17*). The trees along the Bahnhofstrasse were being cut back. Their bare, wild, outstretched arms spoke in a language of their own, making a counterpoint to the rows of buildings. Their powerful melody excited me. "You see", I said to Arp, "that is what I look for. The elements of the tree, its essence. The living

skeleton." – "And I", Arp replied, caressing the air with his hand as if stroking a woman's body, "I love the skin." Arp breathed life into the skin, and I went on looking for the essence. Both of us were right; our attitudes, opposed as they were, belonged together. The difficulty was semantic rather than real. The 'fault' lies with language, and as language is the tool of thought, the fault lies with our way of thinking.

Dada took hold of something that can neither be grasped nor explained within the conventional framework of 'either/or'. It was just this conventional 'yes/no' thinking that Dada was trying to blow sky high. This radical attack on dualistic thought was in the very nature of the movement. The liberation and expansion of thought and feeling was to be followed by the integration of both in verse, in painting, and in musical sound. "Reason is a part of feeling, and feeling is a part of reason" (Arp). As soon as this premise is accepted, the contradictions of Dada resolve themselves and a picture of the world takes shape in which, besides 'causal' experiences, others that were previously unknown and unmentioned find a place. Laws appear which include within themselves the negation of Law.

Absolute acceptance of chance brought us into the realm of magic, conjurations, oracles, and divination 'from the entrails of lambs and birds'.

This was all right for a time. Tzara's poems made out of newspaper clippings were (on their own level) poems belonging to the 'person who was Tzara'. This was true once, twice, three times . . . but there it stopped.

Tzara exploited the same chance factors as did Arp, but while Arp made conscious use of his eye and brain to determine the final shape, and thus made it possible to call the work his, Tzara left the task of selection to Nature. He refused the conscious self any part in the process. Here the two paths Dada was to follow are already apparent.

Arp adhered to (and never abandoned) the idea of 'balance' between conscious and unconscious. This was fundamental to me as well; but Tzara attributed importance exclusively to the Unknown. This was the real dividing-line. Dada throve on the resulting tension between premeditation and spontaneity, or, as we preferred to put it – between art *and* anti-art, volition *and* non-volition, and so on. This found expression in many ways and was apparent in all our discussions.

Whatever may have been going on at the same time in New York (and later in Berlin and Paris), in the euphoria induced by the discovery of the spontaneous, we in Zurich saw Dada as a means of attaining what Arp called "a balance between heaven and hell". We wanted to stay human!

60

As this tension between mutually necessary opposites vanished – and it ended by vanishing completely in the Paris movement – Dada disintegrated. In the resulting general tumult and chaos personal relationships disintegrated too, and so did the image of Dada in the memories of our contemporaries.

I remember very well that this tension between myself and not only Arp and Serner, but also the Talmudic philosopher Unger, the journalist-politician del Vayo, his Spanish friend Count Pedroso (whom I painted as a 'blue man'), the Janco brothers and Tzara, gave me a lot of trouble. My sense of order and of disorder shuttled me back and forth and I only occasionally achieved the 'balance between heaven and hell' that Arp was born with – and that Tzara had no interest in.

We were all fated to live with the paradoxical necessity of entrusting ourselves to chance while at the same time remembering that we were conscious beings working towards conscious goals. This contradiction between rational and irrational opened a bottomless pit over which we had to walk. There was no turning back; gradually this became clear to each of us in his own secret way.

It is difficult to talk about this 'secret way' in connection with others; it represents an inner process. I can describe this process only from my own experience; but this is probably typical, in essentials, of the path (or the impasse) in which we all found ourselves at various times.

The completely spontaneous, almost automatic process by which I painted my *Visionary Portraits* (1917, *Pl. VII*) no longer satisfied me. I turned my attention to the structural problems of my earlier Cubist period, in order to articulate the surface of my canvases. For the sake of simplicity I chose 'Heads' made up of black and white surfaces balanced against each other.

Ferruccio Busoni, with whom I sometimes discussed my problems by the Kaspar Escher fountain in front of Zurich railway station, advised me to study the principles of counterpoint, since my experimentation with positive and negative shapes, my 'black-and-white obsession', showed analogies with contrapuntal theory. He suggested that I should play through the little preludes and fugues that Bach wrote for his wife. This would teach me, he said, better than any explanation, the spiritual beauty that lay in this principle. So, 'by chance', I came upon the analogy between music and painting. And by a later 'chance', this was to take on a new meaning I never dreamed of at the time. Meanwhile, I at least had a point of departure for my 'harmonization' of surfaces, in which white and black entered into a dynamic relationship. This black-white relationship demanded to be organized musically. Organization submitted to chance.

Chance gave variety to organization. A balance was achieved. In this way I discovered, in many hundreds of more or less abstract 'Heads', the freedom to make music in my own way *(Ill. 24)*.

One day early in 1918, Tzara knocked on the thin partition between our rooms in the Hotel Limmatquai in Zurich, and asked me to come and meet the Swedish painter Viking Eggeling. He had mentioned this artist several times before, and had hinted that he was "experimenting with similar ends in view". I found a burly man of average height, with an aquiline nose and the brilliant blue eyes of a viking. Eggeling showed me a drawing. It was as if someone had laid the Sibylline books open before me. I 'understood' at once what it was all about. Here, in its highest perfection, was a level of visual organization comparable with counterpoint in music: a kind of controlled freedom or emancipated discipline, a system within which chance could be given a comprehensible meaning. This was exactly what I was now ready for.

While I, using surfaces, could only produce a limited number of pairs of opposites, he had an inexhaustible supply of such pairs in the realm of the line. Whether this was Art or Anti-art, to me it was the occasion of new insights into the realm of mental and spiritual communication. These brought within my reach the famous 'balance between heaven and hell'.

In our excitement at the startling similarity of our aims and methods, we became and remained friends. The enthusiastic approval with which I greeted his work was something that had hitherto been denied him, and must have been as much of a surprise to him as was to me the discovery of the artistic possibilities I had been seeking.

In the enthusiasm of our first meeting he presented me with the picture reproduced here *(Ill. 25)*. (He later borrowed it back from me and gave it to Arp. Later Tzara had it.) I was so delighted with this gift that I asked him to come at once to my studio, so that I could give him one of my own pictures. In his presence, I painted a medium-sized abstract canvas, impromptu, in exactly one hour *(Ill. 21)*. This he found impossible to understand. How could even one brush stroke be applied, without painstaking analysis and preparation, and without a clearly-defined theme? And in colour, too! But the contrast between us, which was that between method and spontaneity, only served to strengthen our mutual attraction, I sought method and discipline to control my spontaneity; he discovered in me the directness of feeling that would allow his methodical art to take wing.

Like me, he had arrived at his theory by way of music, and always explained it in musical terms. He came from a very musical family (to this day there is an

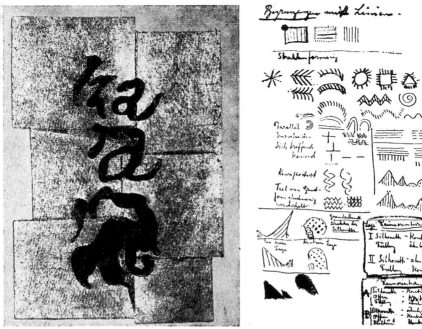

Hans Arp, Cover for de luxe edition of *Mr. Antipyrine*, 1918

Viking Eggeling, Material for the *Generalbass der Malerei*, 1918

'Eggeling's Music Shop' in Lund, Sweden, where he was born). My own first encounter with the arts also took place through music. As a child, I often used to hide under the piano at my mother's weekly musical evenings and listen, overcome with emotion.

As his starting-point, Eggeling had taken the most elementary pictorial element, the line, and he was working on what he called its 'orchestration' (a concept first used by Gauguin in speaking of colour). This was the interplay of relationships between lines which he had arranged (as I had done with positive and negative surfaces), in contrapuntal pairs of opposites, within an all-embracing system based on the mutual attraction and repulsion of paired forms. This he called *'Generalbass der Malerei'*. The drawing that had impressed me so much at our first meeting was, he told me, the product of his systematic creative use of this *'Generalbass'*.

Over and above this, he had an 'all-embracing philosophy' which had led him to formulate rules of everyday conduct which had, for him, absolute validity. The interplay of 'opposites' and 'affinities' was for him the true principle of creation so much so, indeed, that he recognized no exceptions. It was not in my nature to agree with this sort of exclusive thinking. But how could one create

63

a new order of things without insisting on dotting all the 'i's? How else could a vision of the world be achieved in which the greatest was exactly mirrored in the smallest and the smallest in the greatest? It was overwhelming. His incisive mind, his intense personality, his whole heart and soul – all were dedicated to the furtherance of his ideas, even in his choice of food. For instance, he refused to have eggs and milk at the same meal on the grounds, expressed in the same terms as he used for his 'linear orchestrations', that "eggs and milk are too 'analogous'."

We were no longer interested in 'form' but in a principle governing relationships. Form could be placed in context only by its opposite, and could be brought to life only by the establishment of an inner relationship between the two opposites. This was the only way to create a unity, that is to say, an artistic whole.

At the time we were convinced that we had set foot in completely unknown territory, with musical counterpoint as its only possible analogy.

In fact, however, this idea of the 'unity of opposites' has been known, under the name of 'contingence', for a very long time. But what we had found still constituted a 'discovery'. Our scientific and technological age had forgotten that this contingence constituted an essential principle of life and of experience, and that reason with all its consequences was inseparable from *un*reason with all its consequences. The myth that everything in the world can be rationally explained had been gaining ground since the time of Descartes. An inversion was necessary to restore the balance.

The realization that reason and anti-reason, sense and nonsense, design and chance, consciousness and unconsciousness, belong together as necessary parts of a whole – this was the central message of Dada.

Laughter

> "Laughter is a reaction against rigidity."

Possessed, as we were, of the ability to entrust ourselves to 'chance', to our conscious as well as our unconscious minds, we became a sort of public secret society. We were known, to laymen and experts alike, more by our roars of laughter than by the things we were really doing. Raised far above the bourgeois world by the power of our inner and outer vision . . . we laughed and laughed.

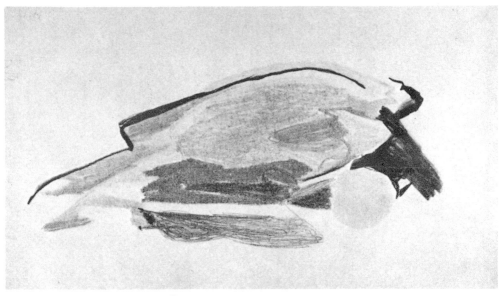

21 Hans Richter, *Abstraction*, 1919. Crayon

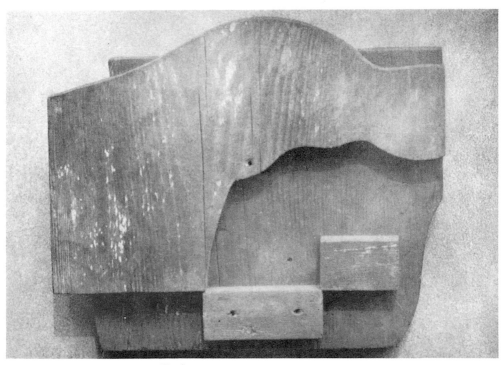

22 Hans Arp, *Construction*, 1919. Wood

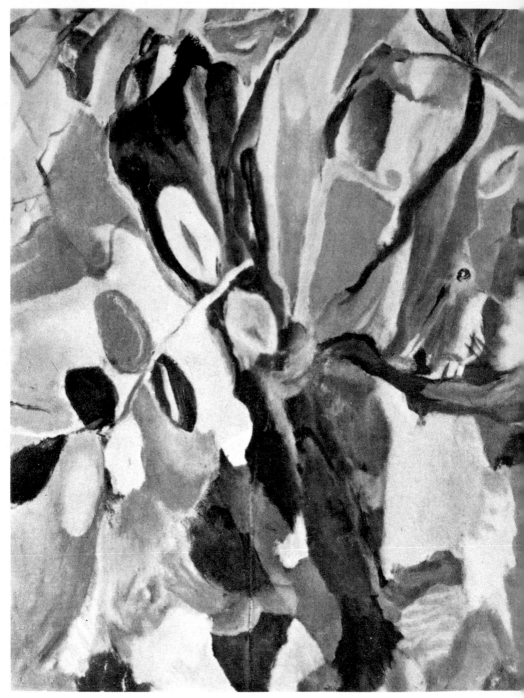

23 Hans Richter, *Herbst*, (Autumn), 1917. Oil

24　Hans Richter, *Dada-Kopf* (Dada Head), 1918. Oil

Viking Eggeling, *Orchestration Horizontal-Vertical*, 1918. Pencil

26 Arthur Cravan, 1916

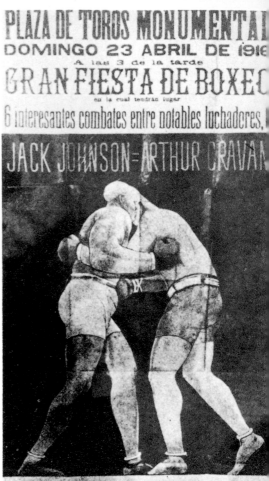

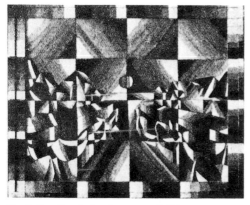

28 Arthur Segal, *Landscape*, 1918. Oil

27 Poster for the fight between Arthur Cravan and the wo[rld]
 champion, Jack Johnson, 1916

We destroyed, we insulted, we despised – and we laughed. We laughed at everything. We laughed at ourselves just as we laughed at Emperor, King and Country, fat bellies and baby-pacifiers. We took our laughter seriously; laughter was the only guarantee of the seriousness with which, on our voyage of self-discovery, we practised anti-art.

But laughter was only the *expression* of our new discoveries, not their essence and not their purpose. Pandemonium, destruction, anarchy, anti-everything – why should we hold it in check? What of the pandemonium, destruction, anarchy, anti-everything, of the World War? How could Dada have been anything but destructive, aggressive, insolent, on principle and with gusto? In return for freely exposing ourselves to ridicule every day, we surely had a right to call the bourgeois a bulging haybag and the public a stall of oxen? We no longer contented ourselves with reforming pictorial art or versification. We would have nothing more to do with the sort of human or inhuman being who used reason as a juggernaut, crushing acres of corpses – as well as ourselves – beneath its wheels. We wanted to bring forward a new kind of human being, one whose contemporaries we could wish to be, free from the tyranny of rationality, of banality, of generals, fatherlands, nations, art-dealers, microbes, residence permits and the past.

Of our countless planned and unplanned mystifications I shall mention only two. Arp tells the story:

"Augusto Giacometti (uncle of the sculptor) was already a successful man in 1916. Although he had no special love for the Dadaists, he often took part in their demonstrations. He looked like a prosperous bear and, no doubt in sympathy with the bears of his native land, he wore a bearskin hat. One of his friends told me in confidence that he carried a well-stocked bank book in the lining of this hat. On the occasion of a Dada festival, he gave us a memento, thirty yards long, painted in all the colours of the rainbow, and covered with sublime hieroglyphics. One evening we decided to give Dada some modest private publicity. We went from one restaurant to the next all along the Limmat-quai. He cautiously opened each door and called in ringing tones: '*Vive Dada!*'

"The diners nearly choked on their sausages. What could be the meaning of this mysterious cry, coming as it did from a fully-grown, respectable-looking man who did not look in the least like a charlatan or a trickster?

"At that time Giacometti was painting stars, flowers, 'cosmic configurations', tongues of flame and fiery chasms. His painting interested us because it developed towards true artistic vision by way of pure colour. Giacometti was also the first to make a mobile object: this he did with a clock, round which

he built up his shapes and colours. It was a wonderful period for us, in spite of the war, and in the next World War, while we are being turned into hamburgers and scattered to the four winds of heaven, we shall look back on it as an idyll."

To outrage public opinion was a basic principle of Dada. Our exhibitions were not enough. Not everyone in Zurich came to look at our pictures, attended our meetings, read our poems and manifestos. The devising and raising of public hell was an essential function of any Dada movement, whether its goal was pro-art, non-art or anti-art. And when the public (like insects or bacteria) had developed immunity to one kind of poison, we had to think of another.

One day the Swiss newspapers received reports of a duel said to have been fought, with pistols, by two Dada-chieftains, Tzara and Arp, in a wood called the Rehalp. One of the seconds was alleged to have been the universally popular sentimental poet J. C. Heer (*König der Bernina*, etc.). When this news appeared, a large section of the public wished that at least one of the duellists, and preferably both of them, had stopped a bullet. But the same public also wondered how a sedate figure like J. C. Heer, who was not in the least eccentric, could possibly have become involved in such goings-on.

The very next morning, the papers that had carried the duel story received a furious disclaimer from the said J. C. Heer. He had not been in Zurich at all but in St Gallen, and had not of course lent himself to any such illegal activities. On the evening of the same day there was a disclaimer of the disclaimer. Its first paragraph caused a sigh of disappointment to be heard all over Zurich; neither of the combatants had been hurt (the report said that they had both fired in the same direction – away from each other). The second paragraph plunged the reader into total confusion. Two witnesses (both Dadaists, it is true) announced that they understood of course that a respected figure like J. C. Heer did not wish to be associated with the stormy quarrels of youth, but that respect for the truth forced them to say (with a polite bow in the direction of the revered poet) that he *had* been there as a second.

There had been no duel, and J. C. Heer had of course been in St Gallen. The technique of disturbing, molesting and openly insulting the public, pioneered with such skill and gusto in the meetings, manifestos and hoaxes of the Zurich movement, was later developed into an independent art-form in Berlin and Paris. It finally became clear, in Berlin, Leipzig, Prague, Paris and elsewhere, that the public likes nothing better than to be made fun of, provoked and insulted. This is the moment when the public finally begins to think. As it is never without a guilty conscience, it begins to say to itself: "Basically these people

are right. We are idiots, after all, so why shouldn't they say so?" And they all go home with a contented feeling that self-knowledge is the first step towards reforming oneself. There were of course some who took the opposite course and stormed the speakers' platform in order to show their tormentors what was what.

Quite apart from these public disturbances, we did not deny our own colleagues the dubious distinction of being the object of our derision. At one meeting there were readings of magniloquent poems by Theodor Däubler, which, although heavily emotional, were not his at all. We enjoyed ourselves hugely, without admiring Däubler one whit the less for the magnificent personality and the true poet he was. Often enough, the mere presence of a handful of mud was enough to make us pelt someone with it, if only to prove to others and to ourselves our lack of respect for age, fame and reputation.

Private Lives: The Café Odéon

When I arrived in Zurich in August 1916, the artists and intellectuals used to meet in the Café de la Terrasse. Only a few months later, we moved to the Café Odéon. The waiters at the Terrasse had gone on strike. In sympathy with them, because they often let us sit for hours over one cup of coffee, we punished the Terrasse by permanently withdrawing our custom, although we had been much more comfortable in the big room at the Terrasse than we were in the cramped, ill-lit Odéon.

The only one of us to continue holding court at the Terrasse was the poetess Else Lasker-Schüler; but even she sometimes honoured us with her presence at the Odéon, to read her poems to Erich Unger and Simon Guttmann and to argue obstinately with us. None of these three actually belonged to the Dada group, but Guttmann almost always sat at our table. He was one of the quickest and best conversationalists I have ever known, and was happiest when exchanging *bons mots* and psychological and artistic theories with the equally sharp-witted Walter Serner.

Erich Unger's ruminative, intelligent, sheep-like face often loomed over the Odéon coffee-cups. He never stopped twirling the hair on his temples, an atavism, according to him, which went back to the *peyes* of orthodox Jews. He was as witty as Guttmann but much slower, an amiably earnest student of classical philosophy, which, for him, clearly included the Cabbala.

Through him I made the aquaintance of the rather more alarming Dr Oscar Goldberg, who did not choose to sit at our Dada tables, so that one always had to go and sit with him in some corner. Both Unger and Guttmann treated him with a sort of mystical reverence; a tribute not lightly bestowed by this pair of sceptics. Dr Goldberg was a numerologist. He examined the secret meaning of the Pentateuch. As every Hebrew letter has a numerical value (he explained), the numerical combinations formed by the words of the Pentateuch would yield a secret message. This was the real, esoteric revelation, the words being only for the profane.

I found this fascinating, but did not feel competent to judge it. Nevertheless, I introduced Dr Goldberg to our charming and prosperous friend Daura. Her less sceptical nature led to the opening of a substantial bank account, which was just what this bald and uncouth but daemonic figure seemed to need for the furtherance of his mysterious mission.

All this was transacted at the Odéon, while a few streets away in Niederdorf, a drama was unfolding in which we had a considerable interest. Hack, the kindly bookseller and antiquarian who sold our drawings and woodcuts, had taken an overdose of his daily cocaine and was found one morning lying dead in his shop in the Oetenbachgasse. It seemed as though he had been destined by fate to give Dada artists the chance to have their own exhibitions. His shop was a meeting-place. Anyone who was not in the Odéon could probably be found in Hack's shop browsing through books, or reading them, or even borrowing them (sometimes for ever). The death of Hack was a great loss to us.

His place was taken by the bearded, broad-shouldered Corray, who took over Hack's shop. My judgments of people have always depended on imponderables. To me Corray looked like a Doré drawing of Bluebeard (with a pointed beard as a danger signal). Somewhere in his flat there must be a locked chamber containing the silk and velvet garments, ruffles and ribbons of discarded ladies who had either been eaten or at least left to languish in some hopeless dungeon. Apart from his Bluebeard aspect, he corresponded exactly to my idea of a perfect businessman. The fact is that he put his gallery (that is, his third-floor flat in the Tiefenhöfe) at our disposal for the first Dada exhibition – and I do not think he charged us for it. He was thought of as the Dada art-dealer; there was plenty of art but there was not much dealing.

Our corner at the Odéon had long ago ceased to be a single table of regular customers. Friends brought their friends, of both sexes. With Arp came the short-sighted art-critic Neitzel, whom we all revered, and Luethy, the painter who painted some of the best Zurich abstracts, and von Tscharner, Gubler and

the indestructible Helbig, with whom I had bitter arguments from 1916 onwards. There was also the immensely tall, teutonically handsome Otto Flake, whose books aroused considerable attention, and whom Arp had brought to the Odéon. One or two of our friends' girl-friends, painters or writers, had problems with the police and crossed illegally from Baden to visit us in the evenings. Their boy-friends then had to escort them back, unless they decided to spend an illegal night in Zurich.

For all these people, two or even three tables at the Odéon were not enough. So we ended by reserving half of the Rämi-Strasse corner of the Odéon for ourselves. The gentle Jawlensky turned up from time to time, as well as his lady-friend Werefkin, and the towering, heavily-bearded Giacometti, whose giant, butterfly-tinted abstracts were among the first and finest examples of abstract art to come from Switzerland.

Jawlensky's numerous 'musical' variations on the human head were among the things that impressed me the most at that time. Perhaps they influenced my own attempts to find a law, which were also based on heads. They were published in successive issues of *Dada*. Jawlensky, who was considerably older than the rest of us, was respected by everyone, although we did not normally treat age with any excessive deference. We loved him not only because of his mature art, but because he was a wise and kindly human being with a Russian's profound melancholy. Arthur Segal also sometimes paid us a visit. He had played tunes on his chromatic colour-scale *(Ill. 28)* before Dada, even before 1914, and had finally allowed it to spill over on to the frame. His colours 'rang'. Their music has still not lost its power to charm. Even further out on the fringe was Dr Lehmann, a very thin paediatrician who put into practice modern ideas about child-rearing that have since had a widespread influence, especially in the United States. He got children to paint. This 'therapeutic' intrusion into our territory was received with some scepticism but with great curiosity, although it had nothing to do with art as such. For me this was a practical confirmation of my unshakable conviction that every child starts off possessing genius, until, under the influence of social pressures and the weakness of the flesh, he first misuses, then loses and finally despises it.

If the Odéon was our terrestrial base, our celestial headquarters was Laban's ballet school. There we met young dancers of our generation. Mary Wigman, Maria Vanselow, Sophie Taeuber *(Ill. 4)*, Susanne Perrottet, Maja Kruscek, Käthe Wulff and others. Only at certain fixed times were we allowed into this nunnery, with which we all had more or less emotional ties, whether fleeting or permanent.

These highly personal contacts – and Laban's revolutionary contribution to choreography – finally involved the whole Laban school in the Dada movement. Its students danced in the ballet *Die Kaufleute* ('The Merchants'). In front of abstract backdrops ('cucumber plantations') by Arp and myself, dancers wearing Janco's abstract masks fluttered like butterflies of Ensor, drilled and directed according to a choreography written down by Käthe Wulff and Sophie Taeuber in Laban's system of notation.

Sophie Taeuber was not only a dancer and a teacher; she was above all a painter of modern abstracts at a time when abstract painting was still in its infancy. Sophie was as quiet as we were garrulous, boastful, rowdy and provocative. Even later, when she and Arp were living in their little house at Meudon, her voice was scarcely ever heard. It was Arp who asked their guests to "come upstairs" and see Sophie's work. Left to herself, she would never have shown it to anyone *(Ill. 13)*.

Naturally, there were occasional problems; for example, Emmy Hennings could not decide whether to leave Ball for the good-looking, fiery Spaniard del Vajo. Ball followed them around with a revolver in his pocket (so Emmy said), and the two lovers hid in my flat, eluding their pursuer by a hair's breadth. Since Emmy could not decide for herself, Tzara and I met to discuss the problem and finally induced Emmy to go back to Hugo, her sorrowful knight. Soon afterwards they were married.

Tzara's rows with his Maja were frequent and noisy, and it was not always possible to keep out of earshot. The lovely Maria Vanselow, who went around with Janco's brother Georges before her eye lighted upon me, was less noisy, but the dramatic upsets that she caused were all the more lasting. Serner, on the other hand, fickle as he was, did not like to pitch the tents of Laban (or anything else) in these lovely pastures for too long at a time. Into this rich field of perils we hurled ourselves as enthusiastically as we hurled ourselves into Dada. The two things went together.

Notwithstanding its anarchic anti-art proclamations, the Dada revolution remained essentially within the sphere of art until after the beginning of 1918. With the arrival in Zurich of Francis Picabia, a new element appeared and the emphasis began to shift. Although this was not immediately apparent in Zurich,

it appeared more clearly when the movement migrated to new headquarters. Tzara particularly seemed to switch suddenly from a position of balance between art and anti-art into the stratospheric regions of pure and joyful nothingness.

The exhibition at the Galerie Wolfsberg in September 1918 marked the end of this period of 'balance' within Dada. Arp had on show some brightly-coloured abstract reliefs composed of wooden discs. Janco had snow-white plaster reliefs, I my visionary abstract portraits *(Pl. VII)*. Baumann, McCouch, Hennings and Morach showed some abstract and some representational pictures. In a dark room on the other side of the gallery from our brightly-lit exhibition hung a series of pictorially almost disembodied 'machine pictures', mainly, as I recall, in gold and black. They were by a Spaniard then unknown to me, Francis Picabia *(Ill. 31)*. These pictures incorporated words, names, interpellations, designed to carry the subject-matter of the picture outside the frame, whether for illustrative, polemical, or poetic purposes. Here, obviously, was a true 'painter', but he hardly 'painted' at all.

Shortly afterwards, Picabia himself arrived in Zurich with his talented wife Gabrielle Buffet. Viewed in retrospect, Picabia's arrival marks the end of an era in the history of Zurich Dada. As an incidental consequence, it gave an enormous boost to Tristan Tzara's rise to fame.

Picabia's most important contribution was his periodical *391*. This was a French version of Dada, although its origins were Spanish. Picabia, like his fellow-Spaniards Picasso and Gris, belonged in every respect to the Parisian school. If he seasoned his French dishes with Spanish pepper, this was merely part of that French art of cooking which becomes truly French only by using seasonings from every nation in the world.

Picabia's first appearance, plying us all with champagne and whisky in the Élite Hotel, impressed us in every possible way. He had wit, wealth, poetry and a Goya head set directly on his shoulders with no intervening neck; he was a cynic and had the vitality of an Andalusian bull. A globetrotter in the middle of a global war! He had taken the title of his periodical *391* from Alfred Stieglitz's New York periodical *291*. Perhaps the number 391 attracted Picabia because of its sheer meaninglessness. Apart from the fact that its digits add up to 13, it has no relevance at all to the contents of the periodical. (And what might be the relevance of the number 13?)

The subject-matter of *391* was mainly literary and full of aggression against everybody and everything. It had antecedents in French literature, Jarry and Apollinaire, which were equally savage. The literary section of *391*,

published at first in Barcelona and later in New York, was accompanied by the machine-drawings already mentioned, by machine-poems, drawn *aperçus,* and contributions by two men I had never heard of, Marcel Duchamp and Man Ray.

Picabia had inexhaustible powers of invention, he was rich, and he was independent, materially and mentally, intellectually and creatively. An artistic temperament which demanded spontaneous self-expression was matched in him with an intellect that could no longer see a 'meaning' in this world at all. He was, at one and the same time, a creative artist, compelled to go on creating, and a sceptic, who was aware of the total pointlessness of all this creative activity, and whose Cartesian intellect ruled out all hope . . . except the hope that this conflict would put an end to his existence. "Reason shows us things in a light which conceals what they really are. And, in the last resort, what are they?"

Tzara and Serner, both writers, could not fail to be excited by such pronouncements. The painters among us took them rather more calmly. Picabia was a painter himself, and the statements he made with his brush had more significance for us than anything he said or wrote.

Tzara and Serner, and Ball too, had already denounced art in every possible way, and the pictures Picabia exhibited alongside ours in the Galerie Wolfsberg did not, in our eyes and in spite of all his anti-art declarations, lie outside the sphere of art. Picabia confronted us with a radical belief in unbelief, a total contempt for art, which proclaimed that any further involvement with the 'communication of inner experiences' would be sheer humbug (this at least was its verbal message). I could see that there was more in him than the anti-art impulses incessantly belied by his works. Over and above this, there was an urge to deny that there is any sense or meaning in life as such, a rejection of art in so far as it constitutes an affirmation of life. Wherever in life the life-impulse might break through (as it does in art) it must be torn apart, disordered and disowned. The life-impulse as such was suspect.

This was the essential difference between Picabia's nihilism and the moralistic pessimism of Serner, who, although a confirmed cynic, always retained in the depths of his being a spark of idealism. (This hope is said to have led him to a miserable death in Russia, where he went in search of a classless society.) Picabia's nihilism also differed from the deeply disillusioned faith in humanity which inspired Ball in the tireless quest which was ultimately to lead him to the Catholic Church. It differed also from the elegant and frivolous but basically materialistic nihilism of Tzara, who took life as he wished to find it, and who believed in himself if in nothing else. It was fundamentally different, too, from

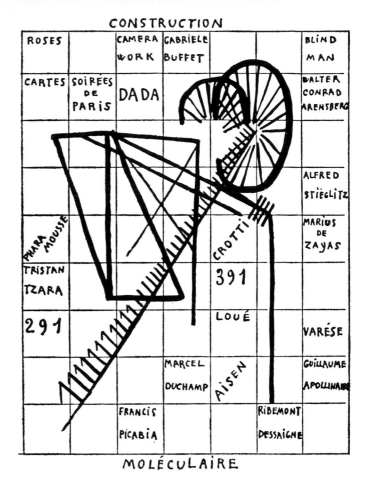

CONSTRUCTION

ROSES		CAMERA WORK	GABRIELE BUFFET			BLIND MAN
CARTES	SOIRÉES DE PARIS	DADA				WALTER CONRAD ARENSBERG
						ALFRED STIEGLITZ
PHARA MOUSSE				CROTTI		MARIUS DE ZAYAS
TRISTAN TZARA				391		
291			LOUÉ			VARÉSE
		MARCEL DUCHAMP	AISEN			GUILLAUME APOLLINAIRE
	FRANCIS PICABIA			RIBEMONT DESSAIGNE		

MOLÉCULAIRE

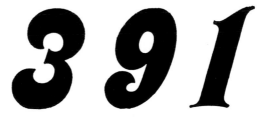

Francis Picabia, Cover for 391, No. 8

AD

J'ai horreur de la peinture de Cezanne elle m'embête.

Francis Picabia

the unshakable faith in art which united Arp, Janco, Eggeling and myself. We regarded even the anti-art formula as a privilege inseparable from man's progress towards true humanity. All this was thrown into prominence by Picabia's appearance on the Zurich scene. He became the prism which showed up the colours and the dark bands of the rainbow that was Dada.

I met Picabia only a few times; but every time was like an experience of death. He was very strange, very magnetic, challenging and intimidating at the same time. All of us seemed to have moments when we temporarily felt the need to obey the anti-life impulse so virulently expressed by Picabia. I remember the moments of despair, caused by the war, by the injustice and stupidity of it all, when I went round my studio kicking holes in my own mutely staring pictures. (I always took them to the brothers Scholl a few days later to be repaired – and then forgot to collect them.) I do not know in what ways this self-destructiveness affected my friends, but I can remember the deep depressions that overtook the otherwise equable and friendly Janco.

Picabia's stay in Zurich produced another issue of *391*. This was issue number eight (see the cover on the previous page) and was official confirmation of Picabia's link with the Dada movement.

Barcelona

391 was founded in Barcelona in January 1917. It was there that the first four issues came out, every month until March 1917. Francis Picabia was Parisian by birth but of Cuban extraction. He was married to Gabrielle Buffet, the very intelligent and lively daughter of a French senator. At the end of 1916 they had left the wartime discomforts of Paris and come to Spain on a 'special government mission'. In Barcelona Picabia found a congenial group of war-émigrés. There were the painter Marie Laurencin, rather lost without her lover Apollinaire, the painter Albert Gleizes, whose wife was a militant pacifist and found wartime France unbearable, the painter and poet Maximilian Gauthier (Max Goth), and the writer and amateur boxer Arthur Cravan (real name Fabian Lloyd), well known in Paris through his *revue scandaleuse, Maintenant.*

The same circle included the Russian painter Charchoune, who later joined the Paris Dada movement and edited a special Russian Dada magazine, and the Italian Canudo, less well known as an artist but a figure of importance in the history of the cinema. Even before the war, the poet Däubler had talked

to me about Deluc and Canudo and their pioneer struggle for the recognition of the film as a new art-form, but at the time the subject had not interested me. The term 'photogenic' was coined by them. The theories of Deluc and Canudo dominated the aesthetics of the cinema in France in the 'twenties. Today there is a Deluc prize; Canudo is forgotten.

The isolation which is the common fate of all émigrés led in Barcelona, as it did in Zurich, to frequent meetings. But their conjunction does not seem to have produced the same incubatory warmth, or the same enthusiastic co-operation, as there was at the Cabaret Voltaire. According to Gabrielle Buffet they do not seem to have been a group of equal collaborators working to produce *391* but rather a circle of émigrés brought together over coffee and Pernod by a consciousness of their common French nationality. *391* drew its strength mainly from Picabia's fiery personality, his money and his complete personal independence. The restlessness that (his wife tells us) never left him acted as a stimulus to them all. He was already beginning to flex his muscles for the attack on art and to rattle at the supports of faith in art as such. His restless, doubting nature reflected all the unashamed scepticism of the Latin peoples.

It is no longer possible to say how much influence Laurencin, Gleizes, Gauthier or Cravan had on *391*, but the relatively mild character of this periodical when it first appeared in Barcelona suggests that there was a certain amount of collaboration. The 'moderates' seem to have held the balance against the irrepressible Picabia and the totally anarchic Cravan. Nevertheless, I would say that *391* was even then basically Picabia's work. Wherever his name appears, the material is provocative, programmatic and, by virtue of its anti-art message, radically opposed to that of his collaborators.

Picabia was his own inexhaustible arsenal of destructive weapons: he could provide negations, contradictions and paradoxes of all kinds, ranging from ridicule to downright slander. All this in the service of a negation of life that was, if the word can be used in such a context, exuberant. It was this negation of life that gave him his dynamic forward momentum. It included a negation of art. This negation of art he daily belied by virtue of his astounding, inexhaustible powers of invention, only to reaffirm it and belie it again. Behind all this there was a craving for freedom and independence which never gave him, or his friends, or his enemies, or *391*, or any of his other periodicals, variants of *391*, a moment's rest.

The place which Picabia assigned to art was, so to speak, a hole in the void. But in spite of the fanatical, truly desperate battle that he waged against art, in spite of the theoretical anathemas he hurled at art, he never escaped from it.

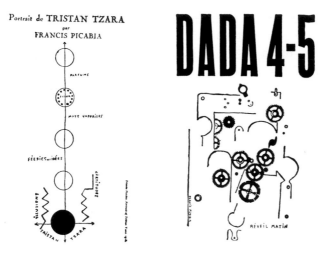

Francis Picabia, *Portrait de Tristan
Tzara*

Francis Picabia, Title page for *Dada*,
Zurich 1919

Gabrielle Buffet writes of her husband *(Dada Painters and Poets*, p. 263):
"It must be stressed in any case that this activity was utterly gratuitous and
spontaneous, that it never had any programme, method, or articles of faith.

"Without other aim than to have no aim, it imposed itself by the force of its
word, of its poetic and plastic inventions, and without premeditated intention
it let loose, from one shore of the Atlantic to another, a wave of negation and
revolt which for several years would throw disorder into the minds, acts, works
of men."

A manifesto by Picabia: "Every page must explode, whether through
seriousness, profundity, turbulence, nausea, the new, the eternal, annihilating
nonsense, enthusiasm for principles, or the way it is printed. Art must be
unaesthetic in the extreme, useless and impossible to justify."

Meanwhile, in the neutral sky of Spain, storm-clouds gathered over the heads
of our stranded group of émigrés.

In Barcelona, as in Zurich, there were certain difficulties about entry visas,
residence permits – in short, trouble with the police. Marie Laurencin was
married to Baron von Waetgen, a German, and had followed him to Spain after
her lover Guillaume Apollinaire had left for the war in which he was killed. As
she was married to a German, she was regarded as a German. For a
Frenchwoman by birth, and in time of war, this was particularly unfortunate.

The Spanish police suspected her and her husband of espionage activities. They thought it strange that a Frenchwoman should be going round Barcelona, in wartime, with a German, and keeping suspicious company *(391)* – especially if she was an attractive Frenchwoman. The alcoholic, mouse-poor, brawling amateur boxer Arthur Cravan can hardly have served to allay suspicion; nor did the aggressive pacifism of Madame Gleizes make things any better.

Picabia himself, who had come under the rather short-lived pretext of making purchases for some French military department, had made himself suspect by his failure to purchase anything. In these circumstances, departure for New York seemed an obvious step. Picabia considered in any case that *391* had sown its fair share of unrest in Spain. He himself, accustomed to freedom of action, could not consent to being hampered by the 'congenital stupidity' of the police. So Picabia and Gabrielle Buffet left for the USA.

Finis Dada Zurich

Meanwhile Dada in Zurich was moving towards its greatest success – and its end. The climax of Dada activity in Zurich, and of Dada as such, was the grand *soirée* in the Saal zur Kaufleuten on 9th April 1919.

I will describe it here in rather more detail, because Dada meetings everywhere took a rather similar course. Arp and I had the job of painting sets for the dances (those of Susanne Perrottet, and the *Noir Kakadu* with Käthe Wulff, choreography by Sophie Taeuber). We began from opposite ends of immensely long strips of paper about two yards wide, painting huge black abstracts. Arp's shapes looked like gigantic cucumbers. I followed his example, and we painted miles of cucumber plantations, as I called them, before we finally met in the middle. Then the whole thing was nailed on to pieces of wood and rolled up until the performance.

Tzara had organized the whole thing with the magnificent precision of a ring-master marshalling his menagerie of lions, elephants, snakes and crocodiles.

Eggeling appeared first (he had been received into our club as a guest member) and delivered a very serious speech about elementary *Gestaltung* and abstract art. This only disturbed the audience insofar as they wanted to be disturbed but weren't. Then followed Susanne Perrottet's dances to compositions by Schönberg, Satie and others. She wore a Negroid mask by Janco, but they let

that pass. Some poems by Huelsenbeck and Kandinsky, recited by Käthe Wulff, were greeted with laughter and catcalls by a few members of the audience. Then all hell broke loose. A *poème simultané* by Tristan Tzara, performed by twenty people who did not always keep in time with each other. This was what the audience, and especially its younger members, had been waiting for. Shouts, whistles, chanting in unison, laughter . . . all of which mingled more or less anti-harmoniously with the bellowing of the twenty on the platform.

Tzara had skilfully arranged things so that this simultaneous poem closed the first half of the programme. Otherwise there would have been a riot at this early stage in the proceedings and the balloon would have gone up too soon.

An animated interval, in which the inflamed passions of the audience gathered strength for a defiant response to any new defiance on our part.

I started the second half with an address, "Against, Without, For Dada" which Tzara called "Malicious, elegant, Dada, Dada, Dada". In this address I cursed the audience with moderation, and ourselves in a modest way, and consigned the audience to the underworld.

Then followed music by Hans Heusser, whose tunes or anti-tunes had accompanied Dada since its inauguration at the Cabaret Voltaire. Some slight opposition. A little more greeted Arp's *Wolkenpumpe* ('Cloud Pump'), which was interrupted from time to time, but not often, with laughter and cries of "Rubbish". More dances by Perrottet to the music of Schönberg and then Dr Walter Serner, dressed as if for a wedding in immaculate black coat and striped trousers, with a grey cravat. This tall, elegant figure first carried a headless tailor's dummy on to the stage, then went back to fetch a bouquet of artificial flowers, gave them to the dummy to smell where its head would have been, and laid them at its feet. Finally he brought a chair, and sat astride it in the middle of the platform with his back to the audience. After these elaborate preparations, he began to read from his anarchistic credo, *Letzte Lockerung* ('Final Dissolution'). At last! This was just what the audience had been waiting for.

The tension in the hall became unbearable. At first it was so quiet that you could have heard a pin drop. Then the catcalls began, scornful at first, then furious. "Rat, bastard, you've got a nerve!" until the noise almost entirely drowned Serner's voice, which could be heard, during a momentary lull, saying the words "Napoleon was a big strong oaf, after all".

That really did it. What Napoleon had to do with it, I don't know. He wasn't Swiss. But the young men, most of whom were in the gallery, leaped on to the stage, brandishing pieces of the balustrade (which had survived intact for several hundred years), chased Serner into the wings and out of the building,

smashed the tailor's dummy and the chair, and stamped on the bouquet. The whole place was in an uproar. A reporter from the *Basler Nachrichten,* whom I knew, grasped me by the tie and shouted ten times over, without pausing for breath, "You're a sensible man normally". A madness had transformed individual human beings into a mob. The performance was stopped, the lights went up, and faces distorted by rage gradually returned to normal. People were realizing that not only Serner's provocations, but also the rage of those provoked, had something inhuman ... and that this had been the reason for Serner's performance in the first place.

Through Serner's contribution the public had gained in self-awareness. This was proved by the third part of the programme, which was resumed after a breathing-space of twenty minutes. It was in no way less aggressive than the second part, but it reached its end without incident. This was all the more remarkable since the ballet *Noir Kakadu,* with Janco's savage Negro masks to hide the pretty faces of our Labanese girls, and abstract costumes to cover their

Programme of the eighth Dada soirée, Zurich, 9th April 1919

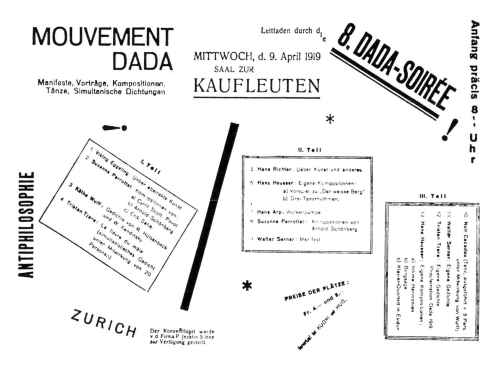

slender bodies, was something quite new, unexpected and anti-conventional. Even Serner was permitted to return to the stage, and his poems, no less provocative than before, were received without protest. So were Tzara's poems, and his highly provocative *Proclamation 1919*. The evening was concluded by some compositions by Hans Heusser which left no tone unturned. The public was tamed ... whether it was also converted is a question that can only be answered today, forty years later.

During the long interval that followed the second part, with the hall still in total uproar, we looked for Tzara, who we thought must have been torn to pieces. Indeed, he was nowhere to be found. It turned out that he had never been there in the first place. We found him at last sitting in the restaurant, peacefully and contentedly counting the takings. I think we had taken 1,200 francs, the biggest sum that Dada had ever seen. Dada had been 'beaten' ... but it was still Dada's victory.

Some time later, in October, 1919, there appeared in Zurich a kind of afterbirth of Dada, the periodical *Der Zeltweg*. It took its name from the street where, for a long time, Arp had his studio. *Der Zeltweg* was edited by the writers Otto Flake, Walter Serner and Tristan Tzara.

By comparison with the classic issues of *Dada*, *Der Zeltweg* was rather tame. The contributors were still the same, but we no longer lived on an island, isolated in the middle of a war. Europe was accessible again. Besides, revolution in Germany, risings in France and Italy, world revolution in Russia, had stirred men's minds, divided men's interests and diverted energies in the direction of political change.

If I am to believe the accounts which appear in certain books about this period, we founded an association of revolutionary artists, or something similar. I have no recollection of this at all, although Janco has confirmed that we signed manifestos and pamphlets, and Georges Hugnet (who admittedly gets his information at second hand) says that Tzara received one of these manifestos from me, scored through it with red pencil, and refused to publish it in *Der Zeltweg*. I regard this as doubtful. Tzara was no red-pencil dictator.

I do remember a series of forty or fifty 'Portraits' of Arp that I did for *Der Zeltweg*. Arp, because of the classic oval shape of his head and his triangular cubist nose, was the basic model for all my 'head fantasies' *(Kopf-Phantasien)* – then as now.

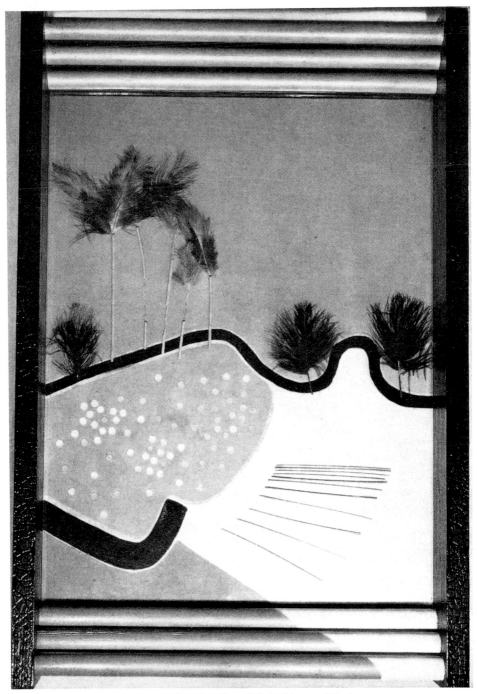

29 Francis Picabia, *Feathers*, 1921. Oil and collage (Galerie Schwarz, Milan)

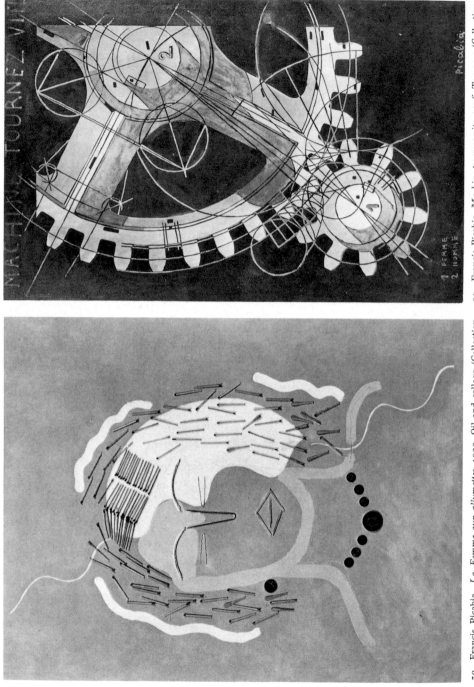

30 Francis Picabia, *La Femme aux allumettes*, 1920. Oil and collage (Collection Simone Collinet, Paris)

31 Francis Picabia, *Machine tournez vite*, 1916. Tempera (Collection Mr. and Mrs. Fred Shore, New York)

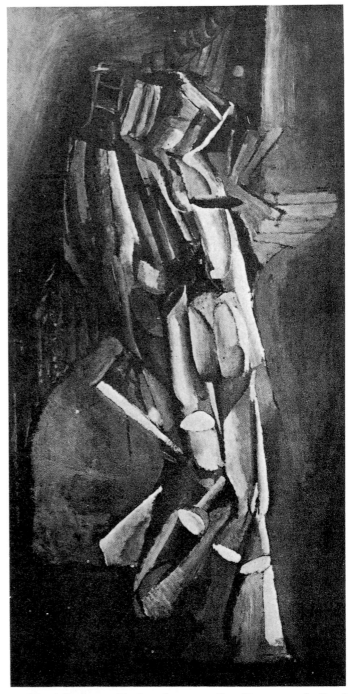

32 Marcel Duchamp, *Nu descendant un escalier*, *No. 1*, 1911. Cardboard
(Philadelphia Museum of Art, Arensberg Collection)

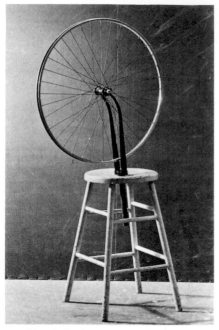

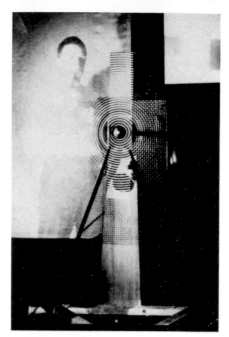

33 Marcel Duchamp, *Bicycle Wheel*, 1913.
Ready-made

34 Rotating glass plates with Marcel Duchamp,
1920

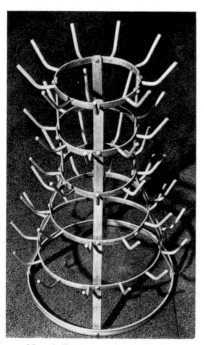

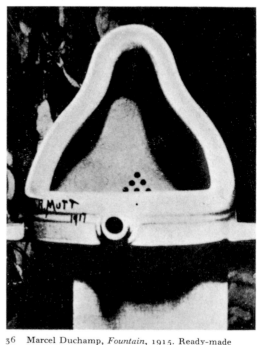

35 Marcel Duchamp, *Bottle Rack*, 1915.
Ready-made

36 Marcel Duchamp, *Fountain*, 1915. Ready-made

2 New York Dada 1915-1920

We in Zurich remained unaware until 1917 or 1918 of a development which was taking place, quite independently, in New York. Its origins were different, but its participants were playing essentially the same anti-art tune as we were. The notes may have sounded strange, at first, but the music was the same.

It began with the ideas of the photo-fanatic Alfred Stieglitz. The catalyst here was not a night-club, not a sceptical philosopher like Ball, but a little photographic gallery and this cheerful, aggressive photographer.

Stieglitz can be regarded as the pioneer of photography. He asked this question: could not the human hand and eye, using photographic plates and paper, achieve results as sensitive and expressive as those achieved by the same hand and the same eye with paint and canvas? Photography can do more than reproduce the world of reality; it can and should contribute to the creation of a new world.

With his photographs he proved this. Around him there gathered a group of young photographers who, both by their words and by their deeds, established their claim to be regarded as artists. Stieglitz's periodical *Camera Work* became their mouthpiece.

In his book *Painting in the Twentieth Century* Werner Haftmann traces Stieglitz's development, and that of his group, with great exactitude.

"In 1902, Stieglitz [1864–1946], one of the pioneers of modern photography, and his friend Edward Steichen [born in Luxembourg in 1879] had founded the 'Photo Secession', an association of modern photographers. In 1905 he had opened the Photo Secession Gallery at 291 Fifth Avenue, with a view to holding exhibitions of modern photography. Stieglitz was a man of lively perception, intensely interested in everything that was new and revolutionary. Stieglitz had made the acquaintance of Gertrude Stein in Paris in 1907 and had become enthusiastic over Rodin, Matisse, Toulouse-Lautrec, Cézanne and Rousseau. He

began to show works of art at his gallery. In January 1908 he held an exhibition of Rodin's drawings, and in April of the following year a small Matisse show. In December 1909 he showed Toulouse-Lautrec and in 1910 Rodin. In the same year he held a small memorial exhibition of Rousseau, and showed some Cézanne lithographs. In March 1911 there were Cézanne watercolours and in April some cubist drawings and watercolours by Picasso. In 1912 he showed Matisse's sculpture . . .

"Stieglitz now sought to form a group of those young American painters who were attracted to the new ideas. Nearly all of them had come by their experience in Paris, where many had lived for years . . ."

This group included Alfred Maurer, Charles Demuth, Abraham Walkowitz, Max Weber, Morgan Russell, Macdonald-Wright, Patrick Bruce, Arthur Dove, Joseph Stella, Marsden Hartley and John Marin. Stieglitz had a specially close friendship with Marin which lasted until the latter's death. In 1912 Stieglitz provided funds for Marsden Hartley to go to Europe, where he ended up in Munich studying under Kandinsky. Stieglitz became a sort of Maecenas, without the financial resources, but with the driving force to become a major factor in the advance of modern art in the USA. Because he recognized the overwhelming importance of European art, he became an intermediary between European and American artists.

"Thus all the new movements which had matured in Europe were reflected in the Stieglitz group. Thus far, however, the new ideas reflected by the *291* painters were known only to a small group. They were to become a centre of attention and controversy through an event of the utmost importance for American art: the Armory Show." (Haftmann)

Another member of Stieglitz's circle was Francis Picabia. He collaborated with Stieglitz on *Camera Work*.

I myself only knew Stieglitz as a sick old man, some years before his death in New York. He and his gallery, 'An American Place', were still full of fight, but the emphasis had shifted somewhat. He had won his youthful battles: photography was recognized as an art, and the modern works he had exhibited had long ago found a place in the public art galleries.

He liked to tell the story of how he started. He had studied at the *Technische Hochschule* in Berlin, where he had been encouraged for the first time to treat photography as something more than mere reproduction. When he returned to New York, he held fast, with a characteristically American matter-of-fact optimism, to the new and coming ideas he had learned in Europe, and by the outbreak of war he had become the nucleus of an avant-garde. In his little

gallery, called '291' after the number of his house on Fifth Avenue, there existed a 'personal union' – which was also an effective union – between artistic photography and modern painting. This gallery prepared the climate in which modern art was to make its explosive entry on to the American scene. Stieglitz himself did not cause this explosion, but it was his dauntless championship of modern attitudes to photography and painting that set the scene, and prepared the minds of the public, for the bombshell that was the 1913 Armory Show.

The Association of American Painters and Sculptors, founded in 1911, whose chairman Arthur Davies had "far-reaching social connections" (Haftmann), had appointed its secretary, Walt Kuhn, to arrange a big exhibition. Davies and Kuhn saw the *Sonderbund* exhibition in Cologne in 1912, and after a visit to Paris, where they were promised French cooperation, they visited London, where Fry's 'Second Post-Impressionist Exhibition' was in progress. Armed with the knowledge and the connections they had acquired on this journey, they organized an "International Exhibition of Modern Art" in the armoury of the 69th Infantry Regiment on Lexington Avenue, New York City. It opened on 17th February 1913, and was visited by over 100,000 people before it closed.

This exhibition made history in the United States. Through it, an unsuspecting public and an even more unsuspecting press were suddenly confronted with a totally new conception of art. The storm that raged round this exhibition gave strength to Stieglitz in his own battle. His belief that light, colours and shapes are poetic in themselves found confirmation in the works of modern artists from Cézanne to Picasso and Duchamp.

The sensation of the Armory Show was Marcel Duchamp's *Nude Descending A Staircase (Ill. 32),* described by Breton as the masterpiece which introduced "light as a mobile factor" into the art of painting. This was the problem that concerned Stieglitz, as a photographer, so deeply. Duchamp's picture was a *succès de scandale* unique in the history of art exhibitions in America, and overnight Duchamp became the much admired *bête noire* of modern art. Fifty years on, this particular 'black beast' has just been washed whiter than the snow by an honorary doctorate of Wayne State University, Detroit, Michigan, USA.

As far as I could tell from my conversations with Stieglitz himself and with the collector Arensberg, a friend of Duchamp and Stieglitz, Stieglitz was closer to Picabia than to any other modern artist except his old friend Marin. His relations with Duchamp and Man Ray remained more formal. Picabia had belonged to Stieglitz's circle even before the Armory Show, and had benefited from his warm-hearted, never-failing support and encouragement. Stieglitz put on his first exhibition of Picabia's work in March 1913, at the time when

the Armory Show had made all America curious about modern art. In the catalogue appeared an important and serious 'Aesthetic Comment' by Picabia on his own work and modern art in general, in which he maintains that there is no longer a purely visual expression for the 'quantitative' view of reality, and that 'objective', representational forms must be eliminated from pictorial expression in order to link it with a new, 'qualitative' view of reality, which is itself close to abstraction, and which can therefore have no suitable expression other than the abstract.

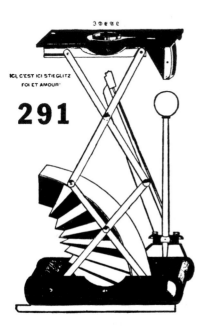

Francis Picabia, *Portrait of Alfred Stieglitz* from *291*, 1916

But, as early as June of the same year, Picabia published in *Camera Art* an aggressive and ironic satire on abstract art which exhibits all the shocking and baffling characteristics of his subsequent Dadaist technique.

The ideas of Stieglitz and Picabia did not entirely coincide. In 1915, when *Camera Work* changed its name to *291*, it published Picabia's diatribes against art, together with some 'machine pictures' of his (which, however, still belonged to the sphere of art). Thus *291* began to reflect the new 'anti-art' currents of thought. Stieglitz went along with this (see his portrait in a woman's silk-stockinged leg in *391*); but the central ideas of Dada lay beyond his sphere of interest.

The elements that made up the Picabia of *391* were, as we have seen, an absolute lack of respect for all values, a freedom from all social and moral constraints, a compulsive urge to destroy everything that had hitherto been given the name of art. All this was directed towards a position quite different from any that Stieglitz could ever have adopted.

When Picabia arrived in New York from Spain, Duchamp was already there. So was a painter from Philadelphia of whom I shall have more to say later: his name was Man Ray. Not long afterwards, Gleizes and Arthur Cravan arrived from Spain.

Cravan (Fabian Lloyd) deserves special mention as a kind of adoptive forbear of the American (and the French) Dada movement, because he pursued the destructive urge inherent in Dada to its ultimate conclusion: the destruction of himself.

The Self-Immolation of Arthur Cravan

I was not present at any Dada activities in New York or in Paris, but I did have frequent contacts with most of the Dadaists. As far as dates and facts are concerned, I must rely on the published material that I have been able to collate.

Anti-art took on a new complexion with the emergence of the writer and amateur boxer Arthur Cravan.

In 1912, he published in Paris the periodical *Maintenant* in which, with great aplomb, he dragged through the mire everything that was good, pure and of good report, especially his friend Robert Delaunay. Cravan was greatly admired, because he succeeded in tearing bourgeois existence apart at the seams. He carried out to the letter all the deeds of anarchy he promised in his writings. He claimed to have committed a perfect burglary in a Swiss jeweller's shop. At the height of the war he travelled on forged passports across the length and breadth of Europe, the USA, Canada and Mexico.

On 7th March 1914, Arthur Cravan published the following autobiographical note in his periodical *Maintenant*: "Confidence man – sailor in the Pacific – muleteer – orange-picker in California – snake-charmer – hotel thief – nephew of Oscar Wilde – lumberjack – ex-boxing champion of France – Grandson of the Queen's Chancellor [of England] – chauffeur in Berlin – etc." This résumé contains some statements that are probably true, as well as a lot of improbabilities that are as likely to be true as false.

He attacked everybody and everything. He handed out the deadliest insults as calmly as someone else might pass round chocolates. As he did this with the utmost elegance, he became the darling of Paris overnight; the darling, that is, of all those who would have liked to settle their own personal accounts as elegantly, directly and coolly as he settled his.

He challenged the world heavyweight champion, the Negro boxer Jack Johnson, to a fight in Madrid on the 23rd April 1916 (he was knocked out in the first round, see *Ills. 26, 27*). Lecturing to an invited audience of society ladies, he took off nearly all his clothes before he could be handcuffed and taken away by the police. The insults he hurled, mostly when drunk, at press and public, strangers as well as friends, were immoderate but brilliantly phrased.

In the end he left the Mexican coast in a little boat to sail across the shark-infested Caribbean. He never reappeared. His wife, the poetess and painter Mina Loy, who had just borne him a daughter, waited in vain for him to rejoin her in Buenos Aires. When he did not come, she looked for him in all the mouldering prisons of Central America. No trace of him was ever found.

His thesis was that art is useless and dead, the self-expression of a decaying society, and that personal action must take its place. Life itself as an artistic adventure! – Not a new idea. But the hero-worship inspired by Cravan's anarchistic career led a certain intellectual '*élite*' to take him as their model.

Rightly or wrongly, most books on Dada have cited Cravan as a 'precursor' of Dadaism. I mention him here because his short span of activity, as an artist and as a human being, illustrates one tendency in Dada taken to its extreme: final nothingness, suicide.

The provocative side of his nature, when drunk (Gabrielle Buffet says he was a charming man when he was sober) seems to have counted more strongly in his favour, thanks to Dada, than his gifts as a poet and critic. An athlete himself, he was totally without fear, and always on the offensive with no thought of the consequences. Because he lived wholly according to his nature, wholly without constraint, and paid the full price, which is death, he became a nihilist hero in an age already long beset by nihilism.

In the long run, Picabia was another who defied life to do its worst and accepted all the consequences. Nothing less than total destruction would content him, at least in the field of art. Yet even at the height of his battle against art he continued to produce astonishing works of art, whether hairpin portraits (*Ill. 30*), profiles in string, faces made of buttons or feather landscapes (*Ill. 29*). All these demonstrate his talent even more clearly than they do his contempt for art. How was he to know that, at the same moment, other artists in Switzer-

land, Germany and Russia were developing styles of their own with totally new materials adopted as a protest against the tyranny of oils? With Schwitters, the result was lyricism, with Arp, humour; and with Picabia it was penetrating wit.

Like Cravan, he led a relatively adventurous life, but he was a rich man and, through his wife's family, enjoyed senatorial protection, so his neck was never in danger. His irony, his boundless aggressiveness, his absolute lack of respect, even for his friends – all this was so wholehearted that it was possible to suspect that he might be defying the world to prove him wrong and reveal to him a meaning or a scale of values. As if, somewhere in the depths of his sceptical soul, he still hoped to find a meaning 'behind it all'.

M. D., or Chance in the Ready-Made

No such 'weakness' is detectable in Duchamp. He approaches life as he does the chessboard: the gambits fascinate him without leading him to imagine that there is a meaning behind it all which might make it necessary for him to believe in something.

Cravan followed his contempt for the world to its logical conclusion by committing suicide in the way he did. This is logical and convincing. Marcel Duchamp has drawn other conclusions. He has found a sublime compromise which obviates the necessity of self-destruction.

Duchamp's attitude is that life is a melancholy joke, an indecipherable non-sense, not worth the trouble of investigating. To his superior intelligence the total absurdity of life, the contingent nature of a world denuded of all values, are logical consequences of Descartes' *Cogito ergo sum*. His total detachment from what goes on around him *('ego cogito')* places him safely in the 'beyond' without the need to kill himself.

Cravan, whether meaningfully or not, consumed himself utterly. An exceptionally strong mental constitution has enabled Marcel Duchamp to survive (he will live till he is a hundred and fifty). From his Archimedean standpoint outside the turmoil of life (and outside meaning), detached from all ideological prejudices (except perhaps vanity), he sees in the activity which surrounds him nothing but a comical, involuntary pathos. This allows him to smile contemptuously, to draw ironic conclusions, to compromise others pitilessly, or to offer his intelligent if condescending assistance. Vanity he regards as a basic

human characteristic ("otherwise we should all kill ourselves") – it is his only concession to humanity. *Cogito ergo sum* is a maxim which, if it had not existed already, would have had to be invented especially for him. In Duchamp it is still as alive as on the first day of its creation. But, like every absolute, it carries with it an element of paradox, and thus reduces itself, of its own accord, *ad absurdum*. At the outset of their career, the three Duchamp-Villon brothers, Jacques Villon the painter, Raymond Duchamp-Villon the sculptor, who died during the 1914–18 war, and Marcel Duchamp, had agreed, as Duchamp put it, "to bring a little intelligence into painting". Marcel supplied enough of that. The way in which art was going did not meet with his approval. Art as a stimulus – for whom? The bourgeois? Painting, this 'turpentine intoxication' was humbug! We think false, we feel false, we see false!

Man Ray once told me how Duchamp arrived in New York from Paris in 1915 with a glass ball (containing Paris air, naturally) as a present for his friend Walter Arensberg, the art collector, and his wife. In the same year, the New York art world, which had in 1913 described his *Nude Descending A Staircase* alternately as an "explosion in a shingle factory" and as a masterpiece, was confronted with a new surprise: ready-mades. The ready-made was the logical consequence of Duchamp's rejection of art and of his suspicion that life was without a meaning. He exhibited to a public of connoisseurs a single bicycle wheel mounted on a stool, a bottle-rack (bought at the Bazaar de l'Hôtel de Ville, Paris) and, finally, a urinal *(Ills. 33, 35, 36)*.

He declared that these ready-mades became works of art as soon as he said they were. When he 'chose' this or that object, a coal-shovel for example, it was lifted from the limbo of unregarded objects into the living world of works of art: looking at it made it into art!

This deliberate process of 'subjectivization' of the world of objects by incorporating it as raw material into works of art was also carried out, on occasion, by Arp, Schwitters and Janco, but it has never been formulated with such Cartesian thoroughness as Duchamp employed.

Anyone who sought to extract aesthetic pleasure (something Duchamp not only did not intend but actively eschewed) from these ready-mades, admiring perhaps the 'rhythm' of the bottle-rack or the lightness and elegance of the bicycle-wheel, must surely have been unable to maintain this attitude when confronted with the urinal. And if he did maintain it? "Let him!" was Duchamp's reaction.

As a member of the jury of the First New York *Salon des Indépendants*, Duchamp submitted his own *Fountain* (the urinal) signing it 'R. Mutt' (the

name of a firm of sanitary engineers). This shameless article was indignantly rejected by his fellow-jurors, but Duchamp insisted that it should be accepted. This was an exhibition of independents, after all! Predictably enough, neither his *Fountain* nor his vote swayed the jury, and he ostentatiously resigned. Since then the *Fountain* has been the centre-piece of countless exhibitions. At the Dada exhibition held at the Sidney Janis gallery in the late 'fifties, it hung over the main entrance, where everyone had to pass under it . . . It was filled with geraniums. No trace of the initial shock remained.

Marcel Duchamp: Ready-Mades

"As early as 1913 I had the happy idea to fasten a bicycle wheel to a kitchen stool and watch it turn.

"A few months later I bought a cheap reproduction of a winter evening landscape, which I called *Pharmacy* after adding two small dots, one red and one yellow, in the horizon.

"In New York in 1915 I bought at a hardware store a snow shovel on which I wrote *in advance of the broken arm.*

"It was around that time that the word 'ready-made' came to my mind to designate this form of manifestation.

"A point that I want very much to establish is that the choice of these 'ready-mades' was never dictated by aesthetic delectation.

"The choice was based on a reaction of *visual indifference* with a total absence of good or bad taste . . . in fact a complete anaesthesia.

"One important characteristic was the short sentence which I occasionally inscribed on the 'ready-made'.

"That sentence, instead of describing the object like a title, was meant to carry the mind of the spectator towards other regions, more verbal.

"Sometimes I would add a graphic detail of presentation which, in order to satisfy my craving for alliterations, would be called *ready-made aided.*

"At another time, wanting to expose the basic antinomy between art and 'ready-mades' I imagined a *reciprocal ready-made:* use a Rembrandt as an ironing board!

"I realized very soon the danger of repeating indiscriminately this form of expression and decided to limit the production of 'ready-mades' to a small number yearly. I was aware at that time that, for the spectator even more than

for the artist, *art is a habit-forming drug* and I wanted to protect my 'ready-mades' against such a *contamination*.

"Another aspect of the 'ready-made' is its lack of uniqueness ... the replica of a 'ready-made' delivering the same message, in fact nearly every one of the 'ready-mades' existing today is not an original in the conventional sense.

"A final remark to this vicious circle:

"Since the tubes of paint used by an artist are manufactured and ready-made products we must conclude that all the paintings in the world are *ready-mades aided.*" (Marcel Duchamp)

After the *Fountain* and Duchamp's break with the New York *Salon des Indépendants,* there appeared a whole series of puzzling objects, Marcel Duchamp's contributions to the environment. In 1919 there was the moustachioed Mona Lisa, as well as a cheque, completely drawn by hand, in payment of his dentist's bill (the dentist quite rightly had it framed) and a closed window with the title *The Battle of Austerlitz.* In *Why not sneeze Rrose Sélavy?* he showed an iron cage filled with pieces of marble cut to resemble sugar-lumps. Rrose Sélavy *(c'est la vie)* was often employed by Duchamp for his poetical demonstrations: "*Rrose Sélavy et moi esquivons les ecchymoses des Esquimaux aux mots exquis.*"

Nihil

Duchamp's discovery bears the stamp of a definitive statement – and a final one, since he includes himself within the scope of his irony. He is, after all, an artist himself – another paradox.

Of course, the bottle-rack and the urinal are not art. But the laughter that underlies this shameless exposure of 'all that is holy' goes so deep that a kind of topsy-turvy admiration sets in which applauds at its own funeral (the funeral, that is, of 'all that is holy').

This laughter strikes a responsive chord in everyone. We all share the feeling that our scientific faith lacks something – that reality is nowhere to be found, not even in ourselves – that these bottle-racks and coal-shovels are only expressions of the emptiness of the world through which we stumble. The bottle-rack says "Art is junk". The urinal says "Art is a trick".

And so the body of art was pierced with darts of ridicule. In opposition to Art, as represented by the *Vénus de Milo* or the *Laocoön*, Duchamp set up

Reality, as represented by his ready-mades. His purpose was to administer a strong purgative to an age riddled with lies – and to the society which had brought it into being – an age of shame for which he found an artistic counterpart in the shape of a Mona Lisa with a moustache.

All that Picabia had argued, passionately, in every line, every poem, every drawing, every manifesto in *391* was now reduced to a precise formula. With Picabia the words "Art is dead" seem always to be followed by a faint echo: "Long live Art." With Duchamp the echo is silent. And that is not all: this silence renders meaningless any further inquiry after art.

Art has been 'thought through to a conclusion'; in other words eliminated. Nothing, *nihil*, is all that is left. An illusion has been dispelled by the use of logic. In place of the illusion there is a vacuum with no moral or ethical attributes. This declaration of *nothingness* is free from cynicism and from regret. It is the factual revelation of a situation with which we have to come to terms! – A situation which Duchamp seems to have discovered rather than created.

The counterpart of Duchamp's non-art is amorality, emptying life as well as art of all its spiritual content. Here Duchamp took a logical, and therefore necessary, step which was also a fatal one. He reversed the signposts of value so that they all point into the void.

This fatalism is just as much an integral part of Dada as is Ball's religious quest. Duchamp did no more than explore a new dimension within Dada. His discoveries belong to Dada, as does the weird hypothesis, employed in modern physics, that matter cannot exist without anti-matter.

Descartes must have been aware of the danger of nihilism which lay in his 'cogito . . .'. In his *Meditations* he attempts to demonstrate the presence of God in human experience in order to give this experience value. Modern science and the state of civilization in the first half of the twentieth century have destroyed the basis of such a demonstration. But the abyss that opened before Descartes is the same abyss that opens before us today. Man is becoming more and more conscious of his isolation. His sense of loneliness and of meaninglessness is becoming unendurable. For, if the world exists *because* I perceive it, who can prove that any reality, any *Ding an sich*, underlies it?

"How can I know that this world is not simply a dream, a shimmering hallucination, a horizon no longer suffused with its own light but with mine?" (Heidegger)

Dada is involved in this progressive disintegration of reality. The fact that Dada *desired* this disintegration, *wanted* to be destructive, counts for little. But Dada's emphasis on chance, on absolute spontaneity, indicated that Dada put its trust

only in the fleeting moment. And this was how the path to nothingness was opened – although chance was pursued on quite different lines in New York.

"As soon as I reflect I find only a world of finite objects.... Why do I attribute value to this rather than to that? Ultimately there is no answer, and there is no argument which can convince the nihilist that the world is more than a configuration of objects, if the intuition of an underlying reality is lacking."

"Camus and others believe that by denying the spirit we will not only escape from nihilism, but return to the Paradise which we have been denied. The old Adam fell when his spirit awoke and let him see his own nakedness. The new Adam will be born when this spirit is brought as a sacrifice. Man, having suffered the pains of individuation, having emancipated himself from the mother and from home, finds that the price he has paid for this emancipation is too high. His world has become meaningless and he wants to return."

"Nihilism appears as a rift within Being, but this rift is also implied by being human. We cannot escape from it without losing our humanity."

"Freedom (I am speaking of Camus) is identified with the spontaneity of life ..."

"Life in its unending spontaneity [is preferred] to the spirit which is seen as stifling."

"By philosophers like Dilthey, Bergson, Heidegger, Nietzsche and James, [Life] is described as an infinite stream; any attempts to exhaust this richness must be inadequate. Life and concepts are incommensurable; ... to seek them is to hack the fundamental unity of life into pieces."

"The desire to free oneself from the fetters of the spirit tends to lead to a victory of the chthonic forces in man. Once the dams have been destroyed, the organic wells up and submerges whatever restraint may be left." (Karsten Harries: *In a Strange Land: An Exploration of Nihilism*)

From Anti-Art to Art

The significance of Duchamp's ready-mades lies in the theory on which they are based and in the conclusions to be drawn from it. These works, as he stresses again and again, are not works of art but of non-art, the results of discursive rather than sensory insights. It is therefore in the causes which gave rise to these insights, and in the consequences to which they in their turn gave rise, that we must seek the true meaning of the ready-mades.

As long as nihilism, in life and in art, appears an inevitable feature of our age, as long as we accept it as a neccesary characteristic of a society at bay – any diametrically opposed philosophy of life gains enormously in importance.

Existentialism has made a clean break with all emotionally-charged attitudes to the self and to the world. What remains is a mirror in which nothing is reflected but the individual self. This work of clearance has been undertaken with the conceptual and exploratory tools of a scientific age, an age which regards scientific method as the only secure anchor in a sea of nothingness. When all moral and ethical values fail, this anchor represents hope.

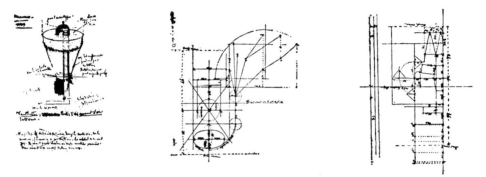

Marcel Duchamp, Sketches for *The Great Glass* 1918–23

The remarkable thing is that it was Duchamp, the nihilist of art, who gave expression and concrete form to this hope – the hope of achieving wonder not through chance but through exact knowledge, the interplay of scientific forces.

His 'Great Glass', *La mariée mise à nu par ses célibataires, même* ('The bride laid bare by her bachelors, even'), which is regarded as his most important work, was begun in his studio on Upper Broadway, New York City, and finished there around 1918. With a precise artistic effect in mind, he let the dust of New York settle on one section of the structure. Anyone who knows New York will understand what that means. For a year and a half, the huge sheet of glass lay on trestles in his studio, with dust pouring in through a window opening on to Broadway. Then Duchamp cleaned the glass carefully (after Man Ray had photographed it) – everywhere except the 'cones', on which he stuck the dust down with fixative *(Ill. 37)*. In this way certain parts of the work took on a slightly yellowish tint, a calculated nuance which distinguished them from the rest of the composition.

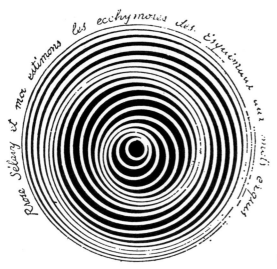

Marcel Duchamp, *Anémic-Cinéma*. Film, 1926

In this game with chance we recognize Duchamp the painter, not Duchamp the anti- or non-artist, although he is admittedly using highly exceptional techniques.

Much more important than this technical trick is Duchamp's extraordinary preoccupation with mathematical 'correctness' in his use of forms. This led him to engage in complicated calculations. He wanted all these calculations to have their place in the final significance of the work of art – and this in spite of the essentially *emotional* nature of art.

Evidence of this preoccupation is to be found in a little collection of drawings in which Duchamp calculated every detail as if he had been designing an aeroplane or a space-capsule. The role of the Muse here is played not by chance but by anti-chance: the reasoning, measuring human will. In a world without ethical values, the measurable is presented as the only reality.

When Duchamp finally considered his Great Glass finished, it was taken to an exhibition in Brooklyn. The glass shattered in transit in such a way that a network of fine lines cut across Duchamp's figurations. The story goes that Duchamp had previously dreamed these fractures exactly as they appeared in the Glass. (Duchamp's career, his way of life and his appearance have made him a natural creator of myths.) The truth of the matter is that he acknowledged the fracture as the work of chance and, with the network of cracks as a last refine-

ment, declared the work 'completed' in 1923. It constitutes the swan song of Duchamp the artist . . . or does it?

Since 1921 (or 1923?) he has given up art in favour of chess; and yet it is still not quite true that the Great Glass marked the end of his artistic career. Indeed, I believe that his most fruitful work was still to come.

In Duchamp's work the machine took on a totally new aspect. From his *Coffee Mill* to his *Cocoa Mill*, and also in the Great Glass *La Fiancée*, he pursued this theme. In his *Glass Machine* (1920), isolated segments of circles revolve in such a way as to create the illusion of three-dimensional circles and spirals *(Ill. 34)*. In 1925, and again in 1926, he designed a number of similar discs, all based on certain problems in the physiology of vision, and producing optical illusions when set in motion. He incorporated some of the first of these in his film *Anémic – Cinéma* in 1926 *(Ill. 43)*. In 1936 he gave the title of 'roto-reliefs' to a series of similar experiments that I showed in action in one sequence of *Dreams that Money Can Buy*. Like his moving discs, the roto-reliefs consisted of simple circles having different centres. When these were set in motion, three-dimensional bodies appeared in the strangest way.

Here, therefore, a scientific mind set out, using artistic materials, to create an artistic statement which would constitute a synthesis between scientific and artistic endeavour. Science in conjunction with the artistic Eros? A new unity of perception and stimulus! . . . Art?

The fruits of this aesthetic-scientific experiment are becoming apparent today. In Milan recently, I saw an exhibition by a group of young artists active in Padua under the name of 'Group N' *(Ills. 40, 41)*, in Milan under that of 'Group T', in France as the *'Group de recherche visuelle'*, and also in Spain and Germany. Their concern is with problems of the Art of Science. In Padua I met the members of 'Group N', half a dozen young men who work together on problems of this kind, and who seek to experience science in art, and art with the tools of science.

"We do not believe in an Art holding aloof from the world of perception in which we live. It is no longer enough to look at the world through the microscope of reason. It is here that art can work together with science to build up a true picture of the world we live in." Again: "We are trying to extend the psycho-physiological potentialities of the human eye. We do not seek personal expression but the elements of a new language consistent with science. For science is one of the few values of which we can be sure."

Does that not sound like the ideas Eggeling and I had in mind when we carried out our experiments in 1918–20? And does it not prove a clear link between

Duchamp's scientific-aesthetic works and those of today's younger generation?

Nobody knows what direction art will take, in its present chaotically disorientated state. But one thing is sure: a new generation has taken up Duchamp's experiments, with optimism, with conviction, and in the spirit of a new artistic humanism.

The Invention of the Useless

The Spaniard Picabia, the Frenchman Duchamp and the American Man Ray made up the creative triumvirate which led the New York Dada group. Picabia could be described as the passionate *destroyer*, Duchamp as the detached *anti-creator*, and Man Ray as the tireless, pessimistic *inventor*.

Man Ray began his career as a painter, and from the very start he was a publicity expert with all the tricks of the trade at his fingertips and oil paint behind his ears. Following the example of Alfred Stieglitz, he became a photographer as well as a painter.

The first work of his I saw was called *Boardwalk (Ill. 42)* and was the trademark of the New York Dada group. It was a chessboard which he had made into a work of art by adding 'anti-artistic' knobs and bits of rope. It was exhibited at the 1957 Dada exhibition in Paris, together with a metronome with an eye clipped to it, under the title of *Object To Be Destroyed*. This invitation was taken up by certain youthful visitors to the exhibition who fired shots at it. The original now bears honourable Dada scars, intended no doubt for the artist.

Man Ray's inexhaustible anti-artistic output has continued right up to the present day in all its three forms: painting, photography and anti-art objects. His powers of invention, schooled in every possible technique, were and are employed to transform the useful objects which surround him into useless ones. The destructive impulse, which is expressed in Picabia's continual flow of polemical attacks and anti-inventions, and in Duchamp's elimination of art as such, led the more tranquil Man Ray to breathe ironic life into his inanimate surroundings (the metronome, the spiral, and so on).

The Uselessness Effect shows us objects from what one might call their human side. It sets them free. It was precisely because these things were useless that we found them moving and lyrical. The humour of the useless machine is Man Ray's discovery.

96

37 Marcel Duchamp, *Elevage de poussière* (Dust on *The Great Glass*), 1920 (Photograph by Man Ray)

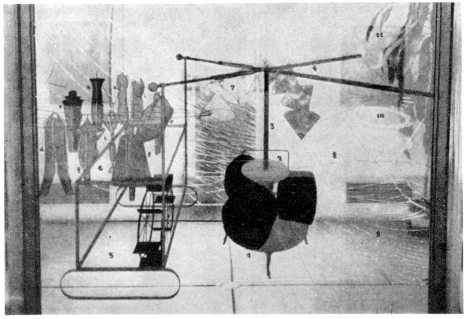

38 Marcel Duchamp, *The Great Glass*, lower section, 1915–23

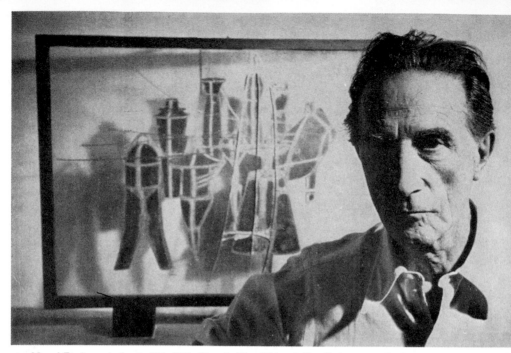

39 Marcel Duchamp in front of his *Little Glass*, in Hans Richter's film *Dadascope*, 1961–62

40 Group N, Padua, *Construction*, 1963

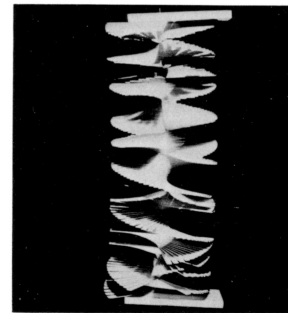

41 Group N, Padua, *Construction* (Getulio Alviani), 1963

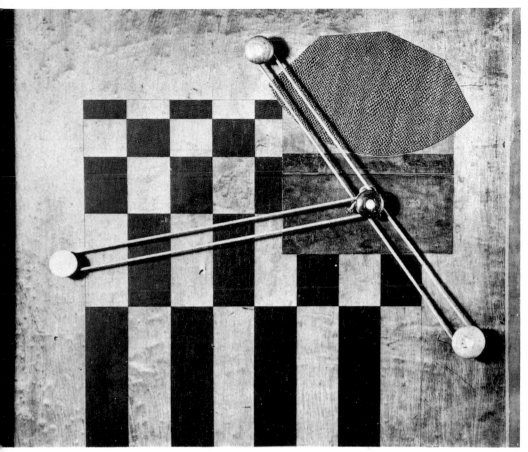

Man Ray, *Boardwalk*, 1917. Oil and assemblage

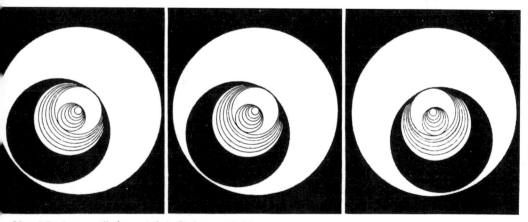

Marcel Duchamp, stills from *Anémic-Cinéma*, 1926. Film

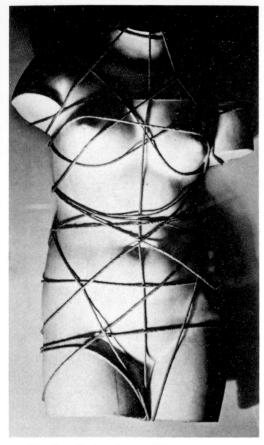

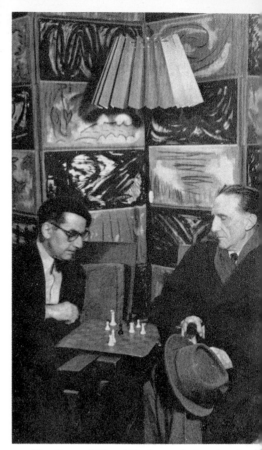

44 Man Ray, *Fascinated*, 1922. Object

45 Man Ray and Marcel Duchamp playing chess in M
Ray's studio, Paris, 1960

Objects are *beings*, like us, because they *are*. This idea of Man Ray's was the starting-point for an important element in today's Neo-Dada movement – of which more anon *(Ill. 44)*.

His almost classical attitude to art is exemplified by a totem pole he made in 1918, which stands 'by itself' like a handsome, elegant Dada spoon and is reminiscent of a phallic symbol. In 1916–17 he did a whole series of collages which he called *Revolving Doors*.

Despite all the humour that is apparent in his works, his composed and well-groomed exterior bears, by preference, a distinctly melancholy air – which he can shake off as soon as a pretty woman comes within reach. His ideas on life tend towards pessimism. "You", he often said to me, "have a totally unjustifiable optimism."

He has the attitude to life of one who *waits* rather than one who *expects*. His scepticism with regard to humanity is boundless. This he had in common with Marcel Duchamp. They became close friends, and still are . . . two chess-players in perfect harmony.

The importance of a shared interest in chess should not be underrated; it makes men brothers *(Ill. 45)*. All non-enthusiasts have the status of outsiders; they count for nothing. Although one might not think so, chess is like love. It can become a raging passion. Those who have once caught the infection need chess as desperately as a morphine addict needs morphine. In Paris in the 'twenties Marcel Duchamp was to be found at any hour of the day or night in the 'Coupole', courteous as ever, engaged in a bitter struggle for victory.

'The Blind Man', 'Rongwrong' and 'New York Dada'

Duchamp had a great influence on Picabia (whose appearances were never more than flying visits) and Man Ray. The fatalistic absence of will which was Duchamp's inner strength was always an attraction to those who themselves possessed will. Thus this talented group was amicably united by their contempt for art and for mankind and by their passion for chess. They developed a 'unified' style of mystification which can be traced in the three New York issues of Picabia's *391* (Nos. 5, 6 and 7), in the two issues of *The Blind Man* (1917, which contains a picture of Duchamp's *Cocoa Mill)*, in the single issue of *Rongwrong*, and in *New York Dada*, all of which were edited by Marcel Duchamp and Man Ray.

This nucleus attracted a small group of artists and non-artists, among them the immensely rich collector Walter Arensberg, one of the most generous patrons of art the USA has ever seen. Neither the notoriety of anti-art nor the blasphemy of non-art deterred him in the least from buying the works of art which these slogans concealed. Nor did he merely buy; he worked like a true Dadaist on the preparation of Dada exhibitions. The *Life* caricaturist Marius de Zayas belonged to this circle. So did the Corsican Edgar Varèse, who both discovered and exhausted the possibilities of noise-music, the art form which does him honour under the various disguises of bruitistic music, electronic music and *musique concrète.* The cubist painter Albert Gleizes arrived from Spain to swell the ranks, and of course there was the Founding Father, Alfred Stieglitz, in his capacity as an intellectual conspirator, as well as de Haviland, editor of the *Washington Post,* who provided both publicity and political support.

The main weight of the Dada-edifice at that particular time was borne by the members of the triumvirate, F. P., M. D. and M. R. It is a moot point whether the output of these three talented artists should stand to the credit of New York, Paris or Barcelona. But I consider it right to refer to them as 'New York Dada' just as I gave the name 'Zurich Dada' to the international group of artists which gathered in Zurich. And when, in Paris in 1921, Man Ray added a new discovery to his already immense array of 'inventions', the new discovery belonged, in its essence and in its significance, to New York Dada.

This discovery was a Gordian stroke: photography without a camera. By placing objects on a piece of photographic paper and lighting them from a particular angle, he created new poetic vistas. He called them Rayograms *(Ills. 46, 47)*. "He plays an incalculable game; he shows the way to things never seen before; he is the rock on which the foreseeable comes to grief", as Breton said. Stieglitz led the advance of photography as an art; Man Ray threw the gates open even wider for photography to lead him into the *'champs délicieux'* of the poetry of light. *Champs délicieux* was the name of his first portfolio of rayograms, which appeared in 1922.

$2 \times 2 = 5$

As I said at the outset, I have tried to establish as far as possible the authenticity and accuracy of all my dates and facts. This has presented unexpected difficulties, which go to prove that twice two is not always automatically four.

While collecting my material for this book I talked to all the former Dadaists I was able to contact. I wrote down the information gained from each interview and submitted it to my informant for his corrections or additions. Discrepancies appeared which, although insignificant in themselves, serve to cast doubt on the accuracy of certain dates. For example: In reply to my questionnaire dated 9th July 1962, Man Ray confirms that Marcel Duchamp arrived in New York in 1915 with a glass ball full of 'Paris air'. Marcel Duchamp's questionnaire (10th November 1962) gives the date as 1919. "I thought of it as a present for Arensberg, who had everything money could buy. So I brought him an ampule of Paris air."

In addition, Duchamp says that he made his experimental stereoscopic film in 1923, while Man Ray gives the year as 1920. "In 1920, Marcel and I made a film test about forty feet long, with two synchronized cameras, in order to photograph the same object from a slightly different position [with each camera]."

"This forty-foot test we decided to develop by hand. In order to do this, Marcel prepared a tray with a wooden bottom into which he nailed about four hundred nails spaced at an equal distance. The tray was then filled with film-developer and the film was wound around these four hundred nails, to be bathed and developed just like any photographic film.

"But in this process the film, that is the emulsion, stuck together and could not be disentangled. It was therefore completely lost, with the exception of a few frames."

Duchamp describes the sequel: "The solution of this artistic problem finally came with the *Discs* (1925) in which true three-dimensionality was achieved, not with a complicated machine (for example the *Glass Machine* of 1920) and a complicated technique [such as development by hand using four hundred nails], but in the eyes of the onlooker, by a psycho-physiological process."

One explanation of the discrepancy between the dates given by Duchamp and Man Ray might be that Man Ray was thinking of the *Glass Wheel* which both assign to the year 1920, and which was a complicated machine designed to produce the same optical illusion later achieved by the use of the movable

Discs. This wheel foreshadowed, and may even have inspired, the film *Anémic Cinéma* (1926), which was based on the discs. But the wheel itself was never used for filming.

It is not surprising that facts and dates lead us such a dance in so many books on Dada, when two leading Dadaists, men of unquestionable integrity, have differing recollections of the same facts.

We may do justice to their conflicting statements by accepting that twice two can sometimes equal five.

III Marcel Duchamp, *Le Passage de la Vierge à la Mariée*, 1912. ▷
Oil on canvas, 53.5 x 59 cm.
Museum of Modern Art, New York

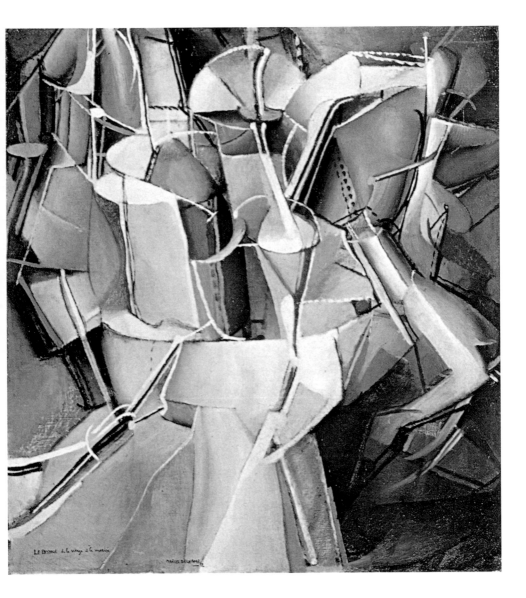

Le Passage de la vierge à la mariée · Marcel Duchamp

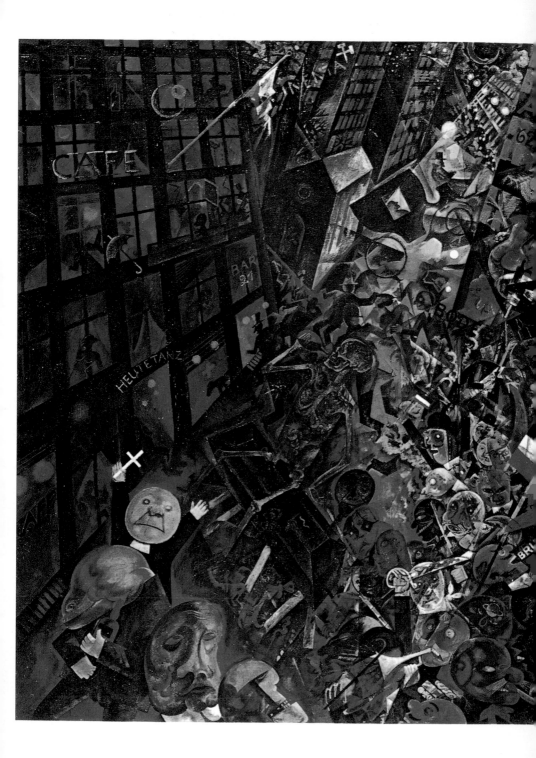

3 Berlin Dada 1918-1923

Pre-Dada

> Dadaism is a stratagem by which the artist can impart to the citizen something of the inner unrest which prevents the artist himself from being lulled to sleep by custom and routine. By means of external stimuli, he can compensate for the citizen's lack of inner urgency and vitality, and shake him into new life.
>
> (Udo Rukser, *Dada-Almanach,* 1920)

In Berlin there appeared a new and glittering facet of Dada. Dada in Berlin had a very different tone from Dada in Zurich and New York. The situation and the city itself were totally different. The Berlin Dadaists might well look down on their Zurich colleagues, who had admittedly insulted the citizenry in all the approved ways, but had no real collapse of the Established so-called Order, no revolution to their credit.

In Berlin they had a real revolution, and they decided to join in. There was the sound of firing in the streets and on the rooftops. Not only art but all thought and all feeling, all of politics and society, had to be drawn into Dada's sphere of influence. Dada applied itself to this task uninhibitedly, vigorously and with no holds barred – full of enthusiasm, as always, for the idea of personal freedom.

While, in one corner of Berlin, sailors were defending the imperial stables against troops loyal to the Kaiser, the Dadaists were laying their plans in another corner. When the stables fell, there was fighting at the Anhalter Bahnhof, in the Belle-Alliance-Platz and in Charlottenburg. Soldiers' councils and workers' councils, meetings, fraternal unions – a new age had dawned! Dada felt called upon to put the new age in perspective – and the old one out of joint.

This is the light in which we must consider the reckless onslaughts carried out, with enthusiasm and a total lack of respect for persons or circumstances, by the political Light Brigade that grew up around Dada.

◁ IV George Grosz, *Funeral Procession. Dedicated to Oskar Panizza,* 1917.
Oil on canvas, 140 x 110 cm.
Staatsgalerie Stuttgart

Even during the war, there had been groups of young artists and budding revolutionaries who expressed their views and their plans in a great variety of periodicals. In the 'good old days' when Lenin, Radek, Axelrod and Zinoviev were allowed to walk round quite freely in Switzerland, police censorship had not, even in Germany, attained that degree of perfection for which the succeeding decades have no doubt received due honour in Hades. Pfemfert's *Die Aktion* was able, even in wartime, to publish prose and verse openly critical of the war. On the stairs at their editorial offices the defeatist words "Only a bad harvest can save us" were often to be heard at a time when *"Gott strafe England"* and similar prayers were to be heard in the streets.

In 1916 the two Herzfelde brothers published *Neue Jugend (Ill. 53)*. Wieland Herzfelde was a practical man like his namesake, Wayland the smith-god. His brother Johann, alias John, had changed his name from Herzfelde to Heartfield out of love for his own romantic vision of America *(Ill. 52)*. *Neue Jugend* (No. 1, 1st May 1916) was a left-wing literary and political paper to which a number of well-known writers contributed, in addition to many unknowns.

At about the same time, the poet Franz Jung and the painter Raoul Hausmann were publishing another periodical, *Die Freie Strasse,* with marked anarchistic tendencies. A later contributor was Johannes Baader, who was to make a sensational reputation in the subsequent Dada movement. Thus, when Richard Huelsenbeck arrived in Berlin from Zurich at the beginning of 1917, he found the right setting and the right colleagues to set off the Dada bomb which had been perfected and tested in Zurich.

Above all, there was George Grosz *(Ill. 51)* who had recently become well-known through his drawings and through Theodor Däubler. A savage fighter, boxer and hater, Grosz, like Heartfield, loved everything 'American' and took pleasure in speaking English in wartime Berlin. His elemental strength was the life-blood of Dada even before the movement got under way.

Huelsenbeck lost no time in laying the Zurich credos and non-credos before an involuntarily curious public – and thereby taking "the reins of Dada government in Berlin" into his well-qualified hands.

Berlin Dada in Action

In February 1918, in the *'Saal der neuen Sezession'*, at a meeting sponsored by the eternally progressive I. B. Neumann, Huelsenbeck delivered his 'First Dada Speech in Germany'.

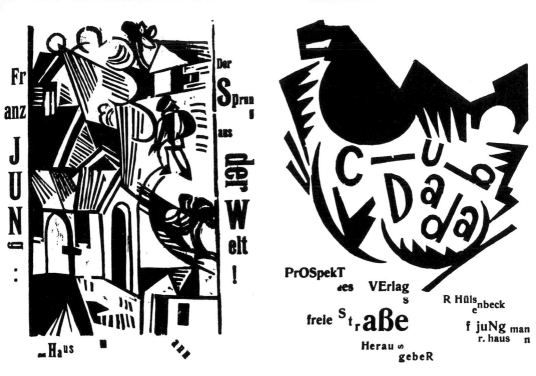

Raoul Hausmann, *Linocut,* 1917

Raoul Hausmann, *Linocut,* 1918

This began with the statement that the meeting was a demonstration of solidarity with international Dadaism, the international 'artistic movement' founded in Zurich two years before. He then launched into a ferocious attack on Expressionism, Futurism and Cubism, and heaped curses on abstract art, proclaiming as he did so that all these theories had been defeated by Dada. He ended with a reading from his *Phantastische Gebete.*

Among the things Huelsenbeck said in this speech were these: "There is one literary form into which we can compress much of what we think and feel: the manifesto. Tzara had enunciated this principle as early as 1916. From the day the Cabaret Voltaire opened its doors, we read and wrote manifestos. We did not only read them, we spoke them as vociferously and defiantly as we could. The manifesto as a literary medium answered our need for directness. We had no time to lose; we wanted to incite our opponents to resistance, and, if necessary, to create new opponents for ourselves. We hated nothing so much as romantic silence and the search for a soul: we were convinced that the soul could only show itself in our own actions."

Huelsenbeck followed up his challenge by writing a manifesto directed at putting art, dislocated by a number of false artistic movements, back into its proper place. This turned into a general declaration of policy which, for all its forcefulness, was nevertheless a pious teatime grace compared with the strident noises that were to follow.

Dadaist Manifesto

"Art in its execution and direction is dependent on the time in which it lives, and artists are creatures of their epoch. The highest art will be that which in its conscious content presents the thousandfold problems of the day, the art which has been visibly shattered by the explosions of last week, which is forever trying to collect its limbs after yesterday's crash. The best and most extraordinary artists will be those who every hour snatch the tatters of their bodies out of the frenzied cataract of life, who, with bleeding hands and hearts, hold fast to the intelligence of their time. Has expressionism fulfilled our expectations of such an art, which should be an expression of our most vital concerns?

No! No! No!

Have the expressionists fulfilled our expectations of an art that burns the essence of life into our flesh?

No! No! No!

Under the pretext of turning inward, the expressionists in literature and painting have banded together into a generation which is already looking forward to honourable mention in the histories of literature and art and aspiring to the most respectable civic distinctions. On pretext of carrying on propaganda for the soul, they have, in their struggle with naturalism, found their way back to the abstract, emotional gestures which presuppose a comfortable life free from content or strife. The stages are filling up with kings, poets and Faustian characters of all sorts; the theory of a melioristic philosophy, the psychological naivety of which is highly significant for a critical understanding of expressionism, runs ghostlike through the minds of men who never act. Hatred of the press, hatred of advertising, hatred of sensations are typical of people who prefer their armchair to the noise of the street, and who even make it a point of pride to be swindled by every small-time profiteer. That sentimental resistance to the times – which are neither better nor worse, neither more reactionary nor more revolutionary than other times, that weak-kneed resistance, flirting with prayers and incense when it does not prefer to build its cardboard cannon with Attic iambics – is the quality of a youth which never knew how to be

dadaitisCHes maniFest

Die Kunst ist in ihrer Ausführung und Richtung von der Zeit abhängig, in der sie lebt, und die Künstler sind Kreaturen ihrer Epoche. Die höchste Kunst wird diejenige sein, die in ihren Bewußtseinsinhalten die tausendfachen Probleme der Zeit präsentiert, der man anmerkt, daß sie sich von den Explosionen der letzten Woche werfen ließ, die ihre Glieder immer wieder unter dem Stoß des letzten Tages zusammensucht. Die besten und unerhörtesten Künstler werden diejenigen sein, die stündlich die Fetzen ihres Leibes aus dem Wirrsal der Lebenskatarakte zusammenreißen, verbissen in den Intellekt der Zeit, blutend an Händen und Herzen.

Hat der Expressionismus unsere Erwartungen auf eine solche Kunst erfüllt, die eine Ballotage unserer vitalsten Angelegenheiten ist?

Nein! Nein! Nein!

Haben die Expressionisten unsere Erwartungen auf eine Kunst erfüllt, die uns die Essenz des Lebens in Fleisch brennt?

Nein! Nein! Nein!

Unter dem Vorwand der Verinnerlichung haben sich die Expressionisten in der Malerei zu einer Generation zusammengeschlossen, die heute schon sehnsüchtig ihre literatur- und kunsthistorische Würdigung erwartet und für eine ehrenvolle Bürger-Anerkennung kandidiert. Unter dem Vorwand, die Seele zu propagieren, haben sie sich im Kampfe gegen den Naturalismus zu den abstrakt-pathetischen Gesten zurückgefunden, die ein inhaltloses, bequemes und unbewegtes Leben zur Voraussetzung haben. Die Bühnen füllen sich mit Königen, Dichtern und faustischen Naturen jeder Art, die Theorie einer melioristischen Weltauffassung, deren kindliche, psychologisch-naivste Manier für eine kritische Ergänzung des Expressionismus signifikant bleiben muß, durchgeistert die tatenlosen Köpfe. Der Haß gegen die Presse, der Haß gegen die Reklame, der Haß gegen die Sensation spricht für Menschen, denen ihr Sessel wichtiger ist als der Lärm der Straße und die sich einen Vorzug daraus machen, von jedem Winkelschieber übertölpelt zu werden. Jener sentimentale Widerstand gegen die Zeit, die nicht besser und nicht schlechter, nicht reaktionärer und nicht revolutionärer als alle anderen Zeiten ist, jene matte Opposition, die nach Gebeten und Weihrauch schielt, wenn sie es nicht vorzieht, aus attischen Jamben ihre Pappgeschosse zu machen — sie sind Eigenschaften einer Jugend, die es niemals verstanden hat, jung zu sein. Der Expressionismus, der im Ausland gefunden, in Deutschland nach beliebter Manier eine fette Idylle und Erwartung guter Pension geworden ist, hat mit dem Streben tätiger Menschen nichts mehr zu tun. Die Unterzeichner dieses Manifests haben sich unter dem Streitruf

DADA!!!!

zur Propaganda einer Kunst gesammelt, von der sie die Verwirklichung neuer Ideale erwarten. Was ist nun der DADAISMUS?

Das Wort Dada symbolisiert das primitivste Verhältnis zur umgebenden Wirklichkeit, mit dem Dadaismus tritt eine neue Realität in ihre Rechte. Das Leben erscheint als ein simultanes Gewirr von Geräuschen, Farben und geistigen Rhythmen, das in die dadaistische Kunst unbeirrt mit allen sensationellen Schreien und Fiebern seiner verwegenen Alltagspsyche und in seiner gesamten brutalen Realität übernommen wird. Hier ist der scharf markierte Scheideweg, der den Dadaismus von allen bisherigen Kunstrichtungen und vor allem von dem FUTURISMUS trennt, den kürzlich Schwachköpfe als eine neue Auflage impressionistischer Realisierung aufgefaßt haben. Der Dadaismus steht zum erstenmal dem Leben nicht mehr ästhetisch gegenüber, indem er die Schlagworte von Ethik, Kultur und Innerlichkeit, die nur Mäntel für schwache Muskeln sind, in seine Bestandteile zerfetzt.

Das BRUITISTISCHE Gedicht

schildert eine Trambahn wie sie ist, die Essenz der Trambahn mit dem Gähnen des Rentiers Schulze und dem Schrei der Bremsen.

Das SIMULTANISTISCHE Gedicht

lehrt den Sinn des Durcheinanderjagens aller Dinge, während Herr Schulze liest, fährt der Balkanzug über die Brücke bei Nisch, ein Schwein jammert im Keller des Schlächters Nuttke.

Das STATISCHE Gedicht

macht die Worte zu Individuen, aus den drei Buchstaben Wald, tritt der Wald mit seinen Baumkronen, Försterlivreen und Wildsauen, vielleicht tritt auch eine Pension heraus, vielleicht Bellevue oder Bella vista. Der Dadaismus führt zu unerhörten neuen Möglichkeiten und Ausdrucksformen aller Künste. Er hat den Kubismus zum Tanz auf der Bühne gemacht, er hat die BRUITISTISCHE Musik der Futuristen (deren rein italienische Angelegenheit er nicht verallgemeinern will) in allen Ländern Europas propagiert. Das Wort Dada weist zugleich auf die Internationalität der Bewegung,

die an keine Grenzen, Religionen oder Berufe gebunden ist. Dada ist der internationale Ausdruck dieser Zeit, die große Fronde der Kunstbewegungen, der künstlerische Reflex aller dieser Offensiven, Friedenskongresse, Balgereien am Gemüsemarkt, Soupers im Esplanade etc. etc. Dada will die Benutzung des

neuen Materials in der Malerei.

Dada ist ein CLUB, der in Berlin gegründet worden ist, in den man eintreten kann, ohne Verbindlichkeiten zu übernehmen. Hier ist jeder Vorsitzender und jeder kann ein Wort abgeben, wo es sich um künstlerische Dinge handelt. Dada ist nicht ein Vorwand für den Ehrgeiz einiger Literaten (wie unsere Feinde glauben machen möchten) Dada ist eine Geistesart, die in jedem Gespräch offenbaren kann, sodaß man sagen muß: dieser ist ein DADAIST — jener nicht; der Club Dada hat deshalb Mitglieder in allen Teilen der Erde, in Honolulu so gut wie in New-Orleans und Meseritz. Dadaist sein kann unter Umständen heißen, mehr Kaufmann, mehr Parteimann als Künstler sein — nur zufällig Künstler sein — Dadaist sein, heißt, sich von den Dingen werfen lassen, gegen jede Sedimentbildung sein, ein Moment auf einem Stuhl gesessen, heißt, das Leben in Gefahr gebracht haben (Mr. Wengs zog schon den Revolver aus der Hosentasche). Ein Gewebe zerreißt sich unter der Hand, man sagt ja zu einem Leben, das durch Verneinung höher will. Ja-sagen — Nein-sagen: das gewaltige Hokuspokus des Daseins beschwingt die Nerven des echten Dadaisten — so liegt er, so jagt er, so radelt er — halb Pantagruel, halb Franziskus und lacht und lacht. Gegen die ästhetisch-ethische Einstellung! Gegen die blutleere Abstraktion des Expressionismus! Gegen die weltverbessernden Theorien literarischer Hohlköpfe! Für den Dadaismus in Wort und Bild, für das dadaistische Geschehen in der Welt. Gegen dieses Manifest sein, heißt Dadaist sein!

Tristan Tzara. Franz Jung. George Grosz. Marcel Janco. Richard Huelsenbeck.
Gerhard Preiß. Raoul Hausmann.

O. Lüthy. Fréderic Glauser. Hugo Ball. Pierre Albert Birot.
Maria d'Arezzo Gino Cantarelli. Prampolini. R. van Rees. Madame van Rees.
Hans Arp. G. Thäuber. Andrée Morosini. François Mombello-Pasquati.

Von diesem Manifest sind 25 Exemplare mit den Unterschriften der Berliner Vertreter des Dadaismus versehen worden und zum Preise von fünf Mark bei Richard Huelsenbeck, Berlin-Charlottenburg, Kantstr. 118, III, zu beziehen. Alle Anfragen und Bestellungen bitte man an die gleiche Adresse zu richten.
Leiter der Bewegung in der Schweiz: Tristan Tzara, Zürich, Zeltweg 83 (Administration du Mouvement Dada F. Arp), Leiter in Skandinavien: Francis Morton, Stockholm, Marholms Gaden 14.

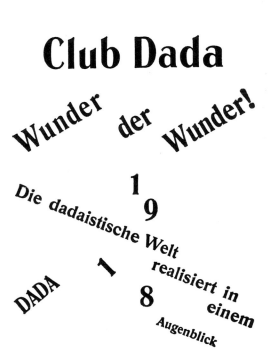

Club Dada

Wunder der Wunder!

Die dadaistische Welt

1918

DADA

realisiert in einem Augenblick

internationaler Rhythmus

young. Expressionism, discovered abroad, and in Germany, true to style, transformed into an opulent idyll and the expectation of a good pension, has nothing in common with the efforts of active men. The signatories of this manifesto have, under the battle cry:

<p style="text-align:center;">DADA!!!!</p>

gathered together to put forward a new art, from which they expect the realization of new ideals. What then is DADAISM?

The word Dada symbolizes the most primitive relation to the reality of the environment; with Dadaism a new reality comes into its own. Life appears as a simultaneous muddle of noises, colours and spiritual rhythms, which is taken unmodified into Dadaist art, with all the sensational screams and fevers of its reckless everyday psyche and with all its brutal reality. This is the sharp dividing line separating Dadaism from all earlier artistic currents, and particularly from FUTURISM which not long ago some puddingheads took to be a new version of impressionist realization. Dadaism for the first time has ceased to take an aesthetic attitude toward life, and this it accomplishes by tearing all the slogans of ethics, culture and inwardness, which are merely cloaks for weak muscles, into their components.

The BRUITIST poem
represents a streetcar as it is, the essence of the streetcar with the yawning of Schulze the *rentier* and the screeching of the brakes.

The SIMULTANEIST poem
teaches a sense of the merry-go-round of all things; while Herr Schulze reads his paper, the Balkan Express crosses the bridge at Nisch, a pig squeals in Butcher Nuttke's cellar.

The STATIC poem
makes words into individuals. Out of the letters spelling 'forest' steps the forest with its treetops, liveried foresters and wild sows; maybe a boarding house steps out too, and maybe it's called Bellevue or Bella Vista. Dadaism leads to amazing new possibilities and forms of expression in all the arts. It made Cubism a dance on the stage, it disseminated the BRUITIST music of the futurists (whose purely Italian concerns it has no desire to generalize) in every country in Europe. The word Dada in itself indicates the internationalism of the movement which is bound to no frontiers, religions or professions. Dada is the international expression of our times, the great rebellion of artistic movements, the artistic reflex of all these offensives, peace congresses, riots in the vegetable market, midnight suppers at the Esplanade, etc., etc. Dada champions the use of the new medium in painting.

Dada is a CLUB, founded in Berlin, which you can join without commitments. In this club every man is president and every man can have his say in artistic matters. Dada is not a pretext for the ambition of a few literary men (as our enemies would have you believe), Dada is a state of mind that can be revealed in any conversation whatever, so that you are compelled to say: this man is a DADAIST – that man is not; the Dada Club consequently has members all over the world, in Honululu as well as New Orleans and Meseritz. Under certain circumstances to be a Dadaist may mean to be more a businessman, more a political partisan than an artist – to be an artist only by accident – to be a Dadaist means to let oneself be thrown by things, to oppose all sedimentation; to sit in a chair for a single moment is to risk one's life (Mr. Wengs pulled his revolver out of his pants pocket). A fabric tears under your hand, you say yes to a life that strives upward by negation. Affirmation – negation: the gigantic hocus-pocus of existence fires the nerves of the true Dadaist – and there he is, reclining, hunting, cycling – half Pantagruel, half St. Francis, laughing and laughing. Blast the aesthetic–ethical attitude! Blast the bloodless abstraction of expressionism! Blast the literary hollowheads and their theories for improving the world! For Dadaism in word and image, for all the Dada things that go on in the world! To be against this manifesto is to be a Dadaist!

(Translation by Ralph Manheim, reprinted from Motherwell, *The Dada Painters and Poets*)

With this manifesto, Dada was officially launched at last. This 'long-awaited event', for people had already heard a lot about the whole puzzling business, aroused universal interest in spite of the continual streetfighting in Berlin. A group of true Dadaists came together and formed the Club Dada. This was no less exclusive than the *Herrenklub* whose members were Herr von Papen and the other amateur jockeys who later rode Germany into the quagmires and catastrophes of the Third Reich.

Thus, some time later, when a Hanoverian called Kurt Schwitters applied for membership, he was, as Hausmann relates in his *Courrier Dada*, blackballed. This rejection gave rise to an antagonism that survived for many years. Huelsenbeck never seems to have got over his hostility to Schwitters, whom he called a 'bourgeois'.

Johannes Baader, on the other hand, was enrolled as a founder-member, giving his profession as 'architect'. He assumed the name of 'Oberdada' and subsequently made good his claim to the title by a series of actions which set the 'crown' on his head – and on Dada's achievements. Hausmann, with whom he

had been on friendly terms since 1905, admired his total lack of inhibitions. At the inception of the German republic, Baader appointed himself, without undue modesty, President of the Republic of Germany. Even this did not satisfy him and he laid claim to the Presidency of the Globe.

There can be no question that it was Huelsenbeck who introduced the Dada bacillus to Berlin. On the other hand, Hausmann, whom I had known before the war, had been infected with a similar bacillus from birth. His aggressive, hell-raising propensities needed no prompting from Dada. Thus we do not know who was the real father of the Berlin Dada movement, but, as the two candidates for the title both have the same initials, the chronicler can best avoid error by awarding the disputed honour to 'RH' and leaving the vexed question of Dada's paternity open.

I myself did not get to Berlin until 1919, so my knowledge of the beginnings of the Berlin movement is entirely based on hearsay. The principal source is the truly Homeric feud, which raged until quite recently with unabated ferocity, about the identity of the real founder of the movement. The contestants were the two RH's, the Dadaist poet and doctor Richard Huelsenbeck, formerly of Zurich, and the Czech-born writer, painter, philosopher, fashion-designer, *photomonteur*, etc., Raoul Hausmann, alias *Dadasoph*, late of Berlin, and now resident in Limoges, France. (Huelsenbeck recently informed me that the feud ended in 1962. I wonder.)

Hausmann tried everything. His versatility was inexhaustible. In everything he did there was an undertone of humour, but it was a fantastical 'gallows-humour' born of hatred. It was what Breton calls *'humour noir'*. On one day he was a *photomonteur*, on the next a painter, on the third a pamphleteer *(Ill. 49)*, on the fourth a fashion designer, on the fifth a publisher and poet, on the sixth an 'optophonetician', and on the seventh day – he rested with his Hannah *(Ill. 61)*.

It is clear, at any rate, that Baader and the two RH's fought side by side – and back to back – with Grosz and the Herzfeldes as the shock troops of the Berlin Dada movement. Huelsenbeck was the 'envoy' of the original Dadas in Zurich, and thus the spokesman of Dada-Religion; Hausmann was a potent representative of artistic Dada, with a long-authenticated, sombre egotism; Baader was a sack of dynamite; and the three others formed the left wing.

There was one thing on which the heavenly twins, RH and RH, were in agreement: Dada was the *only* anti-art. All the others concurred: George Grosz, the two Herzfeldes, Baader, Jung, Einstein, Mehring, and so on. They may all

have been 'anti' different things, and for different reasons – this certainly became the case later on – but everyone of them was anti-authoritarian.

This soon became evident. There was a revolution going on, and Dada was right in the thick of it. At one moment they were all for the *Spartakus* movement; then it was Communism, Bolshevism, Anarchism and whatever else was going. But there was always a side-door left open for a quick getaway, if this should be necessary to preserve what Dada valued most – personal freedom and independence.

How little they understood of party politics (the two Herzfeldes were an exception to this) is illustrated by the following telegram addressed to the Italian nationalist poet d'Annunzio, already at that time a rabid fascist:

ILLMO SIGNORE GABRIELE D'ANNUNZIO CORRIERE DELLA SERA MILANO
IF ALLIES PROTEST TELEPHONE CLUB DADA BERLIN STOP CAPTURE OF FIUME DADAIST MASTERSTROKE WILL MAKE EVERY EFFORT TO SECURE RECOGNITION STOP L'ATLANTE MONDIALE DADAISTICO DADAKO EDITORE KURT WOLFF LEIPZIG RICONOSCE FIUME GIA COME CITTA ITALIANA STOP AI 15,333
 CLUB DADA
 HUELSENBECK BAADER GROSZ

Hans Richter,
Portrait of Raoul Hausmann, 1915

1918 – 1919. The Trump of Doom

In Berlin, as in Zurich and New York, it was the individual who finally determined the direction and scope of the movement.

Neither Herzfelde nor Heartfield ever needed a political side-door. They have stuck consistently to the Party Line from that day to this. Before the war their mouthpiece was *Neue Jugend*; after the war it was Dada. Herzfelde later started a publishing house, the Malik-Verlag, near the Potsdamer Bahnhof, where he published left-wing literature. Although he was a good writer himself, he preferred to publish better ones. His publishing house had little to do with Dada, but a lot to do with the political class-struggle. Only the George Grosz portfolios, *Das Gesicht der herrschenden Klasse* ('The Face of the Ruling Class') and others, in which he mocked and assailed the ruling class with unremitting savagery, constituted a link with Dada. The obscene bitterness that characterized the work of Grosz's best period is as apposite to the revolt represented by Dada as it is to the idea of class-warfare represented by the Herzfeldes.

There followed a whole series of ferocious political publications, in which Grosz, Herzfelde and Heartfield, along with the poets Carl Einstein, Walter Mehring and Franz Jung, not forgetting Hausmann and Huelsenbeck, blew repeated blasts on the Trump of Doom.

Carl Einstein, who later came into prominence through his knowledge of Negro sculpture and modern music, had already delighted us with his slim volume *Bebuquin* (published by Pfemfert's Aeternisten-Bibliothek). He now edited the periodical *Der blutige Ernst* ('Deadly Earnest'). *Jedermann sein eigner Fussball* ('Every Man His Own Football') (*Ill. 55*) appeared with photomontages by Heartfield (*Ill. 52*), who thus acquired the title of 'photomonteur'. Grosz illustrated the paper and thus assumed by right the rank of Marshal. There was also *Die Rosa Brille* ('Rose-Coloured Spectacles', or perhaps 'Monocle': it was a lavatory seat).

All of these were very quickly banned, only to reappear under new titles: *Die Pleite* ('Bankrupt'), *Der Gegner* ('Adversary'), *Die Pille* ('The Pill'), and so on, rushing one, two or three issues on to the streets before they were banned again.

Walter Mehring (*Ill. 54*) illustrates the risks to which Berlin Dadaists exposed themselves when he tells the story of *Jedermann sein eigner Fussball*:

"As I remember it, the credit belongs to our pair of Dadaist publishers and brothers, who also financed the enterprise with the aid of a little legacy they had. But the way we sold it in the streets was my idea. We hired a char-a-banc

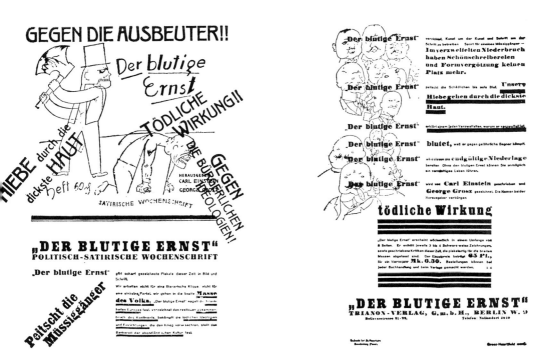

George Grosz, Drawings for the periodical *Der blutige Ernst*

of the sort used for Whitsuntide outings, and also a little band, complete with frock coats and top hats, who used to play at ex-servicemen's funerals. We, the editorial staff, paced behind, six strong, bearing bundles of *Jedermann sein eigner Fussball* instead of wreaths."

"In the sophisticated west end of the city we earned more taunts than pennies, but our sales mounted sharply as we entered the lower-middle class and working-class districts of north and east Berlin. Along the streets of dingy grey tenements, riddled by the machine-gun fire of the *Spartakus* fighting and sliced open by the howitzers of the Noske régime, the band was greeted with cheers and applause as it played its two star pieces, which were the sentimental military airs *Ich hatt' einen Kameraden* and *Die Rasenbank am Elterngrab.* After the cannibal war-dances of the *Kapp-Putsch*, more grotesque than Sophie Taeuber's marionettes, after the *danses macabres* of the militarist *Stahlhelm* movement, and its swastika ornaments that seemed taken straight from Hans Arp's 'Heraldry', our Dadaist procession was greeted with delight as spontaneous as the '*on y danse*' of the Paris mob in front of the Bastille. And 'every man his own

football' entered the Berlin language as an expression of contempt for authority and humbug. The periodical even looked like becoming a best-seller – and would have, if we had not been arrested on our way home from serenading the governmental offices in the Wilhelmstrasse. (We carried a supply of gummed labels saying '*Hurra Dada!*' for sticking on the walls of police-station cells.)

"*Jedermann sein eigner Fussball* was permanently banned, and we were charged with seeking to bring the Armed Forces into contempt and distributing indecent publications.

"I have to confess that it was a Dada song I had written, a really distressing, obscene piece of anti-militarism for which there was no excuse even as a product of Dadaism, that gave the police a case against us.

"At the hearing before the Moabit district court, Berlin, C. 3, the prosecution had demanded sentences of eight months' imprisonment for Vize as editor and Walt Merin as author. They called as a witness one Professor Brunner, an officially acknowledged authority on the law of indecency, while the defence plea of mitigating circumstances was supported by the expert medical testimony of Dr Gottfried Benn, who cited two textbooks, *Der Marquis de Sade und sein Zeitalter* ('The Marquis de Sade and his Age'), by Dr Eugen Dühren (Dr Iwan Bloch) and *Sexuelle Zwischenstufen* ('Sexual Borderline Cases') by Dr Magnus Hirschfeld, in the course of a disquisition on the relationship between satire and sexual pathology which is unfortunately not included in his collected works."

But efforts to abolish art, whether or not they were based on some social theory, met with unexpected difficulties. Hausmann preached anti-art, and yet most of his works were very close to that same 'abstract' art that Huelsenbeck and Grosz so despised. Collages and photomontages later became important components of a 'new art' – new because it opened the way to a vision of the world consistent with our experience.

They followed the play-instinct wherever it led them and paid no heed to God or man, art or society, but only to their own unrest, THEMSELVES, the need for change. So, when Dada gradually assumed the positive social function of rousing the public from its sleep and making it conscious of its own banality, the presence of a social and cultural purpose was in itself a sign of decadence. Dada in its pure state was pure revolt, ANTI-EVERYTHING!

The flirtation with communism was solely the product of this *anti-everything* mentality, not of any devotion to the doctrines of Karl Marx – even though Marx possessed, for the Herzfeldes and Grosz, the status of an anti-saint. Freud, on the other hand, was consigned to the scrap-heap, as were Jung and Adler;

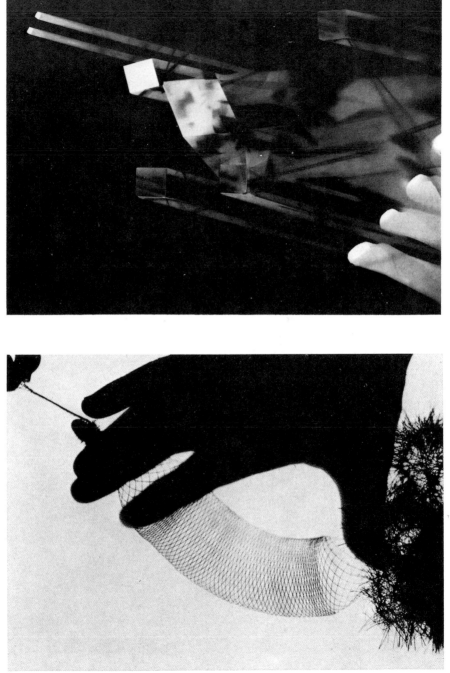

47 Man Ray, *Rayogram*, 1921–22. Photograph taken without a camera

46 Man Ray, *Rayogram*, 1921–22. Photograph taken without a camera

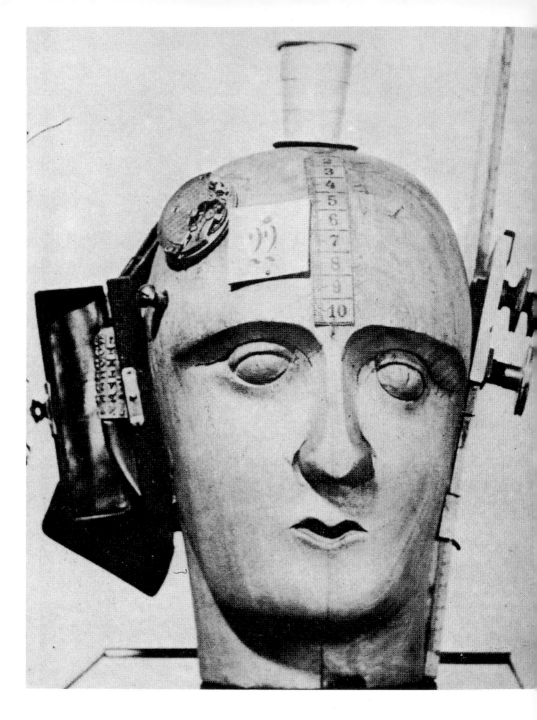

48 Raoul Hausmann, *Holzkopf* (Wooden Head), 1918. Assemblage

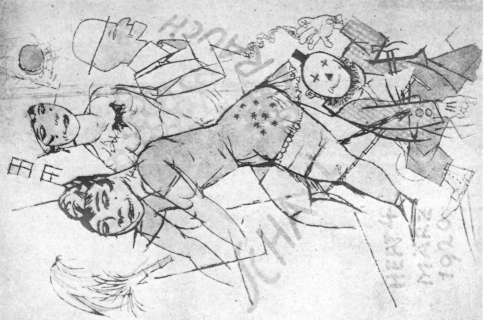

49 Raoul Hausmann, pamphlet, 1918

50 George Grosz, programme booklet for *Schall und Rauch*

51 George Grosz

52 John Heartfield

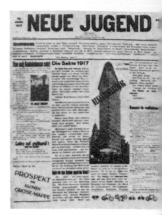

53 Cover of *Neue Jugend*, Berl
1917

54 Walter Mehring

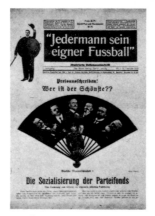

55 Cover of *Jedermann sein
eigner Fussball*, Malik-Ver-
lag, Berlin 1919

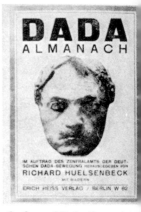

56 Cover of *Dada Almanach*, e
ed by Richard Huelsenbe
E. Reiss Verlag, Berlin 19

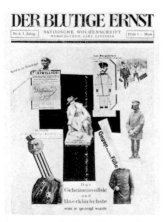

57 Cover of *Der blutige Ernst*,
Trianon Verlag, Berlin 1919

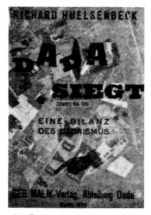

58 Cover of *Dada siegt*, ed-
ited by Richard Huelsen-
beck, Berlin 1920

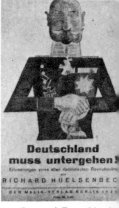

59 Cover of *Deutschland
muss untergehen*, edit
by Richard Huelsenbec
Malik-Verlag, Berlin 19

and a psychologist named Herr Gross was canonized by Hausmann and placed in the vacant niche.

Most Dadaists reserved their enthusiasm for the SELF, working out its own laws, its own form and its own justification, free from guilt and remorse. In Picabia, Duchamp, Man Ray, this method worked wonders – of art. It worked wonders because the circumstances favoured, and indeed demanded, unlimited revolt.

The idea of putting people in a position to exploit their mental and physical energies in a spirit of unbounded optimism and faith in themselves – this was the idea behind the wild and exuberant antics of Dada. "To hell with art, if it gets in the way!"

This anarchistic spirit enabled the Berlin Dada movement to live life to the full, in its own way. It provides some excuse for even the most revolting lapses of taste and for all the violent manifestoes that sometimes even have a Nazi ring to them.

In practice, the demand that art should be banished to the scrap-heap turned into a battle, not against art as such, but against social conditions in Germany.

As late as 1924, George Grosz wrote in my periodical for elementary *gestaltung, G:* "The answer to the question, whether my work can be called art or not, depends on whether one believes that the future belongs to the working class." The Herzfeldes would certainly have said the same, but there was no such certainty for the others. In the years that followed, Grosz himself changed his views. When he came back from the USSR, which he had visited as an honoured guest, the following conversation took place (there are many different versions):

"What was it like over there, Böff? [see p. 132] Did you see *him*, the old fellow in the Kremlin?" Grosz merely growled, "There was once a chemist in Stolp, in East Pomerania, his name was Voelzke. Neat little goatee beard, frock-coat, upright bearing, a real honest bourgeois, like this . . . ! He had a cure for everything:

'Can I help you?'

'I've got a weak feeling in the pit of my stomach.'

'Effervescent powder. Next?'

'I am desperately in love with Liberty!'

'Blue packet: one dessertspoonful before retiring. And you?'

'I've got a funny rash on my chest –'

'The syphilis, you swine. Red capsules.'

Three patent medicines for everything. Lenin? A little chemist."

(from Walter Mehring, *Berlin Dada*)

Grosz reaffirmed his hatred of communism in 1927 or 1928, when I dined at Schlichter's, the haunt of the better-off bohemians, with him and his wife and a man who had just come back from Russia. Obviously with the intention of pleasing Grosz, the traveller spoke of how wonderful he had found everything in the USSR. This went on for a while, Grosz becoming more and more taciturn. Then, totally without warning, he reached over and punched his unsuspecting table-companion full in the mouth.

In those early years of Dada, however, Grosz supported the cause of world revolution with all the savagery of which he was capable, side by side with the Herzfeldes and Jung. This in no way cut them off from politically less clearly orientated Dadaists like Huelsenbeck, Hausmann, Hannah Hoech, Baader and Mehring. Even when Dada called for changes in the established order, Art always lay behind it somewhere – even though all the talk was of Anti-Art.

This concept can only be accepted *cum grano salis;* proof of this is supplied by a meeting in the Berlin *Sezession* where pure provocations (Hausmann) and phonetic poems were accompanied by gentler tones (Hannah Hoech) and above all by the wise words of the philosopher-satirist Dr Salomon Friedländer-Mynona. Mynona may not have belonged to the Dada movement as such, but he had a profound *understanding* of Dada, as the 'neutral point' between two poles – right and left – and as a living force. His philosophical 'Grotesques' were staple Dada fare.

Photomontage

Here as in Zurich, total liberation from preconceived ideas and previous relationships created new possibilities. Chance, acclaimed as a miracle in Zurich, became in Berlin an article of daily use. It had abolished logic; so much the better. Whatever came along would do – and was preserved just as it was. For periodicals, manifestoes, bookbindings, posters and other printed matter, the conventional style of presentation was no longer good enough. Something new was needed. They cut up photographs, stuck them together in provocative ways, added drawings, cut these up too, pasted in bits of newspaper, or old letters, or whatever happened to be lying around – to confront a crazy world with its own image. The objects thus produced were called photomontages. In this way they produced flysheets, poems and political obscenities or portraits;

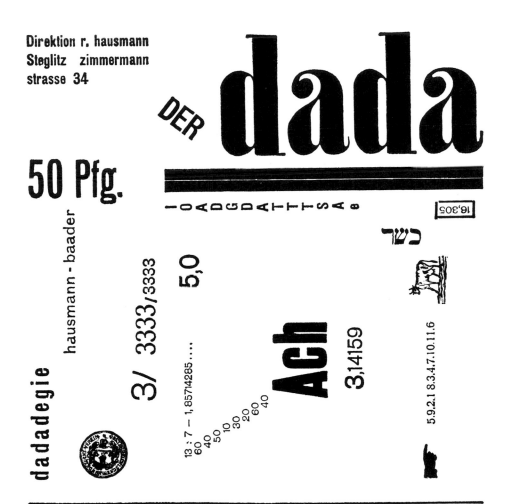

Direktion r. hausmann
Steglitz zimmermann
strasse 34

DER **dada**

50 Pfg.

dadadegie hausmann - baader

IOADGDATTSA ®

16,305

3/ 3333/3333

5,0

13 : 7 – 1,8574285.....
60
40
50
10
30
20
60
40

Ach

3,14159

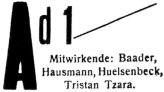

5.9.2.1 8.3.4.7.10.11.6

Jahr 1 des Weltfriedens. Avis dada

Hirsch Kupfer schwächer. Wird Deutschland verhungern? Dann muß es unterzeichnen. Fesche junge Dame, zweiundvierziger Figur für Hermann Loeb. Wenn Deutschland nicht unterzeichnet, so wird es wahrscheinlich unterzeichnen. Am Markt der Einheitswerte überwiegen die Kursrückgänge. Wenn aber Deutschland unterzeichnet, so ist es wahrscheinlich, daß es unterzeichnet um nicht zu unterzeichnen. Amorsäle. Achtuhrabendblattmitbrausendeshimmels. Von Viktorhahn. Loyd George meint, daß es möglich wäre, daß Clémenceau der Ansicht ist, daß Wilson glaubt, Deutschland müsse unterzeichnen, weil es nicht unterzeichnen nicht wird können. Infolgedessen erklärt der club dada sich für die absolute Preßfreiheit, da die Presse das Kulturinstrument ist, ohne das man nie erfahren würde, daß Deutschland endgültig nicht unterzeichnet, blos um zu unterzeichnen. (Club dada, Abt. für Preßfreiheit, soweit die guten Sitten es erlauben.)

Die neue Zeit beginnt mit dem Todesjahr des Oberdada

Ad 1

Mitwirkende: Baader, Hausmann, Huelsenbeck, Tristan Tzara.

Cover for *Der Dada*, No. 1, Berlin

they created inflammatory book-jackets and a new typography which gave to the individual letter, word or sentence a freedom it had never possessed (outside the Futurist and Zurich Dada movements) since Gutenberg. An inspired dip into the compositor's type-case, and school orthography was replaced by heterography. Large and small letters joined in new combinations and danced up and down; vertical and horizontal words arranged themselves to carry the meaning, and gave new life to the printed page, so that it not only described the new freedom to the reader, but allowed him to see and feel it for himself.

Collage, pieces of paper and cloth stuck on to a picture, had already been tried in Zurich. But Berlin added a new dimension: the 'alienation' of photography, which is after all basically a means of representing visible objects. They created new combinations of form and tone. They made free use of photographic reporting for purposes of political attack. The situation which gave rise to this new use of photography was the product of political struggle and a deep need of freedom.

Hausmann, the self-styled inventor of this technique, remarks in his article *Definition der Foto-Montage* ('Definition of Photomontage'):

"The Dadaists, who had 'invented' static, simultaneous and phonetic poetry, applied the same principles to visual representation. They were the first to use photography to create, from often totally disparate spatial and material elements, a new unity in which was revealed a visually and conceptually *new* image of the chaos of an age of war and revolution. And they were aware that their method possessed a power for propaganda purposes which their contemporaries had not the courage to exploit . . ."

"The field of photomontage has as many possibilities as there are changes in the *milieu*, its social structure and the resulting psychological superstructure – and the *milieu* alters every day . . ."

"Photomontage in its earliest form was an explosive mixture of different points of view and levels, more extreme in its complexity than futuristic painting. Everywhere people are becoming aware that this particular optical element is an extremely versatile artistic resource. In the specific case of photomontage, with its contrast of structure and dimension, rough against smooth, aerial photograph against close-up, perspective against flat surface, the utmost technical flexibility and the most lucid formal dialectics are equally possible... The ability to manage the most striking contrasts, to the achievement of perfect states of equilibrium, in other words the formal dialectic qualities which are inherent in photomontage, ensures the medium a long and richly productive span of life . . ."

Inevitably, ideas mature and come to the surface in several places at the same time. I have known this to happen more than once. Hausmann's claim to be the true inventor of photomontage is supported by a story told to me by his former girl-friend Hannah Hoech, now decidedly not on friendly terms with him.

In 1917 or 1918, Hausmann and she had rented a room in Gribow, near Usedom on the Baltic, for their holidays (Hausmann says it was in Heidebrink). On the wall in front of their bed hung a large framed oleograph. In the centre was the youthful Kaiser Wilhelm II surrounded by ancestors, descendants, German oaks, medals, and so on. Slightly higher up, but still in the middle, stood a young grenadier under whose helmet the face of their landlord, Herr Felten, was pasted in. There, in the midst of his superiors, stood the young soldier, erect and proud amid the pomp and splendour of this world. This paradoxical situation aroused Hausmann's perennial aggressive streak. Of course, this 'glueing on' could be used in many other ways; against stupidity and decadence, to lay the world bare in all its abstruse inanity. On his return to Berlin, he began to juxtapose photographic banalities in order to produce abstrusenesses of his own.

His claim to have created a new art form is disputed by Grosz and Heartfield *(Ill. 62)*. Today, forty years later, it is impossible to ascribe the invention with certainty to one or other of them. There is the usual battle royal over this question of authorship. But, as I am in no position to decide the matter, I offer both claims. This was Grosz's version:

"In 1916, when Johnny Heartfield and I invented photomontage in my studio at the south end of the town at five o'clock one May morning, we had no idea of the immense possibilities, or of the thorny but successful career, that awaited the new invention.

"On a piece of cardboard we pasted a mischmasch of advertisements for hernia belts, student song-books and dog food, labels from schnaps- and wine-bottles, and photographs from picture papers, cut up at will in such a way as to say, in pictures, what would have been banned by the censors if we had said it in words. In this way we made postcards supposed to have been sent home from the Front, or from home to the Front. This led some of our friends, Tretjakoff among them, to create the legend that photomontage was an invention of the 'anonymous masses'. What did happen was that Heartfield was moved to develop what started as an inflammatory political joke into a conscious artistic technique."

Heartfield did develop a conscious artistic technique, with remarkable results which he applied to the design of book-jackets for his brother Wieland's Malik-

Verlag. Kurt Tucholsky said of them: "If I were not Kurt Tucholsky, I should like to be a Malik-Verlag book-jacket by the Dada *monteur* Heartfield."

Heartfield's photomontages had their own flavour just as Hausmann's had. Heartfield's montages were often classically composed; Hausmann's were wild and explosive, not to be contained by any aesthetic framework. Hausmann's were certainly fiercer and more uninhibited; Heartfield's were more direct. Both set standards by which their successors are still judged; they have been imitated and copied by thousands who have pocketed the financial rewards always denied to Hausmann and Heartfield, the creative artists.

Hausmann gives this explanation of the use of the term 'photomontage' to describe this technique: "We called this process photomontage because it embodied our refusal to play the part of the artist. We regarded ourselves as engineers, and our work as construction: we *assembled* (in French: *monter*) our work, like a fitter." Apart from Heartfield and Hausmann, Baader and Hannah Hoech also used this technique for Dadaist self-expression (*Ill. 66.*)

"In 1917, when Huelsenbeck first introduced us to his *Phantastische Gebete* and to *Cabaret Voltaire*", writes Hausmann, "the members of the group could see in which direction the battle for a new art would develop. Two different tendencies appeared: one towards a kind of satirical surrealism, the other towards non-representational art. In visual art this tendency was represented by photomontage (Baader, Hausmann, Heartfield, Hoech, Grosz), which introduced the simultaneous juxtaposition of different points of view and angles of perspective, as in a kind of motionless moving picture; in literature by the recognition of the importance of the 'unconscious' and of automatic writing, as in the *Manifest von der Gesetzmässigkeit des Lautes* ('Manifesto on the Laws of Phonetic Sound') and the phonetic poems of Hausmann (1918)."

From Abstract Poetry to Optophonetics

"The great step by which total irrationality was introduced into literature took place with the introduction of the phonetic poem . . ." Hausmann, in his *Courrier Dada*, gives an interesting survey of experiments in this direction:

Abstract Poetry

"I should be glad if someone would show us the amazing development by which the phonetic poem appeared 'at one stroke' (as Isidore Isou claims that his – derivative – work did). I had already made several discoveries in this field

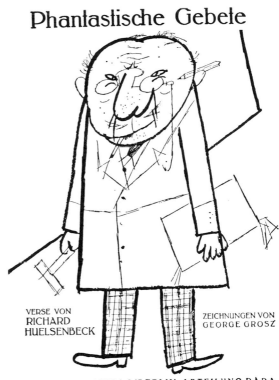

Phantastische Gebete

VERSE VON
RICHARD
HUELSENBECK

ZEICHNUNGEN VON
GEORGE GROSZ

DER MALIK-VERLAG/BERLIN, ABTEILUNO DADA

myself, for instance the 'inner language' of *The Prophetess of Prevost*, a book published by Justinus Kerner in 1840. This includes the sentence 'Clemor tona in diu aswinor', which means, 'Because I love you, I quarrel with you'.

"There are many instances of the wish to create new languages. Think, for instance, of the inventions of Jonathan Swift in the third and fourth books of *Gulliver's Travels*, where he gives us words used in the speech of the Laputans and in that of the horses in the land of the Yahoos.

'The sources of the abstract poem can be found, mixed with medieval folk-poetry, in the French *comptines* such as *'Am-stram-gram et pic et pic et co-légram'* which corresponds to 'eeny-meeny miney mo'.

"When language becomes petrified in the academies, its true spirit takes refuge among children and 'mad' poets.

"There had been two instances of deliberately abstract poetry in German literature, but they found no imitators. One surprising instance was that of

Scheerbart, who, in three dozen volumes of cosmic fantasies (which aroused no public interest and were soon sunk without trace) wrote one single phonetic poem. Here it is, as it appears in Paul Scheerbart's *Ein Eisenbahnroman, ich liebe dich* ('A Railway Novel, I Love You'), 1900:

> *Kikakoku!*
> *Ekoralaps!*
> *Wiso kollipanda opolôsa.*
> *Ipassata îh fûo.*
> *Kikakoku proklinthe petêh.*
> *Nikifili mopa Léxio intipaschi benakaffro-propsa*
> *pî! propsa pî!*
> *Jasollu nosaressa flipsei.*
> *Aukarotto passakrussar Kikakoku.*
> *Nupsa pusch?*
> *Kikakoku buluru?*
> *Futupukke – propsa pî!*
> *Jasollu . . .*

"Five years later, Christian Morgenstern, who did not know of Scheerbart's poem, published a phonetic poem of his own, *Das grosse Lalula* ('The Great Lalula'):

> *Kroklokwafzi? Semememi!*
> *Seiokrontro – prafriplo:*
> *Bifzi, bafzi, hulalomi:*
> *quasti besti bo . . .*
> *Lalu lalu lalu lalu la!*

"Morgenstern broke new ground with his *Fisches Nachtgesang* ('Night Song of a Fish'), made up entirely of metrical signs arranged an the shape of a fish [thus anticipating Man Ray's Dadaist dumb poem, published in *391* in 1924].

"In 1920 I was taken aback to discover that Hugo Ball had been writing phonetic poems as early as 1916."

Thus, when Ball recited his first phonetic poem in 1917, he had been anticipated by others. Hausmann, too, was following in a definite tradition when he composed his *f m s b w* , which in its turn gave rise to Schwitters' classically constructed *Ursonate*. Schwitters not only drew inspiration from Hausmann, but even used the same opening sequence of letters.

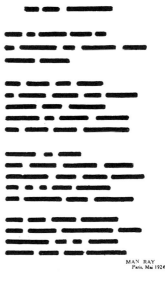

kp·eriOUM **lp'er**ioum
Nm' periii PERno-...
ʰᵖʳE**tiBerreₑ**eRR**E**b**e**ₑₑ
ONNOo gplanpouk
konˈmpout ᵖᴱᴿᴵᴷᴼᵁᴸ
RᵣEE**e**ₑ **E**Ee**e** ᵣᵣᵣₑₑᵗₒ**A**
oapAerrraEE**E**
mgl ed padANou
M**T**Nou tnₒᵤₘ **t**

Raoul Hausmann,
Optophonetic poem,
1918

"The poem is an act consisting of respiratory and auditive combinations, firmly tied to a unit of duration." This means that breath, as well as the sound produced, should play a creative role in the performance of a phonetic poem.

"In order to express these elements typographically", Hausmann continues in his *Courrier Dada*, "I had used letters of varying sizes and thicknesses which thus took on the character of musical notation. Thus the optophonetic poem was born. The optophonetic and the phonetic poem are the first step towards totally non-representational, abstract poetry."

Fisches

Nachtgesang.

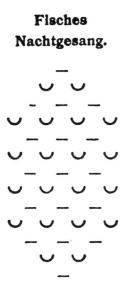

Christian Morgenstern, Phonetic poem

Man Ray, Phonetic poem, 1924

The Un-Community

Berlin Dada was distinguished by more than its political element and its new technical discoveries in painting and literature. The Cabaret Voltaire had fostered a spirit of collective, friendly co-operation which, to the end, remained characteristic of personal relationships between the individual Dadaists concerned.

But whereas Zurich Dada, in placid Switzerland, preserved a sort of psychic equilibrium, the hectic situation in Berlin encouraged rebels there to turn their rebelliousness even against each other.

Berlin Dada presents all the symptoms – good and bad – of a neurosis. There were ample reasons for this:

- four years of senseless slaughter in which many friends had died on both sides;
- the inconclusiveness of the revolution that was being fought out on the street-corners at that very moment;
- the spirit of opposition, so long suppressed;
- despair, hatred and the moral and practical ineffectualness of most of the Dadaists;
- the pressures of Communism, with whose slogans one identified oneself without knowing quite what it would lead to;
- the successful and tempting precedent set by Zurich Dada;
- and finally the vacuum created by the sudden arrival of freedom and the endless possibilities it seemed to offer if one could grasp them firmly enough.

All this made the group and all its individual members intoxicated with their own power in a way that had no relation to the real world at all. It was a classic case of what the psychologists would call 'inflation'. The vacuum was there, and there was no holding back the forces which hastened to fill it. Their apparently inexhaustible energy, their vision of mental freedom which included the abolition of everything (especially Expressionism and Tristan Tzara) – all this was closer to hysteria than to a cultural mission. This is neither the fault of an individual nor that of the group. The whole atmosphere was hysterical, convulsive and unreal; artistic expression could hardly have taken any other form.

I held aloof from active participation in Berlin Dada, although I was living in Berlin at the time. I could hear only too clearly, in the streets, the sinister sounds of discord that we had so hated during and after the war and were to hear, more frightening still, in later years. This did not prevent me from

maintaining friendly relations with Hausmann, Mehring, Grosz, Hoech, Huelsenbeck and others.

What they all wanted to find in anti-art was a new way of self-expression. Not one anti-artist consistently followed his own principles – and this made them all the readier to detect backsliding in others.

Huelsenbeck reproached Tzara with never having practised the poetic method he had devised – that of eliciting a poem from scraps of newspaper scattered at random. Huelsenbeck nevertheless claimed the same privilege for himself and went on creating *art* while he preached *anti-art*. He wrote poems which fitted just as well into the Expressionist tradition (on which he poured such scorn) as they did into anything that one could call 'typical' of Dada.

Each of them denounced the others for the failings he himself possessed – power-mania especially. Tzara had displaced Ball, the real originator of the movement – or so Serner was said to have asserted. The truth is that Ball himself became weary of Dada and went to Berne to involve himself in political life. The rivalry between Hausmann and Huelsenbeck for the leadership led to a bitter, public quarrel which lasted almost up to the present day.

The feeling that one must in all circumstances be opposed to the banal led to a suspicion of all emotional human contacts and a determination to plant one's foot squarely on one's neighbour's corns. Rows and offensiveness became normal behaviour. Grosz was another who had no love for mildness of manner. They were in the front-line all the time and one could not be too particular about whose face one was beating in. Civilized manners had given place to barbarism, however well one might get on with any individual in private.

Hausmann and Baader

Hausmann was greatly attracted by Baader's total lack of inhibitions. They understood each other. Hausmann himself had a dark side to his nature which would suddenly break through in the middle of even the most absorbing conversation. Sometimes a Kubin-like nightmarish expression would come over his grimacing features and one would forget to listen to his words, fascinated by the extraordinary way in which he was changing from Dr Jekyll to Mr Hyde.

Hausmann tells us in his *Courrier Dada* (pp. 77–79) how these two conspirators, he and Baader, celebrated one night under the street-lights the one hundredth birthday of the great Swiss novelist Gottfried Keller. In the midst of the traffic they took turns to read, skipping whole pages at a time, their own

brand-new version of *Der grüne Heinrich* ('Green Henry'). It must have been an eerie spectacle.

The Hundredth Birthday of Gottfried Keller.

There were times when I could work extremely well with Baader.

"Today is Gottfried Keller's one hundredth birthday" he said to me suddenly one beautiful summer evening in 1918. We were in the middle of the Rhein-strasse in Friedenau. The sky was orange. A gentle twilight hovered in the wide streets flanked with tall buildings; trams slid along under leafy trees and between grass verges. I made up my mind at once.

"Have you got anything by Keller on you?"

"Yes, I've got *Green Henry*."

"Good, let's celebrate."

Without wasting a word, we made for the middle of the street and stood under a powerful electric street-light, high – too high – in the air. We took out the tome and began to read, shoulder to shoulder. 'Poetry, made to measure, on the spot.' We took turns to open the book at random and read scraps of sentences with no beginning and no end, changing our voices, changing the rhythm and the meaning, leafing backward and forward, spontaneously, without hesitation and without a pause. This gave the whole thing a new meaning and produced some remarkable juxtapositions. We did not notice the passers-by; we certainly noticed no sign of public interest. Zealously we stuck to our task for at least a quarter of an hour. The words of the book, illuminated by our exalted mode of speech, borne up on the wings of our elation, tormented by new associations, took on a meaning beyond meaning and beyond comprehension.

All at once we had had enough, and, closing the book, we set off to the fore-court of a little bar somewhere near (I think it was on the corner of the Kaiser-allee) and there, over a Grätzer beer, we passed an enjoyable hour talking a psychoanalytic nonsense-language we had invented ourselves, with hardly a normal, straightforward word in it. Our unconscious was in a state of excitation which led it to pour out its secrets at every turn.

It was a very good celebration, with all due solemnity, and I am sorry it was not filmed. But talkies did not exist in those days.

None of the Berlin Dadaists suffered from any inhibitions, either in his private or public life. But the palm must go to Baader, whom, as a friend of Hausmann's, I had met and drawn in Berlin at the beginning of the war, or perhaps a little

earlier. It was Hausmann who introduced Baader to our circle, and he says of him:

"Johannes Baader was born in Stuttgart on 22nd June 1876. He was an ingenious and pseudologistical monomaniac, and believed all his life that he was 'Jesus Christ returned from the clouds of heaven'. Short-sighted and untalented people objected to this, but I had seen in him a man capable of driving his head through a brick wall (as we say) in the service of an idea. Baader was the man Dada needed, by virtue of his innate unreality, which was curiously linked with an extraordinary practical awareness. In 1917, Baader had the idea of standing in a Reichstag election at Saarbrücken. Of course he was not elected, but the enterprise was novel and, in principle, Dadaist.

"In June of the same year, it became clear to myself, Franz Jung and Baader that the masses needed to be shaken from their stupor. Franz Jung gave the order, I had to provide the plans. I said to myself that a big shock was needed to deal with this state of subordination. My psychological analysis was as follows: as each human being is a compromise between his own will and external authority, it was necessary to subordinate external authority to the individual will.

"I took Baader to the fields of Südende [where Jung then lived], and said to him: 'All this is yours if you do as I tell you. The Bishop of Brunswick has failed to recognize you as Jesus Christ, and you have retaliated by defiling the altar in his church. This is no compensation. From today, you will be President of The Christ Society, Ltd, and recruit members. You must convince everyone that he too can be Christ, if he wants to, on payment of fifty marks to your society. Members of our society will no longer be subject to temporal authority and will automatically be unfit for military service. You will wear a purple robe and we shall organize an Echternach procession in the Potsdamer Platz. I shall previously have submerged Berlin in biblical texts. All the poster columns will bear the words "He who lives by the sword shall perish by the sword".' Baader agreed to all this. But Jung did not provide the promised money in time. So the procession did not take place." (Hausmann. *Courrier Dada*, pp. 74–75).

The inhuman ruthlessness which lay behind this employment of Baader as a mere blunt instrument, a crowbar to release the pent-up energies of a revolutionary situation, does not seem to have perturbed Hausmann unduly. But this is characteristic of the Berlin Dada mentality, which had liberated itself from all the scruples which govern conventional human relationships.

There was something uncanny about Baader. For sheer lack of inhibition he put in the shade even the activities of Dadaists in Zurich, New York, Berlin

and Paris; and this is saying a great deal. This was exactly what Berlin Dada needed in order to carry out its 'programme' of protest and resistance in conditions of maximum publicity. No one but Baader could have found the means to carry this out. He was the furthest removed from normality (and therefore from convention) of them all. He it was who, at the ceremony inaugurating the first German Republic, in the Weimar State Theatre in 1919, caused home-printed flysheets bearing the title *Das grüne Pferd* ('The Green Horse') to flutter from the gallery on to the heads of the founding fathers assembled in the stalls. In these flysheets he nominated himself for the post of first president of the new republic. And he was quite serious . . . or was he? In any case, Dada had insulted the country's leading politicians, and the whole nation heard about it. The resulting laughter strengthened opposition, sowed confusion and weakened authority.

> Dadaists against Weimar
> On Thursday the 6th February 1919 at 7.30 p. m.
> in the *Kaisersaal des Rheingold* (Bellevue-Strasse) the
> OBERDADA
> will be proclaimed as
> PRESIDENT OF THE GLOBE
> according to the word of the Newspaper:
>> "We shall probably have several more elections this year,
>> for the Prxsldentrx and for the V lkshaus.
>> Let us not make our decision with the instinctive
>> mechanical certainty of the unconscious masses;
>> let us g and se k ou the true individual genius who
>> must exist in some section of our nation, if we are
>> not to become an extinct race!"
> All intellectual and spiritual workers will take part in this search; deputies, members of the middle classes and comrades of both sexes (soldiers without insignia of rank) – all who have an interest in the happiness of mankind.
> We shall blow Weimar sky-high. *Berlin* is the place .. da . . . da .. Nobody and nothing will be spared.
> Turn out in masses!
> The Dadaist Headquarters of World Revolution.
> BAADER, HAUSMANN, TRISTAN TZARA, GEORGE GROSZ, MARCEL JANCO, HANS ARP, RICHARD HUELSENBECK, FRANZ JUNG, EUGEN ERNST, A. R. MEYER.

On another occasion, Baader interrupted former Court Chaplain Dryander, preaching in Berlin Cathedral, by bellowing, from high up in the choir, "To hell with Christ!" or, according to another version, "You are the ones who mock Christ, you don't give a damn about him". Baader was promptly brought down – but such a brutal declaration of war against the authority of the Church could only come with safety from someone who stood under the protection of the law dealing with criminal responsibility. No one else would have thought of it, either. Baader was in a permanent state of euphoria. His friend Hausmann credits him with having been the first to make giant collages out of lifesize posters torn from hoardings and assembled in his room. (This was in 1920, and thus 'Before Schwitters'.) This art-form is now being exploited – very profitably – by the Neo-Dadaists, and gives them a reputation for boldness and freedom from artistic convention. Baader destroyed these poster collages, which were designed purely for 'direct action', as soon as he had done with them. A large sculpture, the *Dio-Dada-Drama* – The Greatness and the Fall of Germany in five storeys, three gardens, one tunnel, two lifts and a door shaped like a top hat – was also designed by Baader, who was in fact an architect.

Dad aisten gegen **Weimar**

V1

DER BLAUEN MILCHSTRASSE

ZUR

und KAP

T SCH

CABARET

Am Donnerstag, den 6. Februar 1919, abends 7½ Uhr, wird im Kaisersaal des Rheingold (Bellevuestraße) der

OBERdADA

als

Präsident des Erdballs

verkündigt werden nach dem Wort der Zeitung:

„Wir werden in diesem Jahre wahrscheinlich noch einigemal wählen, den Präsidentrx, das V Ikshaus. Und dann wollen wir uns nicht mehr bloß mit dem Instinkt, der mechanischen Zielsicherheit der unbewußt, ahnungslos vollen Masse bescheiden, sondern das persönliche Genie s ch n geh s, das wir m irgend einer Schichte unseres Volkes endlich doch und doch hervorgebracht haben mussen, wenn wir nicht schon jetzt eine abgestorbene Rasse sein sollen"

(B. Z. v. 27.1.19.)

?

Zu dieser Suche werden alle geistigen und geistlichen Arbeiter, Volksbeauftragte, Bürger und Genossen beiderlei Geschlechts (Soldaten ohne Rangabzeichen) erscheinen, denen an dem Glück der Menschheit gelegen ist.

Wir werden Weimar in die Luft sprengen. **Berlin** ist der Ort

Top ·· op ·· Es wird niemand und nichts geschont werden.

Man erscheine in Massen!

Der dadaistische Zentralrat der Weltrevolution.

BAA ER, HAUSMANN, TRISTAN TZARA, GEORGE GROSZ, MARCEL JANCO, HANS ARP, RICHARD HÜLSENBECK, FRANZ JUNG, EUGEN ERNST, A. R. MEY, **ER**

Flysheet, Berlin 1920

RH and RH

Along with Huelsenbeck, Raoul Hausmann was the most representative Dadaist figure in Berlin. It is true that Huelsenbeck was a match for him as regards enthusiasm, egotism and fertility of invention; but the difference between RH and RH was surely that Hausmann was a true fanatic.

Huelsenbeck was a rebel, not from a desire to lacerate the world (like George Grosz), nor from a love of vivisection (like Hausmann) but from sheer youthful vitality; raising hell was a natural expression of his appetite for life. He hoped to blow the gloomy spectre of artistic reaction on to the rubbish heap together with all the banality and dishonesty of this world. His wildness sprang from high spirits rather than fanaticism. Later, when Dada lost its head of steam, he lost interest completely and consigned the whole business of art and anti-art 'to hell'. He became a ship's surgeon, a journalist, and finally a psychoanalyst. It was not until his old age that the self-styled 'Dada Greybeard' took up the artistic class struggle once more, this time on an existential basis. In parenthesis: As before, Dada was able to take this new *post hoc* existential infrastructure and make it its plaything, with meanings unthought of at the time of its origin. Huelsenbeck says today: "What Dada was in the beginning, and what developed later, is totally insignificant in comparison with what it means today." One or two generations later, Dada may 'mean' something else again!

For a time, the two RH's were an unbeatable combination: Hausmann monocled, with the face of an intelligent assassin; Huelsenbeck with the bearing of an arrogant student, betraying a fatal link with the ruling class – a fraternity member; also with a monocle.

With Baader they ranged through Germany (Dresden, Hamburg, Leipzig) and Czechoslovakia (Teplice and Prague). They thumbed their noses at the public whenever they had the chance – and it was not unknown for them to be assaulted in return. But everywhere they shook people awake, campaigned against banality, spoke the truth (even if it did come in an offensive or indecent wrapping), preached and bellowed. Of course there was an element of clowning in all this, but they really meant everything they said or wrote – even when clowning.

A host of periodicals appeared in these years of Berlin Dada. The most prominent was Hausmann's *Der Dada (Ill. 60)* along with *Pleite, Jedermann sein eigner Fussball, Die rosa Brille, Das Bordell* ('The Brothel' 1921) and others, all of which represented the Marxist wing of Dada. Contributors included writers, poets, painters, doctors, adventurers, boy-friends, girl-friends,

62 George Grosz and John Heartfield, Berlin 1920

61 Raoul Hausmann and Hannah Hoech at the Dada Fair, Berlin 1920

60 The periodical *Der Dada*, edited by Raoul Hausmann, 1919–20

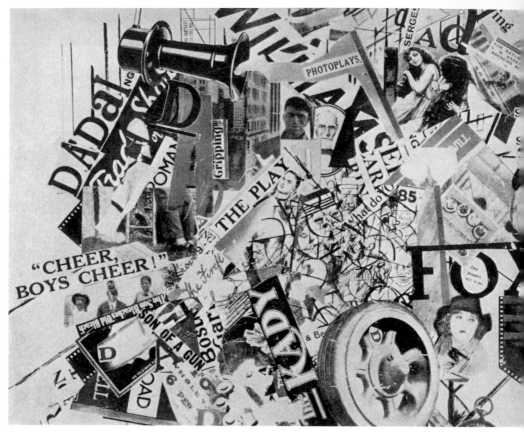

63 John Heartfield, *Dada-Fotomontage*, 1920

64 Christian Schad, *Schado-graph*, 1918. Photograph taken without a camera

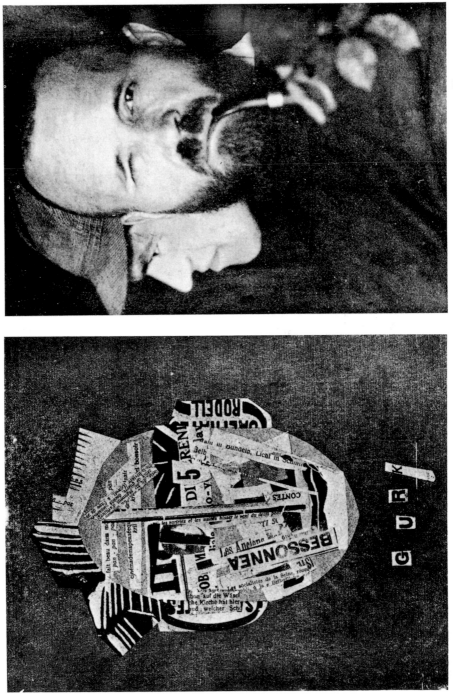

66 Raoul Hausmann and Johanres Baader, 1919. Photomontage

65 Raoul Hausmann, *Gurk*, 1918. Photomontage

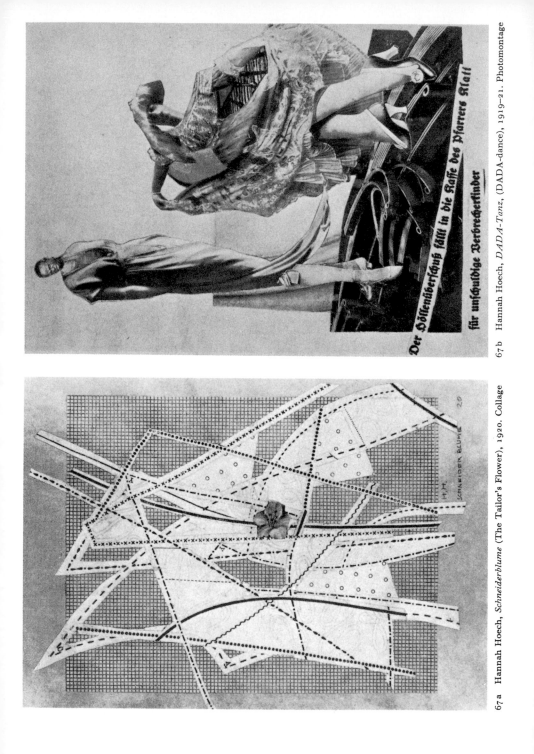

67a Hannah Hoech, *Schneiderblume* (The Tailor's Flower), 1920. Collage

67b Hannah Hoech, *DADA-Tanz*, (DADA-dance), 1919–21. Photomontage

and of course the self-appointed head of the movement, Johannes Baader the 'Oberdada'. He set himself up, with his enormous bushy beard, as the God and father-figure of the movement, and occasionally disappeared for an enforced holiday in an institution. In this way, he received the so-called 'hunting permit'; that is to say, the police declared him incapable of criminal responsibility. Such declarations were nothing new to us – the Zurich and Berlin press had certified us insane every day for years – but this was the first time one of us had achieved the privileged legal status conferred by an official 'hunting permit'.

1919 – 1920. Anti-Art Activities

While the Herzfeldes, Grosz and Jung were embarking on a conventional career at the Malik-Verlag, Baader and Hausmann emerged as the active spearhead of the movement, pursuing Dada for its own sake and with no specific political commitments.

The new line taken by the Berlin Dada group was emphasized by the fact that meetings now pursued aggressive but not Bolshevist ends. The manifestos that were read at these meetings were directed against bourgeois decomposition, lunatic Expressionism and every kind of false emotionalism.

The advertisements announcing these events were not always entirely accurate. The organizers often advertised harmless lectures which they had no intention of presenting. This attracted an unsuspecting audience which found itself addressed from the platform as a 'bunch of idiots'. There were frequently riots. These not unjustified audience reactions soon took up most of the evening, and the cries of rage uttered by the press provided excellent publicity.

The Club Dada organized twelve public readings: on 12th April 1918 in the Neue Sezession in Berlin, in June 1918 in the Café Austria, on 30th April 1919 in the Meister-Saal, Berlin, two matinées on 7th and 13th December in a theatre called Die Tribüne, in Dresden and Leipzig in January 1920, and in March 1920 in Prague (two evenings) and Teplice.

The periodical Der Dada was founded in June 1919, by Raoul Hausmann. The third issue was edited jointly by Hausmann, Heartfield and Grosz, and published by the Malik-Verlag.

In 1920, Huelsenbeck published the Dada Almanach (Berlin, Verlag Erich Reiss, Ill. 56) and a little book called En avant dada (Hanover, Verlag Steegemann).

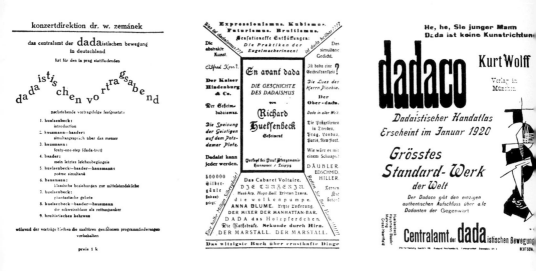

Examples of Dadaist typography, 1920/21

En avant dada (1921) is the first conspectus of the Berlin Dada movement, a review of the golden age of Berlin Dada.

Huelsenbeck makes a point of emphasizing that he writes "with a revolver". The result is explosive both in style and content. *En avant dada* is a brilliantly written pamphlet which condemns all art, including that of the brilliantly written pamphlet. First and foremost, it is a statement of policy on behalf of Berlin Dada at a time when Huelsenbeck, Hausmann and Baader were still hurling down the gauntlet side by side. This was before they started using the gauntlet to beat each other round the head.

In 1921, Huelsenbeck succeeded in persuading the firm of Kurt Wolff to publish *Dadako*, 'the world's greatest work of reference'. With the assistance of all the members of the group, he worked on this with all the savage energy usually reserved for riots and personal feuds. Unfortunately the work was never published, and all the material he had gathered, which would be priceless today, was lost.

Alongside the group of Dada heavyweights I have been describing, there were two lightweights who deserve to be remembered, as they contributed very different but clearly audible notes of their own to the Dada orchestra: they were Walter Mehring and Hannah Hoech.

Walter was from Berlin, where his *Kaufmann von Berlin* ('Merchant of Berlin') had been staged by Piscator at his theatre in the Nollendorfplatz.

Walter Mehring, DADA yama song (Poet's manuscript of English version) ▷

DADAyama song 1919
by
Walter Mehring

DADAyama
 non stop
 Here we go
 [the salto mortale!]
 Hypocracy — bourgeoisie
 The Ego s.o.b.
 through the looking glass
 malice in
 J Wonderland/
 the melting pot
 What's cooking ?
 Lots of own country —
 HEIL! Hail! Hell!
 dadaYAMA!
 *
Calling DADA YAMA
 1 2 3 o!o!
 WHO is WHO
 arp TZARAO where from?
So dom Lourdes Potsdam
 Moscow/
 Praise the Landlord! glory!
 welcome to
 DADAyama — napoli
 e mori!

131

From Grosz, who gave nicknames to everybody, he received the American pseudonym Walt Merin. Grosz called Heartfield 'Mutt' and his progressive brother Wieland Herzfelde 'Vize'. Dr Schmalhausen, his brother-in-law, received the title of 'Dada-Oz', and Dr O. Burchardt, who financed the 'Dada Fair', was 'Finanz-Dada'. Grosz himself liked to be called 'Böff'.

Mehring was Grosz's devoted friend and admirer. At the night-club *Schall und Rauch* ('Sound and Fury') Walt thundered and fumed in his capacities as *conférencier*, poet, stimulant and satirist. In this last capacity, he fitted excellently into the ranks of Dada. He liked the ill-fated Republic as little as he liked the *Kaiserliche Exerzier-Regiment*. While his idol, Grosz, laid about him with a hammer (and a sickle, too, at first), Walt wielded a needle-sharp rapier without losing any of his general love of mankind – the human part, not the inhuman. His thrusts struck home, and his delicate weapon added a subtle note of wit to the thunder of the heavy Dada artillery.

But how did Hannah Hoech, a quiet girl from the little town of Gotha, a model Orlik pupil, come to be involved in the decidedly *un*quiet Berlin Dada movement? At the first Dada shows in Berlin she only contributed collages. Her tiny voice would only have been drowned by the roars of her masculine colleagues. But when she came to preside over gatherings in Hausmann's studio she quickly made herself indispensable, both for the sharp contrast between her slightly nun-like grace and the heavyweight challenge presented by her mentor, and for the sandwiches, beer and coffee she managed somehow to conjure up despite the shortage of money.

On such evenings she was able to make her small, precise voice heard. When Hausmann proclaimed the doctrine of anti-art, she spoke up for art and for Hannah Hoech. A good girl.

Her collages were sometimes political (everyone was in the line of battle), sometimes documentary (she put all the Berlin Dadaists and their friends, in significant attitudes, into an immense collage which is now in the Dahlem Art Gallery, Berlin), sometimes lyrical (little girl that she was). At exhibitions and readings she would turn up and the earnestness of her nature would lend weight to her tiny voice.

She later had a very close relationship with Schwitters and, like all the lady-friends of that great man, she had to change her name. He added an H to the end of 'Hanna', so that she, like Anna (Blume), should be "from behind as from before". But Schwitters' relationships were not always easy. Hannah writes of this, in the catalogue of the 1958 Dada exhibition in Düsseldorf, with an astringent charm that is all her own.

1920 – 1923. Dada Conquers!

The climax of the public activities of the Berlin Dada movement was the great 'First International Dada Fair', Berlin, 1920, held at the gallery owned by Dr Otto Burchardt ('Finanz-Dada'). All the Berlin Dadaists took part, whether they belonged to the left, right or centre of the movement. The tone was set by a number of provocative political pieces expressing hatred for the Authority that had "brought us to this" *(Ills. 58, 59)*.

From the ceiling hung the stuffed effigy of a German officer with a pig's head, bearing a placard saying "Hanged by the Revolution". The all-important prefix 'anti-' seemed here to be directed against the ruling class rather than against art. These pieces of political polemic were the work of Grosz, Heartfield, Hausmann, Hannah Hoech and Otto Dix (for whom this was his only appearance as a Dadaist). It was these grisly scenes of war and revolution by Dix and Grosz that made a lasting impression on the minds of Berliners.

While there was constant friction between Hausmann and Huelsenbeck, there was between Hausmann and the highly-gifted, far from innocuous Franz Jung (who died recently, mourned by us all), a remarkable friendship, cold-blooded and macabre.

In 1913, Jung had published, in the *Aeternisten-Bibliothek* series issued by the Aktion-Verlag, a remarkable little volume called *Trottelbuch* ('Booby Book'), a savage, anarchistic, difficult book, but intensely stimulating, the work of a true anarchist in the making. Jung was well-known to the German public, not so much for his participation in Dada or his *Trottelbuch* as for an exploit that took place in 1923. Together with a friend and fellow-passenger, he hijacked a German freighter in the Baltic and forced the captain to set his course for Petrograd. There he presented ship and cargo to the Soviet authorities. They did not accept the gift, but Jung remained in great honour among the Soviets for some time – until his anarchist tendencies became too much for them and he was sent back to Germany.

Jung, Hausmann and Baader constituted the moral (or rather amoral) focus of Berlin Dada, plagued as they were by no scruples of conscience. Jung's guest appearance as a Dadaist was brief. He soon turned his attention to political action. Later, in the days of inflation, he published in Berlin a news-sheet on financial transactions, stock-exchange speculations, and so on, matters for which this exceptionally intelligent man had a special gift. This gift notwithstanding, he always remained as poor as a church mouse.

Forty years later, in 1960, I met him again at the opening of a Hausmann exhibition in Paris. He still had the same croaking voice and the same graceful, incisive wit. As the little room was filled with the sound and fury of Hausmann's phonetic poems blared out by a loudspeaker, we arranged to meet again at the Hôtel du Dragon, where he was staying. I then realized that – perhaps intimidated by the then fashionable pugnacious manner of speaking – I had hardly spoken a word to him when I met him in Berlin in the twenties and before. How I regret it now! He was a unique human being, a sad primeval moralist, of whom life had taken a heavy toll. I spent one of the most fascinating evenings of my life with him in Paris. Some time later when I called again at the Hôtel du Dragon, I found that the impoverished Jung had been taken to a hospital in Stuttgart. There he died, soon after completing his impressive and disturbing autobiography, *Der Weg nach Unten* ('The Way Down').

As long as Dada remained in the fight, Huelsenbeck, Hausmann, Baader, Grosz and the Herzfeldes were its true representatives. They wrote the manifestoes, they arranged the meetings, they discussed political and sociological problems with serious and passion. Most of them appeared at the decisive Dada meetings in Berlin, Leipzig, Prague and elsewhere.

But in 1922, when the power of the faith began to wane and all-too-human conflicts began to appear, these same people began to lose their sense of common loyalty. Baader turned against one RH, who, in his turn, deserted and slandered the other RH, or else tried to outdo him in power and status. No longer moved by the enthusiasm that sprang from their shared experience, the individual personalities were worth what they and their anti-art were worth, and no more. By the beginning of 1923, all the 'storm' had been stressed out of *Sturm und Drang*. The painters had reverted to being painters, the poets to being poets, the doctors to being doctors. That first-magnitude star, the *Oberdada*, was extinguished as suddenly as he had appeared.

Baader did survive Dada, but with the end of Dada he went out of circulation. Mehring reports in *Berlin-Dada*:

"When, some years ago, I passed through Hamburg and asked after him, I was told that he was still around, occasionally tacking up the length of the Binnenalster and sleeping there. But no one, not one sea-dog, nor the hoariest husky in the Hagenbeck Zoo, knew his address."

According to Hausmann it was Baader who designed the Hagenbeck Zoo in Hamburg, in which the animals ran free, separated from the spectators only by ditches. He would have liked to apply this to human beings too – but they are still too wild. This remarkable tribute constitutes Hausmann's decent bourgeois

monument to his friend. Baader died a few years ago, totally forgotten, in an old people's home near Berlin.

George Grosz, too, is no longer with us. He died in 1959, in the place where he had found subjects for his art, Berlin. He would brook no mention of Dada, modern art, or Communism. Even the species he had immortalized, the German (or rather universal) bourgeois, no longer interested him. He would have liked to become one himself – with American trimmings – if his genius had permitted it. At long intervals he became his old self once more, the savage demon who painted his scenes of terror in colours of filth and blood, a man who, in his art, supped full of the horrors which were spared him in real life.

His friend Walter Mehring, who wrote his affectionate obituary in *Berlin-Dada,* Walt the fragile, has survived the thousand intervening years. Sharp and quick as a weasel, he darts across Europe from one café to another, from one radio or television station to another, reading works whose literary quality is not one whit less high than it was in the days of Dada. He still works at a little table in a café, receives visitors there, knows everyone since Herodotus, goes to bed at seven, gets up early and walks for an hour in the morning, brandishing a gigantic cudgel, mentally preparing his day's work.

Hausmann continues to seek new paths in many artistic and scientific fields: in photography, in psychology, in painting. Like a true mental explorer, he has persisted in his quest for the absolute, never faltering despite his failing vision. Many live by what he has done, and reap the harvest where he, his courageous wife beside him, will never garner a red cent, thaler or franc. [He died in 1974.]

Huelsenbeck, despite a consulting-room filled from nine in the morning to nine at night with neurotics, has continued to write poetry, as well as developing an individual journalistic style, enigmatic and packed with meaning, and painting a few magical pictures. He still asks questions and answers them, still doubts and still affirms as he always did, and still believes in Dada – although Dada responds by shaking its grey old head. [He died in 1971.]

Hannah Hoech lives in a little gingerbread house full of 'twenties periodicals, pictures and memories, in the midst of a garden luxuriant with flowers, nuts and apples. There (*An der Wildbahn,* at one of the remotest corners of West Berlin) she gardens and collects. She slips from one room to another, all of them crammed with objects from a world that has collapsed around her. Nothing is lost where she is. She preserves a living past, and above all the works of Raoul the Mighty. She is the indispensable ant, and the rest of us are grasshoppers.

4 Hanover Dada

Schwitters the Man

"Eternal lasts longest."
(Kurt Schwitters)

While Baader, Hausmann and Huelsenbeck in Berlin were taking the Globe itself under Dada's wing, each member playing his own part in keeping the prevailing anarchy alive, two less influential German cities, Hanover and Cologne, possessed independent Dadaisms of their own, which were less noisy, perhaps, but no less important than Berlin Dada.

As early as the beginning of 1918, in his little room at the Hotel Limmatquai in Zurich, Tzara showed me photographs of pictures by a certain Kurt Schwitters. These pictures were made of cardboard, wood, wire and broken bits and pieces. Why these photographs were not reproduced in our next issue of *Dada*, I do not know; but I do know that none of us in Zurich had heard of Schwitters before. In Berlin, after the war, his name was often mentioned, especially by Hausmann.

"In the Café des Westens, one evening in 1918," he recalls in his *Courrier Dada*, "Richard, the red-haired, hunchbacked paper-boy, came up to my table and said to me, 'There is someone here who would like a word with you.' So I went over. There indeed sat a man of about my own age, with brown hair, blue eyes, a straight nose, a rather weak mouth and an unforceful chin. All this surmounting a high collar and a dark tie.

"'My name is Schwitters, Kurt Schwitters.' I had never heard the name before.

"We sat down and I asked, 'What do you do?'

"'I am a painter and I nail my pictures together.'

"This seemed to me both new and attractive. We continued our questions and answers, and I learned that he also wrote poems. They appeared still to be under the influence of Stramm, but one of the poems seemed good and new.

"Finally this man whose name was Schwitters said, 'I should like to join the Club Dada.'

"Of course. I could not decide this on my own initiative. So I said that I would discuss it with the Club and give him an answer.

"The next day, at a 'general meeting' held at Huelsenbeck's flat, I discovered that something was known of this Schwitters after all. But, for some reason, Huelsenbeck had taken an aversion to him. He refused to admit every Tom, Dick or Harry to the club. In short, he did not like Schwitters."

Even forty years later, although he had long ago been reconciled with the now dead Schwitters, he dealt him a passing blow in one of his books, on the grounds that he could not bear Schwitters' "bourgeois face".

This first rebuff which Schwitters received in Berlin caused him to set up shop on his own in Hanover under the name of MERZ, which he extracted from the word 'Commerzbank'.

Schwitters (*Ill. 69*) was absolutely, unreservedly, 24-hours-a-day PRO-art. His genius had no time for transforming the world, or values, or the present, or the future, or the past; no time in fact for any of the things that were heralded by blasts of Berlin's Trump of Doom. There was no talk of the 'death of art', or 'non-art', or 'anti-art' with him. On the contrary, every tram-ticket, every envelope, cheese wrapper or cigar-band, together with old shoe-soles or shoe-laces, wire, feathers, dishcloths – everything that had been thrown away – all this he loved, and restored to an honoured place in life by means of his art (*Ills. 68–74*).

But instead of being grateful to this man for the happiness he gave to us and to all his unregarded objects, for the inexhaustible wit he applied to the juxtaposition of tram-tickets, nail-files, cheese-paper and girl's faces, for his many poems, apophthegms, stories, plays, in which the loftiest sense went hand in hand with the profoundest nonsense – and were united in deathless language as boy and girl are united in springtime – instead of being grateful for all this, we allowed him, a German painter and poet, to die unrecognized in poverty and exile, and protected only by an English girl, Edith Thomas, and an English farmer by the name of Pierce.

This does not perhaps strictly belong in this place, but I wanted to set Schwitters, and his work, in the perspective in which history will see him.

Schwitters' art and his life were a living epic. Something dramatic was always happening. The Trojan war cannot have been as full of incident as one day in Schwitters' life. When he was not writing poetry, he was pasting up collages. When he was not pasting, he was building his column, washing his feet in the

same water as his guinea-pigs, warming his paste-pot in the bed, feeding the tortoise in the rarely-used bathtub, declaiming, drawing, printing, cutting up magazines, entertaining his friends, publishing *Merz,* writing letters, loving, designing all Günther Wagner's printing and publicity material (for a regular fee), teaching academic drawing, painting really terrible portraits, which he loved, and which he then cut up and used piecemeal in abstract collages, assembling bits of broken furniture into MERZ pictures, shouting to Helmchen, his wife, to attend to Lehmann, his son, inviting his friends to very frugal luncheons ... and in the midst of all this he never forgot, wherever he went, to pick up discarded rubbish and stow it in his pockets. All this he did with an instinctive alertness of spirit, an *intensity,* that never failed.

He got on especially well with Arp. In many ways they spoke the same language, a kind of sophisticated schizophrenic dialect, a German raised above all conventions. From this language they conjured colourful rhythms, associations and forms, and consequently new thoughts, new experiences and new sensations.

No one could perform poetry as he could. It is possible (as Hausmann maintains in a letter) that Schwitters' *Ursonate* ('Primeval Sonata') is based on Hausmann's earliest phonetic poem, *Rfmsbwe.* But what Schwitters made of the poem, and the way he spoke it, were totally unlike Hausmann. Hausmann always gave the impression that he harboured a dark menacing hostility to the world. His extremely interesting phonetic poems resembled, as he spoke them, imprecations distorted by rage, cries of anguish, bathed in the cold sweat of tormented demons.

Schwitters was a totally free spirit; he was ruled by Nature. No stored-up grudges, no repressed impulses. Everything came straight from the depths, without hesitation, like Athena from the head of Zeus, ready-made, fully-armed and never seen before.

Everything he said was coloured by his Hanover dialect, one notoriously ill-suited to poetical and gnomic utterances. But everything he said was so new that one ended by being ready to accept Hanoverian as a new world language. People laughed at him. They were right to laugh, but only if they understood why.

There was never a moment's boredom when 'Kurtchen' was around. Whatever he did was in deadly earnest, even when we took it as a joke. This disconcerting ambivalence was a source of tremendous energy released, in fifty per cent of the cases, in an explosion of laughter. But it was laughter of a special kind, laughter that awakened and stimulated the spirit.

O du, Geliebte meiner siebenundzwanzig Sinne, ich
liebe dir! — Du deiner dich dir, ich dir, du mir.
— Wir?
Das gehört (beiläufig) nicht hierher.
Wer bist du, ungezähltes Frauenzimmer? Du bist
— — bist du? — Die Leute sagen, du wärest, — laß
sie sagen, sie wissen nicht, wie der Kirchturm steht.
Du trägst den Hut auf deinen Füßen und wanderst
auf die Hände, auf den Händen wanderst du.
Hallo, deine roten Kleider, in weiße Falten zersägt.
Rot liebe ich Anna Blume, rot liebe ich dir! — Du
deiner dich dir, ich dir, du mir. — Wir?
Das gehört (beiläufig) in die kalte Glut.
Rote Blume, rote Anna Blume, wie sagen die Leute?
Preisfrage: 1.) Anna Blume hat ein Vogel.
 2.) Anna Blume ist rot.
 3.) Welche Farbe hat der Vogel?
Blau ist die Farbe deines gelben Haares.
Rot ist das Girren deines grünen Vogels.
Du schlichtes Mädchen im Alltagskleid, du liebes
grünes Tier, ich liebe dir! — Du deiner dich dir, ich
dir, du mir, — Wir?
Das gehört (beiläufig) in die Glutenkiste.
Anna Blume! Anna, a-n-n-a, ich träufle deinen
Namen. Dein Name tropft wie weiches Rindertalg.
Weißt du es, Anna, weißt du es schon?
Man kann dich auch von hinten lesen, und du, du
Herrlichste von allen, du bist von hinten wie von
vorne: «a-n-n-a».
Rintertalg träufelt streicheln über meinen Rücken.
Anna Blume, du tropfes Tier, ich liebe dir!

1919

ANNA BLUME

O beloved of my twenty-seven senses, I
love your! – you ye you your, I your, you my.
– We?
This belongs (by the way) elsewhere.
Who are you, uncounted female? You are
– are you? People say you are, – let
them say on, they don't know a hawk from a handsaw.
You wear your hat upon your feet and walk round
on your hands, upon your hands you walk.
Halloo, your red dress, sawn up in white pleats.
Red I love Anna Blume, red I love your! – You
ye you your, I your, you my. – We?
This belongs (by the way) in icy fire.
Red bloom, red Anna Blume, what do people say?
Prize question: 1.) Anna Blume has a bird.
 2.) Anna Blume is red.
 3.) What colour is the bird?
Blue is the colour of your yellow hair.
Red is the cooing of your green bird.
You simple girl in a simple dress, you dear
green beast, I love your! You ye you your,
I your, you my. – We?
This belongs (by the way) in the chest of fires.
Anna Blume! Anna, a-n-n-a, I trickle your
name. Your name drips like softest tallow.
Do you know, Anna, do you know already?
You can also be read from behind, and you, you
the loveliest of all, are from behind, as you are from
before: "a-n-n-a".
Tallow trickles caressingly down my back.
Anna Blume, you trickle beast, I love your!

(Kurt Schwitters)

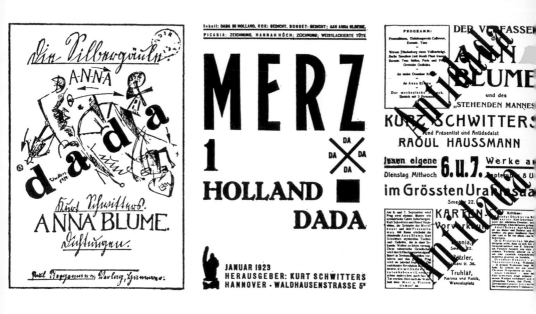

Schwitters the Poet

In this connection, I remember Schwitters' first public reading of the *Ursonate*, at the house of Frau Kiepenhauer in Potsdam, about 1924 or 1925. Those invited were the 'better sort' of people – and in Potsdam, the military citadel of the old Prussian monarchy, this meant a crowd of retired generals and other people of rank. Schwitters stood on the podium, drew himself up to his full six feet plus, and began to perform the *Ursonate,* complete with hisses, roars and crowings, before an audience who had no experience whatever of anything modern. At first they were completely baffled, but after a couple of minutes the shock began to wear off. For another five minutes, protest was held in check by the respect due to Frau Kiepenhauer's house. But this restraint served only to increase the inner tension. I watched delightedly as two generals in front of me pursed their lips as hard as they could to stop themselves laughing. Their faces, above their upright collars, turned first red, then slightly bluish. And then they lost control. They burst out laughing, and the whole audience, freed from the pressure that had been building up inside them, exploded in an orgy of laughter. The dignified old ladies, the stiff generals, shrieked with laughter, gasped for breath, slapped their thighs, choked themselves.

Kurtchen was not in the least put out by this. He turned up the volume of his enormous voice to Force Ten and simply swamped the storm of laughter

in the audience, so that the latter almost seemed to be an accompaniment to the *Ursonate*. The din raged round him, like the sea against which, two thousand years earlier, Demosthenes had tried the strength of his voice. The hurricane blew itself out as rapidly as it had arisen. Schwitters spoke the rest of his *Ursonate* without further interruption. The result was fantastic. The same generals, the same rich ladies, who had previously laughed until they cried, now came to Schwitters, again with tears in their eyes, almost stuttering with admiration and gratitude. Something had been opened up within them, something they had never expected to feel: a great joy.

Fümms bö wö tää zää Uu, pögiff, kwiiee.
Dedesnn nn rrrrr, Ii Ee, mpiff tillff toooo? Till, Jüu-Kaa.
(gesungen)
Rinnzekete bee bee nnz krr müü? ziuu ennze ziuu rinnzkrrmüüüü;
Rakete bee bee.
Rummpff tillff toooo?
Ziiuu ennze ziiuu nnskrrmüüüü, ziiuu ennze ziiuu rinnzkrrmüüüü;
Rakete bee bee,
Rakete bee zee.
Fümmsbö wö tää zää Uu,
Uu zee tee wee bee
 zee tee wee bee
 zee tee wee bee
 zee tee wee bee
 zee tee wee bee
 zee tee wee bee Fümms.

Schluss:
Fümms bö fümms bö wö fümmes bö wö tääää?
Fümms bö fümms bö wö fümms bö wö tää zää Uuuu?
Rattatara rattatara tattatara
Rinnzekete bee bee nnz krr müüüü?
Fümms bö
Fümms böwö
Fümmes bö wö tääää???? (gekreischt)

zweiter teil:

largo
(gleichmäßig vorzutragen. takt genau ¼. jede folgende reihe ist um einen folgenden viertel ton tiefer zu sprechen, also muß entsprechend hoch begonnen werden)
Ooooooooooooooooooooooooooooooooo (leise) (J)
Bee bee bee bee bee
Oooooooooooooooooooooooooooooooooo
Zee zee zee zee zee
Oooooooooooooooooooooooooooooooooo
Rinnzekete . . . bee . . . bee . . .
Ooooooooooooooooooooooooooooooo
änn ze änn ze
Oooooooooooooooooooooooooooooooo
Aaaaaaaaaaaaaaaaaaaaaaaaaaaaaaa (laut) (K)
Bee bee bee bee bee
Aaaaaaaaaaaaaaaaaaaaaaaaaaaaaaa
Zee zee zee zee zee
Aaaaaaaaaaaaaaaaaaaaaaaaaaaaaaa
Rinnzekete . . . bee . . . bee . . .
Aaaaaaaaaaaaaaaaaaaaaaaaaaaaaaa
Enn ze enn ze
Aaaaaaaaaaaaaaaaaaaaaaaaaaaaaaa
Oooooooooooooooooooooooooooooooo (leise) (L)
Bee bee bee bee bee
Ooooooooooooooooooooooooooooooooo
Zee zee zee zee zee
Ooooooooooooooooooooooooooooooooo
Rinnzekete . bee . . bee .
Ooooooooooooooooooooooooooooooo
änn ze änn ze
Oooooooooooooooooooooooooooooooou

Kurt Schwitters, Part of the score of the *Ursonate*, 1924/25

His wit and humour were a part of the freedom he enjoyed as a human being and as an artist. And yet he was a real bourgeois, miserly rather than generous, owner of a house which he let off one floor at a time, collecting the rents himself every month. He understood money matters. He invariably travelled fourth class and always toted two enormous portfolios, one hanging on his chest, the other on his back, full of collages (and sheets of cardboard for collages he intended to make on the journey). Wherever he went he sold collages out of his great portfolios for 20 marks each. He never hired a porter.

With his incessant magical gesticulations, he always seemed about to break through the fetters of reason. His restlessness, his constant activity, were

perturbing to others, but he himself was never exhausted ... people became used to them and to him and their initial suspicions vanished.

His publicity-sense was as well-developed as his other faculties. During the early 'twenties, I had a fifth-floor studio in a very *petit-bourgeois* house in Friedenau, where I was very unpopular on account of my late hours and suspect visitors. When Schwitters came to see me, he used to deface the stained-glass windows on the landings (St George, St Nepomuk and some queen or other) with little stickers bearing the words 'Anna Blume' or 'Join Dada'. The adhesive he employed (waterglass) made these very hard to wash off and was the cause, along with many other transgressions, of my receiving final notice to quit.

On his pictures there appeared not only the identifying sign 'Merz' *(Ills. 68, 72)* but sometimes also his real name and address. He received some extremely rude letters this way, as well as all sorts of rubbish.

His uninhibited directness gave him much in common with Van Doesburg, with whom he carried out a Dada cultural tour of Holland. After Does had once experienced Dada, he threw himself into it wholeheartedly. With his wife – the pianist Nelly Van Doesburg, who played modern music – and with Schwitters, he executed a unique Dada tour of Holland, in which Does appeared as orator and expounded the Spirit of Dada. In these expositions, he was interrupted from time to time by a member of the audience who gave a very realistic imitation of a barking dog. When the audience made ready to eject the enormously tall gentleman who was doing the barking, the speaker on the platform introduced him as Kurt Schwitters. He was not ejected, but took his place on the platform where he uttered a variety of other noises, as well as barking and reading more or less naturalistic poems like *Anna Blume* or the splendid *Revolution in Revon*.

This stratagem never failed in its purpose of arousing the public from its good natured complacency. Everywhere the public played its unsuspecting part in the proceedings. Thus it was that Doesburg, who as a Dadaist had assumed the name of Bonset, introduced Dadaism into Holland.

Anyone who knows that country from its Flemish aspect – the plateaux of meat on the lunch-time plate, the *Oude- en Jonge-Klaare* drunk by the bottle, the incomparable *matjesherings*, the crude, obvious jokes (two muscular directors of Philips once bore me off from my hotel room in my underpants to a mixed dinner party given in my honour), the ladies of easy virtue who sit crocheting in pairs in shop windows, fishing for clients, the Jordaens, Rubens, Brueghels, etc. – anyone who has seen all this will understand that Dada was bound to strike a juicy, responsive note in the Netherlands.

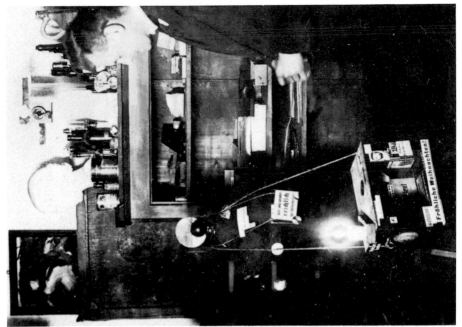

69 Kurt Schwitters with his Christmas tree, Hanover, 1920

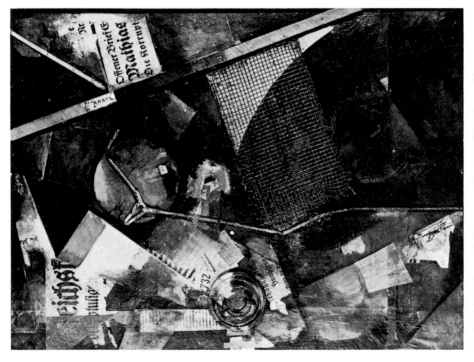

68 Kurt Schwitters, *Mathias*, 1919. Merzbild. Oil and assemblage

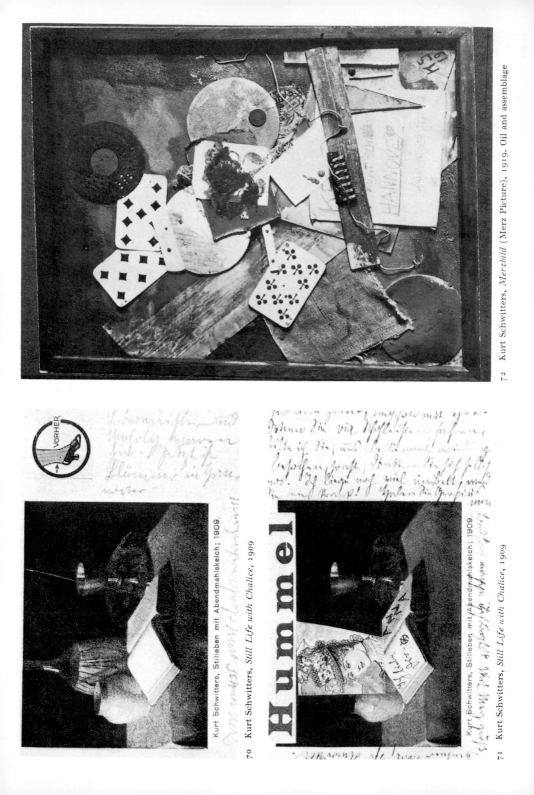

72 Kurt Schwitters, *Merzbild* (Merz Picture), 1919. Oil and assemblage

Kurt Schwitters, Stilleben mit Abendmahlskelch; 1909.

70 Kurt Schwitters, *Still Life with Chalice*, 1909

Kurt Schwitters, Stilleben mit (Abendmahlskelch; 1909.

71 Kurt Schwitters, *Still Life with Chalice*, 1909

Hummel

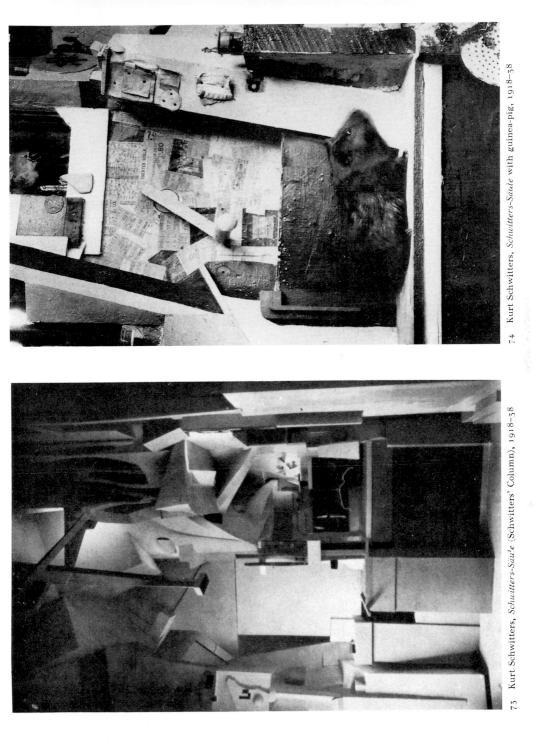

73 Kurt Schwitters, *Schwitters-Säule* (Schwitters' Column), 1918–38

74 Kurt Schwitters, *Schwitters-Säule* with guinea-pig, 1918–38

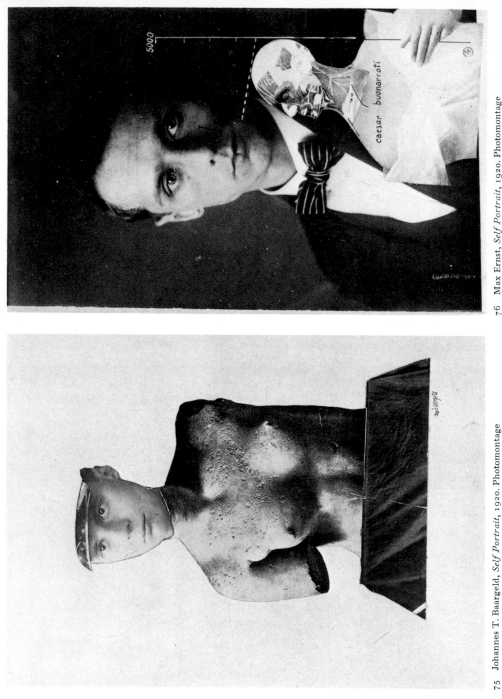

75 Johannes T. Baargeld, *Self Portrait*, 1920. Photomontage

76 Max Ernst, *Self Portrait*, 1920. Photomontage

Schwitters was so often away on artistic or business trips that it is hard to understand how he could produce so much in Hanover. He went to Prague with Hausmann, to Holland with Doesburg, to Switzerland, to France. Everywhere his unfailing immediacy and persuasive power disarmed audiences which had come to see some Dadaist mayhem. The quickness of his tongue was something I have only seen equalled, in his much gentler way, by Hans Arp.

One day Schwitters decided he wanted to meet George Grosz. George Grosz was decidedly surly; the hatred in his pictures often overflowed into his private life. But Schwitters was not one to be put off. He wanted to meet Grosz, so Mehring took him up to Grosz's flat. Schwitters rang the bell and Grosz opened the door.

"Good morning, Herr Grosz. My name is Schwitters."

"I am not Grosz," answered the other and slammed the door. There was nothing to be done.

Half way down the stairs, Schwitters stopped suddenly and said, "Just a moment".

Up the stairs he went, and once more rang Grosz's bell. Grosz, enraged by this continual jangling, opened the door, but before he could say a word, Schwitters said "I am not Schwitters, either." And went downstairs again. *Finis.* They never met again.

In spite of his incessant activity he knew exactly what he was doing. Behind his apparently unpremeditated actions, behind the spontaneity of his decisions, an acute, disciplined mind was at work.

Every verbal or formal creation was a structured whole. Number-poems, essays, epics (like his *Ursonate),* were wholly classical, almost mathematical, in their form. In almost all his works he demonstrated the continued vitality of classical from, which, as he proved, can absorb incongruous material of a vehemence undreamed-of by Lessing or Goethe.

The Art Critic
"He is a peculiar beast, the critic: a camel before and a window behind."

Critics
"Tran 27
"Critics are a special kind of human being. To be a critic one has to be born to it. The born critic, thanks to the exceptional sheeepness of his wits, finds out exactly what it is not all about. He invariably sees, not the faults of the work of art, not those of the artist, but his own. The critic, thanks to the natural sheeeepness

of his wits, becomes aware of his own deficiencies through the medium of the work of art. This is the tragedy of all critics: they see faults instead of art. For the critic, seeing art consists of marking all the faults in red ink and writing comments underneath. Critics resemble those justly popular men, the school-masters, although it is true that the critic needs to pass no examinations: critics are born not made. The critic is a gift to humanity from Heaven. Suckled by a schoolmarm, he feeds on artistic faults to the greater profit of the sheeeeep-farming business. The grater profits by rainstorms. The critic drinks another wee dram of red ink the while. Every critic has an umbrella, into which, in a way, he has married. For the grater profits by rain to the grater profit of the sheeeeeep-farming business. The said schoolmarm is a thick syrupy juice manu-factured from the gall of true Privy Schoolmasters and the stomach juices of senile sheeeeeeep. The said sheeeeeeeep, like the critic, need to take no examinations. The umbrella is used by the critic for the purpose of turning it upside-down. Critics do not have to give up their umbrellas when they go to an art-exhibition. The umbrellas do, however, have to take an examination. Only umbrellas with holes are admitted to art criticism. The more holes, the more rain. The more rain, the grater pain, the grater pain, the more criticism. To return to the sheep: critics are a special kind of human being. To be a critic one has to be born to it. Critics are sheepborn, sheepsuckled by a schoolmarm and half-asheep when faced with a work of art. The difference between artist and critic is this: the artist creates, the critic bleats."

ANXIETY PLAYS
A Dramatic Fragment

a. Sir.
b. Yes?
a. You are under arrest.
b. No.
a. You are under arrest, Sir.
b. No.
a. I shall shoot, Sir.
b. No.
a. I shall shoot, Sir.
b. No.
a. I shall shoot, Sir.
b. No.

 a. I hate you.
 b. No.
 a. I shall crucify you.
 b. Not so.
 a. I shall poison you.
 b. Not so.
 a. I shall murder you.
 b. Not so.
 a. Think of the winter.
 b. Never.
 a. I am going to kill you.
 b. As I said, never.
 a. I shall shoot.
 b. You have already said that once.
 a. Now come along.
 b. You can't arrest me.
 a. Why not?
 b. You can take me into custody, but no more.
 a. Then I shall take you into custody.
 b. By all means.
 b. allows himself to be taken into custody and led away. The stage grows
dark. The audience feels duped and there are catcalls and whistles. The
chorus cries:
"Where's the author? Throw him out! Rubbish!"

For all its apparent violation of normality, this is premeditated and done with skill. It has an unassailable Schwitters logic of its own.

 In 1923, when I asked him for a contribution to my periodical *G*, he sent me the following theoretical account of his poetry:

Logically Consistent Poetry

 The basic material of poetry is not the word but the letter.
 The word is:
 1. A combination of letters
 2. Sound
 3. Denotation (significance)
 4. The bearer of associations of ideas

It is impossible to explain the meaning of art; it is infinite. Material consistently formed must be *unequivocal.*

1. The sequence of letters in a word is unequivocal, the same for everyone. It is independent of the personal attitude of the beholder.
2. Sound is only unequivocal in the spoken word. In the written word, the sound depends on the capacity of the beholder to imagine it. Therefore sound can only be material for the reciting of poetry and not for the writing of poetry.
3. Meaning is only unequivocal when, for example, the object signified by the word is actually present. Otherwise it is dependent on the imaginative capacity of the beholder.
4. The association of ideas cannot be unequivocal because it is dependent solely on the associative capacity of the beholder. Everyone has different experiences and remembers and associates them differently.

4. Classical poetry depended on the similarity of human beings. It regarded the association of ideas as unequivocal. It was wrong. In any case, it was based on associations of ideas: *'Über allen Gipfeln ist Ruh'* ('On the hill-tops all is tranquil'). Here Goethe is not simply trying to tell us that it is quiet on the hill-tops. The reader is expected to experience this 'tranquillity' in the same way as the poet, tired by his official duties, escaping from the urban social round. How little such associations of ideas are universal becomes clear if one imagines a native of the Hedjaz (average population-density, two people per square kilometer) reading such a line. He would certainly be noticeably more impressed by 'Lightning darts zag the Underground runs over the skyscraper'. In any case, the statement that 'all is tranquil' produces no poetic feeling in him, because to him tranquillity is normal. Poetic feeling is what the poet counts on. And what is a poetic feeling? All the poetry of 'tranquillity' stands and falls by the capacity of the reader to feel. Words in themselves have no value here. Apart from a quite insignificant rhythm in the cadence, there is only the rhyme linking *'Ruh'* with *'du'* in the next line. The only unifying link between the constituent parts of a classical poem is the association of ideas – in other words, poetic feeling. Classical poetry as a whole appears to us today in the guise of Dadaist philosophy, and the less Dadaist the original intention, the crazier the result. Classical poetic form is nowadays only used by variety singers.

3. Abstract poetry released the word from its associations – this is a great service – and evaluated word against word and in particular, concept against concept, with some thought paid to the sound. This has more logical consistency than the evaluation of 'poetic feeling', but it is not logical enough. The end

pursued by abstract poetry is pursued, logically, by Dadaist painters, who, in their pictures, evaluate object against object by sticking or nailing them down side by side. Concepts are easier to evaluate in this way than they are when signified indirectly by words.

2. To make the sound the vehicle of the poem also seems to me logically inconsistent, because sound is only unequivocal in the spoken, not in the written word. Sound poetry is only consistent with logic when it is created in actual performance and not written down. A strict distinction must be drawn between the writing and the reciting of poetry. To the reciter, written poetry is merely raw material. It makes no difference to him whether his raw material is poetry or not. It is possible to speak the alphabet, which is purely functional in its origins, in such a way that the result is a work of art. A lot could be written about the speaking of poetry.

1. Logically consistent poetry is made up of letters. Letters have no conceptual content. Letters have no sound in themselves, they only contain possibilities of sounds, which may be interpreted by the performer. A logically consistent poem evaluates letters and groups of letters against each other.

(Kurt Schwitters, in *G*, No. 3, 1924)

The Painter, Publisher and 'Colleur'

Schwitters held his own equally as a poet, as a painter, and as an organizer. Thanks to his teaching, his advertising contract with Günther Wagner in Hanover and his prosperous father (owner of several blocks of flats), he was financially secure. Thanks above all to his overwhelming personal powers of persuasion (he did his portraits in oils and sold them to people whether they wanted them or not, sold his collages by the hundred, and was a first-class businessman, a born shopkeeper) even his most difficult enterprises were invariably successful. He published his periodical *Merz*, he sold the most fascinating Merz portfolios (works by Schwitters, Arp, Lissitzky, etc.), he found publishers for his Merz books, wrote for many periodicals and went on tour as a performer. I wish I still had all the portfolios, periodicals, fly-sheets, invitations and posters that he produced (or had other publishers produce) with such seeming effortlessness: *Auguste Bolte*, *Die Blume Anna* ('The Bloom Anna'), *und*, two postcards published by *Der Sturm*, a *Sturm* picture-book, *Anna Blume*, *Die Kathedrale* ('The Cathedral'), and seven postcards published by Paul Steege-

mann, *Memoiren Anna Blume in Bleie* ('Memoirs of Anna Blume in Lead'), published by Weltly, and so on. As early as 1918, in the first photographs of his work I saw in Zurich, there appeared the word *Merz*. Extracted from the word *Commerzbank*, Merz came into view like a nova in an unknown sky in the shape of a picture nailed and stuck together, held in place with paste and crossed by wires. From his newspaper collages he transferred the trademark to his little periodical *Merz*, and finally to himself:

"Kurt Schwitters is the inventor of Merz and i, and he acknowledges no merz or i artist other than himself. Yours faithfully." (from *Die Blume Anna*)

He did not scorn to endow his old pictures with new authorship. In 1923 he took a painting he had painted in 1909 as a student under Professor Bantzer in Dresden, and sent it out as a postcard, in an improved form and under the title of *Ich liebe dir, Anna* ('I love your, Anna'). On this postcard he writes, among other things, "Baumeister & Moholy have been here. Blümmer is now in Hanover. Yours merzially, Kurt Schwitters." *(Ill. 71)*.

He did not only work with scraps of newspaper and other objects that had lost their value. He adopted the typographic style which Dada had taken over from Futurism and transposed it into his own characteristic Schwitters world. With Doesburg and Käte Steinitz he wrote and set up in type the picture-book *'Die Scheuche'* ('The Scarecrow').

From Hausmann he had taken the optophonetic technique of presentation; perhaps, indeed, they had evolved it together.

The contents of his Merz portfolios were contributed by Arp, Lissitzky and other inhabitants of a number of different artistic and anti-artistic worlds. Like Arp, he was at home with Chance; one might almost say he was more effortlessly so than the cautious, reflective Arp. Even as an anti-artist, Arp remained Apollonian. In Schwitters, Apollo and Dionysus always went hand in hand – and occasionally stood on their heads.

He would take any risk and did not appear to give a damn for aesthetic effect, the laws of aesthetics, harmony or beauty. He leapt into the fray with claws, toenails, fists and teeth – whatever was necessary. 'Chance' chanced his way in the street, in restaurants, in friends' houses, on journeys. The world was full of it. And just because he laid hold of things – and stuck them down – with such energy, his work 'came off'. Sometimes like a Vermeer, sometimes like a jungle. Chance was always his assistant; Schwitters remained the master, the planner and the thinker.

In his *Courrier Dada,* Hausmann tells of a detour they made during a trip through Czechoslovakia:

Schwitters in Lobosice. The day after the performance, we started out on the return journey. First we went to the little town of Lobosice, because it had the Elbe, in which Schwitters wanted to bathe, and also a ruin. We left Prague in the afternoon, and, to Schwitters' great regret, we were compelled to take an express train in order to get to Lobosice on the same day. It was packed, so Kurt and Helma [his wife] got into one carriage and Hannah [Hoech] and I into another.

It was evening when we arrived at Lobosice. There was only a sort of covered platform on a high railway embankment. We went down some steps, looked round and saw nothing a pine forest, nothing else whatever apart from the station building, about two hundred yards away. There we stood. Was this Lobosice?

Schwitters said "Hausmann, you and Hannah go over there and ask if the town is far away and whether there is a hotel where we can spend the night." No sooner said than done.

We came back. Under an apple-green evening sky, against a high black embankment, burned a single feeble street-light. There stood a statue; it was a woman with her arms stretched out in front of her and draped with shirts and underclothes. She stood there like Lot's pillar of salt, while on the ground knelt a man, surrounded by shoes and articles of clothing, before him a suitcase full of papers, like the intestines of a slaughtered animal.

He was doing something to a piece of cardboard with scissors and a tube of adhesive. The two people were Kurt and Helma Schwitters. The picture is one I shall never forget: these two figures in the great dark Nothingness, totally absorbed in themselves.

As I approached I asked "Kurt, what are you doing?"

Kurt looked up and replied, "It occurred to me that collage 30 B 1 needs a little piece of blue paper in the lower left-hand corner. I shan't be a moment." Such a man was Kurt Schwitters.

The Schwitters Column

And so he pasted, nailed, versified, typographed, sold, printed, composed, collaged, declaimed, whistled, loved and barked, at the top of his voice, and with no respect for persons, the public, technique, traditional art or himself. He did everything, and usually he did everything at the same time.

His guiding principle was not so much to create the *Gesamtkunstwerk*, the Total Work of Art (as in Ball's case, or Kandinsky's), the temporal conjunction of all the arts, but rather to blur the distinctions between the arts and finally integrate them all with each other. He even wanted to integrate the machine into art – as an abstract representation of the human spirit – along with *kitsch*, chair-legs, singing and whispering.

In reality he himself was the 'total work of art': Kurt Schwitters. There was also one work in which he sought to integrate all his activities, and that was his beloved '*Schwitters-Säule*' (Schwitters Column). For all his competence as a business man and as a propagandist, this one thing was sacred to him. This, his principal work, was pure, unsaleable creation. It could not be transported or even defined. Built into a room (and rooms) of his house, this column was always in a protean state of transmutation in which a new layer constantly covered, enclosed and hid from sight yesterday's shape.

At the end of a passage on the second floor of the house that Schwitters had inherited, a door led into a moderately large room. In the centre of this room stood a plaster abstract sculpture. When I first saw it, about 1925, it filled about half the room and reached almost to the ceiling. It resembled, if anything Schwitters made ever resembled anything else at all, earlier sculptures by Domela or Vantongerloo. But this was more than a sculpture; it was a living, daily-changing document on Schwitters and his friends. He explained it to me and I saw that the whole thing was an aggregate of hollow space, a structure of concave and convex forms which hollowed and inflated the whole sculpture.

Each of these individual forms had a 'meaning'. There was a Mondrian hole, and there were Arp, Gabo, Doesburg, Lissitzky, Malevich, Mies van der Rohe and Richter holes. A hole for his son, one for his wife. Each hole contained highly personal details from the life of one of these people. He cut off a lock my hair and put it in my hole. A thick pencil, filched from Mies van der Rohe's drawing-board, lay in *his* cavity. In others there were a piece of a shoelace, a half smoked cigarette, a nailparing, a piece of a tie (Doesburg), a broken pen. There were also some odd (and more than odd) things such as a dental bridge with several teeth on it, and even a little bottle of urine bearing the donor's name. All this was placed in the separate holes reserved for the individual entries. Schwitters gave some of us several holes each, as the spirit moved him ... and the column grew.

When I visited him again three years later, the pillar was totally different. All the little holes and concavities that we had formerly 'occupied' were no longer to be seen. "They are all deep down inside," Schwitters explained. They

were concealed by the monstrous growth of the column, covered by other sculptural excrescences, new people, new shapes, colours and details. A proliferation that never ceased. The pillar had previously looked more or less Constructivist, but was now more curvilinear.

Most important of all, the column, in its overwhelming and still continuing growth, had, as it were, burst the room apart at the seams. Schwitters could add no more to the breadth, if he still wanted to get round the column; so he had to expand upwards. But there was the ceiling. Schwitters found the simplest solution. As landlord of the house, he got rid of the tenants of the flat above his, made a hole in the ceiling, and continued the column on the upper floor.

I left Germany before Hitler came and heard nothing of Schwitters until he arrived in Norway just one step ahead of the Nazis, who had ordered his arrest in Hanover. He began a new structure in Norway, and a third in England, but he never forgot or forgave what the Nazis had done in destroying with their bombs his life's work, the work with which he identified himself more than with any other, the work which, in the truest sense of the word, had grown with him, physically and mentally, through all the periods of his life.

It is all very well now for art-dealers, directors of galleries and critics to recognize the value of works which not so long ago (e.g. at the 1942 New York exhibition and elsewhere) they held in contempt. Today, when he lies buried in England and is famous and his son is rich, everyone knows that he was a great creative artist; but he was also, as the following letter shows, a brave man who lived as he thought, no opportunist but a man of action. He sent the letter in 1936 from Hanover, in the Nazi Germany in which he was a suspect and a 'lunatic', to Tzara, notifying him of a mysterious 'consignment'. This consignment, as Tzara has told me, consisted of a photograph album with microfilms concealed in its cover. These microfilms from Hitler's Reich showed the Hitler posters which hung in tatters from the walls in Hanover, ration cards with minimal quantities of food, and all sorts of other things. An enlargement of this clandestine document was later published by Tzara in the French periodical *Regards*.

Dear Herr Tzara,

Some days ago I received the news that the consignment despatched at the beginning of April arrived safely.

I would now request you on behalf of Herr S. to forward the negatives of the consignment, together with a printed copy, securely packed in a sealed envelope, to our overseas department. The address is: Herre Ch. Iversen, Djup-

vasshytta ved Geiranger, Norge. He will be at the address indicated from the 3rd until the 8th of July. I would therefore ask you to despatch the consignment so as to arrive not later than the 8th July. Please mark the envelope clearly 'via Amsterdam'.

Please send the fee for publication to the same address, by postal order, before the 8th of July.

As and when it is possible to assemble a new consignment, we shall naturally forward it to you. I am sure that you appreciate the difficulties that this work entails.

With my sincere gratitude in advance for your assistance, I remain

with very best wishes
Overseas Department.

If Schwitters had been caught, he would certainly have been sent to a concentration camp, and would have died there. He was literally risking his life – but he had not forgotten the 'fee for publication'!

He was forced to flee from Germany. Cut off from his Dada column in Hanover, shut out of Germany as a 'cultural Bolshevik', he finally found asylum in England after fleeing from the Nazis in Norway.

Collages, collages and more collages appeared. He was still the old Schwitters, but when I wrote to him in England and signed it 'your *old* Hans Richter', he emphasized that he was not the old but the *young* Schwitters.

He had found a barn near Ambleside in Westmorland, owned by a farmer named Pierce, where he could work free. And so, already a sick man, he began a collage to cover the walls, considered by him this third 'column'. But his health was broken. His friend Edith Thomas kept him alive, physically and materially. His letters, written in comic English, underlined the fact that he would never speak or write German again. He had no occasion to do so, and, in spite of devoted care, he died in 1948, exactly sixty years old. Pierce preserved the barn with the one decorated wall just as Schwitters had left it. But few people came to see it, and in 1965 the Fine Arts Department of the University of Newcastle undertook the difficult task of removing the wall to Newcastle, to gain it a wider public.

V Kurt Schwitters, *Weltenkreise*, 1919. Collage and oil, 117.5 x 83 cm. Marlborough Fine Art Ltd, London ▷

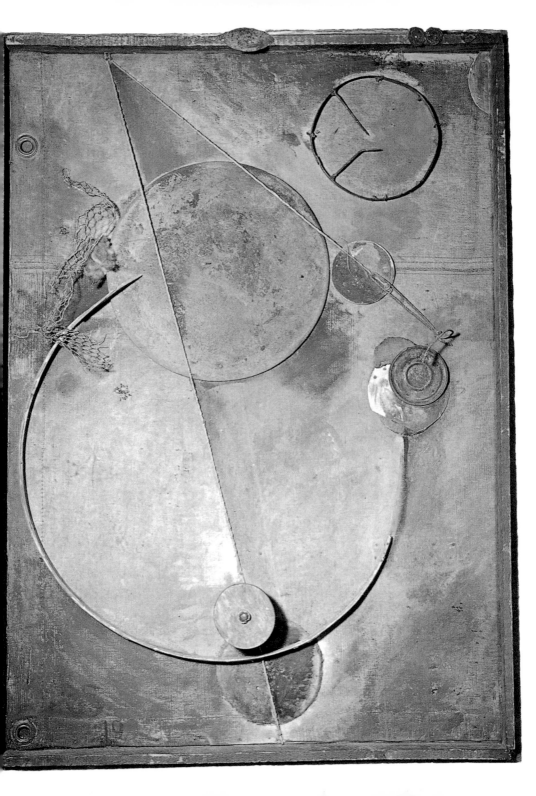

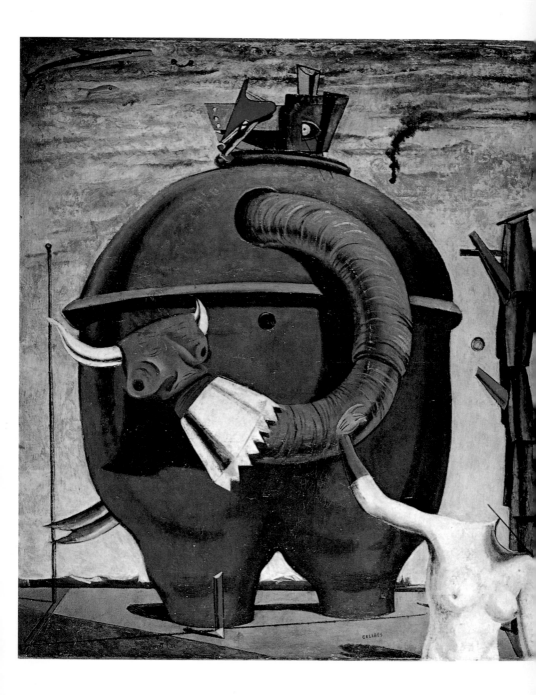

5 Cologne Dada

Max Ernst and Johannes Baargeld

Schwitters was a unique phenomenon in Hanover, where Hindenburg's garden is still pointed out, but where there is still no iron Schwitters, no Schwitters-Strasse, no Schwitters-Platz and no memorial tablet; in the same way, Max Ernst was unique in Cologne. At the same time (1918, in Zurich) as Tzara showed me the first photographs of Schwitters' work, he also showed me a photograph of a picture (or a collage?) by Max Ernst, who, like Schwitters, was quite unknown to me at that time.

The dominant faculty in Schwitters was undoubtedly the intuitive. In Max Ernst intuition was balanced by a highly developed intellect. This was an essential difference between him and Schwitters, who was very intelligent but not in the least intellectual. Max Ernst's cultivated mind, with its store of philosophical learning, is dominated by a sharp intelligence which never fails to produce results. Where Schwitters *felt*, Ernst *thinks;* Schwitters remained essentially uncultivated, while Ernst possesses an excellent classical education.

He himself tells the story of his life as follows: "Max Ernst had his first contact with the world of sense on the 2nd April 1891 at 9.45 a. m., when he emerged from the egg which his mother had laid in an eagle's nest and which the bird had incubated for seven years. This took place at Brühl, six German miles south of Cologne. Here Max grew into a beautiful child. His childhood was marked by several dramatic incidents, but could not be described as unhappy.

"Cologne was once a Roman colony called Colonia Claudia Agrippinensis, and later became the most important cultural centre of the medieval Rhineland. It is still haunted by the spirit of the great magician Cornelius Agrippa, who was born there, and by that of Albertus Magnus, who lived and died there. The bones of three other magi, Caspar, Melchior and Balthazar, the three wise men from the East, lie in Cologne Cathedral. Their golden, bejewelled shrine is shown

to the faithful every year on the 6th January. Eleven thousand virgins once gave up their lives in Cologne rather than lose their chastity. Their sweet relics adorn the walls of the convent church at Brühl, from which vantage-point they have possibly helped Max to many of his achievements, for he had to spend many a long hour in their church as a child.

"Cologne lies at the very edge of a wine-producing region. Beer country lies to the North, wine country to the South. Are we the product of what we drink? If so, it may not be without significance that Max has always preferred wine. When he was two years old, he secretly drank the dregs of several wine-glasses and then, taking his father by the hand, pointed to the trees in the garden and said, 'Look, Pa, they're going round'. When, in later life, he reflected on the Thirty Years' War, it occurred to him that this was a war between beer-drinkers and wine-drinkers. Perhaps he was right.

"The geographical, political and climatic situation of Cologne is such as to produce stimulating conflicts in the mind of a sensitive child. Here the principal cultural currents of Europe meet: early Mediterranean influences, Western rationalism, Eastern tendencies towards *Occultism,* Nordic mythology, the Prussian categorical imperative, the ideals of the French Revolution and much besides. All these antithetical tendencies can be detected in the course of the mighty drama which unfolds in Max Ernst's works. Will elements of a new mythology emerge one day from this drama?

"Little Max's first contact with painting was in 1894, when he watched his father painting a watercolour entitled *Loneliness.* It showed a monk sitting in a beech-wood, reading a book. There was a frightening stillness about *Loneliness* and the way in which it was depicted. Each of the thousand beech-leaves was painted with anxious minuteness; each of them had its own individual life. The monk was so disquietingly absorbed in the book he was reading that he seemed to be living outside the world altogether. Even the sound of the word 'Monk' *(Mönch)* caused a magical tremor in the child's mind (the same thing happened, at that time, whenever he heard the words Struwwelpeter or Rumpelstiltskin). Max never forgot the thrill of terror and delight that he experienced when, some days later, his father took him into the forest. An echo of these feelings can be found in several of Max Ernst's *Wald- und Dschungel-Bilder* ('Forest and Jungle Pictures', 1925–42).

(1896)

Little Max did a series of drawings, of his father, his mother, his sister Maria who was his elder by one year, himself, two younger sisters, Emmi and Luise, a

friend by the name of Fritz and the level-crossing keeper. All were standing, with the exception of Luise, who was only six months old and too small to stand. In the background was a train, emitting copious quantities of steam. When someone asked him what he wanted to be when he grew up, Max invariably answered 'A level-crossing keeper.' It may be that he was influenced by the longing for far-off places that is aroused by passing trains, and by the mystery of the telegraph wires which move when seen from a moving train, and stay still when one is not moving. In order to fathom the mystery of the telegraph wires, and to escape from his father's tyranny, five-year-old Max fled the paternal home. Blue-eyed, fair haired, in a red nightshirt and with a whip in his left hand, he walked across the street and became involved in a procession of pilgrims. Enchanted by the appearance of this attractive child and believing that they were seeing an angel or the Christ-child himself, a number of children in the procession could be heard to shout, 'Look, the Christ-child'. After a few hundred yards the 'Christ-child' slipped away from the procession, addressed his steps to the railway station and went for a wholly delightful and enthralling walk along the embankment and past the telegraph poles. When a policeman took him home, Max sought to escape his father's wrath by asserting boldly that he had been led on by the child Jesus. This in its turn inspired his father to take his son as a model for a picture of the Christ-child. He painted him, with his blue eyes and fair curls, in the act of blessing the world, dressed in a red nightshirt and with a cross – in place of the whip – in his left hand.

Although flattered by this picture, Little Max was unable to rid himself of the impression that the painter rather saw himself in the role of God the Father, and it may be that the picture *Souvenir de Dieu* (1923) contains a reminiscence of this event.

(1897)
First contact with the void: his sister Maria kissed him and her sisters goodbye and died a few hours later. Since this time, a feeling for Nothingness and destructive forces has been dominant in his temperament, in his behaviour and – later – in his work.

(1897)
First contact with hallucinations: measles. Fear of death and destructive forces. A fever vision, inspired by a panel of imitation mahogany opposite the foot of his bed. The grain of the wood gradually took on the appearance of an eye, a nose, a bird's head, a 'menacing nightingale', a spinning top, and so on.

It is certain that little Max enjoyed being plagued by such visions. And later he voluntarily induced similar hallucinations by staring at wooden panels, clouds, wallpaper and unpainted walls in order to allow his imagination free play. If someone asked him 'What do you like doing most of all?' he always answered 'Looking'.

Similar influences later led Max Ernst to investigate these illusions more deeply and discover new technical possibilities in drawing and painting, directly connected with processes of inspiration and revelation (frottage, collage, 'decalcomania', etc.). It is possible that the 1924 picture *Zwei Kinder bedroht durch eine Nachtigall* ('Two children menaced by a nightingale') has some connection with the delirium of 1898.

(1898)

Second contact with painting. He saw his father paint a picture from nature in the garden and finish it in the studio. His father suppressed a bough in his picture because it disturbed the composition. Then he cut off the same bough in the garden, so that there should no longer be a difference between nature and his picture. The child felt within himself the first stirrings of a revolt against such pedestrian realism and resolved to work towards a juster appraisal of the relationship between the subjective and the objective worlds.

(1906)

First contact with occult and magical powers. One of his best friends, a highly intelligent and devoted pink cockatoo, died on the night of 5th January. It was a fearful shock to Max when he found the dead bird next morning, at the same instant as his father informed him of the birth of his sister Lori. Such was the boy's perturbation that he fainted. In his imagination he connected the two events and blamed the baby for the bird's decease. A series of emotional crises and depressions followed. A dangerous confusion between birds and human beings took root in his mind and later found expression in his drawings and paintings. This idea did not leave him until he set up his *Vogeldenkmal* ('Bird Monument') in 1927; even later Max identified himself with 'Loplop, the Superior of the birds'. This phantom remained inseparable from another, called *Perturbation ma soeur, la femme 100 têtes*.

Excursions into the world of prodigies, chimaeras, phantoms, poets, monsters, philosophers, birds, women, madmen, magi, trees, erotica, stones, insects, mountains, poisons, mathematics etc. A book he wrote at this time was never published. His father found it and burned it. Its title: *Diverse Tagebuch-blätter* ('Divers Pages from my Journal').

(1914)

Max Ernst died on 1st August 1914. He returned to life on 11th November 1918, a young man who wanted to become a magician and find the central myth of his age. From time to time he consulted the eagle which had guarded the egg of his prenatal existence. The bird's advice can be detected in his work."

Thus far Max Ernst on himself.

The aquiline Max Ernst *(Ill. 76)*, for whom the *Gymnasium* (classical high school) held no secrets (and it would not have been able to show him any) opened new doors which led Dada into mysterious and unearthly regions. His extraordinarily acute intelligence, which matched the sharpness of his line, found expression in extraordinary, esoteric collages *(Ill. 78, 80)*. In these, it was not the technique that was original. Hausmann and Heartfield laid claim to it as well as he. The originality lay in the literary and intellectual content. These were not merely pictures; they were stories and very alarming ones. There is always something menacing in or behind the decor of the human universe manipulated by Ernst.

"I remember very well the occasion when Tzara, Aragon, Soupault and I first discovered the collages of Max Ernst", writes André Breton. "We were all in Picabia's house when they arrived from Cologne. They moved us in a way we never experienced again. The external object was dislodged from its usual setting. Its separate parts were liberated from their relationship as objects so that they could enter into totally new combinations with other elements."

Parts of machines become people, people become things, moving, hovering or rigidifying in a mechanical space.

These 'combinations' make up his collages as well as his pictures *(Ill. 77)*. They create a world of monsters, brought to life by new artistic techniques, which become magic at the touch of his hand.

He developed his method of *frottage* while gazing at the floor-boards of his room. Fascinated by the strange patterns in the wood, he put a piece of paper over them and rubbed (in French, *frotter*) this natural pattern through with a pencil. This produced an imprint which opened the way to further discoveries. From this developed all those countless forest and wood-grain formations that recur again and again in Max Ernst's landscapes, trees, people and animals.

He has continued with these mediumistic frottages and collages to this day. One day, he tells us, when he was in hospital with pleurisy, a friend brought him a pile of magazines and books dating from the 'eighties, with hundreds of those prim Victorian woodcuts that adorned the books and ladies' journals of

that period. By cutting out the woodcuts and re-combining them in his own weird fashion, he transported these harmless insipidities into worlds of demoniacal horror which he then brought together in the five little volumes of his *La Semaine de Bonté,* one of his most richly imaginative works.

In the Dada chorus of periodicals and manifestoes that were proliferating like may-bugs and insulting the bourgeoisie, the police, and the State, the voice of Cologne was first heard through a pro-Communist periodical which appeared just after the war and had the appropriate name of *Der Ventilator.* Its purpose was to try and blow some fresh air into the stale and stifling political atmosphere of that period. *Der Ventilator* was founded by Johannes Theodor Baargeld, a young painter who had met Ernst in Cologne. The periodical attacked Church and State, the Establishment and Art, and was a big success. It resembled the Berlin periodicals of the same period but preferred to avoid following their example. Neither Baargeld nor Ernst agreed at all with the Berlin Dadaists, who wanted to use the movement for ends of political propaganda. Artistic and political development should take place side by side without one suppressing or patronizing the other. It must be recalled that Cologne was a long way from the firing at the Berliner Schloss or in Charlottenburg and knew nothing of the murders on the Landwehrkanal, or the assassination of Liebknecht and Rosa Luxemburg. Berliners saw all this on their doorstep, if not in their own living-rooms. The political programme of *Der Ventilator,* its brand of criticism and mockery, so fitted the needs of the age that twenty thousand copies were sold in a short time – before it came to the notice of the British occupation authorities who banned it as subversive.

Max Ernst did work on his friend Baargeld's periodical *(Ill. 75),* but this amalgam of anti-art and politics did not really suit him. Revolted by the power-seeking, the political crimes and the hypocrisy that accompanied the setting-up of the first German republic, Ernst decided to play his own tunes on an instrument other than *Der Ventilator.* The instrument he chose was *Die Schammade.* I imagine that this is a portmanteau word made up from *Schalmei* (shawm), sweet and earnest tones, *Scharade* (charade), a guessing game played in earnest, and *Schamane* (witch-doctor), a dangerous, earnest necromancer. Financial support came from Baargeld's father, a rich banker, who was (as Arp, another 'Schammade'-player, reported to me at the time) very anxious about his son, who was said to have dangerous leanings towards Communism. Arp and Max Ernst convinced young Baargeld that Dada went much further than Communism and that its combination of new-found inner freedom and powerful external expression could set the whole world free: every man a personality through Dada!

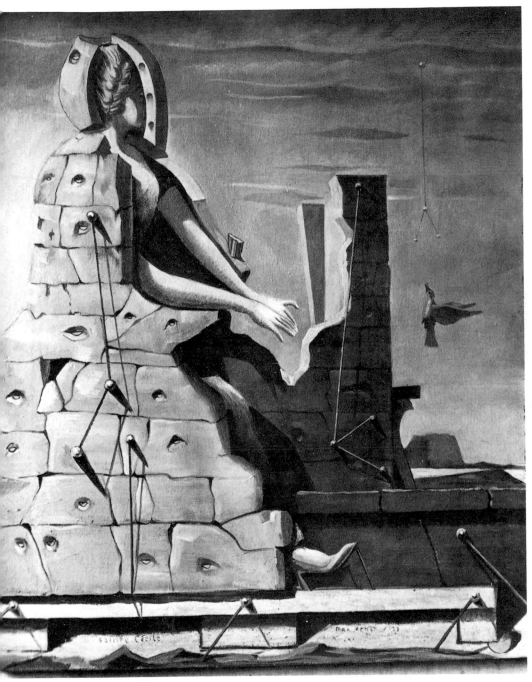

7 Max Ernst, *Sainte Cécile*, 1923. Oil

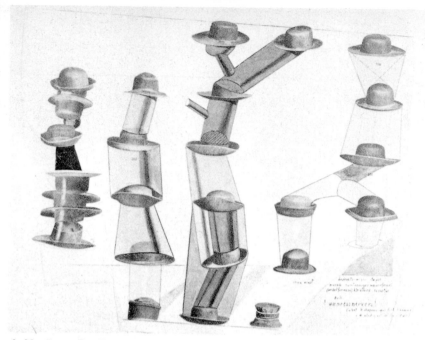

78 Max Ernst, *Der Hut macht den Mann* (The Hat makes the Man), 1920. Collage

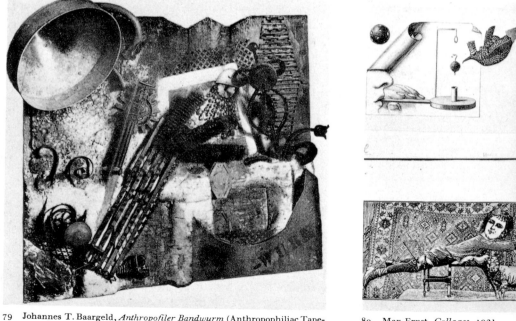

79 Johannes T. Baargeld, *Anthropofiler Bandwurm* (Anthropophiliac Tapeworm), 1919. Assemblage

80 Max Ernst, *Collages*, 1921

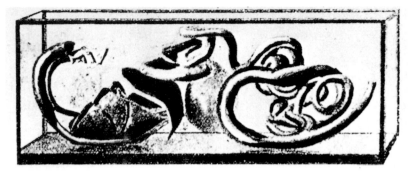

81 Max Ernst and Hans Arp, *Laokoon*, 1919. Collage-sculpture (fatagaga)

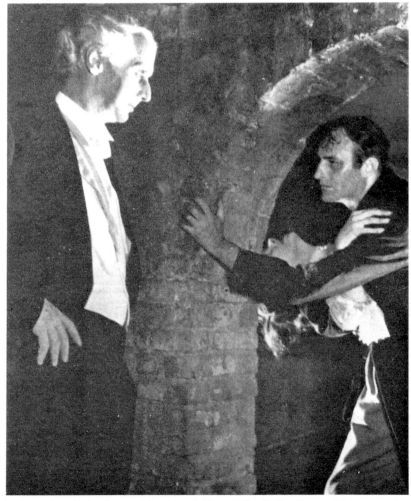

82 Max Ernst, Julien Levy and Jo Maison in Hans Richter's film *Dreams That Money Can Buy*, New York, 1945

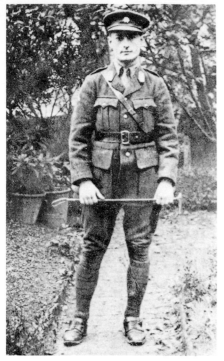

83 Jacques Vaché in uniform, 1918

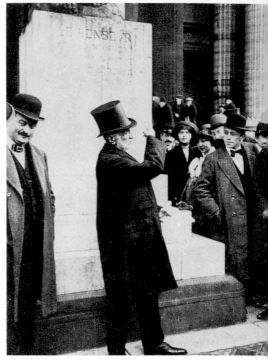

84 Jean-Pierre Brisset expounding his ideas in front of Rodi
Penseur, c. 1886

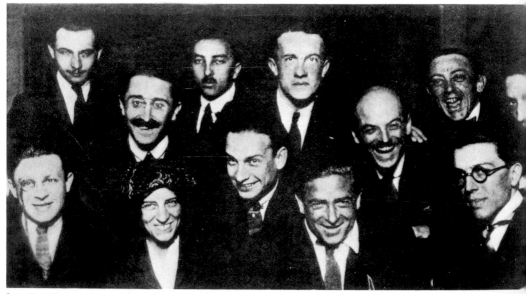

85 Contributors to *391* and *Littérature*, 1919–21.
Front row (left to right): Tristan Tzara, Céline Arnauld, Francis Picabia, André Breton. Second row: Paul Derm
Philippe Soupault, Georges Ribemont-Dessaignes. Third row: Louis Aragon, Théodore Fraenkel, Paul Elua
Clément Pansaers(?), Emmanuel Fay

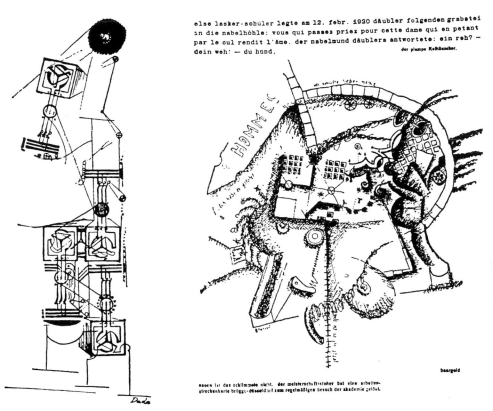

else lasker-schuler legte am 12. febr. 1920 däubler folgenden grabstei
in die nabelhöhle: vous qui passez priez pour cette dame qui en petant
par le oul rendit l'âme. der nabelmund däublers antwortete: ein reh? —
dein weh: — du hund. der plumpe Roßhäuseber.

Max Ernst, Title-page drawing for
Die Schammade, Cologne 1920

Johannes Baargeld, Drawing in Die Schammade, Cologne
1920

When old Baargeld heard that his son was exchanging Communism for a share
in Dada (see *Ill. 79*), he was so delighted that he folded Arp and Ernst (meta-
phorically) to his bosom, thus releasing enough money to start and finance *Die
Schammade*.

Among the names of the contributors to *Die Schammade* there soon appeared
those of the French poets Breton, Éluard, Aragon and others, who had also
contributed to the last issues of the Zurich *Dada* in 1918–19. This is evidence
of the early contact that existed between Cologne, halfway between Berlin
and Paris, and the virulent Paris Dada movement. Contacts between Berlin and
Paris remained rare.

In 1921 Ernst was to move to Paris. His temperament was such that, if there
had been no Paris, it would have had to be built specially for him.

The Cologne Dada movement was heading for a storm. The 'First Dada Event', with Arp, Baargeld and Ernst, was advertised for 20th April 1920, but did not go off without complications. Someone had warned the police that the Dadaists were worse than the Communists. The authorities lost no time in closing the 'Event'. It was not hard to find a pretext: the exhibition could only be entered through the *pissoir* of a beer-hall, frequented by unsuspecting beer-drinkers. The users of the *pissoir*, attracted by the din which came from the other side, came through and found themselves in the middle of a Dada exhibition. This Dada-Fair was crammed with all sorts of suggestive objects, collages and photomontages. People were reciting poems into which the hearer could project his wildest fantasies. The unexpected shock received by the customers of the beer-hall led to such a commotion that the police came and closed the Fair. They more or less assumed it to be a gathering of homosexuals. On closer inspection, it became apparent that the only morally objectionable object in the exhibition was by a certain Albrecht Dürer . . . and the Fair was re-opened.

Max Ernst's private world of spirits and demons very probably inspired the monstrosities and deformities created by later Dadaists. He seems to have had an irresistible effect on female surrealist painters. Leonor Fini, Leonora Carrington, Dorothea Tanning, Meret Oppenheim and others have all learned how close Max Ernst's primeval and unearthly phenomena lie to the realm of Faust's 'Mothers', and how they lend themselves to reinterpretation by Woman within her own universe. They also show how much of a destructive female principle there is in Max Ernst's art.

His weird visions have their origins in the German art of the Middle Ages and the Romantic period. They recapture the fearful concreteness and depth of a Dürer or a Schongauer, the emotional, often sentimental Romanticism of a Caspar David Friedrich, and tne allegory, inflated to the point of bathos, of Böcklin and Klinger, two artists whom Max Ernst admired. In Max Ernst's work these fragments of tradition are twisted into spectral combinations. Ernst subjects the satanic aspect of the German soul to a process of vivisection. The genial is linked with the abominable, and the product is Evil . . . which lies outside the sphere of conventional art altogether: not art, but indictment or prophecy.

An idea that always preoccupied C. G. Jung was that we have expelled the Devil from the world of experience only to give him the freedom of our subconscious. This is the idea embodied in Ernst's paintings. Satan appears in countless guises, without his horns, hoofs and tail, but blatant and horrifying in typical twentieth-century style.

Ernst's antecedents are also to be found among the ancient Chinese and Greeks. For although frottage was discovered anew by Max Ernst, it had been known in ancient Greece and China. In caves and on tombstones in China and ancient Greece there were mythological or historical scenes cut into the stone. By rubbing these through on to rice-paper or parchment, it was possible to obtain a negative impression.

Max Ernst subjected this process to a refined process of development and perfected several methods of producing images and impressions which must be respected as his professional secrets.

It was also not unknown for Baargeld and Ernst to work together on the same picture. This was not a new idea either. It was known in the Middle Ages, and it returned to fashion with the Cubists. When Arp saw and admired the results of this, he too joined in. This produced a series of collages called *Fatagagas*, which is short for the equally illuminating title *Fabrication des tableaux garantis gazométriques*. Ernst also illustrated Arp's book of poems *Weisst du schwarzt du* (very approximately: 'Do you know do you yes') with collages, and did a number of lithographs for Arp's poems *Fiat Modes*.

Whereas Arp has more or less never changed since I first knew him – in 1916 – Max Ernst has passed from one period to another, each often totally different in form from that which preceded it. The unifying element is the alarming Gothic atmosphere, the *sombre* quality that unmistakably links Ernst's work with German Romanticism. Arp was and remained at home in the world of forms; he was concerned to "let objects be absorbed into Nature". Ernst concerned himself with inner vision, dreams and nightmares, illuminating those dark corners of the unconscious mind where the Devil comes into his own and asserts his existence without any moral emphasis. This is apparent not only in Ernst's paintings, collages, frottages, linocuts and drawings, but also in the eerie cement sculptures he created in the South of France and later in Sedona, Arizona, and in his mesmeric *Chessmen,* whose dark sun-like heads and triangular bodies have their home somewhere in the Underworld.

"No one has known better than Max Ernst how to turn pockets inside out", says Tzara in the catalogue of the 1951 Max Ernst exhibition in Brühl. "Max Ernst reverses the appearance of objects to the point of a direct attack on their essence. He reduces passions, powerful in their normal, social aspect, to mere schemas. Mechanical technique is called in to assist in the dehumanization of the world of phenomena. Max Ernst reminds man of his role as link in the chain of historical determinism, and of the impotence of all his endeavours – at least as an individual – to escape from this role through the power of ideas.

"The human aspect of Max Ernst's work consists firstly in his free use of stimuli, produced by experiences of whatever kind, and secondly in his discovery of a new kind of humour. This humour results from comparison and contrast between antithetical worlds, thus destroying the claims of both worlds to universal validity. His sense of humour places him above both, with the object of making the interaction of the two spheres serve the needs and the development of humanity.

"Max Ernst's poetic activity has unfolded in the icy silence of a pitiless inward gaze, in a state between dreaming and waking. It may be defined from a conscious standpoint as a state of intoxication or as unbroken contact between the personality, with all its powers of intuitive comprehension, and the passing world of images."

Max Ernst had his first exhibition in Paris on 2nd May 1921, soon after he arrived from Cologne. He then made his home in Paris. Breton wrote the introduction to the catalogue: I shall refer to it in more detail in the chapter on 'Paris Dada'. Paris never lost its hold on him. He did succeed in escaping from occupied France to America, but he could never settle down there. His sharp and delicate wit was out of place as a weapon against American directness. They saw only the morbid side of his imagination, and wanted none of it. He withdrew to Arizona, where an inescapable Indian element still lingers in the landscape. There he created fabulous sun-pictures and lunar landscapes, some of them vest-pocket size *(Microbes)*. He surrounded his house with evil, spectral sculptures, until he was able to go back to France. He was welcomed like a long-lost son. Then, at last, New York remembered him and honoured him (or itself) with a big exhibition at the Museum of Modern Art.

Max Ernst's work was rightly described as 'Dadaist' until 1923. From 1924 onwards, thanks solely to the word-magic of André Breton, it turned 'Surrealist' without really changing at all. If the work he did at that time were scrutinized carefully, no difference would be found between what he did before 1924 and what he did afterwards. This remarkable conjuring-trick is an interesting phenomenon to which I should like to return in my discussion of the origin of Surrealism.

Ernst's work is one more illustration of the fact that Dada's anti-art tirades, although seriously meant, were impossible to put into practice. A work of art, even when intended as anti-art, asserts itself irresistibly as a work of art. In fact, Tzara's phrase "the destruction of art by artistic means" means simply "the destruction of art in order to build a new art". This is precisely what happened. This is not only true of artists like Schwitters, Ernst, Eggeling, Arp,

Janco and myself, but also of the most radical exponent of anti-art, Picabia. His works of anti-art still contain artistic food for thought enough to act as a stimulus for future generations of artists – and this again is precisely what is happening.

Dada liberated the mind, mobilized the senses and produced its own works of art on all sides – even if these works sometimes had no direct or indirect connection with the official theories of Dada. Often enough they were part of a battle against these theories.

I first met Max Ernst in his Paris studio in 1925. Eluard was sitting on a sofa on the left, Marie-Berthe his wife on a chair on the right. Between the two – and between the grey-green pictures that gleamed like moss – paced Max Ernst. The purpose of my visit was to get a contribution for my periodical *G*. Nothing came of it, because the periodical disappeared soon afterwards.

We worked together, years later, in New York, when he inspired and appeared in the 'Desire' episode in my film *Dreams that Money Can Buy*. He was more exciting to work with, more inspiring and more inventive than anyone I have ever met. The vigour of his mind made working with him a delight *(Ill. 82)*.

6 Paris Dada 1919-1922

The Renewal of Language

NOUVELLE SÉRIE

Dada had already set up ripples in Paris before Tristan Tzara made his entrance as Monsieur Dada at the end of 1919. He had been in close contact with literary circles in Paris since 1917, had corresponded with Apollinaire and worked on pre-Dada periodicals like Pierre Reverdy's *Nord-Sud* and Albert Birot's *Sic*. In these he wrote articles on Negro art and contributed poems to prove that the art of poetry was still a living force – in all its guises, even that of anti-poetry.

The French writers seemed to hesitate at first before embarking on the strange adventure of Dada. But by 1918 some members of the Paris avant-garde, including Breton, Aragon, Soupault, Huidobro and Ribemont-Dessaignes, were contributing to Nos. 4 and 5 of the Zurich *Dada*.

Breton, Aragon and Soupault were at the same time publishing in Paris a periodical called *Littérature,* whose somewhat stilted title was meant to imply its opposite. This rather diffident gesture was nullified by the array of names inside the cover. Gide, Valéry, L. P. Forge, Max Jacob, André Salmon, Cendrars, Reverdy, Larbaud, Paulhan, Stravinsky – this did not sound much like Dada.

But, by the second issue, *Littérature* had been infected with Dada by way of Zurich *(Ill. 85).* Tzara himself was a contributor.

Anti-art proclamations heralded like flashes of lightning Dada's arrival in Paris. From New York came the non-art proclamations of Duchamp and Man Ray's mockeries of pictures: the deeds of anti-artistic violence committed by Huelsenbeck and Hausmann in Berlin were also just becoming known. The barrage had begun.

Issue IX of *391,* the first issue that Picabia published in Paris, came before the Parisian public decked out by Tzara in all the colours of Dada. Picabia's stay in Zurich had led to a close relationship with Tzara. *391* was the trumpet on which Dada proclaimed the approach of the Last Judgment and the impending arrival of Tristan Tzara.

He was awaited like a sort of Anti-Messiah whose anti-gospel would mobilize minds and anti-minds that the war had left prepared to accept anything.

Picabia, through the press and through his own café conversations, had already made Dada, and the name of its prophet Tristan Tzara, well known in Paris. Everyone was eager to see this phenomenon in person. The group of young poets who had already contributed to Zurich *Dada:* Breton, Aragon, Soupault, Ribemont-Dessaignes and others, were eagerly looking forward to his arrival.

History ought to relate how Tzara, standing in a snow-white (or lilac-coloured) automobile, passed through cheering crowds, along the Boulevard Raspail, past the Café du Dôme and the Rotonde, to the Closerie des Lilas, where, beneath a triumphal arch of pamphlets (written about him) and to the accompaniment of a firework-display, his chosen disciples Picabia, Breton, Aragon and others awaited him. In reality, he was not greeted with a firework-display, nor did he travel down the Boulevard Raspail. He arrived one evening from the Gare de l'Est, carrying a little suitcase, and rang Picabia's doorbell. The startled Picabias, who had invited him but were not expecting him, put him up for the night on their sofa.

Despite this unimpressive entry, Tzara at once became the focus of attention in avant-garde circles. The firework-display that had failed to materialize on his arrival he soon provided himself. Through him Paris Dada went off like a Roman candle, raining sparks in the shape of names, ideas and events. The names have since acquired importance in literary history; the ideas belonged to the whole avant-garde tradition of French literature; the events, staged with pomp, gave Dada the distinguishing marks it was to bear for many years to come, absurdity, ephemerality and frequently ridiculousness.

Thus Paris, the capital of European culture, followed Zurich, New York and Berlin into the vortex of Dada. There were favourable factors here which Zurich, New York and Berlin lacked. A revolution in literature had been on the way for several generations, and bore several of the characteristics of Dada. André Breton includes a number of these antecedents in his *Anthologie de l'Humour noir:* not only Alfred Jarry, whose invigorating independence of spirit inspired a whole generation of imitators and continuators, but also Mallarmé, Rimbaud, Baudelaire, Lautréamont . . . right up to Roussel and Apollinaire.

One of the most remarkable of them is Jean-Pierre Brisset, who attributed to language a sort of divine consciousness. His theory is very close to Dada. From the sound of speech and from affinities of sound he deduced a deeper, divine meaning and on it based his 'Great Law, or Key to Words'. In his *Anthologie,* Breton writes of Brisset as follows: "The Word, which is God, has

preserved within its folds the history of the human race." And Brisset himself *(Ill. 84)* says, "From the very first day, and in every language, words have preserved the history of every nation with an irrefutable certainty that astounds the most learned as it does the simplest of us."

Les dents, la bouche
les dents là bouchent
l' aidant la bouche
l'aide en la bouche
Laides dans la bouche
Lait dans la bouche

.
Les dents – là bouche

(Jean-Pierre Brisset)

Others were also fascinated by the results of letting words sound and allowing the meaning to emerge from the sound.

Paroi parée de paresse de paroisse
A charge de revanche et a verge de rechange
sacre de printemps, crasse de tympan
Daily lady cherche démêlés
avec Daily Mail

(Marcel Duchamp)

Anti-Art in Paris

This game with language, sound, words and associations of sound has become part of the growth of language. In the 'heard' word, this word-game is as meaningful as it appears meaningless. It was taken up on all sides and in many countries (Scheerbart, Ball, Apollinaire, and so on), and Joyce developed his own artistic style from it.

There were many who prepared the ground even before Dada broke through the barriers of language with the revolutionary poems of Ball, Tzara, Hausmann and others. Apollinaire, more than any of his contemporaries, had

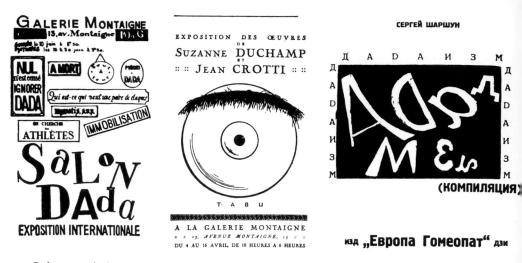

Dada typography in French and Russian

questioned the traditional use of language. In Paris (unlike Berlin) there was thus an existing tradition which provided fertile soil for Dada.

It looked as if the tempo of Dada was quickening as it got older. After wildness in Berlin – paroxysm in Paris! *Littérature* and *391* formed a solid front. But Paris Dada, unlike the Zurich, New York, Berlin, Hanover and Cologne movements, belonged almost exclusively to writers, not to visual artists. Painting does appear in Paris alongside literature, but the painters did not play a decisive part; their work neither influenced the Paris movement essentially nor was influenced by it. The visual artists continued with things they had already begun elsewhere. Meanwhile they applauded the Dada writers and identified themselves with the revolt that was led by them.

Jean Crotti *(Ill. 89),* who had met Marcel Duchamp in New York and had married his sister, the painter Suzanne Duchamp *(Ill. 88),* joined both of them in breathing life into Paris Dada. Both exhibited in Paris under the auspices of Dada. Ribemont-Dessaignes, a faithful comrade-in-arms of Picabia, was a writer rather than a painter, although, during the Dada period, he was known also through his exhibitions. The most independent of all was the Russian Serge Charchoune, who had made a name for himself as a painter. He not only contributed to *Dada* and *391,* but also produced in Paris his own Russian version of Dada *(Ill. 97).*

In visual art, nobody achieved a truly characteristic Paris Dada style which might have contributed a new note of its own to the international concert of twentieth-century art. But, if Paris Dada produced few painters of its own, it was all the more succesful in attracting them from outside. Dada blossomed again in Paris after its spring had withered in Zurich, New York and Berlin. And the migratory birds followed. The migration of artists to Paris strengthened the case for Dada, which in its turn gave strength to the artists.

Painters were in a different situation from writers. Painters were involved in the metaphysical revolt of the writers but the visual medium could not, by its very nature, give form to pure protest. Unless they rejected the visual altogether as a field of formal creation and communication (as Duchamp did) they had to achieve communication by means of un-literary form. This was how the visual artists preserved continuity in the field of formal creation, however anti-traditional their attitude might be. Unlike their colleagues in the verbal field, they were not forced to commit themselves to polemical statements of theory, nor to stand up for themselves in manifestoes, rows or provocations. Insofar as they were artists, their work was art, however great their enthusiasm for anti-art.

The regeneration of visual art that Dada had begun proceeded on its way without even replying to the increasingly hysterical demands for the destruction of art that were to be heard, and without misgivings over the verbal battles, shadow-boxing and cudgellings that went on between Dadaists and public and among the Dadaists themselves. Works of art appeared without any breach of the peace, and continued in the tradition of art while using the watchwords of anti-art to open up new paths. This is how visual artists preserved their independence while the Dada movement pursued its erratic course, and this enabled art to survive unscathed the violent end of Dada.

Jacques Vach

It was in Paris that Dada achieved its maximum volume and here that it met its dramatic end. The wheel had come full circle. It had started with riots, poems, speeches and manifestoes in Zurich in 1916, and with riots, poems, speeches and manifestoes it came to its end in Paris.

I was not myself present at any of the Dada activities that took place in Paris, so I know of them only by hearsay. I shall therefore rely on what Ribemont-Dessaignes, Tzara, Breton and Hugnet have written, on the original Dada

periodicals and on the personal anecdotes I have heard from time to time. The facts of this final period, the brief flowering and the long decline of Dada, have been so thoroughly dealt with in print that they may be regarded as trustworthy.

On 23rd January 1920, four years almost to the day after Ball, sitting at an out-of-tune piano in the Cabaret Voltaire, had first given the signal for the attack, the 'Premier vendredi de Littérature' was held in the Palais des Fêtes in Paris. Littérature had published Rimbaud, Mallarmé, Cross and Apollinaire, as well as those 'Lettres de guerre' by Jacques Vaché whose content (and form) so moved Breton.

The young writer and poet Jacques Vaché (Ill. 83) acquired special importance through his influence on André Breton, who, along with Tzara, was the dominant figure of Surrealism and Dada. Vaché's total independence of thought and action seems to have been adopted by Breton (and Duchamp) as a 'model' and as a symbol. Vaché "played" (as he put it) his part as a soldier in the First World War, the war he hated and despised, as he did all patriotism.

"I object", he wrote in a letter which was later published, "to being killed in war" . . . "I shall die when I want to die, and then I shall die with somebody else. To die alone is boring; I should prefer to die with one of my best friends."

Shortly after the Armistice he was indeed found lying dead with a friend, side by side, as though they had been sleeping. They had drunk the same poison. Vaché was twenty-three when he killed himself.

His fate seems to have acquired a special significance for this particular group of French intellectuals. His contempt for life and for death hangs over them like a shadow. The idea of suicide recurs frequently in poetry (Aragon) and in real life (Rigaut killed himself some years later). Vaché also clearly influenced the form that Dada took in this, its last flowering. Breton has written him a moving epitaph:

"A young man of twenty-three, who scanned the universe with the most beautiful gaze I have ever known, has mysteriously departed from us. It is easy for a critic to say that this was the result of boredom. Jacques Vaché was not the man to leave a testament behind him. I can still see him smiling as he spoke the words 'last will'. We are not pessimists. This man, who was painted lying on a chaise-longue, so very fin-de-siècle, to avoid disturbing the psychologists' categories, was the least disturbed, the most subtle of us all. I can still sometimes see him as he was when he explained to a provincial fellow-passenger in a tram: 'Boulevard Saint Michel – Quartier Latin – the shop window signals its comprehension.'

"We are reproached with failing to admit that Jacques Vaché did not create anything. He always pushed the work of art to one side – the ball and chain that hold the soul back even after death. At the same time as Tristan Tzara was issuing his decisive proclamations in Zurich, Jacques Vaché quite independently confirmed Tzara's principal thesis: philosophy is the question whether we should look at life from the standpoint of God, the Idea, or from that of other phenomena. All that we look at is false. I do not think that the nature of the finished product is more important than the choice between cake and cherries for dessert."

The Poets Attack

The December issue of *Littérature* protested against the arrest of Marinetti and contained a reply by Tzara and Rivière to an attack on Dada in the *Nouvelle Revue Française*. All this led up to the 'First Friday'.

Tzara was there in person and read his poems. The whole subsequent *haute-volée* took part: Breton, Aragon, Soupault, Ribemont-Dessaignes, Éluard, Paul Dermée, Birot, Radiguet and even Cocteau *(Ills. 85, 95)*.

Linked with this first public appearance of Dada, there was an exhibition of works by Juan Gris, Ribemont-Dessaignes, de Chirico, Léger, Picabia and Lipchitz. The music of Satie, Auric, Milhaud, Poulenc and Cliquet was played. The astonished citizens of the *quartier* were shown what they had to expect from now on. Tzara read out a newspaper article to the accompaniment of clangings, tinklings and other noises. Picabia executed a large drawing on a slate, wiping out each section as he finished it, before going on to the next. So it went on. But the Parisians, less patient than the people of Zurich, started a riot – and the whole thing ended in pandemonium.

Encouraged by this success, Tzara shortly afterwards published his *Bulletin Dada* as No. 6 of the periodical *Dada*, founded in Zurich. This bulletin contained the programmes of the next two Dada events. It was printed in the fragmentary typographical style that Dada had developed in Zurich and later in Berlin: a dance of the letters aided by all the resources of the printer's type-case. The contributors were Picabia, Tzara, Aragon, Breton, Ribemont-Dessaignes, Éluard, Duchamp, Dermée and Cravan.

Then, on 5th February 1920, in the *Salon des Indépendants*, thirty-eight speakers read manifestoes. Manifestoes by Picabia: ten speakers. Manifesto by

Ribemont-Dessaignes: nine speakers. Breton: eight speakers. Dermée: seven. Èluard: six. Aragon: five. Tzara: five. And one journalist.

These manifestoes were chanted like psalms, through such an uproar that the lights had to be put out from time to time and the meeting suspended while the audience hurled all sorts of rubbish on to the platform.

Breton defended Dada: "No effort has been made to give Dada credit for its desire not to be regarded as a school of artists. Everyone insists on using words like group, leader of a group, discipline. Some people even say that, under the pretence of stressing individuality, Dada is really a danger to individuality. They do not understand for a moment that it is our differences that unite us. Our common resistance to artistic and moral laws gives us only momentary satisfaction. We are very well aware that, beyond and above it, the individual imagination retains its total liberty – and that this, even more than the movement itself, is Dada."

PIÈCE FAUSSE

Pièce fausse
Du vers en cristal de Bohème
Du vers en cris
Du vers en cris
Du vers en
En cristal
Du vers en cristal de Bohème
Bohème
Bohème

(André Breton)

In any event, Dada had shown its claws and succeeded in unnerving the public. The third event took place at the *Université Populaire*, where the Dadaists had been invited to a public discussion of Dada and their own endeavours. This centre for adult education was an old liberal institution, and the organizers were prepared to present the most modern ideas to their students, mostly workers. By comparison with the *premier vendredi de la littérature*, this event took place in a markedly civilized atmosphere. Tzara's Dada style may have been a little cramped by his respect for the working class; provocations were avoided at the outset. Here, as in Berlin, Dada showed itself to be an anti-bourgeois movement which had a certain feeling of solidarity with the anti-bourgeois working class.

But, as Ribemont-Dessaignes points out, "It was necessary to make them understand that we were against Culture, and that we were rebelling not only

TA...RA

LA PLUS BELLE DÉCOUVERTE DE L'HOMME ES
BICARBONATE DE SOUDE.

IL N'Y A PAS D'INCONNUS EXCEPTÉ POUR MOI.

NOUS SOMMES DANS UN TUBE DIGESTIF.

...Tch D A D A paul
SA NAISSANCE, SA VIE, SA MORT

POESIE

Dermée

ALE

LE PAR LES CATHOLI

E CHOSES SUR TERRE

IRE NOTRE PHILOSO

AIT PAS LU SPINOZA

NS COMME LE VENTR

RIERE NOTRE SEXE

COLLABORATIONS DE :

LBERT BIROT
ELUARD. PIERRE
BENJAMIN PÉRET
G. RIBEMONT

...LLETIN

DADA

ON DES INDÉPENDANTS

LAMPSHADE

MAN RAY

PROVERBE
FEUILLE MENSUELLE

ÉCHANTILLON GRATUIT
Abonnements :
Édition ordinaire : 5 fr. par an
Édition de luxe : 15 fr. par an

tristan tzara

sept
manifestes
dada

quelques dessins de francis picabia

éditions du diorama
jean budry & c°
3, rue du cherche-midi
paris

PRIX : 1 FR. 50
AU SANS PAREIL

Z
1

PAUL DERM

Qu'est-ce que Dada

ADAPHONE

VENTION N° 1 N° 7

et
Proverbe
N° 6

Abonnements

PRIX :
1 FR. 50
PARIS
MARS 1920

nous aide et fait pousser

DESSIN

"391"

DADA

FRANCIS PICABIA

C'est très bon de sentir d'où vient

against the bourgeois order but against all order, all hierarchy, all sacralization, all idolatry, whatever might be the idol."

Claims of this sort became progressively more 'theoretical' as the evening wore on. The audience clearly found difficulty in swallowing ideas that consigned Napoleon, Kant, Cézanne, Marx and Lenin to the same scrap-heap. Ribemont-Dessaignes is forced to admit that the Dadaists failed to convince the workers. And this is not to be wondered at, since the movement as a whole tended towards the anarchism of Picabia. It was not until the advent of Surrealism that a socio-political programme, opposed to anarchism, was to reappear and be followed up systematically.

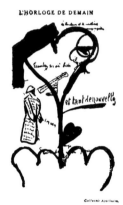

Georges Ribemont-Dessaignes,
Poem, 1920

Louis Aragon, Poem, 1920

Guillaume Apollinaire, Poem,
1915

Periodicals from A to Z

Several issues of *391* had appeared in the meantime. Picabia added a further aggressive note to his published utterances *(Ill. 86)* by publishing, between Nos. 12 and 13 of *391*, two issues of *Cannibale* (this was between March and July, 1920). New periodicals appeared as fast as old ones vanished. Paul Dermée, 'the Cartesian Dadaist' as he called himself, published *Z*, of which only one issue ever appeared. Éluard edited *Proverbe*, a publication which hinged on the question of language itself: the secrets of words, the mystery of grammar, sentences which reverse themselves, opposites that do not contradict each other, syntax, its meaning and not-meaning.

"O mouth man is seeking a new speech that cannot be dictated to by the grammarians of any language!"

176

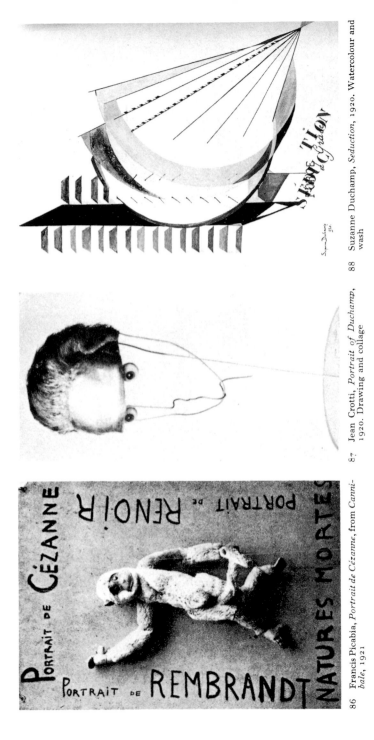

86 Francis Picabia, *Portrait de Cézanne, from Canni-bale*, 1921

87 Jean Crotti, *Portrait of Duchamp*, 1920. Drawing and collage

88 Suzanne Duchamp, *Seduction*, 1920. Watercolour and wash

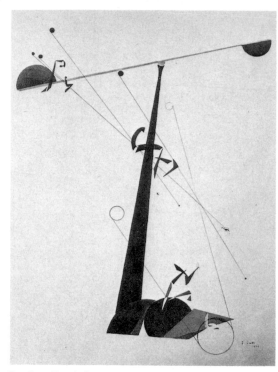

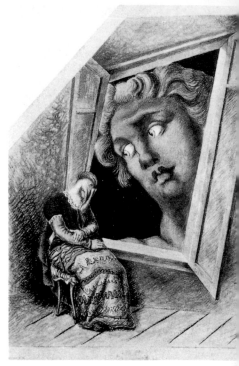

89 Jean Crotti, *Structure*, 1920. Oil

90 Alberto Savinio, *Annunciazione*, 1929. Oil

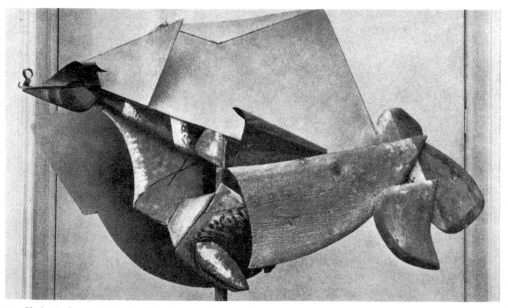

91 Umberto Boccioni, *Cavallo* (Horse), 1911. Metal and cardboard

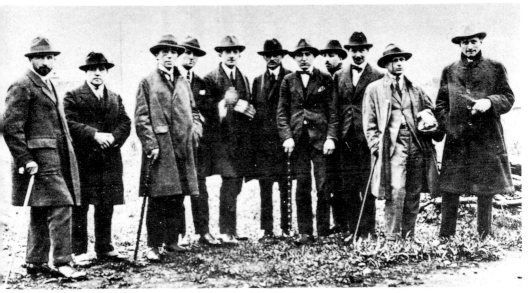

Dada excursion to Saint Julien le Pauvre, 1921. (left to right): Jean Crotti, a journalist, André Breton, Jacques Rigaut, Paul Eluard, Georges Ribemont-Dessaignes, Benjamin Péret, Théodore Fraenkel, Louis Aragon, Tristan Tzara, Philippe Soupault

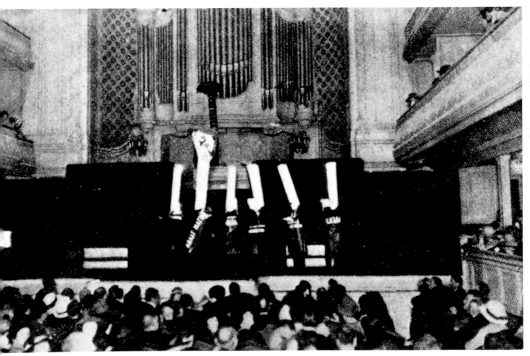

3 Dada *soirée* in the Salle Gaveau, Paris, 16th May 1920

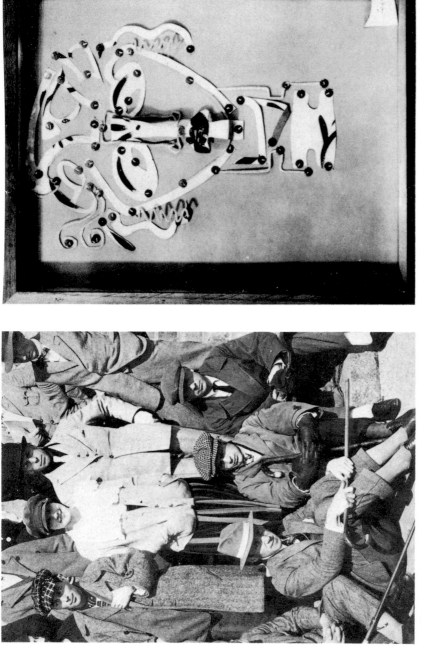

94 The final Dada reunion, Weimar 1922. Standing (left to right):
El Lissitzky, Nelly and Theo Van Doesburg. Seated: Hans Richter,
Tristan Tzara, Hans Arp

95 Jean Cocteau, *Tête aux punaises* (Head with Drawing-Pins), 1920. Collage

Proverbe investigates words and phrases, spoken and written language, the problems of form and content with which the poets of the avant-garde, like Ball, Arp and Huelsenbeck, concerned themselves. But Éluard had the advantage, to which he owed his significance, of forming part of a tradition which had lasted a hundred years, from Baudelaire, by way of Huysmans, to Apollinaire, all of whom had concerned themselves with the meaning of language.

"Aphorisms, sayings, rebuses, advertising slogans, the hallucination of words combined by usage and now taken apart: = *Proverbe.*" (Hugnet)

Tzara printed a letter-heading and some stickers with Dada slogans in various colours: not advertising slogans like 'Anna Blume' or 'Join Dada', the messages that Schwitters used to stick on things wherever he went, but Parisian slogans like "Explain: Amusement of the red bellies at the red mills of the empty skulls. Tristan Tzara."

Au Sans Pareil published a reprint of Aragon's poems, as well as *Les Animaux et leurs hommes* by Éluard, *Les champs magnétiques* by Breton and Soupault, Tzara's *Calendrier du cœur abstrait* with woodcuts by Arp, and *Unique eunuque* and *Jésus Christ Rastaquouère* by Picabia. All these publications have become the 'classics' of the French Dada movement. They constitute the high-water-mark of literary production in 1920.

Profiles

I can imagine that André Breton, whom I did not meet until the later 'twenties, when he was absolute ruler of the surrealists, must have been an astonishing figure even in his Dada period. None of the anti-authoritarianism of Dada had rubbed off on him. None of the humour either! He was a dynamic principle, whose human side could only be discovered by the use of a special kind of compass that I did not possess. In the 'thirties I often saw him at the Café Deux Magots where I used to meet Tanguy. The last occasion was just before the war when I saw Breton come across the Boulevard St-Germain, already wearing the purple collar of an army medical officer. I met him again a few times in New York, in Max Ernst's and Peggy Guggenheim's house on the East River, or at a Tanguy exhibition, or at his own studio-flat in the Village. But he was always the mountain and I was always the mouse. His *humour noir*, the only kind of humour I ever discovered in him, was always a judgment, made final by his penetrating, leonine gaze.

As I never really crossed his path, or him, I only know him from his polite side. This has prevented me from ever talking to him about anything of significance. I was careful to avoid falling into the clutches of the surrealist movement. However much I might admire, indeed love, his *Nadja,* I could not bring myself to enter the magic circle in which contests between Surrealism and Sub-realism, ex- and in-communication, adoration and damnation, never ceased. A short while ago I saw him in Paris, walking past the Café Flore with the springy, dancing gait that reminds me of Huelsenbeck, a solitary figure like a still-unmoulded monument.

Louis Aragon I only met a few times, in 1931, and my memories of him are vague but quite amicable, as one might remember a seaside holiday spent with one's family on the Baltic. I have maintained a sort of anonymous contact with him through reading his books, and have always retained an image of him as a magnificent poet and writer which has kept his memory fragrant even in the absence of another meeting.

With Philippe Soupault, on the other hand, I have had frequent contacts. We corresponded as early as the Dada period itself. He sent me his poems, or I found them somewhere. One of them I published in my periodical *G* in 1924, in a translation by Walter Benjamin. Soupault's elegance and lightness of touch, together with his great gifts as a poet, appealed to me enormously, so much so that I intended to make a film of one of his poems. Something or other prevented this, to my great and lasting regret. Our contacts in later years have been less fruitful, although I have met him in person far more often, both in Europe and in America.

I did not meet Benjamin Péret until after the Second World War, in Paris. A group of very young surrealists, who used his reputation as a sort of alibi, introduced me to him. We had a meal together and were going down the Boulevard Saint-Germain when a Catholic priest came along. To my bewilderment, Péret stopped in front of this unsuspecting and inoffensive individual and spat on the ground. Péret's opposition to all national and ecclesiastical authority was still just as unyielding when he died, in a squalid little room, a few years later. He never had any money, and never, at any time, had the remotest idea of how to come by the necessities of everyday life. A wholly unromantic Romantic, an anti-politician who engaged in politics, he was an uncompromising rebel and spat whenever he felt like it. He was the only one of the old guard to remain a loyal and admiring follower of Breton all his life. His unyielding nature is expressed in a literary output which reveals a unique talent.

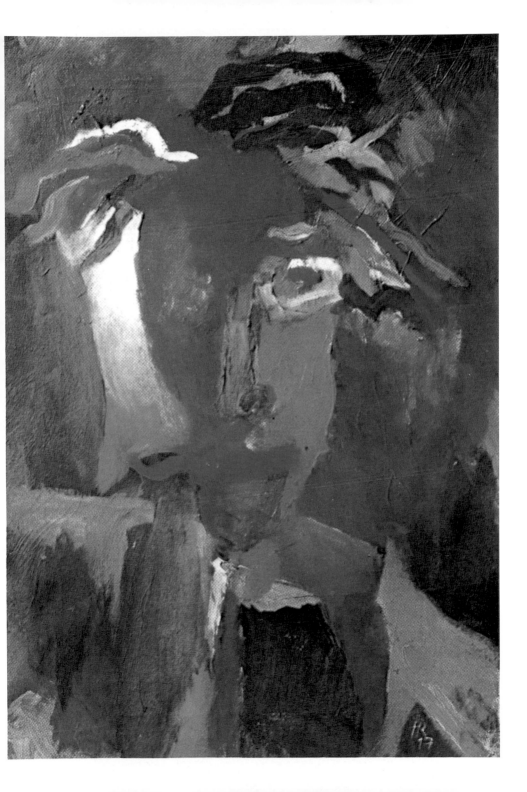

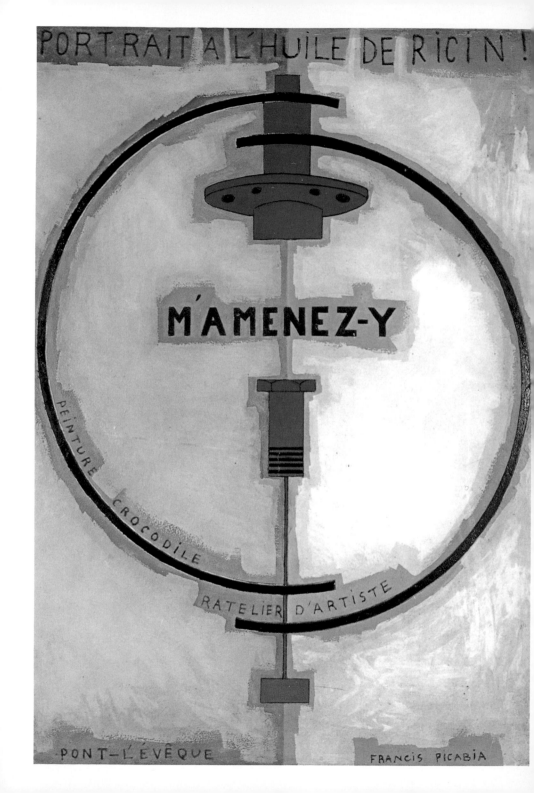

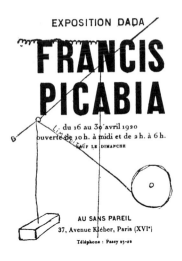

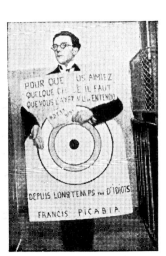

Francis Picabia, Exhibition catalogue,
Paris 1920

André Breton with a Dada placard
by Francis Picabia

Climax

In April 1921, in the gallery *Au Sans Pareil*, Picabia had an exhibition of pictures from his 'mechanist' period, like those he had shown in Zurich in 1918. Ribemont-Dessaignes also had an exhibition, which gave proof of the passionate love of painting that even his intensive literary activity could not serve to displace.

Meanwhile, Dr Walter Serner, who had close links with the Paris movement, turned up in Geneva. There he held a great Dada Ball with musical items which included a piece played on a piano without a keyboard and a love-duet between an *ornithorynque* and a *feuille fédérale*, along with a '*Rêverie du brontausaure* [sic] *délaissé*' by Tzara. All this in the setting of an exhibition of Arp, Picabia, Schad and Ribemont-Dessaignes.

But not everybody remained in step. Archipenko, who had revolutionized modern sculpture in 1909, Gleizes, one of the first theoreticans of Cubism and a former New York and Barcelona Dadaist, and Survage, a member of the respected '*Section d'Or*', which represented modernism (yesterday's modernism?) had taken a drawing of Ernst's between their sights and criticised it. Enough is enough! They broke with Dada.

On 7th March 1920, appeared the seventh issue of *Dada* which Tzara had rechristened *DADAphone,* and which contained, *inter alia,* portraits of the Paris group and a poem by Breton.

◁ VIII Francis Picabia, *M'amenez-y, Portrait a l'huile de rhizin.* Oil on cardboard 125 x 90 cm.
Collection Hans Arp, Solduno

On the day when *DADAphone* was published, which was the twenty-fifth anniversary of the tumult that accompanied the première of Jarry's *Ubu Roi*, there was a great Dada soirée at the Théâtre de l'Œuvre. But this time everything had been carefully planned. It was a proper variety show, but instead of un-dressed girls, there appeared the fully-dressed Breton, Soupault, Dermée and others, acting in their own plays. The programme included Tzara's *La première aventure céleste de M. Antipyrine,* with which he had already achieved success in Zurich, *Le serin muet* by Ribemont-Dessaignes, *S'il vous plaît* by Breton and Soupault, *Le ventriloque désaccordé* by Paul Dermée, and Picabia's *Manifeste cannibale dans l'obscurité.* But as Picabia never appeared in person – Ribemont-Dessaignes has accused him of physical cowardice – the manifesto was read by Breton.

Manifeste cannibale Dada

"You are all indicted; stand up! It is impossible to talk to you unless you are standing up. Stand up as you would for the *Marseillaise* or *God Save The King.*

"Stand up, as if the Flag were before you. Or as if you were in the presence of Dada, which signifies Life, and which accuses you of loving everything out of snobbery if only it is expensive enough.

"So you have sat down again. So much the better. You will listen more atten-·tively.

"What are you doing here, crammed in like a lot of serious-minded crusta-ceans? Because you are serious-minded, aren't you? Serious, serious, serious unto death. Death is a serious matter, isn't it?

"One dies a hero's death or an idiot's death – which comes to the same thing. The only word that has more than a day-to-day value is the word Death. You love death – the death of others.

"Kill them! Let them die! Only money does not die; it only – goes away for a little while.

"That is God! That is someone to respect: someone you can take seriously! Money is the *prie-Dieu* of entire families. Money for ever! Long live money! The man who has money is a man of honour.

"Honour can be bought and sold like the arse. The arse, the arse, represents life like potato-chips, and all you who are serious-minded will smell worse than cow's shit.

"Dada alone does not smell: it is nothing, nothing, nothing.

It is like your hopes: nothing.

like your paradise: nothing.
like your idols: nothing
like your politicians: nothing.
like your heroes: nothing.
like your artists: nothing.
like your religions: nothing.

"Hiss, shout, kick my teeth in, so what? I shall still tell you that you are half-wits. In three months my friends and I will be selling you our pictures for a few francs."

Ribemont-Dessaignes describes the evening from a psychological point of view in *Déjà jadis*.

"A numerous audience (the hall was full to bursting) had run riot. What they already knew about Dada had brought them along in the pleasurable anticipation of a scandal. And they were indeed continually provoked; their artistic and intellectual habits of mind were assailed. To laugh at art, at philosophy, at aesthetics, at ethics, at the established order, at dogmas, at the Absolute which governs all actions, collective and individual, was to make a fool of the audience itself. This is what Dada did, breaking open the categories in which are contained, and which express, all those principles that are still in any way sacred. So the audience felt within its rights in launching a counter attack, shouting, booing and hissing. At the same time, however, it was glad to have got what it came for.

"As for Dada, it too had got what it wanted: the fury of the bourgeois. This gave it new vigour and a solid base from which it could launch new attacks."

The climax of the Paris Dada movement came on 26th May 1920 at the monster gathering at the Salle Gaveau *(Ill. 93).*

It had been advertised that the Dadaists would have their hair cut off on the stage, and for this spectacle the audience was prepared. After all the provocations it had received, it was now prepared to play an active part in the proceedings.

"Breton with a revolver attached to each temple, Eluard as a ballerina, Fraenkel in an apron, Soupault in shirt-sleeves, all the Dadaists wearing tubes or funnels on their heads . . ." (Hugnet)

Tomatoes and eggs were thrown on the stage. "In the interval, some [members of the audience] even went to a local butcher's shop and provided themselves with escalopes and beef-steaks . . . According to their trajectory, these missiles either fell on the stage or, sometimes, went astray . . ." An appropriate accompaniment to the poems, manifestoes and sketches of Paul Dermée, Éluard, Tzara,

Ribemont-Dessaignes and Breton! "One ripe tomato burst on a pillar of the box where Mme Gaveau [the owner of the hall] was watching the show, not without indignation . . ."

"One of the best acts was Soupault's, which was called '*Le célèbre illusionniste*'; it consisted of releasing multi-coloured balloons, each bearing the name of a famous man." (Ribemont-Dessaignes)

Not only Mme Gaveau, but Breton and even Ribmont-Dessaignes were not entirely pleased with the performance, which included a musical item, Tzara's *Vaseline Symphonique* (performed by twenty people). Breton detested music in general, and seemed particularly put out that he, who has always had a just awareness of his own importance, had to play the part of a mere performer in something by Tzara.

The performance at the Salle Gaveau was nevertheless an enormous *succès de scandale*, both with the audience, which immensely enjoyed its active participation, and with the press, which tore Dada to bits and spat out the pieces. Paris was – in this way – conquered, and there was nothing left for Dada to do. The demolition of bourgeois attitudes had been set in train. Everyone was discussing Dada and reacting, whether positively or negatively, to its programme, which consisted of anti-authority, anti-conduct, anti-church, anti-art, anti-order, daemonic humour.

In spite of his annoyance, Breton succeeded in getting a very flattering article about Dada into the *Nouvelle Revue Française* and thus making Dada a fit subject for discussion in the salons. The very classicists of the *N.R.F* themselves discussed and criticized Dada. Dada was taken seriously!

Shortly before this, Breton had introduced the painter Max Ernst to the Parisian public for the first time in an exhibition at the '*Sans Pareil*'.

"A little pink prospectus promised the public 'Drawings, mechanoplastic and plastoplastic. Pictopictures, anaplastic anatomic antizymic aerographic antiphonary irrigable and republican. Entry free – with hands in pockets. Exit easy – with picture under arm. BEYOND PAINTING".

A critic wrote: "The setting was the cellar. All the lights were out, and groans came from a trapdoor in the floor. Another joker, hidden behind a cupboard, was insulting those present . . . André Breton was striking matches. G. Ribemont-Dessaignes was shouting, over and over again, 'It is raining on to a skull.' Aragon was mewing. Ph. Soupault was playing hide-and-seek with Tzara, while Benjamin Péret and Charchoune were shaking hands again and again . . . " (Hugnet)

Humour, anti-seriousness, was the basic Dada attitude: the irony of a bluff totally without good-humour. Mockery of all the values of bourgeois society, of all its debased and phony ideals of decency and morality, of religion, state and fatherland – this constituted the defeat of everything that was 'holy' to the bourgeois. Not only 'black humour' and annihilating satire, but simple laughter could destroy. And this was something the Dadaists spared neither their contemporaries nor themselves.

The internationalism of Dada found expression in 1921 in a pamphlet called *Dada soulève tout*. It ended with the statement that the signatories of the manifesto, although they lived in France, Germany, Italy, Switzerland, Belgium, etc., belonged to no nationality. "Dada knows everything. Dada spits on everything. Dada is no *idée fixe*", and so on. We have heard this tone of voice before, in Zurich and Berlin. It admittedly sounds different in French, but repetition gives it a certain *haut goût*.

Something was bound to happen. Ribemont-Dessaignes describes, in *Déjà jadis,* how they met every week in Picabia's studio or in a café to thrash out new ideas. It was obvious that the public was now ready to accept 'a thousand repeat performances' of the evening at the Salle Gaveau. "At all costs, they must be prevented from accepting a shock as a work of art." (Ribemont-Dessaignes)

The eternal repetition of the same antics, month after month, began to embarrass some of the Dadaists; Breton accused Tzara, who, as 'Monsieur Dada', still held the reins in his own hands, of being responsible for this stagnation.

Excursions and the 'Procès Barrès'

At these sessions, at which Picabia seems to have been in the chair, each individual was expected to make suggestions as to how they could escape from this impasse. Two plans were finally accepted. The first: excursions in Dada style. The second: a mock-trial of Maurice Barrès.

The first excursion was to be on 14th April, to Saint Julien le Pauvre *(Ill. 92)*. This was a deserted, almost unknown church in totally uninteresting, positively doleful surroundings. More excursions were due to take place later. The guides were to be Gabrielle Buffet (Picabia's first wife, now separated from him), Aragon, Breton, Eluard, Fraenkel, Huszar (of *De Stijl*), Péret, Picabia, Ribe-

mont-Dessaignes, Rigaut, Soupault and Tzara. Picabia backed out at the last moment, as he usually did on public occasions.

This first excursion, manned by the whole Dada group, was a complete failure. It rained, and no one came. The idea of further similar enterprises was abandoned. They turned to the second suggestion, the trial of Barrès. This was staged on 13th May 1921, in the Salle des Sociétés Savantes, under the title of *'Mise en accusation et jugement de M. Maurice Barrès'*, and was planned as a monster affair.

Here the currents and cross-currents existing within Dada were brought into the open. One section of the Dada movement took the trial quite seriously. Both as a writer and as a person, Barrès had been the ideal of many of the Dadaists in their youth. He had then turned 'traitor' and become the mouthpiece of the reactionary newspaper *L'Echo de Paris*.

The presiding judge was Breton, and his two colleagues on the bench were Fraenkel and Dermée. The public prosecutor was Ribemont-Dessaignes, the defence counsel Aragon and Soupault, the witnesses Tzara, Rigaut, Péret and others, among them the Italian poet Giuseppe Ungaretti. Barrès himself was tried in his absence, his place being taken by a tailor's dummy. He, the former hero of the young intellectuals, was accused of an 'offence against the security of Mind'.

Prosecution and defence counsel, and the witnesses, spoke for and against Barrès. The whole thing was a mixture of idealism and farce, the two opposing poles being represented by Péret and Tzara. Breton, in his *Entretiens*, singles out Péret (who played the 'unknown soldier') for special praise, and says that he threw himself into "the poetic adventure" without reserve, while Tzara persisted in "Dadaist buffoonery" and ended his testimony with a song.

Picabia, who left the hall before the end of the trial, and Tzara had opposed this excessively serious undertaking on principle. They had regarded the whole thing as merely an opportunity for 'cannibalistic provocations'. It was therefore understandable that Tzara should seek, in Dada style, to reduce the whole thing to the level of absurdity, while Péret, on the other hand, used it to convey an anti-nationalist message through his impersonation of the *'soldat inconnu'*. The general effect on the public was "not much like Dada". (Ribemont-Dessaignes)

After the Barrès affair the paths of the three groups led respectively by Breton, Tzara and Picabia began to diverge. A soirée and a *'Grande Après-Midi Dada'* were announced for the 8th and 18th of June, but Breton refused to take part. For him the time for anarchy was past. Picabia, on the other hand, demanded yet more anarchy. His periodical *391* now bore the name *Le PILHAOU-*

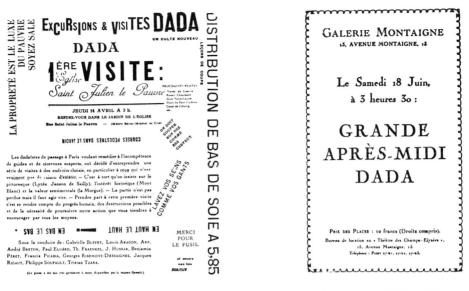

First Dada excursion, April 1921 Dada 'afternoon', 18th June 1921

THIBAOU, the origin and meaning of which were and are a mystery to even the most learned linguists among his friends. These two tendencies now faced each other. They brought into the open an apparently irreconcilable divergence of views. But this very contradiction revealed something that was always characteristic of Dada, its double nature in which the forces of dissolution were always matched with other forces seeking form and substance. Dada grew on the tension between the two, as long as they remained in equilibrium; when this was lost, the presence of incompatible personalities caused the whole thing to disintegrate.

The angry nihilism of Picabia, the cheerful cynicism of Ribemont-Dessaignes, the practical cynicism of Tzara, rejected all values as such. With Duchamp, these three denied the existence of an 'adequate reason' for this earthly life. But the things they then created represented a kind of Order. Looking at their works – pictures and collages, poems and manifestoes – one can detect the echo of a search for form and substance. Their nihilism was sincere but limited. The artistic temperament is obviously incapable of destroying anything without at the same time creating something else.

Meanwhile the controversy over the Barrès affair continued. Even Ribemont-Dessaignes, who had hitherto been ready to stand by Picabia in any exploit

185

designed to implant Dada with a red-hot iron in the *Sitzfleisch* of the public, now rebelled.

"The ceremony itself, with its embryonic judicial costumes and properties, its tone of high seriousness with scarcely a hint of satirical comedy [although this was just what it was supposed to be!] aroused considerable public interest . . .

"Aragon was defending counsel and was brilliant. There was something in him still of the student who had worshipped Barrès. But what can I say? Breton himself had loved Barrès, as had many others. It was doubtless for this reason that he chose him as the victim of his first 'indictment'.

"But Dada itself was no longer on the scene. Dada could be a criminal, a coward, a destroyer or a thief, but not a judge. The 'first indictment' left us morose, with an unpleasant taste in our mouths. There were no others." (Ribemont-Dessaignes: *Déjà jadis*)

Anti-Anti and the 'Congress of Paris'

However, there was as yet no breach between the different groups despite the open disagreements about the Barrès 'trial'. In the summer of 1921 we find Breton and Tzara with Ernst and Arp at Imst in Tirol, where they published together one more Dada document, *Dada au grand air (Ill. 96)*. Exhibitions of the work of Man Ray, who had just turned up in Paris, and Picabia should also be mentioned. But the element that had held the Dada movement together, the fury of public opinion, had lost some of its cohesive power, and not only through the 'trial' of Barrès. Not much remained of the explosive shock of arousal, the *anti*, which had been Dada's original moral credo.

The enthusiasm that had led to the formation of the group had now dissipated. It left behind a number of individuals who now felt themselves to be individuals rather than members of a group.

Soon there were open divisions. Picabia was against Tzara, Ribemont-Dessaignes against Picabia, Tzara against Breton, Breton against Picabia, and so on.

Dada was approaching a crisis to which there was no solution. The weapons it had wielded with such success for six years, with so much expenditure of wit and perfidy, sense and nonsense, art and anti-art, the weapons of confusion and provocation, were now turned against Dada itself. The whirlpool it had itself set in motion now sucked it under.

As was proper, it went down with drums beating and colours flying, and not without an almighty row.

The matter was brought to a head by the so-called 'Congress of Paris', convened, according to Tzara, to decide "whether a railway-engine was more modern than a top-hat."

If the title 'Congress of Paris' aroused Napoleonic associations, this was only appropriate in that a new dominant figure appeared, one who replaced the former caprice and confusion with strict authority and discipline: this was André Breton.

Breton was weary of demonstrations which led to nothing. His methodical mind naturally inclined towards orderliness. The process of dissolution, of society and of art, that he had himself supported, he now considered to be accomplished. Apart from this, he now wanted to take over the leadership himself and lead the movement his own way towards his own ends.

Tzara and Breton had both become 'public figures' through Dada and were the leaders of a Parisian avant-garde that was taking up a leading position in the world of European art and letters. This position was now at stake. Daggers were drawn, phials of poison prepared, man-traps laid.

This was the atmosphere in which the '*Congrès international pour la détermination des directives et la défense de l'esprit moderne*' was to take place. A number of the delegates were more or less opponents of Dada: Léger, who later made *Ballet mécanique,* one of the best Dadaist films, Delaunay, Ozenfant (representing *Esprit Nouveau*), Paulhan *(N.R.F.),* Vitrac *(Aventure)* and Breton *(Littérature)* as well as the composer Auric, against whom the composer Satie carried on a savage feud in *391.* In spite of this, it seemed an interesting idea to 'compare' Dada's stylistic components with those of the Cubists, Orphists, Purists, and so on.

From the Dada point of view, this congress was, to say the least, a curious undertaking. To engage in a rational discussion with these artists, free of all confusion, appeared to be totally contrary to the spirit of Dada.

As Tzara told it to me (I shall give Breton's side of it later), Dada accepted the invitation solely for the purpose of torpedoing the whole business and making the efforts of the congress ridiculous from the very start. Tzara's followers thought that Breton 'as a good Dadaist', would take on himself the role of a detonator to blow the Congress sky high.

But Breton did nothing of the sort. He took the Congress perfectly seriously. He appeared to attach importance to answering the problems that stood on the agenda – and if one considers his later career, this seems quite logical.

The Dadaists learned of his 'treacherous' attitude and rebelled. Breton came under the cross-fire of his former friends, and failed to justify himself.

Breton naturally has a totally different assessment both of the situation and of what he owed to himself and to the Dadaists. In *Entretiens* he says that the committee declared itself ready to take part in the discussion of these problems, but "a bitter struggle was on the way. Tzara's inevitable opposition, and the insidious ways in which it operated, led me – I freely admit it – into an error of judgment."

Breton's error of judgment was to direct personal insults at Tzara. The fact that he described Tzara, in a 'common newspaper', as an interloper from Zurich and a 'publicity-seeking impostor' shows how cornered and alone Breton must have felt, he who had always condemned such arguments as 'vulgar'.

Le cœur à barbe (The Bearded Heart)

The reaction to this unpardonable blunder was the opposite of what Breton had intended. The 'old guard' of Dada spontaneously closed their ranks against Breton and offered their services to Tzara for his counter-manifesto *Le cœur à barbe*. The pamphlet was written by Huidobro, Péret, Satie, Serner, Rrose Sélavy (Duchamp), Soupault and others.

"We, the undersigned, withdraw our confidence from the committee of the Congress: Satie, Tzara, Ribemont-Dessaignes, Man Ray, Éluard, Zadkine, Huidobro, Metzinger, Charchoune, Radiguet, Emmanuel Fay, M. Herrand, Férat, Roch Gray, Raval, Nic. Bauduin, Zborowsky, van Doesburg, Zdanévitch, Voirol, Pansaers, Survage, Mondzain, Marcelle Meyer, Arp, Dermée, Céline, Romoff, Péret, Sauvage, Arlan, Cocteau."

The rift within Dada was first publicized in a frontal attack by Picabia on Dada and Tzara. In *Comœdia* there was a report, in complacent tones, headed 'Picabia breaks with Dada'. This was the signal for a slump in Dada's share values from which Dada was never, except fleetingly, to recover. *Le PILHAOU-THIBAOU*, which appeared as No. 15 of *391*, deepened the rift with all Picabia's diabolical thoroughness. Thereupon most of Picabia's contributors disowned the 'traitor'. Even his most faithful friend, Ribemont-Dessaignes, switched to Tzara's side. Picabia invited a new team to contribute to *391*. Of these, Cocteau especially was a thorn in Dada's flesh. Other new contributors were Ezra Pound and the Belgian Clément Pansaers. Picabia himself meanwhile changed neither

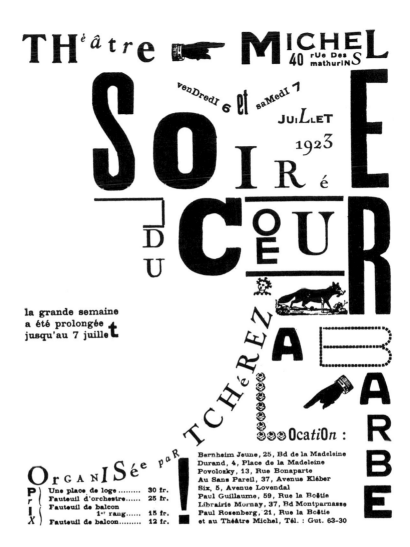

The Bearded Heart, Théâtre Michel, 6th and 7th July 1923: poster

his style nor his attacks. With a special pamphlet called *La pomme de Pin*, written against Tzara, he took Breton's part against all the signatories, while these, together with Tzara, backed the attacks contained in *Le cœur à barbe*.

The '*Soirée du cœur à barbe*', July 1923, had music (Auric, Milhaud, Stravinsky), designs (Delaunay, Doesburg), films (Sheeler, Richter, Man Ray) and plays (Ribemont-Dessaignes' *Mouchez-vous* and Tzara's *Le Cœur à gaz*), readings (Herrand) and phonetic poems (Iliazde).

"I remember that evening," writes Hugnet, "which ended with an uproar that came close to carnage. When the time came for the performance of *Le cœur à gaz,* the actors . . . were suddenly interrupted by violent protests from the stalls. Then an unexpected interlude: Breton hoisted himself on to the stage and started to belabour the actors. The latter, hampered by Sonia Delaunay's solid cardboard costumes, were unable to protect themselves and made efforts to flee with tiny steps. Breton boxed Crevel's ears roundly and broke Pierre de Massot's arm with his walking-stick. Recovering from its stupefaction, the audience reacted. The implacable demonstrator was brought down from the stage. Aragon and Péret joined him and all three were shaken, dragged away and forcibly expelled, their jackets torn apart. Hardly had order been restored when Éluard climbed on to the stage in his turn. This action seemed surprising in one who was a friend of Tzara. But the members of the audience were not concerned with such subtleties, and the author of *Répétitions* was at once leapt on by a group of spectators inflamed by the preceding rough and tumble. Overwhelmed by their numbers, Éluard collapsed into the footlights, breaking several lamps. While his friends sought to save the gentle poet from reprisals, the uproar in the hall brought the intervention of the police. When the mêlée had dispersed and the pushing subsided, the silence seemed unnatural. I can still hear the director of the Théâtre Michel, tearing his hair at the sight of the rows of seats hanging loose or torn open and the devastated stage, and lamenting 'My lovely little theatre!' "

Le cœur à barbe and *Le cœur à gaz* were Dada's swan-song. There was no point in continuing because nobody could any longer see any point. So there were exchanges of smears, insults libels between one group and the other, and indeed between a periodical (*391*) and its own contributors. All this was linked with the movement's gradual loss of its inner power of conviction. The more it lost this power, the more frequent became struggles for power within the group, until the hollow shell of Dada finally collapsed.

In this situation of decadence it became clear that the deeds of the participants – and the things they imagined – sprang not only from an idea but from a personal struggle for power. It was the same process that had finally brought

about the end of Berlin Dada. Dada's span of life was accomplished, and there was no cure for that. Of course, both Breton and Tzara did stand for something: Tzara for the rescue and preservation of Dada, which was fast disintegrating, and Breton for a new idea.

Envoi

At the *Bauhausfest* in Weimar in May 1922, a few Dadaists – Doesberg, Arp, Tzara, Schwitters and myself among them – met for a farewell to Dada *(Ill. 94)*. Tzara delivered a funeral oration in Weimar, Jena and Hanover, and Schwitters printed it in his periodical *Merz* as *Conférence sur la fin de Dada*.

"Dada marches on, destroying more and more, not in extension but in itself. From all these feelings of disgust it draws no conclusion, no pride and no profit. It no longer even fights, for it knows that this serves no purpose, that all this has no importance. What interests a Dadaist is the way he himself lives. Here we come to the great secret.

"Dada is a state of mind. This is why it transforms itself according to the races and the events it encounters. Dada applies itself to everything, and yet it is nothing; it is the point at which Yes and No, and all opposites, meet; not solemnly, in the palaces of human philosophy, but quite simply, at streetcorners, like dogs and grasshoppers.

"Dada is useless, like everything else in life.

"Dada has no pretensions, just as life should have none.

"Perhaps you will understand better when I tell you that Dada is a virgin microbe which penetrates with the insistence of air into all those spaces that reason has failed to fill with words and conventions."

On one more occasion Dada showed a certain solidarity in resistance and negation. Marinetti and Russolo put on a Bruitistic concert and were hissed by their former friends. Both had been forerunners and trail-blazers for Dada. The row ended with Dada being, literally *'à l'instant'*, thrown out of the Theâtre des Champs Elysées, where the concert took place.

Picabia, prudently absent, had completely withdrawn into his own Dada citadel when the final storm began.

Meanwhile, Breton had marshalled his forces, and at the opening of a Picabia exhibition in Barcelona in 1923 he made a policy speech on the character (and the characters) of the evolution of modern art. It goes without saying that Tzara and his friends did not get a mention.

Picabia went on giving constant proof of his independence. In painting, his machine period was over. Now he was drawing what I might almost call popular prints. They were quite conventional in style, but closer examination left no doubt as to Picabia's undiminished aggressiveness. This was directed principally against Rimbaud, who then enjoyed a particularly high reputation, but also against his former friends and contributors to *391*.

In November 1924, he founded, together with Duchamp and Dermée, the very last offshoot of Dada, the 'Instantaneist' movement, to which he devoted the nineteenth and last issue of *391*. Under the text of the title page there appeared an affectionate portrait of Arthur Cravan drawn by Picabia in 1920. The word 'Instantaneism' emphasized yet again the central experience of Dada, as Picabia saw it, and as he wanted it to be: the 'value of the instant'.

This issue contained furious attacks on Breton, with whom he had earlier leagued himself against Tzara. "André Breton reminds me of Sacha Guitry, but is more antiquated that he is", etc., etc. After this last frontal assault Picabia permanently associated himself with Breton and Breton's Surrealism . . . loyal to the last to his own disloyalty and to his principle of having no principles!

After Dada had proclaimed for six years that everything must be, ought to be, and was being put an end to, turned upside down and left there – it put an end to itself.

"Dada will survive only by ceasing to exist", J. E. Blosche prophesied in his manifesto *Dada Prophetie* (1919). Dada had given birth to a new way of thinking, a new attitude, a new ethos both in the world of men and in the world of objects, both in art and in thought. But, by its very nature, it could never refuse to accept 'transitoriness', the ephemeral, even if they applied to Dada itself. It could not become a discipline or a theory – not in a universe of liberty that it had itself set out to claim.

Tzara, Picabia and Ribemont-Dessaignes were perfectly justified in opposing Breton's efforts towards normalization. Dada believed in the divine rightness of individual freedom as the only source of what is new. It was this that brought Tzara one last victory, and isolated Breton. If Dada's time had not run out, Breton might well have been the loser. But the dialectical process which led from total lack of system to a new systematic structure was ineluctable.

Thus Breton was perfectly justified too. A discipline, a theory, a definite attitude, had become both inevitable and essential. In the end Breton grew tired of the monotonous repetition of rows, betrayals, pieces of nonsense all springing from a pure spirit of contradiction, and of the performances which followed each other in such rapid succession. He treated the irrepressible Picabia with

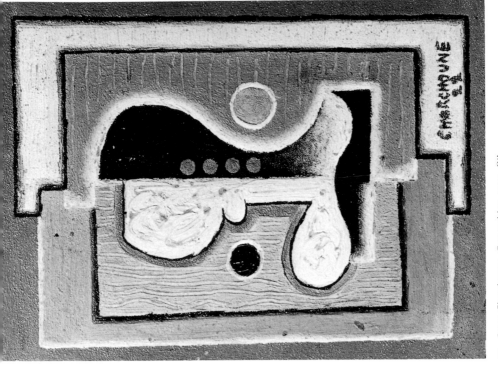

DADA

DER SÄNGERKRIEG

IN TIROL

AU GRAND AIR

TARRENZ B. IMST 16 SEPTEMBRE 1886–1921 1 FR. 2 MK.

EN DEPOT AU SANS PAREIL 37 AVENUE KLÉBER PARIS

NET

MAX ERNST: Die Leimbereitung aus Knochen

La préparation de la colle d'os

Un ami de New-York nous dit qu'il connait un pickpocket littéraire; son nom est Funiggy, célèbre moraliste, dit bouillabaisse musical avec impressions de voyage.

Tzara envoie à Breton: une boîte de souvenirs conservés dans du lait d'autruche et une larme batavique munie d'indications pour sa transformation en poudre d'abeilles. Il est attendu à Tarrenz b. Imst par le rire morganatique des plaines et des cascades.

Le titre de ce journal appartient à Maya Chrusecz.

Wir kochen geneigte Herrschaften in Parafin und hobeln sie auf.

Arp visse S. G. H. Taeuber sur le tronc d'une fleur.

Dans le catalogue du salon Dada il se trouve une erreur que nous tenons à corriger. Le tableau mécanique de Marcel Duchamp. Marcel n'est pas daté de 1914, comme on voulait nous faire croire, mais de 1912. Ce premier tableau mécanique a été peint à Munich.

La baronne Armada de Duidgedazlen, connue dans l'histoire sous le nom La Cruelle, a organisé devant des invités, sur les domaines à Tarrenz, un massacre parmi les paysans des environs.

Maintenant que nous sommes mariés, mon cher Cocteau, vous me trouverez moins sympathique. En Espagne on ne couche pas avec les membres de sa famille, dirait Marie Laurencin.

Tzara envoie à Soupault: « baleines en éponge molle, 2 aiguilles pour l'empoisonnement des arbres, un peigne perfectionné à 12 dents, un lama vivant et agité et une pomme cuite au jambon de cadavre. » A Mic les salutations de son cœurouvert.

Arp envoie à Eluard: un turban d'entrailles et 4 chambres Benjamin Péret: des minéraux bouillis des crapeaux de fourmilières et des postiches sur l'impériale couronnée par les putains des souris.

Funiggy a inventé le dadaïsme en 1899, le cubisme en 1870, le futurisme en 1867 et l'impressionnisme en 1856. En 1867 il a rencontré Nietzsche, en 1902 il remarqua qu'il n'était que le pseudonyme de Confucius. En 1910 on lui érigea un monument sur la place de la Concorde tchéco-slovaque, car il croyait fermement dans l'existence des génies et dans les bienfaits du bonheur.

Tzara envoie à Marcel Duchamp: des bonbons d'amour trempés dans du whisky nègre et un nouveau divan turc muni de cuisses vivantes te pucelle.

A Man Ray: Une carte postale transparente avec les montagnes et le reste, et d'un frigorifère qui parle français à l'approche d'un magnéto.

A Marguerite Buffet: un paquet de chocolat à la boutonnière ainsi que 3 notes musicales d'une qualité tout-à-fait exceptionnelle.

TRISTAN TZARA

Paris (16), 12 rue de Boulainvilliers.

Der Sängerkrieg in Tirol: Dada au grand air (Dada in the Tyrol), 1921, with a collage-drawing by Max Ernst

Serge Charchoune, *Composition*, 1920. Oil

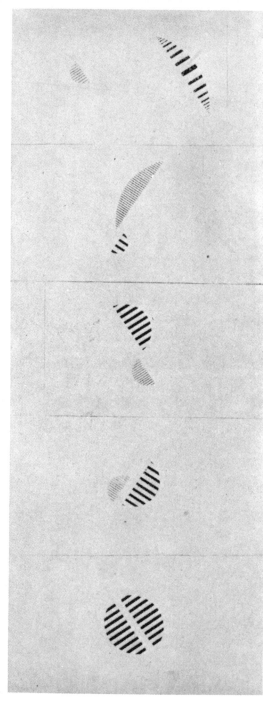

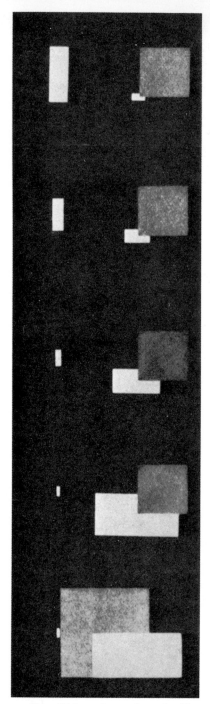

98 Viking Eggeling, frames from the film *Diagonal Symphonie*, 1921–23

99 Hans Richter, frames from the film *Rhythmus 21*, 1921

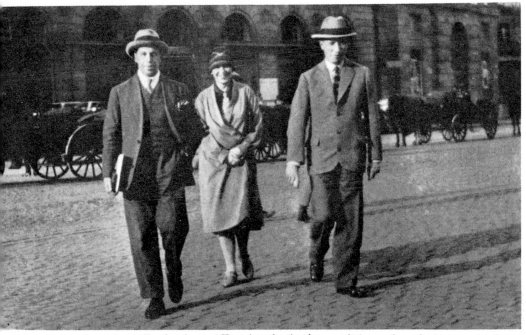

Theo van Doesburg, Sophie Taeuber-Arp and Hans Arp, shortly after completing work on the Restaurant Aubette, Strasbourg, 1927

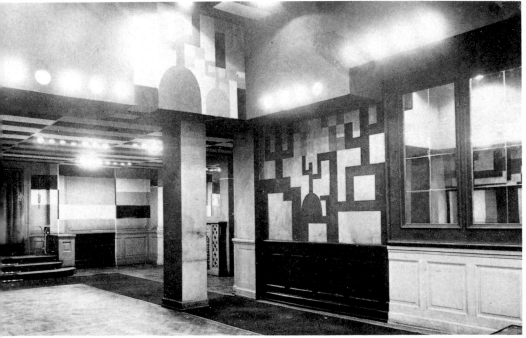

Sophie Taeuber-Arp, room at the Aubette, 1927

PLASTIQUE MODERNE DE L'ESPRIT ITALIEN

MÉCANICIEN PLASTIQUE: THEO VAN DOESBURG

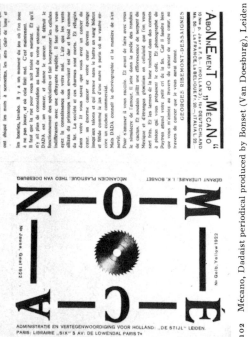

MÉCANO

GÉRANT LITTÉRAIRE: I. K. BONSET

No Geib: Yellow 1922
No Jaune: Geel 1922

ABoNnEMENT OP "MÉCaNo"
p. Jaar: 4 F. F. (HOLLAND), für DEUTSCHLAND
M. 50.—, p. Jaar: 4 F. F. LA FRANCE, LA BELGIQUE: 10.—, ITALIA: 22

GEORGES RIBEMONT-DESSAIGNES

MANIFESTE A L'HULLE

La Chimie est une science élégante et s'avance avec la vitesse d'un myriapode. Les artistes qui colorisent leur science comme les prêtres posent qui colorisent le hasard en ont tiré des résultats merveilleux. C'est ainsi qu'on découvre le rôle du fer, du calcium, d'azure, du zinc dans l'organisme humain et leur nécessité. Et l'on attend de découvrir la même nécessité pour des corps nouveaux.

[...]

ADMINISTRATIE EN VERTEGENWOORDIGING VOOR HOLLAND: "DE STIJL" LEIDEN.
PARIS: LIBRAIRIE "SIX" 5 AV: DE LOWENDAL PARIS 7e

102 Mécano, Dadaist periodical produced by Bonset (Van Doesburg), Leiden 1922

103 Lajos Kassák, *Collage*, Vienna-Budapest 1922

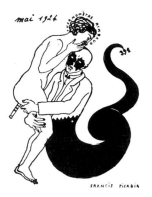

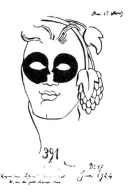

Francis Picabia, Drawings from *391*, 1924

great respect, it is true, but he had too much sense of purpose, despite his respect for Picabia, to allow himself to subscribe for long to mere riot for riot's sake.

There is hardly any question that Breton felt at the end of 1922 that Dada's task was done. He increasingly saw even this task from a negative angle. Tzara's *Manifeste Dada 1918* had seemed at the time to open many doors, but Breton discovered in 1921–2 that "these doors led into corridors that went round in circles".

The process of 'softening up' public opinion appeared complete. The tension against Tzara grew in proportion to Breton's feeling that the whole business had now become unnecessary.

Sub-Dada, Sur-Realism

The fruits of Dada revolution were to be enjoyed by better gardeners than we, who could prune the trees (not without secretly wishing they could grow to touch the sky!) and who could lay detailed plans and then carry them out. The pot had to be kept on the boil; but the many cooks who might have spoilt the broth had to be eliminated. At the end of a relentless process of destruction, there appeared a new discipline, and a philosophy directed towards 'positive goals': this was Surrealism.

The word Surrealism, invented by Apollinaire, was first of all used as a weapon to destroy Dada. When Breton states that he was a Surrealist even

when he was a Dadaist, this is perfectly true, as far as he personally is concerned. His right to the word 'Surrealism' was disputed at first by Paul Dermée and Ivan Goll, who had started another kind of Surrealism, but with Breton's first Surrealist manifesto (1924), signed by all those who until a short time before had been Dadaists, such questions were finally settled. Or were they?

We may begin to have doubts, when Breton extends the concept of Surrealism to include things that can clearly not be described as Surrealistic except *post factum*.

"Between October and December 1919, *Littérature* published, over my signature and that of Soupault, the first three chapters of *Champs magnétiques*. This was unquestionably the first *Surrealist* work and not Dada at all, since it resulted from the first systematic employment of automatic writing."

How this can have been a Surrealist document in 1919 is impossible to imagine. Precisely the same process that Breton refers to as *'écriture automatique'* had been employed by Ball, Arp, Serner and Huelsenbeck in Zurich, both individually and collectively, from 1916 onwards. Breton continues:

"We sometimes continued for eight or ten hours at a time . . . [this] led us to some far-reaching conclusions."

This says a good deal for Breton's methodical determination to gain deeper insight into *'écriture automatique'* but does not make the latter a 'Surrealist' activity. It may be called so today, just as the works of Arp, Picabia, Man Ray, Max Ernst and others are called Surrealist, although they have remained since 1916 or 1918 exactly what they were before: Dada-realism or Sur-Dada-realism or whatever. In its beginnings, Surrealism seems to me to be as like Dada as two peas in a pod. The tone of the manifesto remained the same, and, as late as 1929, Dali tells us in a declaration which could not possibly be more precise as a description of Dada:

"Surrealism is the systematization of confusion. Surrealism appears to create an Order, but the purpose of this is to render the idea of system suspect by association. Surrealism is destructive, but it destroys only what it considers to be shackles limiting our vision."

Surrealism devoured and digested Dada. Similar cannibalistic methods are by no means rare in history and as Surrealism had a strong digestion, the qualities of the devoured were transferred to the invigorated body of the survivor. So be it!

It is certain that the method and discipline of Surrealism are essentially Breton's handiwork. Out of the explosive Dada element in Surrealism he fashioned, on rational principles, an irrational artistic movement which,

although it took Dada over wholesale, codified the Dada revolt into a strict intellectual discipline.

Breton not only took Dada over, but continued it by developing an all-embracing theory and method which embodied dreams and chance carried to the point of hallucination. It is this theoretical and methodical infrastructure that distinguishes Surrealism from Dada. But it was inevitable that Dada's indiscipline would eventually give way to a theory and a discipline which would sum up all it had discovered, just as it was inevitable that theory and discipline, developed to their conclusion, would lead to academicism.

Neither Dada nor Surrealism is an isolated phenomenon. They cannot be separated; they are necessary conditions of one another – as a beginning must have an end, and an end a beginning. They are basically a single coherent experience reaching like a great arch from 1916 until about the middle of the Second World War, a renaissance of meaning in art, a change in our field of vision that corresponds to a revolutionary change in the nature of our civilization.

All this grew naturally on the 'crab-apple tree' of Dada that Breton proposed to cut down, but whose fruit was to nourish Surrealism, after the latter had grafted, pruned and tended the tree so that its fruit finally became a popular product in a way that Dada could never have attained. The significance of both movements lies in their mobilization of the subconscious in the service of a new conception of art. Surrealism gave Dada significance and sense, Dada gave Surrealism life.

7 Post—Dada

After 1924 there was no Dada, but the Dadaists remained. In 1927 Arp received his first big commission, to paint the interior of the Restaurant Aubette in Strasbourg, his home town. He invited his wife Sophie and Theo van Doesburg to help him *(Ill. 100)*. Each of the three decorated one third of the building. In this way they produced the first great abstract frescoes. Arp's agile arabesques, Doesberg's neo-plastic purism and Sophie's lively divisions of space *(Ill. 101)* did not conflict with each other. They complemented each other. Anti-art and art had come together, and now each gazed into the other's face as if in a mirror, restored to youth and, as if miraculously, sprung from the same stock. This was no longer Dada, but quite simply new art, the fruit of Dada. These fruits ripened everywhere.

Another fruit was ripening in the shape of the collaboration between Eggeling and myself. Our friendship had led my parents to invite him to our country house at Klein-Kölzig. There, for three years, we marched side by side, although we fought on separate fronts. In 1919, on the basis of what Eggeling called *'Generalbass der Malerei'*, we produced our first scroll-pictures: variations on formal themes, drawn in pencil on long rolls of paper. Eggeling's was called *Horizontal-Vertikal-Messe* and mine, *Präludium*. In 1920, we began our first film experiments, based on the implications of motion contained in these rolls. Eggeling finally made a film of his second roll, *Diagonal Symphonie (Ill. 98)* and I made one called *Rhythmus 21 (Ill. 99)*. Both were abstract films, but very different in spirit and in their approach to artistic problems. Eggeling started out from the line and I from the surface.

Eggeling orchestrated and developed forms, while I renounced form altogether and restricted myself to trying to articulate time in various tempi and rhythms. Eggeling died in 1925, exactly forty-five years old.

We had both turned to the film for the solution of a problem we had encountered in painting. I had no intention whatsoever of continuing to make films, but the new dimension t, and the possibility of orchestrating time as I had orchestrated form, drew me to the film more and more. For the last forty years

I have pursued the film as a means of artistic expression, alongside my activities as a painter.

In 1927–8 I made a little film called *Vormittagsspuk* ('Ghosts Before Breakfast', *Ill. 106*) for which Hindemith wrote the music and which was shown for the first time at the international music festival in Baden-Baden in 1927 or 1928. As we were still in the blessed days of silent films, the film music was performed according to a roll of paper that unrolled in front of the conductor's music-stand at the same speed as the film. This was the invention of a certain Herr Blum.

Without really meaning to, this film became a true Dadaist document. It showed the revolt of objects: hats, cups, ties, hoses, etc., against man. In the end the old relationship of man-master and object-slave was re-established. But for a short time, the audience had perhaps begun to doubt the inevitability of normal 'subject-object' relationship.

Marcel Janco had returned to Bucharest and resumed his real profession, which was that of an architect. But he never forgot Dada. From time to time we received a periodical called *Contimporanul* which we could not read as it was in Rumanian, but which was said to pursue "Dada ideas into practical life".

Picabia, not content with applying his anti-artistic energies to literature and painting, proposed to the director of the Swedish ballet in Paris, Rolf de Marée, that he should show a little film during the long interval. The result was *Entr'acte (Ill. 104)*, a funereal grotesque in which the hearse was drawn by a camel. Those taking part in the film, which was partly in slow motion, partly speeded-up (René Clair was the director) gave the cortège a decidedly Dadaist character, underlined by the appearance of Duchamp and Man Ray playing chess.

Picabia intended to use the interval murmur of the theatre audience as background noise for this (silent) film, but they all fell silent, as though the sight of his extraordinary cortège had taken their breath away. Picabia, enraged, shouted at the audience "Talk, can't you, talk!" Nobody did.

Apart from the main centres of Dada activity, there were individuals and little groups in almost all Western countries who agreed with the ideas formulated by Dada. This sometimes happened through direct contact with the active centres of the movement, sometimes spontaneously and independently. Curiously enough, Dada tendencies seem to have made their first appearance in Russia, where Futurist influence was still very strong. Puni's *Barber's Shop* and *Window-cleaner* are a poetic combination of Simultaneist experience and original experimentation. His empty *Hunger Plate* (see 'Neo-Dada') is a piece

of defiance that, both in its directness and in its form of expression, can be regarded as a Dada document (*Ill. 107*). Tzara mentions other Russian Dadaists, Krutchony and Terentieff, of whom I know nothing more than that they, together with Zdanevich (who played a not unimportant part in Paris Dada under his pseudonym of Iliazde), formed the *41* group. A Russian Dada periodical appeared in Berlin under the name of *Perevoz Dada*.

In Spain, the influence of *391* lived on, and in 1919, when Picabia had long been in France, Spanish Dada became active again. J. Salvat and Papa Socit (?) published a book of poems called *Poèmes en Ondes Hertzianes* with a title-page by J. Torres García. And in 1923, when Breton opened a Picabia exhibition in Barcelona, there was still an active Dada 'cell' in existence there, made up of Jacques Edwards, Guillermo de Torre, Lasso de la Vega and Cansino d'Assons, all of whom refused to accept that Dada was on the decline.

The Italian poets Ungaretti and Savinio and the painter Prampolini had been active in the sphere of Paris Dada, without succeeding in establishing a native Dada movement in the land of Futurism and de Chirico. Futurism and Dada were still too close together, in time and in ideas. Boccioni had anticipated so many of the features of Dada and so much of its spirit and technique (free use of new materials like cardboard, wire, pieces of wood, and so on) that Dada was not really necessary in the land of the Futurists. Nevertheless, Tzara includes the artists I have just named, as well as the second-generation Futurists Evola, Cantarelli and Fiozzi, in his list of Dadaists.

In Hungary, Dadaist typography was consistently employed by Lajos Kassák, the editor of *Ma*, who also owed allegiance to Dada in his capacity as a painter. Years later, in 1927, when Dada had already given way, in Western countries, to Surrealism, it enjoyed a short second flowering in Hungary in the shape of the 'Green Donkey' group of artists. The organizer of this Post-Dada movement was Odon Palasowski, who put on public recitals in Dada style. After a few months, this Dadaist last sigh died away on the breeze. During the Dada period itself, between 1918 and 1922, Sandor Barta had published Dada short stories in Hungarian under the title *Mesek es Novellak*.

There was great activity in Zagreb, Yugoslavia, where the periodical *Tank*, published in 1922, had a powerful effect despite the shortness of its life. This periodical, more rebellious and more 'anti' than *Ma*, carried the unmistakable stamp of Dada and, as far as I have been able to tell, its manifestoes and poems were true provocations in Dada style.

The only Dada movement, outside the main centres, that struck an independent and truly Dadaist note centred on the periodical *Mécano* in Holland (*Ill. 102*),

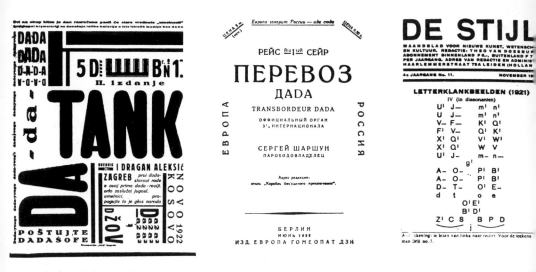

Dada periodicals in Yugoslavia and Berlin The periodical *De Stijl*, Holland

which was edited by the Dadaist Theo van Doesburg, founder of *De Stijl*. Four issues appeared, in the Neo-Plastic colours of blue, yellow, red and white, but the contents were juicy, green, Dutch Dada. Doesburg – whose Dada name was Bonset – went with Schwitters on Dada tours of Holland which, for originality and hell-raising ability, were on a level with anything that happened in the main centres of Dada. But Dutch Dada lasted only a short time, a Dada shower that fructified men's minds but produced few new recruits. The most important of these was Paul Citroën, whose urban montages appeared in many Dadaists publications both inside and outside Holland. Doesburg himself remained a Dadaist, because that was just what he was. He went on producing phonetic poems that he, as a painter, was able to compose visually in forms characteristic of *De Stijl*. As a phonetic poet, he stood beside Ball, Hausmann and Schwitters and developed Hausmann's optophonetic style in his own *De Stijl* Dadaist manner. In painting, however, he remained true to his 'Neo-Plasticist' principles – *sans* Dada!

His commitment to Neo-Plasticism soon led him to return, after his successful tour with Schwitters, to the realm of the right-angle, in which his true vocation lay. Like Eggeling, he died very young, in Davos in 1931.

Many of our friends have died since then, and the fate of many others is unknown. Only Tzara knew the whole list of 'Dada Presidents', although I am

not sure whether all those whose names appear here would agree with the description.

Quelques Présidents et Présidentes:

Dr Aisen, Louis Aragon, Alexandre Archipenko, W. C. Arensberg, Maria d'Arezzo, Céline Arnauld, Arp, Cansino d'Assens, Baader, Alice Bailly, Pierre-Albert Birot, André Breton, Georges Buchet, Gabrielle Buffet, Marguerite Buffet, Gino Cantarelli, Carefoot, Maja Chrusecz [Kruscek], Arthur Cravan, Crotti, Dalmau, Paul Dermée, Mabel Dodge, Marcel Duchamp, Suzanne Duchamp, Jacques Edwards, Carl Einstein, Paul Éluard, Max Ernst, Germaine Everling, J. Evola, O. Flake, Théodore Fraenkel, Augusto Giacometti, George Grosz, Augusto Guallert, Hapgood, Raoul Hausmann, F. Hardekopf, W. Heartfield, Hilsum, R. Huelsenbeck, Vincente Huidobro, F. Jung, J.-M. Junoy, Mina Lloyd, Lloyd, Marin, Walter Mehring, Francesco Meriano, Miss Norton, Edith Olivië, Walter Pach, Clément Pansaers, Pharamousse, Francis Picabia, Katherine N. Rhoades, Georges Ribemont-Dessaignes, H. Richter, Sardar, Christian Schad, Schwitters, Arthur Segal, Dr W. Serner, Philippe Soupault, Alfred Stieglitz, Igor Stravinsky, Sophie Taeuber, Tristan Tzara, Guillermo de Torre, Alfred Vagts, Edgar Varèse, Lasso de la Vega, Georges Verly, A. Walkowitz, Mary Wigman. (From *Dada*, No. 6, Paris, 1920)

8 Neo—Dada

I have been looking for a motto which could be used to sum up the 'new' Dada situation which is apparent in contemporary art. It describes itself as Neo-Dada, Neo-Realism, Pop Art, etc. I can find not *one* slogan, or *one* motto, but several.

1) "The desert grows, woe to him who bears deserts within himself." (Nietzsche)
2) "Art must first be totally despised, it must first be thought totally pointless, before it can once more come into its own." (Philipp Otto Runge)
3) "I have seldom seen so much inventiveness combined with so little talent." (L. K.)
4) "*Kitsch* is always in the process of escaping into rationality." (Hermann Broch)
5) "Dada fell like a raindrop from Heaven. The Neo-Dadaists have learnt to imitate the fall, but not the raindrop." (Raoul Hausmann)
6) "The new art is a contribution to art criticism." (Harold Rosenberg in the *New Yorker*)
7) "Like a joke without humour, told over and over again until it begins to sound like a threat." (ibid.)
8) "Advertising art which advertises itself as art that hates advertising." (ibid.)

The Garden Dwarfs

The intellectual and moral situation today is similar to that which existed forty years ago. Fatalism and rejection of life are now even more strongly marked; they are reactions to a world which has become even more lunatic than it was. There now seems no prospect of returning it to normality. But this world still affords art the possibility of offering some release through the caricaturing of emotions.

"Since the bankruptcy of ideas has stripped the image of man right down to its deepest layers, the instinctual background manifests itself in a pathological manner. As no form of art, politics or religion seems adequate to deal with this breach in the dam, the only possibilities are bluster and total artificiality." (Hugo Ball)

If the new Dadaism, which belongs to this fate-ridden age, finds such a powerful echo in people's minds, it must be because some 'inner voice' answers its call – even if that voice is the voice of nothingness. Sigmund Freud gave this warning more than half a century ago: "From the moment a man doubts the meaning and value of life, he is sick." Are we sick? More and more people are going to psychoanalysts, because they doubt the meaning and value of life, because they live in an 'existential vacuum'. As a psychiatrist, Dr Fraenkel, puts it in an article in *Time* magazine, we have destroyed within ourselves the instinctive certainties of the animal world to which we belong, while at the same time losing our sense of social coherence and tradition. Nothing is left to tell man what he *should* do; and soon, when he no longer knows what he would *like* to do, he will be in a state of total confusion.

In this state of confusion, the creative elements in the younger generation have made a violent attempt to recreate Something out of nothing – on whatever level.

I set out to discover the reason for their act of violence.

I had met a young pop-artist between twenty-five and thirty years old, Roy Lichtenstein, whose enormous enlargements of comic strips made me curious to find out from him what the 'idea' behind his pictures was and how this idea had come into being.

This is what he told me. His little son's schoolfellows asked him what his father was. An artist? What kind of artist? An abstract expressionist! Oh, said the children, somebody who paints abstracts because he's no good at drawing. Lichtenstein Junior came home crying and told his father he couldn't draw. Lichtenstein Senior assured him that this wasn't true and drew him a great big Mickey Mouse, just like in the comic strips. This didn't satisfy him: his father had to prove he could draw people too. So Papa L. drew him a big George Washington in comic-strip style. That satisfied him!

But the strange thing was that not only L. Junior, but L. Senior too, liked it. Lichtenstein began to play around with all sorts of enlargements of comic strips. This gave him a lot of pleasure, and he began to imitate not only the comics themselves but even the dots made by the printing process. Friends came and they found it interesting too . . . and, lo and behold, L. had suddenly found

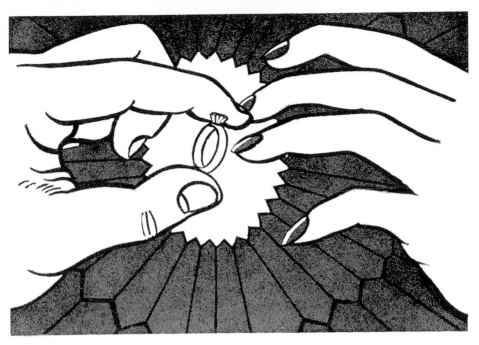

Roy Lichtenstein, *Painting*, 1962

his line, a simple, healthy, natural line, which was really the 'six-year-old's line' – but which made him 'famous' overnight.

The anti-aesthetic gesture of the 'ready-made', and the blasphemies of Picabia, now reappear in Neo-Dada in the guise of folk-art – as comic strips or as crushed automobile bodies. These are neither non-art nor anti-art but objects to be enjoyed. The feelings they evoke in the beholder's mind belong on the artistic level of a garden dwarf. The pleasure offered to the public is plain infantilism, however sauced by the descriptions of ingenious writers on art, who speak of Neo-Realism, Neo-Functionalism, Neo-Dada and heaven knows what else. What has appeared is a Romanticism reinterpreted in terms of Dada and Surrealist experience, which enables one to look at things complacently. Uncompromising revolt has been replaced by unconditional adjustment. Duchamp's coal-shovel, bottle-rack and *pissoir* can now be the objects of a calm aesthetic judgment – which was exactly the thing on which Duchamp vented his scorn forty years ago. The prefix Anti has become a feather-bed on which bourgeois and art-collectors complacently recline. As if, after Cubism, Dada, Surrealism, Abstractionism, Expressionism, Tachism, all they wanted was to have a rest, without having to perform any more modish antics. Who can blame them?

Have Your Cake and Eat It!

Take motor cars half way through the crushing process: set up crumpled mudguards, newly-painted. Dip a naked, well-shaped girl in paint and roll her over the canvas. Put a stuffed dummy corpse in a pram. A musical performance in which the pianist sits at the piano for ten minutes and does not play. A theatrical play in which not a scrap of theatre is played. Feed a stuffed teddy bear with beaten eggs, hang a potato on an old lavatory-chain. A pitch-dark labyrinth in which the visitor to the gallery sprains his ankle. A hall with juke-boxes, rubber animals and an artificial swimming-pool. A room where the furniture hangs from the ceiling and the pictures lie like galaxies *à la* Kiesler on the floor. A shooting-gallery where the customer shoots at rotating bags of paint so that a direct hit splashes a huge snow-white sculpture with colour. Its title: 'My Contribution to Art.' Etc., etc.

Mountains smoke, castles tremble, phalluses tingle, the whole bazaar is sold out.

All these provocations (they are nothing of the kind) would easily outdo Dada – if Dada had not already exhausted the field. It seems as if people needed the material object as something they could grasp and hold on to, something that would confirm their own existence to themselves. As if Man could never be sure of his own existence except through some contact achieved through his five senses, since within him everything is nebulous and uncertain. A void that drives him outwards, the need to obtain a proof of his own existence, through the medium of the *object,* because the *subject,* man himself, is lost.

The passion, the joyous enthusiasm with which all this is done is no more than a proof of the urgency of the need for this 'last hope'. And isn't this sad? – however funny it looks.

In this tissue of influences and gags, spontaneity and junk, surprise has an essential place. Glue the scraps of your girl-friend's breakfast on to the tray, glue this to a chair, and glue the chair to the same wall where used to hang the reproduction of the Sistine Madonna or even the picture by Schwitters (now dismissed – because of the closeness of the relationship – as a reactionary). It is comforting to see that there were eggs, coffee, marmalade and cigarettes *(Ill. 108)*. Forty-two years before, Ivan Puni (Jean Pougny) had glued an empty plate (whose breakfast?) to his canvas. But in Russia in 1918 they were in the middle of a revolution, and one potato a day was a lot. The empty plate was a challenge (to something or someone); the solid breakfast is a satisfaction of something or someone. The repetition of this theme after forty years does not

improve it, but rather empties it of meaning, typifies an 'empty existence', a vacuum.

Our time (as well as we ourselves?) has developed such a lust for physical presence that even the lavatory-seat has become holy to us. We want not only to see it on a picture but also to *have* it physically.

As if by some magic, this aphoristic exaggeration of mine has come true. Man Ray has embodied it in a 'door-knocker' for which he uses the French title *Marteau (Ill. 110)*. But he has a prescriptive right to do this. He was doing things like this forty years ago – when he was the object of attacks more gross than anything he has done, and before these things became approved of. His lavatory-seat is an anti-garden-dwarf, an illustration of the point we and art have reached (even anti-art).

Someone wrote in *The Times* that Neo-Dada has brought us down from the wine culture of the last hundred and fifty years into a Coca-Cola culture. Although the Neo-Dada movement has spread through England, France, Germany and Switzerland, it seems to me essentially American, like Coca-Cola. Not because it started there (the term pop-art is said to have been coined by the Englishman Alloway), but because it is aimed at our prefabricated way of life and way of thinking, because it has turned the popular, folk elements of a tangible thing into an object of affection, and even of love and enthusiasm. In place of the garden-dwarfs of yesterday, the beer-cans of today: the refuse of technological civilization in all its forms, the style of the twentieth century (?), with materials and products, mind and unmind, reproaches and rubbish forming a new landscape.

In the catalogue of the 'New Realists' exhibition at the Sidney Janis Gallery in New York, ten out of fifty-four works incorporated bits of food; Oldenburg's *Oven and Cake-Box;* Rayse's *Supermarket;* Rotella's *Coffee-cups;* Thubaud's *Salad, Bread and Butter and Dessert;* Indiana's black square with the injunction "Eat!"; Wesselmann's 'Still-life' with hamburgers, coffee, tomato ketchup, etc.; Utfeld's *Night-table with Contents;* Segal's *DinnerTable.* There are also coloured sponges and knives and forks. Sex as well: twenty-five Marilyn Monroes in one picture.

Looking at the thing from a superficial – but not entirely erroneous – point of view, these new Pop-people have chosen Marcel Duchamp as their patron saint and placed him in an honoured niche. But Marcel Duchamp escaped from this niche very quickly. In a letter dated 10th November 1962, he writes to me:

"This Neo-Dada, which they call New Realism, Pop Art, Assemblage, etc., is an easy way out, and lives on what Dada did. When I discovered ready-mades

I thought to discourage aesthetics. In Neo-Dada they have taken my ready-mades and found aesthetic beauty in them. I threw the bottle-rack and the urinal into their faces as a challenge and now they admire them for their aesthetic beauty."

Zero Point

During a symposium held on the occasion of an 'Assemblage' exhibition at the New York Museum of Modern Art, I heard Professor Roger Shattuck define the real problem of Neo-Dadaism with great clarity. His point of departure was the same series of questions that Marcel Duchamp had answered in Dada fashion, forty years before, with his ready-mades, the coal shovel, the bicycle wheel, the urinal.

The professor said that a Cézanne, or a Picasso, or any work of art, could be seen again and again and yet afford new sensations, new emotions, new matter for meditation. The work of art is not exhausted by being looked at many times; on the contrary, it gains in the process.

This is not true of the coal shovel, the bicycle wheel, the urinal. They were not intended by Duchamp to stimulate meditation or artistic emotions, they were intended to shock – to tear the beholder away from the stagnant meaninglessness of his habitual attitude to art, his conventional artistic experience. Such a shock is not repeatable. The second time one sees them, the coal shovel, the wheel, etc., are simple articles of use with no implications, whether they stand in their appointed place in one's house or whether they make a pretentious appearance at an exhibition. They no longer have any anti-aesthetic or anti-artistic function whatever, only a practical function. Their artistic or anti-artistic content is reduced to nothing after the first shock effect. At this point they could be thrown away, put in some store or returned to their normal functions. As Professor Shattuck puts it, the (anti-)artistic value they used to possess has gone back to zero.

If, like Duchamp's, they are the first of their kind, such works may be preserved in museums, as the old aeroplanes are in the Smithsonian. If so, one would need to have a sort of resting-place for works of 'art-for-a-day'. But this would be a museum, not an art gallery.

Neo-Dadaism is an attempt to establish such a shock as a value in itself. The Neo-Dadaists are trying to restore to the anti-fetish the attributes of 'art'.

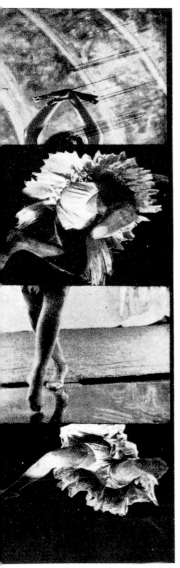

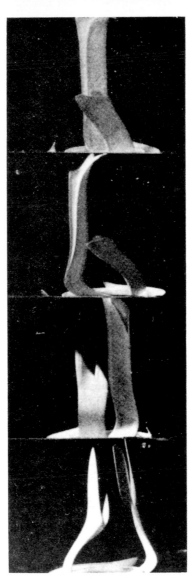

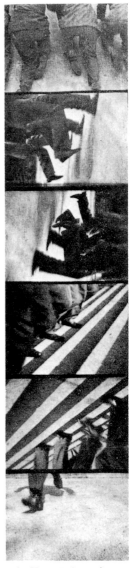

Francis Picabia, frames from the film *Entr'acte*, directed by René Clair, Nice 1924

105 Man Ray, frames from the film *Emak Bakia*, Paris 1926

106 Hans Richter, frames from the film *Vormittagsspuk* (Ghosts before Breakfast), Berlin 1927

107 Jean Pougny (Ivan Puni), *Plate*, Petrograd 1918. Oil and assemblage

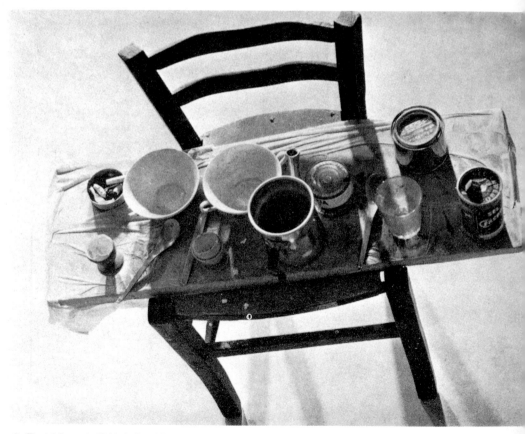

108 Daniel Spoerri, *Kishka's Breakfast*, 1960. Assemblage (Museum of Modern Art, New York, Philip G. Johnson Fun

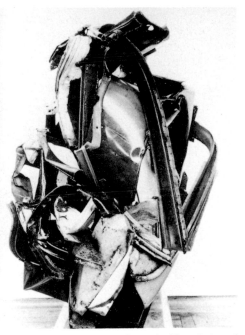

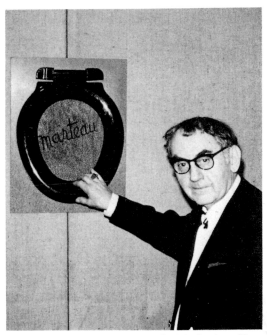

9 John Chamberlain, *Nutcracker*, 1960. Motor-bodywork
assemblage (Leo Castelli Gallery, New York)

110 Man Ray with his *Marteau*, Paris 1963. Assemblage
(Galerie Schwarz, Milan)

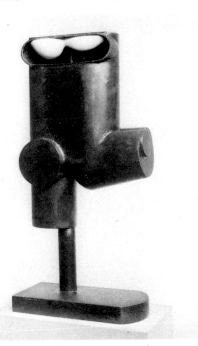

1 Edward Higgins, *Torso*, 1962. Wood (Leo Castelli
Gallery, New York)

112 Enzo Pagani, *Sunday Morning*, Milan 1960.
Assemblage

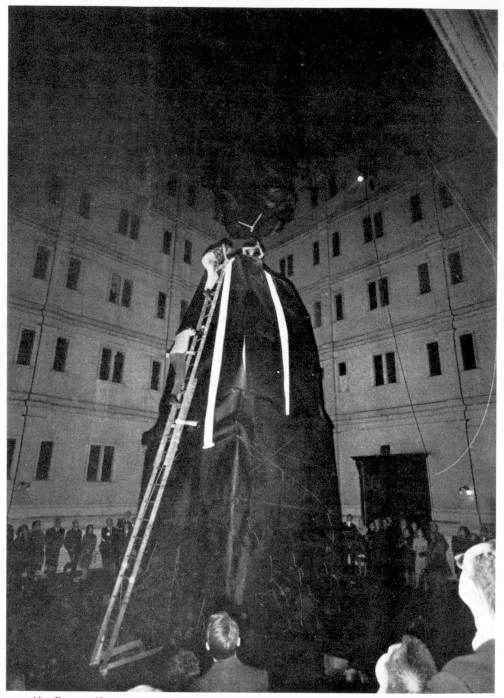

113 Alan Kaprow, *Happening*, New York, 1962 (Photograph by L. Shustak)

But it is pointless to employ a shock effect that no longer shocks. Or, as Brian O'Doherty, the critic of the *New York Times,* put it on 31st October 1963: "Things may have reversed themselves and now it may be the bourgeois who shocks the avant-garde." He shames them by reacting, not with shock, but with pleasure, and by opening his purse. He buys, and he enjoys himself immensely. In other words, he does not believe in the rebels' rebellion at all – and the dealers and the public galleries enthusiastically back him up in this.

This is not a rebellion, but the opposite: an adjustment to so-called popular taste, a deliberate return to the garden-dwarfs. Or as Huelsenbeck puts it: "Art of the streets, art for the little man: people want to put behind them the last remaining ideals . . . the atmosphere of the cafeteria, the hot dog stand and the hamburger-heaven is transplanted into the art gallery."

And Brian O'Doherty again:

"The occasion is a rearguard action by the advance guard against mass culture – the mass culture that pushes the individual below the line into the lowest common denominator. In fact, it might be called an artful attempt to enrich spiritual poverty. . . .

"This is one of the most interesting developments in the galleries, for it marks the entrance of artists into social criticism with ephemeral works that can be thrown away when circumstance has changed enough to remove their relevance. America has been a pioneer in throw-away cups and saucers, milk containers, tablecloths. Now it is a pioneer in throwaway art. . . .

"Since big money in the arts is here to stay, let us hope that its current attempts to rape the artist will result in a future breed less liable to seduction. If not, art may well become a packaged product, with the artist on the assembly line gulled into thinking he is an individual in possession of his freedom."

Public Galleries and Art-Dealers

Fifty years ago, the art gallery was regarded as a place 'in which the Gods spoke'. The works exhibited there, consecrated by tradition, by history and by accepted criteria of value, constituted a reservoir of human experiences and scales of values against which generation after generation could measure itself.

I remember very well how I used to go day after day to the Kaiser-Friedrich-Museum in Berlin to see and converse with a large portrait of a court lady by Velasquez in one of the farthest rooms. She stood with the timeless immobility

of all Velasquez' people, one hand resting on the back of a chair, against the dead-alive grey-green of her background, her black dress glowing, her face expressionless and dead. A touch of brownish-red somewhere. There she lived, a representative of infinity, cut off from the vulgar world of transience by her heavy gold frame. She was neither beautiful nor ugly, but a goddess, and had such presence that I never overcame my diffidence for one instant, although I copied the picture for months on end. This diffidence was not inspired by the woman but by the artist, whose soul had reached up to heaven, and who had set up a court lady to speak to us from Olympus.

In this way I came to know art galleries, or rather the value of art galleries. They are not there to be walked through, even if there are thousands of pictures in them, as there are in the Louvre or the Metropolitan Museum. They are there for meditation – if only that were still possible! Directors of public galleries today, as the head of one great American gallery explained to me, are in a difficult position. As art historians, they are conscious of their traditional responsibility for preserving values and criteria of value. But they want to take part, with their institutions, in the life of the present day. This often places them in situations where the distinction between good art and bad or indifferent art becomes blurred. Youth, after all, wants something different from the 'old stuff'. Nor is it possible, with this generation, to open people's minds to the 'old stuff' if you refuse to let them see the 'new stuff'. Thus avant-garde exhibitions appear, which admittedly give 'youth' its due, but make the task of the public galleries difficult by offering the public entertainment rather than objects of contemplation, which is what real works of art are. I still think that *one* person who meditates before a work of art is worth more than thousands who just gawp.

The Masses

Alexander Trocchi describes this situation in a note on George Orwell in the *Evergreen Review*, No. 6, 1958:

"The proliferation of vast projects in human engineering, and the resultant threat to the integrity of the individual, is a direct consequence of the *sudden* emergence of the mass. Ortega y Gasset speaks of the 'vertical invaders', referring to the hundreds of millions of men of no tradition being born into history through a trapdoor – a consequence of the Industrial Revolution. By and large, the education for these men-without-roots has been governed by the

technological requirements of expanding industry. What culture they have has been acquired from the daily newspapers, pulp or slick magazines, the popular cinema, lately television. The technician, *qua* technician, is essentially passive, and the structural attitude which is imposed on him during his working hours is carried away by him into his leisure hours; he is the victim of leisure, not its master. Restless, passive, with few vital inner resources and little creative doubt, he has to be amused, and, as a customer of amusement, he is subjected to the same battery of techniques which have boosted production. There is no doubt that this kind of efficiency-consciousness is dangerously closed. One might say that man's idea of himself is something less than it was before God became a stuffed owl in the museum of natural history."

Huelsenbeck writes:

"Neo-Dada has turned the weapons used by Dada, and later by Surrealism, into popular ploughshares with which to till the fertile soil of sensation-hungry galleries eager for business.

An old pair of shoes is an old pair of shoes. But if you hang an old pair of shoes on the wall, they are no longer 'the old shoes' but 'THE shoes' which are old, and they arouse in us certain thoughts and certain associations. Pop Artists, the New Realists, are people who hang old shoes on the wall and seek thereby to arouse emotions in us. But, as the shoes are only manufactured objects, these emotions fail to appear. Thus, while the artists experience a certain satisfaction in hanging up and exhibiting old shoes or chamber-pots, the beholders are forced into a position of mental discomfort. They are therefore unable fully to appreciate the artist's irony and cynicism, things that only have a real meaning when they are directed against dehumanization. Because a lot of snobbish collectors buy the shoes or the chamber-pots, beholders living in a conformist society are placed in an even more awkward position. They are soon like the donkey which no longer knows whether to turn its head to the left or to the right."

Whichever way it turns, it gets a punch on the nose. This shock therapy brings us to absolute zero and writes *finis* to the story of art as we knew it – and as we can find it, long before the Renaissance in the wooden fetishes of primitive peoples.

Art in this zero form has taken on a new meaning, no longer magical but socio-psychological, no longer transcendental but therapeutic. It confirms our existence by confronting the self with an object, and by means of this confrontation, evoking the sensations of the self when it is face to face with the outside world. But the object must always be of a new and surprising kind if it

is to command our attention. For objects we are used to are parts of our ordinary environment and go unnoticed. If the object is an ordinary one it must be shown in an unexpected juxtaposition with other objects (a man's corpse in a pram) or in a situation that we recognize as 'sensational' (a wrecked car).

In all these cases the stress is on the *moment* and the momentary state of the self. In this there may be the basis of a new 'aesthetics of the moment', as expressed in all Neo-Dada's manifestations, whether they are called Happenings, Neo-Realism, Neo-Activism or Pop Art.

Behind all this there is a loss of faith in any value outside the direct experience of the Self. There is also a readiness to accept nothingness, *nihil*, rather than deceive oneself with 'ideas' and values which, we assume, have no place in the real world in which we live, can have no influence on one's life, and are obviously both incapable of altering a hopeless situation and still more incapable of changing human nature.

The Future

In October of last year Duchamp drew my attention to the so-called 'Happenings' that were taking place in very peculiar places in New York. The 'Happening' I went to see took place in the enormous courtyard of a skyscraper, the Mills Hotel in the Village. This is the biggest 'flophouse' in the world, with twelve hundred little rooms for the poorest of the poor, who still have to pay 50 cents a night. In the middle of this courtyard, this immense chasm, Alan Kaprow and his assistants had built a high scaffold about five storeys high, covered with black paper, cardboard and sacks. Two ladders gave access to the platform on top. High in the air, many floors above this scaffold, hung an immense dome, also covered in black *(Ill. 113)*.

About two hundred spectators lined the walls of this dream-prison. Hundreds looked down at us from little barred windows hardly a foot and a half across. Then we were issued with brooms and the 'audience' began to sweep the ground, which was covered with newspapers and other litter. When all was clean, black charred scraps of paper showered down out of the sky to the accompaniment of wailing sirens and someone blowing a trumpet. More paper rained down, empty sacks and cardboard boxes began to fall out of the night sky ... and we noticed a cyclist who was very slowly riding round and round and round the giant scaffold, and who continued to do so all evening. A motor-tyre on the end

of a cable swung out of a corner high above us and knocked some large cardboard boxes (which had fallen from the dome) off the top of the scaffold and down on to the spectators. An Ophelia in white began to dance, with a transistor radio held to her ear, round the scaffold that now looked like a sacrificial altar. After several circuits she climbed up the ladder (she had pretty legs) to the platform five storeys up. Fearful noise of sirens. She was immediately followed by two photographers, who climbed up the two ladders after her. Half way up, one of them lost his camera and had to go back and fetch it. Up above, Ophelia was photographed in provocative poses; only her legs were visible from below. Deluges of paper, thunder-effects, howlings and screechings, and the dome began to sink slowly until it had covered Ophelia, photographers, cardboard boxes and motor-tyre. The sacrifice was at an end.

A Ritual! It was a composition using space, colour and movement, and the setting in which the Happening took place gave it a nightmarish, obsessive quality, although 'the meaning' of the 'action' was more or less non-existent. This combination of acting, dramatic arrangement, colour and sound recalled the *Gesamtkunstwerk* (total work of art) of Kandinsky, Ball and others. It required the collaboration of the public.

Of course, Happenings are not paintings, but this one was close to visual art in its traditional sense – and was also Dada.

In a café, later, I talked to Kaprow. We understood each other. A year later he wrote to me from New York: "Pop Art is still in its prime; some of it is good, but, as with all so-called movements, most of it is bad. I think it will soon become *something else*, something real. We shall see."

Even the cultural pessimism that led to Pop Art, the surrender to nothingness, can not wholly destroy the transcendental significance of art. Humanity still asserts itself. Man the artist lives on in figures like Alan Kaprow or Tinguely, that mixture of businessman, clown and genius, in Jasper Johns' meditative number-pictures, in Higgins *(Ill. 111)*, Bontecou, Dine, Rauschenberg, César; in Arman's knives and forks, and in many other gifted and imaginative artists. They still maintain their link with their anti-artistic antecedents the Dadaists, whose ideas are sometimes freely and creatively developed, sometimes exploited to the point of necrophilia.

From Italy to Iceland, from Spain to Japan, the same symptoms appear, and so does the inevitability of the same approach to the same problems. It is no use to summon Old (or New) Masters to our defence. Neo-Dada shows us WHAT WE ARE TODAY. Doesn't it?

One hundred and fifty years ago, Goethe's Faust entered on a pact with the devil on this one condition: "If ever I say to the passing moment, 'Linger for your beauty's sake!' – *then* you can put me in chains, then I will freely go to Hell."

The devil has kept his side of the bargain; and Pop Art's desperate enthusiasm for the 'beautiful' moment confirms that the bargain still holds. There is some doubt, to say the least, as to how we can escape from this situation. Shall we, like the old, blind Faust, finally reaffirm our humanity, or perhaps see it reaffirmed? It seems to me that all we can do is know how far and in what directions we must extend or make narrower the bounds of our humanity: to know where the point of 'balance between Heaven and Hell' lies for us.

Science develops from one hypothesis to another; art today seems to be lurching from one recipe for success to another. But this is only on the surface. "Creation survives in fragments under the ruins of a world for which we can no longer find expression." (W. Weidlé in *L'Immortalité des Muses.*) Under the surface the effort goes on: the self-sacrifice of the individual in the service of an inner, morally-binding conviction, whether it be Pop Art or classical art. No one can say when, where and from what direction Man, in his unflagging search for a true picture of himself, will escape from this vacuum. Will he escape this time, as he did in his other anti-artistic phase? I should like to think so.

Postscript

by Werner Haftmann

In the December 1918 issue of the periodical *Die freie Strasse*, Johannes Baader, the *Oberdada* of Berlin, gives a definition of Dada, which, although certainly false etymologically, is uncommonly apposite.

"A Dadaist is someone who loves life in all its uncountable forms, and who knows, and says that, 'Life is not here alone, but also there, there, there (*da, da, da*).'"

Dada was the effective (and thus historically right) expression of a mighty surge of freedom in which all the values of human existence – "the whole range of human manifestations of life", as Baader puts it – were brought into play, and every object, every thought, turned on its head, mocked and misplaced, as an experiment, in order to see what there was behind it, beneath it, against it, mixed up in it: and in order to find out whether our well-known and familiar 'Here' was not perhaps complemented by an unknown and wonderful 'There' ('*Da*'), the discovery of which would transform our established 'Here-world', with its easily comprehensible three dimensions, into a multi-dimensional 'There-world'. Dada was a state of mind feverishly exalted by the freedom virus, a unique mixture of insatiable curiosity, playfulness and pure contradiction.

By its nature, Dada could find articulate expression only in the realm where Mind is active independently of its own logical manifestations – that is, in art. True, the spirit of contradiction disposed of the outworn conception of art, and put the artist in the paradoxical position of having to insist that "Art is useless and impossible to justify" (Picabia) – while practising art himself. But this very paradox illustrates the importance they attached to ambivalence and unlimited artistic freedom – the freedom which it was historically inevitable that someone one day assert.

Such an assertion of freedom is, by its nature, incompatible with the idea of a group. It can only be justified with reference to the individual. Dada was never a 'school', a 'current', a 'style'. Dada was a gathering of a few spirits who possessed this freedom and who stimulated each other. When Dada was at its height, the sharp intellect of André Breton summed up this situation with great

accuracy: "Our collective resistance to artistic or moral laws gives us only momentary satisfaction. We are very well aware that beyond and above this, a distinctive individual imagination is at work in each of us – and that this is more 'Dada' than the movement itself."

Looked at in retrospect, Dada has a definite, inevitable and even foreseeable place in the historical development of art. Dada is an event which took place between 1916 and 1922. It belongs within the framework of the great movements to which it constituted a reaction, Expressionism, Cubism and Futurism, and the movement which followed it, and to which it passed on powerful impulses in its turn, Surrealism. To me, this cultural situation appears to have been a more decisive factor in the formation of the Dada mentality than the influence of external events, although it cannot be denied that the political situation – the Great War and the ensuing scenes of national collapse and revolution – fostered the growth of every kind of revolt, resistance and protest.

However, the basic impulse of Dada is not despair and protest but a rebellious feeling of joy inspired by new discoveries. This joy was responsible for the manic, clowning aspect of Dada. Dada's aggressiveness is not the rage of the slave against his chains, but springs from a sensation of total freedom. Dada was unwilling to examine and weigh up the pros and cons of any argument; it preferred to let contradictory positions harden before setting them awhirl in spontaneous or deliberate antithesis one to the other, in the hope of stumbling on some more complete unity. This very fact would suggest that Dada was not the consequence of political events, but an event in cultural history that would probably have taken place even if there had been no war and no revolutions.

Dada's points of departure had been established before the war. As I have said, they were Expressionism, Cubism and Futurism. All the Dadaists had some connection with these movements. Tzara and Marcel Janco were familiar with developments in French art, knew Cubism and admired Apollinaire and Max Jacob. Arp and Hans Richter came from the circle of Berlin Expressionists centering on Herwarth Walden and his *Sturm,* and had come into very close contact with the whole international avant-garde at the 1913 '*Erster Deutscher Herbstsalon*' (First German Autumn Salon). Hugo Ball came from Munich and knew Kandinsky, Klee and the endeavours of the *Blaue Reiter* school, and through them the theories of Cubism and Futurism. Marinetti himself, the spokesman of Italian Futurism, exchanged letters with the Zurich Dadaists – and of course Futurism was one of the main arsenals from which Dada drew its weapons. Marcel Duchamp, the protagonist of New York Dada, had paid

homage to the Futurist theory of formation through motion in his famous *Nude Descending A Staircase*, which caused such a sensation at the 1913 Armory Show. A less obvious influence was de Chirico's hallucinatory vision of the Object as the silent and spectral Adversary, and the shock effect produced by his distortion of the most ordinary objects into something quite 'other', something strange, fearful and wonderful. The poet Savinio, de Chirico's brother and the inventor of the '*manichino*' (an anthropomorphic thing-figure), was in close contact with Zurich Dada. The Expressionists, Cubists and Futurists, as well as Kandinsky, Klee and de Chirico, were shown in exhibitions at the Dada gallery in Zurich which served to illuminate Dada's wide artistic background. A rapid survey of Dada's various techniques and formal innovations will show that these derive almost exclusively from the stylistic movements I have already mentioned:

- Dada's improvisatory cabaret technique, with its shock-effects, is a product of Futurism. It is clear from contemporary accounts that Dada's *soirées* were virtually indistinguishable from the Futurist performances which had been taking place all over Europe since 1912.
- The 'manifesto' as a literary genre, whether declaimed from a stage with all sorts of provocative and often clownish trimmings or distributed as a fly-sheet, goes back to the manifestoes of the Futurists, beginning with Marinetti's famous first Futurist manifesto, published in *Le Figaro* in 1909.
- The layout of Dada posters and fly-sheets, which employed typographical elements as capriciously as painters used the various elements that made up their collages, incorporated Futurist ideas.
- The phonetic poem was quite certainly not inspired by the obscure and isolated experiments of Scheerbart, nor yet by Mallarmé's reflections on the subject of *vers libre;* the source lay much closer at hand. It was the '*parole in libertà*' of the Futurists.
- Photomontage, so enthusiastically practised by Hausmann, was basically no more than a 'correct' application of the 'realistic' Futuristic principle of assembling suggestive documentary items to produce an all-embracing, dynamic pattern of interpenetrating aspects of reality. All Hausmann did was to apply this principle exclusively to mechanically-reproduced items.
- Collage had its origin in Cubist techniques.
- The grotesque cardboard costumes, used in Dada stage performances to create an alienation-effect, were inspired by the human figures in Cubist paintings. Light is thrown on this relationship by the larger-than-life cardboard costumes that Picasso designed at the same time (1917) for the 'managers' in the Rome production of Cocteau's ballet *Parade*.

- *Montages* of incongruous objects, or even a single article on an empty stage (e.g. a chair with a bunch of paper flowers) exploited de Chirico's alienation-effects and his '*pittura metafisica*'.
- The free use of colour in the work of Richter, Janco and Arp stems from Expressionist discoveries concerning the expressive significance of colour.
- The free use of colour in the work of Richter, Janco and Arp stems from and important Dada techniques, had been anticipated in the astonishing drawings produced by Kandinsky between 1911 and 1914.

Examined in isolation, the various techniques used by Dada invariably show a link with one or other of the pre-war stylistic movements.

Even so, Dada has its own place in history and its own originality. In Dada, these isolated elements formed a unity for the first time. Dada took up all these separate ideas, assembled them and established them as a unified expression of experiences and emotions that were wholly of the present.

In this way, Dada finally cut the umbilical cord that bound us to history. The movements of the pre-war period all saw themselves as a continuation of history. The Cubists stood firmly on the shoulders of Cézanne, who, in his turn, traced his harmonic equations back to Poussin and Veronese. The Futurists took Neo-Impressionism as their point of departure. In a totally realistic spirit, they sought to find a contemporary urban equivalent for the momentary sensations of light in motion which had so captivated the Impressionists. This equivalent they found in the sensations of 'simultaneity' and speed – the two "absolutes of modern life". The Expressionists harked back to Van Gogh and Gauguin, and sought their justification in the work of Grünewald and the late Gothic period, in Gothic woodcuts, in medieval stained-glass windows or in the Primitives. Dada dispensed with all these sincere or disingenuous appeals to the past. Aggressive and uncompromising, with more interest in asserting the artist's state of mind than in the finished product as such, Dada seized all these contributions, declared them relevant only to the present, and applied them to the present, pure and simple. Dada carried them to delirious excess (personal provocation, taunts and clowning proved highly useful for this purpose), experimented with new combinations, and thus created, all unawares and in the heat of the moment, a new and unified platform. Dada was, in a true sense, Nothing. Dada was, so to speak, pure connective tissue, an elusive, gelatinous substance which held together the individual blocks that composed modern art and made of them a unified idea.

The essential was not the finished product: it was the creation of a state of affairs that made new products possible. Brancusi once said that it was not hard

to make an object; the difficulty lay in putting oneself in the state of mind in which one could make it. The historical function of Dada was to produce this state of mind, and thus to bring a new self-awareness into modern art. Dada led to a new *image of the artist.*

The Dadaist claimed Genius, as the term was understood by the Romantics, as his natural prerogative. He saw himself as an individual outside all bounds, whose native environment was unrestricted freedom. Committed only to the present, freed from all bonds of history and convention, he confronted reality face to face and formed it after his own image.

One thing he regarded with uncompromising seriousness: the autonomy of the self. Every spontaneous impulse, every message from within, was therefore greeted as an expression of pure reality. Every possible artistic technique suited his purpose of provoking these impulses. Absolute spontaneity, chance regarded as the intervention of mysterious and wonderful forces, pure automatism as a revelation of that store of hidden reality within the individual over which consciousness has no control – these were the techniques that opened the way to a more comprehensive view of the relationship between Self and world. The artist was free to turn either towards visible, logically explicable objects or ideas, or completely away from them; but he was free above all to come face to face with himself. Even though all the individual techniques used by Dada had had their origin elsewhere, and even though Dada's positive achievements remain comparatively uncertain and elusive, it remains true that Dada's conception of the artist was something quite new. From that time onwards it acted as a ferment. Dada was the freedom-virus, rebellious, anarchic and highly contagious. Taking its origin from a fever in the mind, it kept that fever alive in new generations of artists. We set out to identify Dada's contribution to cultural history; this is it.

Even in 1922, when Breton began to canalize Dada's aims and methods in the direction of Surrealism and the exploration of the Unconscious and its store of images, Dada's 'image of the artist' retained all its hypnotic power. This hypnotic power may also explain the surprising and logically unaccountable fact that the Dada message caught on in several widely separated places at almost the same time, and that the incomprehensible stuttering sound 'Dada' became for a while the battle cry of some highly exceptional intellects. 'Dada' stood for a new vision of humanity!

It is well known that in recent years – beginning with 'Cobra' and approaching a climax in today's 'Pop Art' – Dadaist ideas and techniques have once

more become endemic and highly virulent. Unexpectedly, Dada has found itself once more the object of universal curiosity. When I asked Hans Richter to contribute an account of his Dada experiences to a series of monographs on twentieth-century art, I naturally shared this curiosity – but the satisfaction I sought could not be found in a general apologia for Dada. What was needed was a critical and historically compelling narrative.

The man to provide this was Hans Richter. He was an enthusiastic member of Zurich Dada, but never without a secret mental reservation; even in the midst of the most chaotic exuberance, he continued to seek a formula representing order. He understood and shared the chaotic impulses within Dada, but never forgot that a constructive alternative was still possible. This was the alternative for which the Constructivists and the Dutch *De Stijl* painters, above all Does-burg and Mondrian, were laying the foundations. In conclusion, then, a word about the author.

Hans Richter was born in Berlin in 1888. After a thoroughly academic training in Berlin and Weimar, he became acquainted with Expressionism through Herwarth Walden's *Der Sturm,* Pfemfert's *Aktion* and the literary and artistic circle that gathered in the old Café des Westens. At the '*Erster Deut-scher Herbstsalon*' in 1910, organized by Walden with the help of the young Hans Arp, Richter gained a comprehensive view of the international Modern Movement in painting. He heard Marinetti speak, distributed Futurist fly-sheets, wrestled with Cubism, and by 1914 had joined the circle of rebels that centred on Pfemfert's *Aktion.* Wounded and discharged from the army in 1916, a chance rendezvous led him to Zurich, where he met Arp again and found himself at the core of the Dada movement, in whose activities he energetically and wholeheartedly joined.

At the same time, he was pursuing his own line of development. In 1917 he painted his great series of violently-coloured *Visionäre Porträts* ('Visionary Por-traits'), influenced by Jawlensky, which took shape as free improvisation, in a trance-like game with colours. By the next year, however, he was beginning to suspect that this free improvisation, this use of chance, automatism and pure spontaneity, should perhaps give way to a higher Order. At about this time Richter met Ferruccio Busoni, who encouraged him to apply the principles of musical counterpoint to pictorial art. He remembers that 'something musical', a "melody of forms and colours", had always haunted him. This idea of setting painting to music, the 'orchestration of painting', had remained persistently alive since Gauguin's day. In the same year, a happy chance brought him together with Viking Eggeling, who was already working on the same problem.

This work required a good deal of system, and led him away from Dada, although he has remained on the friendliest terms with the Dadaists and has maintained a lively interest in their activities. In 1919, Richter and Eggeling moved to an estate owned by Richter's parents at Klein-Kölzig, near Berlin, and worked together in close cooperation for three years.

Their purpose was to make the picture a rhythmical development of formal themes. In thousands of experiments, both artists attempted to build complicated rhythmic sequences out of simple elements. The technique they used to achieve a temporal sequence of movements had already been applied by Delaunay. They elongated the picture so that it was impossible to take it in at one glance, thus forcing themselves, and the beholder, to read off the individual pictorial elements one after the other, as one reads a message written on a strip of paper. A study of Chinese calligraphy soon suggested a better solution – the scroll. As this unrolled, the formal theme was developed in a period of time comparable with that required for the unfolding of a fugue in music. In 1919, Richter painted his first scroll-picture, *Prélude*, which was followed by others, many of which bore the title 'fugue' or 'orchestration'.

If this idea of articulating time and movement was to be carried into the realm of real motion, the film was a logical next step. In 1921, Richter finished his first abstract film, *Rhythmus 21*, the rhythmical development of a single formal element, the rectangle, chosen because the rectangular shape of the screen is basic to the rhythmic interplay of all two-dimensional quantities and proportions.

The choice of this elementary shape, already chosen as a basic formal element by Malevich and Mondrian and passed on by them to the Constructivists, points to the circles in which Richter was moving at that time. He was particularly associated with the Constructivists and the *De Stijl* group, Gabo, Lissitzky and Van Doesburg, although his personal and artistic relationship with his Dada colleagues was as close as ever. From 1923 onwards, he edited a periodical called *G*. Among the contributors were Arp, Hausmann, Tzara, Schwitters, Man Ray and Soupault, but the single letter title (*G* for '*Gestaltung*') was Lissitzky's idea, and a square was placed after it as a tribute to Van Doesburg. The aspect of Richter's nature concerned with order, form, *Gestaltung*, structure, was taking the upper hand.

Once he had embarked on film-making, it never let him go. It drove painting further and further into the background. In 1926 he made his film *Filmstudie*, with music by Stuckenschmidt, and in 1927 he made *Vormittagsspuk* ('Ghosts before Breakfast'), for which Hindemith subsequently wrote a score. *Vormittags-*

spuk is one of the first Surrealist films. The 'characters' are everyday objects incited to incongruous juxtapositions and demented sequences of actions by a 'revolt against routine'. At this point Richter committed himself wholly to the cinema and relegated painting to a subordinate position. He studied all aspects of film technique, made numerous documentary, advertising and experimental films, and wrote a number of works on the history, theory and practice of the film.

Richter lived in Switzerland from 1932 until 1940, when he left Europe for the USA. In 1942 he took charge of the Institute of Film Techniques at the City College of New York, where he taught for nearly fifteen years. Between 1944 and 1947 he made his famous Surrealist film *Dreams that Money Can Buy*, in which such important artists as Léger, Duchamp, Max Ernst, Man Ray and Calder took part. Among his other films are *8 x 8* and *Dadascope*. He died in 1976, as well as his friends Max Ernst and Alexander Calder. Man Ray died a year later. Marcel Duchamp died in 1968.

During the years in America, painting returned once more to the foreground. From 1942 onwards, great scroll pictures made their appearance, in which his musical and rhythmic developments of formal themes, enriched by the use of collage, often embody allusions to the events of contemporary history, as in the huge pictorial strip *Sieg im Osten* ('Victory in the East') on the theme of Stalingrad. In 1957, Richter visited Berlin for the first time in almost thirty years. After 1958 he made frequent visits to Europe, and he then divided his time between Ascona and his country house in Connecticut. He later turned his attention wholly to painting. His pictures have become known in Germany through major one-man shows in Munich, Hanover, Kassel, Essen, Baden-Baden and Dusseldorf. They illustrate, in a sublimated form, the dialectic between chaos and form, pure spontaneity and deliberate *Gestaltung*, free improvisation and conscious Constructivism, that has characterized this artist's whole career.

It was this dialectic that led him to Dada and then, as if by reaction, to his experiments with the contrapuntal treatment of pictorial forms. It brought him close at one time to the most rigorous Constructivists, and at another time it brought him within the sphere of Surrealism. This same dialectic has given him the insight and the detachment that govern his present attitude to the two poles between which his development has taken place. This dialectic, too, enabled him to see Dada at once with deep sympathy and with critical detachment, and thus to write this book, without doubt the most important account yet written of this remarkable movement within modern culture.

Appendix

Tristan Tzara: Zurich Chronicle 1915–1919

November 1915 Exhibition of Arp van Rees Mme van Rees, at Galerie Tanner – great uproar new men see in paper – and see only a world of crystalsimplicitymetal – neither art nor painting (Chorus of critics: What shall we do? Exclusive constipation) a world of transparenceline-precision turns somersaults for a certain foreseen brilliant wisdom.

February 1916 In the most obscure of streets in the shadow of architectural ribs, where you will find discreet detectives amid red street lamps – birth – birth of the Cabaret Voltaire – poster by Slodky, wood, woman and Co., heart muscles Cabaret Voltaire and pains. Red lamps, overture piano Ball reads Tipperary piano "under the bridges of Paris" Tzara quickly translates a few poems aloud, Mme Hennings – silence, music – declaration – that's all. On the walls: van Rees and Arp, Picasso and Eggeling, Segal and Janco, Slodky, Nadelman, coloured papers, ascendancy of the New Art, abstract art and geographic futurist map-poems: Marinetti, Cangiullo, Buzzi; Cabaret Voltaire, music, singing, recitation every night – the people – the new art the greatest art for the people – van Hoddis, Benn, Tress, – balalaika – Russian night, French night – personages in one edition appear, recite or commit suicide, bustle and stir, the joy of the people, cries, the cosmopolitan mixture of god and brothel, the crystal and the fattest woman in the world: "Under the Bridges of Paris."

February 26, 1916 Huelsenbeck arrives – bang! bang! bangbangbang. Without opposition year perfume of the beginning. Gala night – simultaneous poem 3 languages, protest noise Negro music / Hoosenlatz Ho osenlatz / piano Typperary Laterna magica demonstration last proclamation!! invention dialogue!! Dada! latest novelty!!! bourgeois syncope, Bruitist music, latest rage, song Tzara dance protests – the big drum – red light, policemen – songs cubist paintings post cards song Cabaret Voltaire – patented simultaneous poem Tzara Hoosenlatz and van Hoddis Huelsenbeck Hoosenlatz whirlwind Arp-two-stem demands liquor smoke towards the bells / a whispering of: arrogance / silence Mme Hennings, Janco declaration, transatlantic art = the people rejoice star hurled upon the cubist tinkle dance.

June 1916 Publication of *Cabaret Voltaire*, Price 2 francs. Printed by J. Heuberger. Contributors: Apollinaire, Picasso, Modigliani, Arp, Tzara, van Hoddis, Huelsenbeck, Kandinsky, Marinetti, Cangiullo, van Rees, Slodky, Ball, Hennings, Janco, Cendrars, etc. Dialogue: Da Dada d a d a dadadadadada dialogue the new life – contains a simultaneous poem; the carnivorous critics placed us platonically in the giddy house of overripe geniuses. Avoid appendicitis sponge your intestines. "I found that the attacks became less and less frequent and if you wish to remain young avoid rheumatism."
Thermal golf mystery The Cabaret lasted 6 months, every night we thrust the triton of the

grotesque of the god of the beautiful into each and every spectator, and the wind was not gentle — the consciousness of so many was shaken — tumult and solar avalanche — vitality and the silent corner close to wisdom or folly — who can define its frontiers? — slowly the young girls departed and bitterness laid its nest in the belly of the family-man. A word was born no one knows how Dadadada we took an oath of friendship on the new transmutation that signifies nothing, and was the most formidable protest, the most intense armed affirmation of salvation liberty blasphemy mass combat speed prayer tranquillity private guerilla negation and chocolate of the desperate.

July 14, 1916 For the first time anywhere, at the Waag Hall:
First Dada Evening
(Music, dances theories, manifestos, poems, paintings, costumes, masks)
In the presence of a compact crowd Tzara demonstrates, we demand we demand the right to piss in different colours, Huelsenbeck demonstrates, Ball demonstrates, Arp *Erklärung* [statement], Janco *meine Bilder* [my pictures], Heusser *eigene Kompositionen* [original compositions] the dogs bay and the dissection of Panama on the piano on the piano and dock — shouted Poem — shouting and fighting in the hall, first row approves second row declares itself incompetent to judge the rest shout, who is the strongest, the big drum is brought in, Huelsenbeck against 200, Hoosenlatz accentuated by the very big drum and little bells on his left foot — the people protest shout smash windowpanes kill each other demolish fight here come the police interruption. Boxing resumed: Cubist dance, costumes by Janco, each man his own big drum on his head, noise, Negro music / trabatgea bonooooo oo ooooo / 5 literary experiments: Tzara in tails stands before the curtain, stone sober for the animals, and explains the new aesthetic: gymnastic poem, concert of vowels, bruitist poem, static poem chemical arrangement of ideas, *Burribum burribum saust der Ochs im Kreis herum* [the ox runs down the circulum] (Huelsenbeck), vowel poem aaô, ieo, aiï, new interpretation the subjective folly of the arteries the dance of the heart on burning buildings and acrobatics in the audience. More outcries, the big drum, piano and cannon impotent, cardboard costumes torn off the audience hurls itself into puerperal fever interrupt. The newspapers dissatisfied simultaneous poem for 4 voices + simultaneous work for 300 hopeless idiots.

July 1916 for the first time:
Dada Collection (patented cocktail)
Just appeared:
Tristan Tzara: *The First Celestial Adventure of Mr. Fire-extinguisher*. With coloured woodcuts by M. Janco. Price: 2 francs. Impotence cured prepaid on request.

September 1916 Phantastische Gebete (Fantastic prayers). Verses by Richard Huelsenbeck 7 woodcuts by Arp, Collection Dada. "indigo indigo / streetcar sleeping-bag / bedbug and flea / indigo indigai / umbaliska / bumm Dadai" / "brrs pffi commencer Abrr rpppi commence beginning beginning"

October 1916 Schalaben Schalomai Schalamezomai by Richard Huelsenbeck, with drawings by Arp, collection Dada. Imcomparable for your baby's toilet! Illustrated!

January—February 1917 Galerie Corray, Bahnhofstrasse, Zurich.
First Dada Exhibition.

Van Rees, Arp, Janco, Tscharner, Mme van Rees, Lüthy, Richter, Hilbig, Negro art, brilliant success: the new art. Tzara delivers 3 lectures: 1. cubism, 2. the old and the new art, 3. the art of the present. Large poster by Richter, poster by Janco. Several elderly Englishwomen take careful notes.

March 17, 1917 Galerie Dada. Directors: Tzara, Ball. March 17, introductory address. First Exhibition of: Campendonk, Kandinsky, Klee, Mense, etc.

March 23, 1917 Grand Opening Galerie Dada, Zurich, Bahnhofstrasse 19.
Red lamps mattresses social sensation Piano: Heusser, Perrottet. Recitations: Hennings, A. Ehrenstein, Tzara, Ball. Dances: Mlle Taeuber / costumes by Arp / C. Walter, etc. etc. great enchanted gyratory movement of 400 persons celebrating.

March 21, March 28, April 4, and every Wednesday 1917 Tour of the gallery guided by L. H. Neitzel, Arp, Tristan Tzara.
Lectures: March 24, Tzara: *Expressionism and abstract art;* March 31, Dr. W. Jollos: *Paul Klee;* April 7, Ball: *Kandinsky;* March 28, Tzara: *On the New Art.*

April 14, 1917 Second Event at Galerie Dada: *Der Sturm* soirée: Apollinaire, van Hoddis, Cendrars, Kandinsky, Heusser, Ball, Glauser, Tzara, Sulzberger, A. Ehrenstein, Hennings, etc. Negro Music and Dancing with the support of Mlles Jeanne Rigaud and Maya Chrusecz, Masks by Janco.
Premiere: *Sphynx and Straw Man* by O. Kokoschka. Firdusi rubberman, anima/Death.
This performance decided the role of our theatre, which will entrust the stage direction to the subtle invention of the explosive wind, the scenario in the audience, visible direction, grotesque props: the Dadaist theatre. Above all masks and revolver effects, the effigy of the director. Bravo! & Boom boom!

April 9–30, 1917 Second Exhibition at Galerie Dada: Bloch, Baumann, Max Ernst, Feininger, Kandinsky, Paul Klee, Kokoschka, etc. etc.
April 28, 1917 Evening of New Art. Tzara: cold Light, simultaneous poem by 7 persons. Glauser: poems. Negro music and dances. Janco: paintings. Mme Perrottet: Music by Laban, Schönberg etc. Ball, Hennings etc. F. Hardekopf reads from his works, etc. The audience makes itself comfortable and rarefies the explosions of elective imbecility, each member withdraws his own inclinations and sets his hope in the new spirit in process of formation: Dada.

May 2–29, 1917 Third Exhibition at Galerie Dada: Arp, Baumann, G. de Chirico, Helbig, Janco, P. Klee, O. Lüthy, A. Macke, I. Modigliani, E. Prampolini, van Rees, Mme van Rees, von Rebay, H. Richter, A. Segal, Slodky, J. von Tscharner etc. Children's Drawings — Negro Sculptures. Embroidery. Reliefs.

May 12, 1917 Galerie Dada: Dada Evening of Old and New Art.
A. Spa: from Jacopone da Todi to Francesco Meriano and Maria d'Arezzo; music by Heusser, performed by composer; Arp: Verses, Böhme — of cold and calcification. Negro Poems. Translated and read by Tzara / Aranda, Ewe, Bassoutos, Kinga, Loritja, Baronga / Hennings, Janco, Ball etc. Aegidius Albertinus, Narrenhatz' Song of the Frogs. The public appetite for the mixture of instinctive recreation and ferocious bamboula which we succeeded in presenting forced us to give, on

May 19, 1917, a Repeat Performance of Evening of of Old and New Art.

May 25, 1917 H. Heusser, Performance of Own Compositions. Piano. Song. Harmonium. Recitation: Miss. K. Wulff.

June 1, 1917 Dada Gallery goes on unlimited vacation.

July 1917 Mysterious creation! Magic revolver! The Dada Movement is launched.

July 1917 Appearance of *Dada* No. 1, a review of art and literature. Arp, Lüthy, Moscardelli, Savinio, Janco, Tzara, Meriano. Wisdom repose in therapeutic art, after long persecutions: neurasthenia of pages, thermometers of those painters named The subtle ones.

December 1917 *Dada* No. 2, price: 2 francs. Contributors: van Rees, Arp, Delaunay, Kandinsky, Maria d'Arezzo, Chirico, P. A. Birot, G. Cantarelli etc. etc.

July 1918 just appeared:
tristan tzara: 25 poems
arp: 10 woodcuts
Collection Dada

July 23 1918 Meise Hall An Evening with Tristan Tzara
Manifesto, antithesis thesis antiphilosophy, DadADADA DADA daDA dadaist spontaneity dadaist disgust LAUGHTER poem tranquillity sadness diarrhoea is also a sentiment war business poetic element infernal propeller economic spirit jemenfoutisme national anthem posters for whorehouses draymen tossed on stage, savage outburst against the rarefaction of the academic intelligence etc.

September 1918 Galerie Wolfsberg. Exhibition of Arp, Richter, McCouch, Baumann, Janco etc.

December 1918 *Dada* No. 3, Price 1.50 francs; de luxe edition: 20 francs.
Liberated order at liberty search for a continous rotary movement I do not even wish to know if there were men before me Long live Descartes long live Picabia, the antipainter just arrived from New York the big sentiment machine check long live dada Dschouang-Dsi the first dadaist down with melody down with the future (Reverdy, Raimondi, Hardekopf, Huelsenbeck, Picabia, Prampolini, Birot, Soupault, Arp, Segal, Sbarbaro, Janco, Richter, Dermée, Huidobro, Savinio, Tzara were contributors). Let us destroy let us be good let us create a new force of gravity No = Yes Dada means nothing life Who? catalogue of insects / Arp's woodcuts / each page a resurrection each eye *un salto mortale* down with Cubism and Futurism each phrase an automobile horn let us mix let us mix friends and colleagues the bourgeois salad in the eternal basin is insipid and I hate good sense.
At this point intervenes / hats off! / *Novissima Danzatrice* Dr W. Serner Attraction! who has seen with his own eyes and squashed the bedbugs between the meninges of the counts of goodness. But the mechanism turns
turn turn Baedeker nocturnes of history

brush the teeth of the hours
keep moving gentlemen
noise breaks pharmaceutical riddles

December 31, 1918 Arp: the columns of reclining legs the cardboard phenomenon dance crater gramophone succession of lights in the darkness cocktail surprises for lovers and progression fox-trot house Flake, Wigmann, Chrusecz, Taeuber, madness in centimetres problematic and visual exasperation / first free exercise of / dadaist spontaneity / in colour / and every man his own war-horse.

January 1919 Exhibition of Picabia, Arp, Giacometti, Baumann, Ricklin, etc. at the Kunsthaus.

January 16, 1919 Kunsthaus. Lecture by Tzara *On Abstract Art* with slides in which professors are seen arranging the ineffable in drawers full of squares cooked in oil of assassin applause on the part of Good-will-explanation from Boomboom, the genuine, by the lack of landscape hat fish in pictures excaping from their frames. Infusion of slow bacteria under shivering veins.

February 1919 Just appeared: / Dada Movement Editions / 391 / Price 2 francs / Travelling magazine / New York-Barcelona / Gabrielle Dada Manifesto Buffet Alice Bailly, Arp the eternal will exhibit tree roots from Venice, Picabia, Picabia. The Blind Man, Ribemont-Dessaignes, Tzara, Duchamp, etc.

April 9, 1919 Kaufleuten Hall Non Plus Ultra
Ninth Dada Evening. Producer: W. Serner.
Tamer of Acrobats, Tzara, signs crucifix of impatience mist of suspicions sparks of anxiety showed their canine teeth 2 weeks before the show and publicity acute disease spread through the countryside.
1500 persons filled the hall already boiling in the bubbles of bamboulas.
Here is Eggeling connecting the wall with the ocean and telling us the line proper to a painting of the future; and Suzanne Perrottet plays Erik Satie (+ recitations), musical irony non-music of the jemenfoutiste gaga child on the miracle ladder of the Dada Movement. But now Mlle Wulff appears / superhuman mask ½ o/o § ? / to accentuate the presence of Huelsenbeck and Laughter (beginning) the candy makes an impression a single thread pases through the brains of the 1500 spectators. And when the shaded Stage is revealed with 20 persons reciting Tr. Tzara's simultaneous poem: *The Fever of the Male* the scandal assumes menacing proportions islands spontaneously form in the hall, accompanying, multiplying underlining the mighty roaring gesture and the simultaneous orchestration. Signal of the blood. Revolt of the past, of education. Feverish fiction and 4 acrid macabre cracks in the barrack. Under the bridges of Paris. In the ammoniac storm a sash is brought to the author by Alice Bailly and Auguste Giacometti.
Richter elegant and malicious. For against and without Dada, from the Dada point of view dada telegraphy and mentality etc. dada. dada dada. Arp hurls the cloud pump under the enormous oval, burns the rubber, the pyramid stove for proverbs bright or swampy in leather pockets. Serner takes the floor to illuminate his dadaist Manifesto and now, 'when a queen is an armchair a dog is a hammock' the tumult is unchained hurricane frenzy siren whistles bombardment song the battle starts out sharply, half the audience applaud the protestors hold

the hall in the lungs of those present nerves are liquefied muscles jump Serner makes mocking gestures sticks the scandal in his buttonhole / ferocity that wrings the neck / Interruption. Chairs pulled out projectiles crash bang expected effect atrocious and instinctive.

Noir Cacadou, Dance (5 persons) with Mlle Wulff, the pipes dance the renovation of the headless pythecantropes stifles the public rage. The balance of intensity inclines towards the stage. Serner in the place of his poems lays a bunch of flowers at the feet of a dressmaker's dummy. Tzara prevented from reading the Dada Proclamation delirium in the hall, voice in tatters drags across the candelabras, progressive savage madness twists laughter and audacity. Previous spectacle repeated. New dance in 6 enormous dazzling masks. The End. Dada has succeeded in establishing the circuit of absolute unconsciousness in the audience which forgot the frontiers of education of prejudices, experienced the commotion of the New.

Final victory of Dada.

May 1919 Latest novelty Dada Anthology *Dada*, Nos. 4–5. Price: 4 francs; de luxe edition: 20 francs.

Alarm clock firecrackers Picabia, electric battery Picabia Tzara ringing calendar 3 easy plays Cocteau mote on midwife poetry Globe Giacometti Reverdy 199 Glove Tohubohu Radiguet triangle catastrophe p. a. Birot, Hausmann latest magic TNT Arp Aa 24 arp in sections asphodel foreskin owl taxi driver G. Ribemont-Dessaignes words at random in priestly function Gabrielle Buffet MAM vivier dada receiver of contributions Dada André Breton the footsoldier Chirico rolls the Dada statue out full length Louis Aragon invents streets Ph. Soupault Eggeling Richter the pretty bird drum Huelsenbeck, the splendours Hardekopf and Serner-SERNER-Ser serves the cablegram Art is dead etc. Inaugurates different colours for the joy of transchromatic disequilibrium and the portable circus velodrome of camouflaged sensations knitting anti-art the piss of integral courage diverting diversities under the latest cosmopolitan vibration.

June 1919 Mock duel Arp + Tzara on the Rehalp with cannons but aimed in the same direction audience invited to celebrate a private bluish victory.

October 1919 Just appeared: *Der Zeltweg* / Dadaists in the spotlight! Price 2 Francs. Contributors: O. Flake, Huelsenbeck, Christian Schad, Serner, Arp, Tzara, Giacometti, Baumann, Helbig, Eggeling, Richter, Vagts, Taeuber, Wigman, Schwitters, etc. Dadaists in the spotlight! Neo-Dadaism Attention aux pick-pockets very much è pericoloso. Tr. Tzara.

Up to October 15, 8,590 articles on Dadaism have appeared in the newspapers and magazines of: Barcelona, St. Gall, New York, Rapperswill, Berlin, Warsaw, Mannheim, Prague, Rorschach, Vienna, Bordeaux, Hamburg, Bologna, Nuremberg, Chaux-de-fonds, Colmar, Jassy, Bari, Copenhagen, Bucharest, Geneva, Boston, Frankfurt, Budapest, Madrid, Zurich, Lyon, Basle, Christiania, Berne, Naples, Cologne, Seville, Munich, Rome, Horgen, Paris, Effretikon, London, Innsbruck, Amsterdam, Santa-Cruz, Leipzig, Lausanne, Chemnitz, Rotterdam, Brussels, Dresden, Santiago, Stockholm, Hanover, Florence, Venice, Washington, etc. etc.

(From *Dada Almanach,* Berlin, 1920. This translation from the French by Ralph Manheim is reproduced by permission from Robert Motherwell's anthology *The Dada Painters and Poets).*

Bibliography

I Documentary and Historical Works

ADES, Dawn. *Dada and Surrealism*. London and NY, 1974. *Photomontage*. London and NY, 1976. *Dada and Surrealism Reviewed*. London, 1978.

AESCHIMANN, Paul. *Le Dadaïsme*. In Montfort Eugène (ed.). *Vingt-cinq ans de littérature française*. vol. 1 pp. 65–67. Paris, Librairie de France, 1925.

ARAGON, Louis. *Projet d'histoire littéraire contemporaine*. *Littérature* (nouv. sér.). Paris, *La peinture au défi*. September 1922, No. 4. Paris, Galerie Goemans, 1930. 32 pp., 23 illus.

BALAKIAN, Anna. *Literary Origins of Surrealism*. New York, 1947.

BARR, Alfred H., Jr. (ed.). *What is Modern Painting?* New York, 1943. *Fantastic Art, Dada, Surrealism*. 3rd ed., New York, 1947. *Masters of Modern Art*. New York, The Museum of Modern Art, 1955. Cont. comments on: Arp, Theo van Doesburg, Marcel Duchamp, Max Ernst, Grosz, Man Ray, Hans Richter, Schwitters, Alfred Stieglitz.

BENET, Raphael. *El futurismo comparado; el movimiento Dada*. Barcelona, 1949.

CASSOU, Jean. *Le dadaïsme et le surréalisme*. In Huyghe, R. (ed.). *Histoire de l'art contemporain: la peinture*, Paris, 1935.

COWLEY, Malcolm. *The Religion of Art; A Discourse over the Grave of Dada*. In *The New Republic*, New York, 10 January 1934. pp. 246–249.

DAIMONIDES. (Pseudonym of Dr Carl Döhmann). *Zur Theorie des Dadaismus*. See *Dada-Almanach*, pp. 54–62. See *Dada, Der*.

FERNÁNDEZ, Justino. *Prometeo: ensayo sobre pintura contemporánea*. Mexico City, 1945.

FLAKE, Otto. *Ja und Nein*. Roman. Berlin, 1920. (*Roman à clef* on Zürich Dada.) *Thesen*. In *Der Zeltweg*.

GAFFÉ, René. *Peinture à travers Dada et le surréalisme*. Brussels, 1952.

GASCOYNE, David. *A Short Survey of Surrealism*. London, 1935.

GIEDION-WELCKER, Carola. *Contemporary Sculpture; An Evolution in Volume and Space*. New York, 1955; 2nd edn, rev., 1961. *Poètes à l'écart; Anthologie der Abseitigen*. Bern-Bümplitz, 1946.

GLAUSER, F. *Dada*. In *Schweitzer Spiegel*. October 1949.

GLEIZES, Albert. *The Dada Case*. See Motherwell pp. 298–303. From *Action*. Paris, April 1920. No 3.

HAFTMANN, Werner. *Painting in the 20th Century*. 2 vols. London, 1960 (superseding an earlier German edition).

HARRIES, Karsten. *In a strange land; an explora-*

tion of nihilism. Yale University dissertation. New Haven, Conn., USA.

HEIDEGGER, Martin, *Holzwege.* Frankfurt am Main, 4 August 1963.

HERING, Karl Heinz, and RATKE, Ewald (eds.). *Dada: Dokumente einer Bewegung.* Düsseldorf, 1958. (Catalogue of exhibition organized by the Düsseldorfer Kunstverein.)

HUELSENBECK, Richard. *Dada; eine literarische Dokumentation,* Hamburg, 1964. (Bibliog. by B. Karpel, pp. 261–95.)

HUGNET, Georges. *L'aventure Dada. 1916–1922.* Introduction de Tristan Tzara. Paris, Galerie de l'Institut, 1957. 101 pp., 32 illus. Quoted in Chapter 6 of present work. *L'Esprit dada dans la peinture.* In *Cahiers d'Art,* Paris, 1932 and 1934 English translation: see Motherwell pp. 123–196.

JEAN, Marcel. *The History of Surrealist Painting.* New York, 1960.

JUNG, C. G., and PAULI W. *Naturerklärung und Psyche.* Zürich, 1952. English edition: *The Interpretation of Nature and the Psyche.* London, 1955.

KAMMERER, Paul. *Das Gesetz der Serie.* Stuttgart, 1919.

KNOBLAUCH, Adolf. *Dada.* Leipzig, 1919. (*Der jüngste Tag,* vol. 73/74.) Woodcut by Lyonel Feininger. 76 pp.

KNOLL, Max. *Transformation der Wissenschaft in unserer Zeit.* Zürich, 1957.

LEMAITRE, Georges. *From Cubism to Surrealism in French Literature.* 2nd edn, Cambridge, Mass., 1947.

MORGENSTERN, Christian. *Galgenlieder.* Berlin, 1914.

MOTHERWELL, Robert (ed.). *The Dada Painters and Poets; An Anthology.* New York, 1951. (Bibliog. by B. Karpel, pp. 318–81.)

MUCHE, Georg. *Blickpunkt; Sturm, Dada, Bauhaus, Gegenwart.* Munich, 1961.

NADEAU, Maurice. *Histoire du surréalisme.* 2 vols., Paris, new edn, 1960; trans. Richard Howard, *The History of Surrealism.* London, 1968.

RAYMOND, Marcel. *From Baudelaire to Surrealism.* New York, 1950.

RUBIN, William, *Dada and Surrealist Art.* New York, 1969.

SANOUILLET, Michel, *Dada à Paris, Histoire Générale du Mouvement. Dada.* Paris, 1965. *Francis Picabia et 391.* Paris, 1966.

SCHIFFERLI, Peter (ed.). *Die Geburt des Dada; Dichtung und Chronik der Gründer.* Zürich, 1957. (Texts by Hans Arp *[Dadaland],* Richard Huelsenbeck and Tristan Tzara.) *Das war Dada; Dichtungen und Dokumente.* Munich, 1963.

SILBERER, Herbert. *Der Zufall und die Koboldstreiche des Unbewußten.* In *Schriften für Seelenkunde und Erziehungskunst.* Vol 3. Bern, 1921.

URBANI. *Über die Rolle des Zufalls in den bildenden Künsten.* Paris, 1894.

VERKAUF, Willy (ed.). *Dada: Monograph of a Movement.* London, 1957. (Bibliog. pp. 176–83.)

VISCHER, Melchior. *Sekunde durch Hirn, ein*

dada-Roman. Hanover, 1920. (*Die Silbergäule,* vol. 59–61.) Cover drawing by Kurt Schwitters.

WEIDLE, Wladimir. *Immortalité des Muses.*

ZURICH. Early exhibition catalogues: Galerie Tanner. 14–30 November 1915. Otto van Rees, Hans Arp, A. C. van Rees-Dutilh: Modern tapestries, embroidery, paintings, drawings. Cat. with preface by Arp. Illus.
Galerie Corray, Zürich. *January-February, 1917. 1. Dada-Ausstellung.* First Dada Exhibition.
Galerie Wolfsberg. September 1918. Ex. Arp, Richter, Janco etc.

II Dada Periodicals

The Blind Man. Ed. by Marcel Duchamp. No. 2, May 1917. (Apparently only number issued.)

Blutige Ernst, Der. Ed: George Grosz and Carl Einstein. Berlin 1919.

Bulletin D. Ed. by J. T. Baargeld and Max Ernst. Cologne, 1919. (One number only.)

Cabaret Voltaire. Ed. by Hugo Ball. Zurich, 1916. (One number only.)

Camera Work. Ed. by Alfred Stieglitz. New York, 1919.

Cannibale. Ed. by Francis Picabia. Paris, 1920. (Two numbers.)

Club Dada. Ed. by R. Huelsenbeck, F. Jung, R. Hausmann. Berlin, 1918. (One number only.)

Cœur à barbe, Le. Journal transparent. Per Ed: Tristan Tzara. Paris, 1922. (One number only.)

Contimporanul. Per Ed: Marcel Janco, I. G. Costin, Jon Vinea. Bucuresti, 1922–36.

Dada. Ed. by Tristan Tzara. Zurich, Paris, 1917–22.

Der Dada. Ed. by Raoul Hausmann. Berlin, 1919–20.

Dada au Grand Air. Der Sängerkrieg in Tirol, Tarrenz Bei Imst. 16 September, 1886–1921. Paris, 1921. 4 pp. illus. Contr: Arp, Baargeld, Eluard, Ernst, Th. Fraenkel, Ribemont-Dessaignes, Soupault, Tzara etc.

Dada soulève tout. Appeared 12 January 1921. *(Dada inaugure l'année en nous annonçant que les signataires de ce manifeste habitent la France, l'Amérique, l'Allemagne, l'Italie, la Suisse, la Belgique etc. . . ., mais n'ont aucune nationalité.)* A pamphlet.

Dada-Tank. No. 1. Ed: Dragan Aleksic. Zagreb, 1922. Contr: Aleksic, Tzara, Castor, Schwitters, Jim Rad.

G. Material zur elementaren Gestaltung. Ed. Hans Richter Nos. 1–5/6, 1923–26.

Gegenstand. Internationale Rundschau der Gegenwart. Ed: El Lissitzky and Ilya Ehrenburg. Berlin, 1922. In French: *Objet.* Russian: *Vesch.*

Das Hirngeschwür. Per. Ed: Walter Serner. Zürich, 1919 (not published).

Jedermann sein eigner Fussball. Per. Ed: George Grosz and Franz Jung. No. 1. Berlin, 15 February 1919.

Ma ('Today'). Per. Ed: Ludwig Kassák. Vienna, 1918–25. (In Hungarian.)

Maintenant. Ed. by Arthur Cravan. Paris, 1913–15. (Repr. with introduction by Bernard Delvaille, Paris, 1957.)

Marstall, Der. ('Antizwiebelfisch'.) Per. Hanover, 1920. Ind.

Mécano. Ed. by Theo van Doesburg. Leiden, 1922–23.

Merz. Ed. by Kurt Schwitters. Hanover, 1923–32.

Neue Jugend. Berlin, 1916–17. Illus. Contr: Grosz, Herzfelde, Huelsenbeck etc. Banned by censors.

New York Dada. Ed. by Marcel Duchamp and Man Ray. New York, 1921. (One number only.)

Nord-Sud. Revue Littéraire. Ed: Pierre Reverdy. Paris, 1917. Contr: Apollinaire, Aragon, Breton, Max Jacob, Philippe Soupault etc.

Pleite, Die. Ed: George Grosz and Wieland Herzfelde. Berlin, 1919–24.

La pomme de pins. Ed. by Francis Picabia. Paris, 1922. (One number only.)

Proverbe. Ed. by Paul Eluard. Paris, 1920.

Rongwrong. Ed. by Marcel Duchamp. New York, 1917. (One number only.)

Die Schammade. Ed. by Max Ernst. Cologne, 1920. (One number only.)

391. Ed. by Francis Picabia. Barcelona, New York, Zurich, Paris, 1917–24. (Reprinted with introduction by Michel Sanouillet, Paris, 1960.)

291. Ed. by Alfred Stieglitz. New York, 1915–16.

Der Ventilator. Ed. by J. T. Baargeld. Cologne, 1919.

Vertical. Per. Ed: Guillermo de Torre and Jacques Edwards. Madrid, 1920.

Z. Per. Ed: Paul Dermée. Paris, March 1920. (One number only.) Contr: Arnauld, Aragon, Dermée, Eluard, Breton, Picabia, Ribemont-Dessaignes, Soupault, Tzara.

Der Zeltweg. Ed. by Otto Flake, Walter Serner and Tristan Tzara. Zurich, 1919. (One number only.)

III Some Leading Dadaists

ARP, Hans.
Der Vogel selbdritt. Berlin, 1920.
Die Wolkenpumpe. Hanover, 1920.
Der Pyramidenrock. Erlenbach-Zurich, Munich, 1924.
– and LISSITZKY, El (ed.). *Les Ismes de l'Art. The Isms of Art. Die Kunstismen.* Erlenbach-Zurich and Munich, 1925. 11 pp. + 48 pl. Text: English, French, German.
Weisst du schwarzt du. Zurich, 1930.
– and HUIDOBRO, Vincente. *Tres inmensas novelas.* Santiago, 1935. (Ger. trans. *Drei und drei surreale Geschichten.* Berlin, 1963.)
Le siège de l'air. Paris, 1946.
Dadaland. Zürcher Erinnerungen aus der Zeit des Ersten Weltkrieges. Zurich, 1948.
On My Way; Poetry and Essays 1912–1947. New York, 1948. (Includes *Dadaland.*)
Onze peintres vus par Arp. Zurich, 1949.
Dreams and Projects. New York, 1951–52.
Collages. Paris, 1955.
Unsern täglichen Traum . . . Erinnerungen, Dichtungen und Betrachtungen aus den Jahren 1914–1954. Zurich, 1955.
Gesammelte Gedichte. Wiesbaden 1963–
GEIDION-WELCKER, Carola. *Jean Arp.* London, Stuttgart, 1957.

READ, Herbert. *Jean Arp*. London and New York, 1968.
SOBY, James Thrall (ed.). *Arp*. New York, 1958. (Exhibition at the Museum of Modern Art.)

BAADER, Johannes.
Sonderausgabe Grüne Leiche. Berlin, 1919. A fly-sheet.
Dio-Dada-Drama. In *Dada Almanach*, Berlin, 1920.

BAARGELD, Johannes Theodor (ed.).
see *Bulletin D*.
(ed.) see *Der Ventilator*.
(ed.) see *Bologna*.

BALL, Hugo.
(ed.). *Almanach der freien Zeitung, 1917–1918*. Bern 1918.
Flametti; oder vom Dandysmus der Armen. Berlin, 1918.
Zur Kritik der deutschen Intelligenz. Bern, 1919.
Die Flucht aus der Zeit. Munich, Leipzig, 1927.
Briefe, 1911–1927. Einsiedeln, Zurich, Cologne, 1957.
Gesammelte Gedichte. Zurich, 1963. (Preface by Hans Arp.)
EGGER, Eugen: *Hugo Ball – ein Weg aus dem Chaos*. Olten, 1951.
(see also HENNINGS-BALL)

BRETON, André.
Mont de piété. Paris, 1919.
– and SOUPAULT, Philippe. *Les champs magné-tiques*. Paris, 1919.
Les pas perdus. Paris, 1924.
Le surréalisme et la peinture. Paris, 1928.
(ed.). *Anthologie de l'humour noir*. Paris, 1950.
Three Dada Manifestoes. See Motherwell, pp. 197–206.
Entretiens. Paris, 1952.

BUFFET-PICABIA, Gabrielle.
Aires abstraites. Geneva, 1957.
On demande: Pourquoi 391? Qu'est-ce que 391? In *Plastique*, Paris, 1937. No. 2.
Arthur Cravan and American Dada. In *Transition*, Paris, 1938, No. 27. See also Motherwell, pp. 13–17.

CENDRARS, Blaise.
Dix-neuf Poèmes élastiques. Paris, 1919.
La Fin du monde, filmée par l'Ange N-D Roman. Paris, La Sirène, 1919. With 'composition en couleurs' by Fernand Léger. Ind.
LEVESQUE, J.H., *Blaise Cendrars*. 1948.

DOESBURG, Theo van.
Wat is Dada? The Hague, 1923.

DUCHAMP, Marcel.
La mariée mise à nu par ses célibataires même. Paris, 1934.
Rrose Sélavy; oculisme de precision; Poil et coups de tout genre. Paris, 1939.
From the Green Box. New Haven, 1957. (Trans. and with a preface by George Heard Hamilton.)
Marchand du sel. Paris, 1958. (Includes notes for *La mariée mise à nu par ses célibataires même*.)
The Bride Stripped Bare by her Bachelors, Even: a typographic version by Richard Hamilton of Marcel Duchamp's Green Box. (Translated by George Heard Hamilton.) New York, London, 1960.
BONK, Ecke. *Marcel Duchamp: The Portable Museum*. London and New York, 1989.
CABANNE, Pierre. *Dialogues with Marcel Duchamp*. London and New York, 1971.
D'HARNONCOURT, Anne and K. McShine (eds.) *Marcel Duchamp*. New York, 1973.
LEBEL, Robert. *Marcel Duchamp*. New York, London, 1959. (Trans. George Heard Hamilton.)
SCHWARTZ, Arturo. *The Complete Works of Marcel Duchamp*. New York, 1969; London, 1970; rev. 1997.
SEIGEL, Jerrold. *The Private Worlds of Marcel Duchamp: Desire, Liberation and the Self in Modern Culture*. California, 1995.

TOMKINS, Calvin (ed.). *The World of Marcel Duchamp*. New York, 1966.
Kunstmuseum Zürich. *Dokumentation über Marcel Duchamp*. Zurich, 1960.
Galerie Schwarz Milano. *Marcel Duchamp: ready-mades, etc., 1913–1964*. Paris, 1964.

EINSTEIN, Carl.
Bebuquin oder die Dilettanten des Wunders, Berlin. *Die Aktion. Aeternisten Bibl.* 1913.

ELUARD, Paul.
Le devoir et l'inquiétude. Paris, 1917.
Les nécessités de la vie et les conséquences des rêves. Paris, 1921.
Répétitions. Paris, 1922.
Les malheurs des immortels. Paris, 1922. (Eng. trans. *Misfortunes of the Immortals*. New York, 1943.)

ERNST, Max.
Fiat Modes (Pereat ars), Cologne, Verlag der ABK, 1919. (Eight lithographs commissioned by the City of Cologne.)
Histoire naturelle. Paris, 1926.
La femme 100 têtes. Paris, 1929.
Rêve d'une petite fille qui voulut entrer au carmel. Paris, 1930.
Oeuvres de 1919 á 1936. Paris, 1937.
Beyond Painting. New York, 1948. (Bibl. by B. Karpel.)
At Eye Level; Paramyths. Beverly Hills, 1949.
Gemälde und Graphik, 1920–1950. Stuttgart, 1951.
Paramythen; Gedichte und Collagen. Cologne, 1955.
ZERVOS, Christian (ed.). *Max Ernst*. Paris, 1937.
WALDBERG, Patrick. *Max Ernst*, Paris, 1958.
LIEBERMAN, W. S. (ed.). *Max Ernst*. New York, 1961.
RUSSELL, John. *Max Ernst*. London and New York, 1967.
SPIES, Werner. *Max Ernst Loplop: The Artist's Other Self*. London, 1983.

Wallraf-Richartz-Museum. *Max Ernst*. Cologne, 1962–63. (Exhibition catalogue.)
Brühl, *Max Ernst*, 1951. (Exhibition catalogue, contains text pp. 155–9 of the present book.)

GROSZ, George.
Kleine Grosz-Mappe. Berlin-Halensee, 1917.
Das Gesicht der herrschenden Klasse. Berlin, 1921.
Ecce Homo. Berlin, 1923.
Die Kunst ist in Gefahr; Drei Aufsätze. Berlin, 1925.
30 Drawings and Watercolors. New York, 1944.
A Little Yes and a Big No. New York, 1946.
BAUR, J. I. H. *George Grosz. New York*, 1954. (Exhibition catalogue.)
BITTNER, Herbert (ed.). *George Grosz*. New York, 1960.
DÄUBLER, Theodor. *George Grosz*. In *Die Weissen Blätter*, Rascher, Zürich, November 1916, No. 11. pp. 167–170. Seven drawings by George Grosz.

HARDEKOPF, Ferdinand.
Der Abend. Dialog. Leipzig, Kurt Wolff, 1913.
(Der jüngste Tag, vol. 4.)
Lesestücke. Berlin, 1916. (*Aktionsbücher der Aeternisten*.) 64 pp.
Privatgedichte. Munich, 1921.
(Der jüngste Tag.)
Anmerkungen. Berlin, 1914.

HAUSMANN, Raoul.
Material der Malerei, Plastik, Architektur. Berlin, 1918.
Hurrah! Hurrah! Hurrah! 12 Satiren. Berlin, 1921.
Pin. (With Kurt Schwitters.) Paris, 1947–48.
Courrier Dada. Paris, 1958.

HEARTFIELD, John.
Photomontagen zur Zeitgeschichte. I. Zurich, 1945.

HERZFELDE, Wieland. *John Heartfield; Leben und Werk, dargestellt von seinem Bruder.* Dresden, 1962.

HENNINGS-BALL, Emmy.
Gefängnis. Berlin, 1919.
Das Brandmal. Berlin, 1919.
Helle Nächte; Gedichte. Berlin, 1922.
Hugo Balls Weg zu Gott. Munich, 1931.
Ruf und Echo; mein Leben mit Hugo Ball. Einsiedeln, Zurich, Cologne, 1953.

HUELSENBECK, Richard.
Phantastische Gebete. Zurich, 1916 and 1960.
Schalaben Schalomai Schalomezomai. Zurich, 1916.
Dadaistisches Manifest. Berlin, 1918. (See also *Dada Almanach.*)
Verwandlungen. Munich, 1918.
Akzenten oder die Knallbude. Berlin, 1918.
Dada Manifesto 1949. New York, 1951. 2 pp. leaflet.
En avant Dada. Hanover, 1920.
Dada siegt. Berlin, 1920.
Deutschland muss untergehen! Erinnerungen eines alten dadaistischen Revolutionärs. Berlin, 1920.
(ed.) *Dada Almanach.* Berlin, 1920.
Doktor Billig am Ende. Munich, 1921.
Die Antwort der Tiefe. Wiesbaden, 1954.
Mit Witz, Licht und Grütze; auf den Spuren des Dadaismus. Wiesbaden, 1957.
Dada: eine literarische Dokumentation. Hamburg, 1964. (Bibliog. by B. Karpel, pp. 261–95.)

HUIDOBRO, Vincente.
Saisons choisies. Poems. Paris, 1921. With portrait by Picasso.
Manifestes. Paris, 1925. 119 pp.
Tout à coup. Poems. Paris, 1925.
See *Creacion.* Per.

ILIAZDE. (Ilya Zdanevich.)
Ledentu le Phare. Paris, 1922.

JANCO, Marcel.
Album; 8 gravures sur bois, avec un poème par Tristan Tzara. Zurich, 1917.
SEUPHOR, Michel. *Marcel Janco.* Amriswil, 1963.

JUNG, Franz.
Opferung. Roman. Berlin, 1916.
Jehan. Mühlheim an der Donau, Saturnen, 1919. With woodcut by Marcel Janco.
Das Trottelbuch. Die Aktion, Aeternisten Bibl. 1913.
Der Sprung aus der Welt. Berlin, 1918.
Der Wig nach unten. Neuwied, Luchterhand, 1961.

MEHRING, Walter.
The Lost Library: the Autobiography of a Culture. New York, 1951.
Berlin-Dada. Zurich, 1959.

PANSAERS, Clément.
Le Pan Pan au cul du nègre. Brussels, Ed: Alde, 1920, with engraving by the author.
L'Apologie de la Paresse. Antwerp, 1921.

PÉRET, Benjamin.
Le Passager du transatlantique. Paris, Au Sans Pareil, 1921 (Collection Dada). With 4 Arp drawings.
Au 125 du boulevard Saint-Germain. Paris, 1923. Illus. by Max Ernst.

PICABIA, Francis.
Poèmes et dessins de la fille née sans mère. Lausanne, 1918.
L'athlète des pompes funèbres. Lausanne, 1918.
Râteliers platoniques. Lausanne, 1918.
Pensées sans langage; Poème. Paris, 1919.
Jésus Christ rastaquouère. Paris, 1920.
Unique eunuque. Paris, 1920.
Dits: aphorismes réunies par Poupard-Liessou. Paris, 1960.
Galerie René Drouin. *491 (Francis Picabia, 1897–1949).* Paris, 1949.

RAY, Man.
Les champs délicieux. Paris, 1922.
Revolving Doors, 1916–1917. Paris, 1926.
Photographies, 1920–1934. Paris, 1934.
Some Papers. Beverly Hills, Calif., 1948.
Self Portrait. Boston, Toronto, London, 1963.
Portraits. Paris, 1963. (collected by L. Gruber.)

RIBEMONT-DESSAIGNES, Georges.
L'empereur de Chine, suivi de Le serin muet. Paris, 1921.
Man Ray. Paris, 1924.
Déjà jadis, ou du mouvement dada à l'espace abstrait. Paris, 1958.

RICHTER, Hans.
Filmgegner von Heute – Filmfreunde von Morgen. Berlin, 1929.
Dada Profile. Zurich, 1961.
A History of the avant-garde. In *Art in cinema:* Cat. Ed: Frank Stauffacher, San Francisco, Museum of Art, 1947.
History of the avant-garde in Germany. In *Experiment in the Film* by Roger Maurell. London, Grey Wall Press, 1949.
Film as an original art form. In *College Art Journal,* New York, 1951.
Akademie der Künste. *Hans Richter: Ein Leben für Bild und Film.* Berlin, 1958. (Exhibition catalogue.)
Museo Civico d'Arte Moderna. *Hans Richter.* Turin, 1962.
Gallerie Denise René. *Jean Arp and Hans Richter,* Paris, 1965. (Exhibition catalogue.)

SATIE, Erik.
Le Piège de Méduse. Comédie lyrique. Paris, Galerie Simon, 1921. Braque wood engravings.
Mémoires d'un amnésique. In *Journal de la Société musicale indépendant.* Paris, 15 April 1912. 15 February 1913. *Memoirs of an Amnesic* (fragments) in Motherwell pp. 17–19. *Notes sur la musique moderne.* In *L'Humanité.* 11 October 1919.

SCHWITTERS, Kurt.
Anna Blume: Dichtungen. Hanover, 1919.
Die Kathedrale; 8 Lithographien. Hanover, 1920.
Memoiren Anna Blume in Bleie. Freiburg, 1922.
Die Blume Anna; die neue Anna Blume, eine Gedichtsammlung aus den Jahren 1918–1922. Berlin, 1923.
Auguste Bolte. Berlin, 1923.
– with STEINITZ, Käte, and DOESBURG, Theo van, *Die Scheuche; Märchen.* Hanover, 1925. *Erstes Veilchen-Heft; eine kleine Sammlung von Merzdichtungen aller Art.* Hanover, 1931.
Ursonate. Hanover, 1932.
ELDERFIELD, John. *Kurt Schwitters.* London, 1985.
SCHMALENBACH, Werner. *Kurt Schwitters.* Cologne, 1967.
THEMERSON, Stefan. *Kurt Schwitters in England.* London, 1958.
Wallraf-Richartz Museum. *Kurt Schwitters, 1887–1948.* Cologne, 1963. (Exhibition catalogue.)

SERNER, Walter.
Letzte Lockerung. Manifest Dada. Hanover, 1920 (*Silbergäule* 62–64), 45 pp.
(ed.) *Das Hirngeschwür.* Per. (Did not appear).
(ed.) *Der Zeltweg.* Per.

SOUPAULT, Philippe.
Aquarium; poèmes. Paris, 1917.
Rose des vents. Paris, 1920.
Westwego; poèmes. Paris, 1922.

TZARA, Tristan.
La première aventure céleste de Monsieur Antipyrine. Zurich, 1916.
Vingt-cinq poèmes. Zurich, 1918.
Cinéma calendrier du cœur abstrait; Maisons.

Paris, 1920.
De nos oiseaux; poèmes. Paris, 1924; rev. 1963; trans. 1977.
Mouchoir des nuages. Paris, 1925.
L'homme approximatif. Paris, 1931.
La deuxième aventure céleste de M. Antipyrine. Paris, 1938.

Morceaux choisis. Paris, 1947.
BÉHAR, H. (ed.). *Oeuvres complètes* (6 vols). Paris, 1975–82.

VACHÉ, Jacques.
Lettres de guerre. Preface by André Breton. Paris, 1919. New edn. Paris, 1949.

Index